Moving Innovation

Moving Innovation

A History of Computer Animation

Tom Sito

The MIT Press
Cambridge, Massachusetts
London, England

First MIT Press paperback edition, 2015

© 2013 Massachusetts Institute of Technology

This book was set in Stone Sans and Stone Serif by Toppan Best-set Premedia Limited, Hong Kong.

Library of Congress Cataloging-in-Publication Data

Sito, Tom, 1956–
Moving innovation : a history of computer animation / Tom Sito.
 pages cm
Includes bibliographical references and index.
ISBN 978-0-262-52840-5 (paperback : alk. paper)

ISBN 978-0-262-01909-5 (hardcover : alk. paper) 1. Computer animation—History. I. Title.
TR897.7.S48 2013
777'.709—dc23
2012038048

For Shamus Culhane
1911–1995

In 1977, a day after visiting NYIT, he looked up from his typewriter and said to me, "Ya know, computers are comin'. Gonna change everything. The Business [animation] won't ever be the same."

Contents

Acknowledgments ix

Introduction 1

1 Film and Television at the Dawn of the Digital Revolution 5

2 Analog Dreams: Bohemians, Beatniks, and the Whitneys 11

3 Spook Work: The Government and the Military 37

4 Academia 53

5 Xerox PARC and Corporate Culture 73

6 Hackers 89

7 Nolan Bushnell and the Games People Play 101

8 To Dream the Impossible Dream: The New York Institute of Technology, 1974–1986 123

9 Motion Picture Visual Effects and *Tron* 145

10 Bob Abel, Whitney-Demos, and the Eighties: The Wild West of CG 171

11 Motion Capture: The Uncanny Hybrid 199

12 The Cartoon Animation Industry 217

13 Pixar 239

14 The Conquest of Hollywood 253

Conclusion 267

Appendix 1 Dramatis Personae 271
Appendix 2 Glossary 283
Appendix 3 Alphabet Soup: CG Acronyms and Abbreviations 287
Notes 291
Bibliography 319
Index 327

Acknowledgments

Trying to write a book about computer animation reminded me of art historian Robert Hughes's observation about trying to carve a marble statue of a motorcar. It is an old technology saluting a young one.

I am truly grateful for the generous help of Dr. Deborah Douglas and the staff of the MIT Museum. Thanks to Doug Berman, and Tom & Ray Magliazzi of the *Car Talk* radio program, for introducing me to the MIT folks; the Computer History Museum in Mountain View, California; the Center for Visual Music (www.centerforvisualmusic. org), the repository of the works and papers of Oskar Fischinger, Mary Ellen Bute, and Jordan Belson; Larry Cuba and the iotaCenter; the library of the UCLA Animation Workshop; the Doheny Library of USC; The Los Angeles Chapter of SIGGraph; J.J. Sedelmeir; Professor Kelly Loosli of Brigham Young University; Professor Larry Loc of California State University, Fullerton for his notes on computer game development; and Professor Ellen Besen of Sheridan College for her information on Canadian universities. Thanks also to Kristof Serran and Evander Reeves for helping me with research on French and other European CG studios.

My deepest debt of gratitude is to the heroes of CG who gave me their time and put up with my questions: Jim Hillin, Larry Cuba, Mike Amron, Tina Price, Bill Kroyer, Tim Johnson, Aaron Simpson, Dave Sieg, Chris Wedge, Jim Blinn, Ed Catmull, Rex Grignon, John Hughes, John Whitney Jr., Alvy Ray Smith, Philippe Bergeron, Dan Phillips, Bil Maher, Mike Wahrman, Dave Seig, Sunil Thankamushy, Lance Williams, Jesse Silver, Tad Gielow, Bill Perkins, Steve Segal, Sherry McKenna, and all the other interviewees. Thank you to my colleague at USC, Dr. Richard Weinberg, for his valuable notes and suggestions.

Also, thanks to my UCLA research assistant Sharon Burian, and to Joy Margheim who did a wonderful first edit of the manuscript. And to Marguerite Avery of MIT Press, for rescuing an orphan in a storm.

And my wife, Pat, my lifelong partner and proofreader.

Without all their cooperation and generosity this book would not have been possible.

Introduction

Invention in the twentieth century was a messy process.
—Dr. Deborah Douglas, MIT

Deep down in the bowels of the museum archives of the Massachusetts Institute of Technology (MIT), behind gray stone walls and row after row of oak shelves and metal file cabinets, in a box sits an old doctoral thesis bound in dark-brown construction paper. The fading title page reads,

Technical Report No. 296, 30th January 1963
 Sketchpad: A Man-Machine Graphical Communication System
 By Ivan Sutherland

On page 66 is a small paragraph that ends, "Sketchpad need not be restricted to engineering drawings. Since motion can be put into Sketchpad drawings, it might be exciting to try making cartoons."

With this sentence a multibillion-dollar industry began. An industry that forever changed the way we experience the art of moving images. Using an obsolete, 1950s Cold War computer, built to track a Soviet nuclear attack, graduate student Ivan Sutherland created the first true animation program. For the first time, instead of presenting a series of numbers, a computer drew lines, and the lines formed recognizable images: a bridge, a leg moving, a face winking. Sketchpad is one of the first of many baby steps for the art of computer animation. Called computer graphic imaging, CGI, or just CG, it is the artistic edge of the information age, the arts and entertainment front of the digital revolution.

Without CG the Titanic in the movie *Titanic* could not sink; the armies of Mordor could not march on Middle Earth. We would never have known the Na'vi, Buzz Lightyear, or Shrek. By the end of the first decade of the twenty-first century the very concept of film had become an anachronism. The Hollywood of today is not the Hollywood I first came to in the 1970s. The studios today would be unrecognizable to Cecil B. DeMille, and Walt Disney. Much of that is due to CG. CG has redefined how we watch movies and broadcast media, how we teach, how we play games.

This book is an attempt to gain an overview of the complete history of computer animation. I began it when I noticed there were not many serious histories of the medium yet written. Any nods toward the history of CG were usually either a brief review in a how-to book or website, or a history of a popular software package. There are many books about the Walt Disney Studios, Pixar, and Industrial Light & Magic (ILM), but by their very nature these focus on their central subject, to the exclusion of most else. This book will show that scientists and artists were working on computer graphics when George Lucas was still a teen racing hot rods in Modesto, Steve Jobs was riding his bike by the Stanford Artificial Intelligence Lab, and John Lasseter was clutching his mother's hand as he watched an ailing Walt Disney wave from the Grand Marshal's float in the Pasadena Rose Parade.

Some CG books can be an endless litany of mechanical innovation, "tech talk." To the uninitiated it all seems like a bewildering blizzard of acronyms—DARPA, PDP-1, NYIT/CGL, DEC VAX 11/750, and more. What I found fascinating are the men and women who conceived this brave new digital world. Starched-shirted scientists, dope-smoking hippies, and insular math nerds, all united in a common goal, dreaming audacious dreams, with the mental acumen to carry them out.

These oddball scientists looked at the huge mainframe computers of IBM and Honeywell and thought, let's make cartoons with them. They created something no one asked them to and made something no one wanted, which they then built into a universe parallel to Hollywood. A universe that ultimately engulfed the older one.

As my research progressed I noticed the same names appearing at key points in the story. A small group of unique scientists and engineers who followed their dream back and forth across the country. Names like Ivan Sutherland, Dave Evans, Ed Catmull, Alan Kay, Jim Blinn, Alvy Ray Smith, Vibeke Sorensen, Jim Clark, and more. They walked away from tenured professorships, scholarships, and government posts, secure positions that would have suited any average person for the rest of their career. Wherever the cutting edge was, they had to be there. Where there was no social culture to share information on what they were creating, they created one.

Today the Digital Revolution is a historical fact. The barbarians have stormed the gates. The digital Visigoths intermarried with the analog Gallo-Romans and spawned a new society. Some of the original leaders have passed on: John Whitney, Dave Evans, Bob Abel, Lee Harrison, Bill Kovacs, Steve Jobs. When I first approached him about this project, Jim Blinn looked off thoughtfully, and said, "Yes, it is time to start writing the history."

The lack of a comprehensive history of CG up till now may be because it's a difficult subject to approach in its entirety. The history of traditional cartoon animation, what we call animation done with tools like pencils and brushes, had followed a simple linear track: flip books, zoetropes, trick films, the peg registration system, cels, rotoscope, sound, color, improved motion and acting, motion pictures, and television.

Luminaries mark the track of animation's growth—Winsor McCay, Walt Disney, Chuck Jones, Ray Harryhausen, and Hayao Miyazaki.

The problem in chronicling the growth of CG is much like the problem facing those who attempt a history of television. There is not one Edison-like genius inventor you can point to. Not one Walt Disney–type megamind who single-handedly advanced the medium by leaps and bounds. The development of CG was never that dramatic. It occurred slowly, over decades, appearing in many different places. To trace the evolution of CG we need to follow several threads simultaneously:

1. Academia
2. Industrial and defense research
3. Special effects for live-action movies
4. Games
5. Avant-garde and experimental filmmakers
6. Corporate research
7. Commercial animation

Like the plot lines of an old Russian novel, these threads developed along parallel paths, socially isolated from each other, until the vertically integrated media conglomerates of the 1990s compelled them all to converge. Writing the history of CG is not tracing a chronicle year by year as much as sewing a quilt made up of unrelated parts. Occasionally we come upon major inflection points: MIT, the University of Utah, Xerox PARC, the New York Institute of Technology, Pixar. These oases provided an intersection for talent, dynamic leadership and funding. The result was to advance the growth of the medium by several steps. So an important figure like Alvy Ray Smith or Rebecca Allen will pop up in several chapters.

I confess I was never a computer enthusiast myself. Discussions of Lissajous curves and splines are surefire ways to put me to sleep. I began as a traditional animation cartoonist. I worked with many old masters from the Hollywood cartoon's golden age, like Art Babbitt and Hanna and Barbera. I began my career painting characters on acetate cels, polishing them with tissues, alcohol, and spit before they were photographed under an Oxberry downshooter camera. I followed the century old route up the job ladder—inbetweener, assistant, animator, storyboarder, then director.

I came of age at a time when you could see the digital revolution rising on the horizon. I recall going to an ASIFA-East meeting at the old Phoenix School in New York and seeing Peter Foldes's *Hunger/La faim* in 1974. As I was putting in long hours drawing on the Richard Williams animated feature *The Adventures of Raggedy Ann and Andy* (1977) I heard about some scientists at the New York Institute of Technology out in Westbury, Long Island, trying to create a cartoon by computer. I watched *Tony de Peltrie* (1985) and *Luxo Jr.* (1986) when they premiered. While working for the Walt Disney Studios on the film *Dinosaurs* (2000), which contributed to the animation

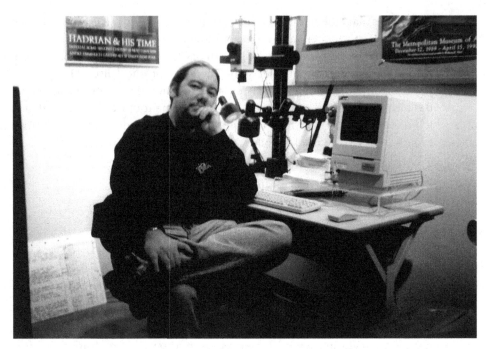

Figure 0.1
The author in his office at Walt Disney Studio in 1992. Note the Apple Macintosh adapted to film animation pencil tests. It also did e-mail.
Courtesy of the author.

software Maya being perfected, I at last began to appreciate what was occurring around me.

I have been a witness to the digital revolution without being one of its devotees. I see my role as not unlike that of the historian Polybius (200–118 BC), who attempted to explain to the rest of the Greek Mediterranean world just who these strange Romans were and why they seemed to be taking over everything.

I don't intend this to be the final word on the history of CG. I'm sure, no matter how thorough I try to be, there will be people and events I will have inadvertently left out. If so, please forgive my ignorance; I shall endeavor to do my utmost to deal with all, evenhandedly. And as any good historian knows, disagreements over the details, and their interpretation, are what make history the living art that it is.

T.S. *Los Angeles, 2012.*

1 Film and Television at the Dawn of the Digital Revolution

Computers ain't here yet. And uh, when they do come, we'll take some night classes.
—Hollywood Union Official, 1993

Motion pictures are an industrial art form. They are dependent on ever-improving technology. Picasso once said an artist can make art even by licking the dust with his tongue, but you need a little more than that to make a movie.

At the birth of cinema, pioneers popped up all around the world, more or less at the same time—Thomas Edison in America, the brothers Auguste and Louis Lumière in France, Alexander Drankov in Russia, Kenji Mizoguchi in Japan. But only in America was the production of motion pictures organized along the lines of industrialized mass production and mass marketing. American movies were cranked out on an assembly line by hundreds of workers as though they were automobiles. By the 1920s Hollywood's output, backed by America's commercial muscle, had come to dominate cinemas around the world. In other nations most film studios were never more than small ateliers of artists. They became hamstrung by the hardships stemming from the world wars and the postwar economic collapse. No other nation could compete with America's output. In 1914, 14 percent of films shown in British theaters were made by British filmmakers. By 1926 that percentage had gone down to 5 percent.

Those who pioneered this new technology often did so out of necessity. They were the dispossessed of mainstream society. Many were immigrant Jews from Central Europe, who back home had been barred from owning property and entering genteel society. When Wall Street banker Joseph Kennedy Sr. came out to California to meet all the studio heads, he came away with the impression that they were "all just a bunch of Austrian pants-pressers"[1]: Louis B. Mayer, Irving Thallberg, Adolphe Zukor, Carl Laemmele, Harry Cohn, Darryl Zanuck, Sam Goldwyn, Charles Fox, and Jack, Abe, and Harry Warner.[2] They fled the festering tenements of eastern U.S. cities to move west to a small town among some orange groves at the edge of the great American prairie. These small-time hucksters, through instinct, collusion, luck, and a touch of ruthlessness, made themselves rich by holding the keys to a kingdom of dreams.

Their movies not only defined our fantasies, they came to define our image of ourselves. They educated the public on what was important and what was not. No one remembered the 1797 mutiny on the HMS *Bounty* until it was in a movie. Until movies were made about them, not many had ever heard of Wyatt Earp, and Herman Melville's *Moby Dick* was just another dusty old novel. Political leaders like Franklin Roosevelt, Adolf Hitler, Josef Stalin, Mahatma Gandhi, and Winston Churchill understood that being seen weekly in the cinema house created a bond of trust with the common citizens that leaders of the past had never been able to enjoy. For better and worse, the movies not only entertained, they created idols for us to worship, villains for us to hate, fashions for us to buy.

Hollywood does everything on a grand scale. It's not about getting funding for making a little film, it's about making an epic, a season of twenty-four episodes for TV, the three-picture deal. Hollywood's unquenchable thirst for talent and product drew in the finest people and best ideas the world could offer.

By the 1940s the studio backstage workers, aware that they were the ants that made things run, got together collectively and unionized. After a decade of threats, blacklisting, picketing, and street fights, all of Hollywood backstage production came under closed-shop union agreements. This enabled them to build the highest standard of living of any media workers in the world. That part of Hollywood was no more glamorous than a steel-mill town. Each day hundreds of workers clocked in, ate lunch in the commissary, clocked out, and went home to an early bedtime. They were awarded gold watches when they retired. A few wrote books about what it was like in the heady days of Hollywood's golden age. The system tolerated an occasional nonconformist like Erich von Stroheim or Orson Welles, yet the steady pattern of the creative assembly line chugged on for years, picture by picture. If the general public cared to peek behind the magic curtain at all, it was to see the after-hours shenanigans of their favorite movie stars, as presented in colorful detail by gossip reporters in the studio-supported press corps.

Jobs titles became specialized, held in place by narrowly defined job classifications. These positions were held not by merit but by strict seniority clauses in contracts. A film director was not allowed to look into a camera lens; that was the domain of the cinematographer. A cameraman could not move any chairs; that was the responsibility of a grip. Actors' agents would haggle over the size of their client's name on screen credits. Since a lot of the alliances in Hollywood were based on trust and personal favors, the front office put their relatives in positions of responsibility. Louis B. Mayer put so many members of his immediate family in key positions, a joke in the 1930s went, that MGM meant not Metro-Goldwyn-Mayer but Mayer-Ganz-Miszpochen, Yiddish for Mayer-and-his-whole-family.[3] At the same time, the backstage unionized force began to hand their steady positions down to their children. Dave Snyder recalled "I went to the USC film school for sound systems classes,

and soon realized I was the only guy there who wasn't someone's son or relative."[4] By the 1960s the same film workers who had embraced the young technology in the 1930s were still on the job, gray hair and all. And woe to anyone who attempted to disturb the system. Steven Spielberg recalled, "When I did my first director job, the TV series *Night Gallery*, I noticed all my backstage crew were over sixty. I looked like a kid, so they hated me!"[5] A new director who did not come up through the ranks, doing some time as an A.D. (assistant director) or second unit director, would have his life made miserable by a hostile crew. By the 1970s the studio production system had ossified into something resembling the protocol of the Manchu Court in the Forbidden City.

The television industry began on the East Coast as pet projects of the radio broadcasting network heads William Paley of CBS and David Sarnoff of NBC. At the World's Fair in 1939, Paley predicted that one day there would be a TV set in every home. Television financing was allotted by selling advertising airtime to commercial sponsors like Lux dishwashing liquid and Twenty Mule Team Borax. Studio executive Pat Weaver (the father of actress Sigourney Weaver) came up with the idea of leasing commercial airtime in thirty-second slots. As the fortunes of nationally broadcast radio declined, the networks—CBS, NBC, and ABC—became known primarily for their television.

In the 1980s they, too, became part of vast corporate media giants like Viacom and Time Warner.

The digital imaging revolution coincided with the larger information revolution. Until the late 1980s television was seven channels—three networks, CBS, NBC, and ABC; three Metromedia[†] or regional stations; and one PBS public station on the UHF frequency. Many would shut down after twelve hours of airplay. But television concentrated the public's attention. In a nation of 140 million in 1964, it was possible to have an audience of 80 million watch Elvis on the *Ed Sullivan Show*. In the twenty-first century, despite a doubling of the population, with hundreds of channels and Internet options, a TV viewing audience of 8 million is considered huge.

Animation began as trick films shown on vaudeville theater circuits. The big newspaper chains paid to make films of their famous comic strip characters to boost sales of newspapers. Felix the Cat, who first appeared in a short in 1919, was the first animation character that did not originate in a printed comic strip. The innocent charm of capering anthropomorphic cartoon animals, a favorite theme since Aesop, grew in popularity, and most mainstream movie studios opened their own cartoon units. By 1941 the animation workers came together and unionized with most of the mainstream Hollywood workforce.

As the fortunes of the great movie studios waned, the television industry created new demand for cartoon entertainment, and from 1966 to 1988 the bulk of the Hollywood animation industry turned out low-budget TV shows and commercials.

In the 1960s and 1970s the most advanced technology in entertainment seemed to be videotape. Film departments of universities were considered cutting edge if they offered courses on video editing. The immediacy of playback, the handheld drifting focus, the guerrilla nature of it all was considered very cool. Doing smears on tape, distortions, and chroma-key traveling mattes were real hot stuff, all under the label of New Media.

For the first thirty years of CG development, you needed at least a PhD in mathematics or engineering to know what you were doing. For most of the twentieth century, Hollywood workers were rarely required to possess more than a rudimentary public school education. Sure, the studios would occasionally call on the services of an F. Scott Fitzgerald or William Faulkner, but to movie people it was considered a waste of time to extend your education beyond a rudimentary degree. Even Hollywood's acknowledged geniuses, like Orson Welles, Charlie Chaplin, and Walt Disney, were self-educated autodidacts.

As an industry, motion pictures began as adjunct entertainments on the bill of theatrical variety shows, collectively known as vaudeville. Their popularity slowly came to push all the live acts off the stage, so by 1934 the press was calling vaudeville dead. First funded by inventors like Thomas Edison, then newspaper barons like William Randolph Hearst, moviemaking evolved into a system of independent studios with ties to national theater chains. They were self-funded through public stock offerings, floating loans from big financial institutions like the Bank of America.

Except for the occasional industrialist wanting to play Hollywood, like Howard Hughes, the movie moguls were pretty much on their own. They made the pictures they wanted to make. Taking the risk of making a picture they knew would be too artsy to make big box office was their decision alone. Films like John Ford's *The Informer* (1936) or Vincente Minnelli's *Lust for Life* (1956) were written off as "prestige pictures," since they attracted favorable press coverage from snooty East Coast critics and earned the studio Academy Awards. The moguls came to own every facet of filmmaking, from the concept, through production, to the viewing in a theater.

In 1938 a coalition of smaller independent studios challenged the majors in court.[6] They said that the Big Five (Paramount, MGM, Warner Bros., Columbia, and Universal) were engaging in monopolistic practices that violated the Sherman Antitrust Act. The case wound through the courts for several years, finally reaching the U.S. Supreme Court in 1948. In the landmark ruling known as *United States v. Paramount* (Paramount representing the interests of all the other major studios), the high court declared that the major studios were indeed a monopoly. They were ordered to sell off their movie theater chains and other ancillary facilities like film processing and supply. This ruling coincidentally came the first year that television started to seriously affect movie-ticket sales.

In 1951 show-biz attorneys Arthur Krim and Bob Benjamin bought United Artists (UA) from aging movie royalty Mary Pickford and Charlie Chaplin. Krim and Benja-

min decided the old dream factory model of keeping all resources—costume making, set building, recording, post, and so on—on one back lot was impractical. Studios had to become engines that provided financing and distribution for films created by independent production entities. As a result UA had a heyday producing films like *Dr. No* (1962), *Goldfinger* (1964), *The Good, the Bad and the Ugly* (1966), *The Pink Panther* (1963), and *A Hard Day's Night* (1964). Their example encouraged studios to shed back lots in favor of contracting with outside service houses and hiring out their remaining studio facilities.

By the 1960s the old moguls' monopoly had crumbled, and by the 1980s the dream factories had all been absorbed into vast multinational media conglomerates. The politics of the 1960s created a taste in the audience for hard-hitting social realism in movies. No room for the Emerald City of Oz or flying carpets of the Arabian Nights. "Almost from the moment film was invented, there was this idea that you could play tricks, make an audience believe they were seeing things that really weren't there, stretch the imagination. But this was completely lost by the 1960s," recalled a young George Lucas.[7] An article in *Look* described Hollywood as a company town where the mine had been closed down.

By 1970 a new generation of filmmakers began to assume control. These young filmmakers—Francis Ford Coppola, Warren Beatty, Peter Bogdanovich, Hal Ashby, Dennis Hopper, William Freidkin, Martin Scorcese, and later George Lucas and Steven Spielberg—were inspired by classic films and global cinema. But they were also interested in introducing new technologies to further the cinematic experience.

At the end of the March 1973 Academy Awards television broadcast, film director Francis Ford Coppola walked up to a plexiglas podium to present that year's Best Picture Oscar. As the creator of the previous year's winner, *The Godfather*, it was his right by custom. But instead of wrapping up the telecast quickly, allowing everyone to adjourn to their parties, Coppola surprised the audience by launching into a manifesto on new technology: "We are on the verge of something that will make the Industrial Revolution seem like a small out-of-town tryout. I can see a communications revolution that's about movies, and art and music and digital electronics and satellites, but above all, of human talent; and it's going to make the masters of the cinema, from whom we've inherited this business, believe things that they would have thought impossible!"[8]

The older studio establishment thought Coppola's rambling outburst as impertinent as it seemed vague. Most were too annoyed to really think about what he had just said. Like an Old Testament prophet crying out in the wilderness, Francis Ford Coppola was announcing to the world the coming age of digital media.

But would Hollywood listen?

2 Analog Dreams: Bohemians, Beatniks, and the Whitneys

It is not the hand anymore, but the spirit, which makes art, and the new spirit demands the greatest possible exactitude of expression. Only The Machine in her extreme perfection can realize the higher demands of the creative spirit.
—Theo Van Doesberg (1883–1931)

Two types of pioneers created the art of computer graphics. One group was the scientist-engineers who longed to be artists. The other group was the artists who yearned to create works that went beyond the traditional medium of paints and pencils. Their muse led them to become inventors in order to realize their vision.

The artists who created CG dwelled on the peripheries of the mainstream media world. Nonconformists, bohemians, beatniks, and hippies—they toiled away in lofts and garages, often with little funding. Their goal, if they would even deign for it to be labeled so, was a melding of human psyche and machine to achieve a new way of experiencing art. They explored the way we experience images, time, and music.

From the time Ice Age humans drew cave paintings of animals with multiple legs up through to Leonardo DaVinci's sketchbooks, artists have tried to create art that moved. The illusion of motion was at last achieved with the development of animated film at the beginning of the twentieth century. To the average person on the street, animation has always meant entertainment cartoons. Anthropomorphized animals with human attributes making absurd faces and bonking one another on the head for Punch-and-Judy–style laughs. But animation always had another, less well-known, side. Early on, artists and composers like Jean Cocteau, Man Ray, Fernand Léger, Paul Hindemith, and Salvador Dalí were intrigued by the possibilities of moving art and by movement itself as art.

The advent of motion pictures was also the age of invention, the age of the machine. Long before anyone had ever heard of a computer, artists were trying to use machines to explore their creative possibilities. Just as nineteenth-century photographer Eadweard Muybridge is considered a father of motion pictures, even though he

himself never touched a movie camera, so there were early artists who anticipated the coming of CG, although they themselves may never have clicked a mouse.[1]

Berlin. A cold, gray day in February 1936. A balding man and his wife sat smoking heavily in their chilly studio.[2]

The clatter of car horns, crowds slipping on the slush, and other city noise on the Friedrichstrasse provided a background to their anxiety as they awaited an important phone call. The couple was surrounded with filmmaking equipment as well as beautiful paintings, prints, and sketches in the twentieth-century abstract expressionist style. Much of it explored the relationship between visual art and music, a form that would come to be referred to as visual music.

Oskar Fischinger (1900–1967) and his wife, Elfriede (1910–1999), had been at the forefront of the modern avant-garde since just after the Great War. Oskar's abstract expressionist films were seen on movie screens across Europe. He went beyond the pencil and brush and explored mechanical means of graphic expression. He employed collage, time-lapsed paint strokes, patterns in oil and wax, and more to make geometric shapes dance to music. They were like cubism in motion.

The art scene of the 1930s was booming with modernism, surrealism, and Dada; its soundtrack was the new sound from America called *jazz*. The "Moderns" rejected the conventions of the Old World that had destroyed itself in the madness of the Great War. They extolled the virtues of a new age, symbolized by The Machine as an engine of liberation. To these artists, science was the new progressive faith. Viking Eggeling and Walter Ruttmann were making abstract films as early as 1921. Fernand Léger and Man Ray created a sensation with their film *Ballet Mechanique* (1924), with music composed by American George Antheil. Also influential was Marcel Duchamp's *Anemic Cinema* (1926).

But the postwar economic depression allowed fascist movements to come to power. These regimes sought to reign in artists and harness them to the needs of the state. After the Nazi Party took over in Germany the type of works Fischinger did were declared *Entartete Kunst*, "decadent art," and so forbidden. The Reich Propaganda Ministry of Josef Goebbels began stamping out all art that did not conform to the state's ideal of National Socialist *Kultur*. He closed the Bauhaus, took over the Babelsburg film studio UFA, and caused many cinema celebrities, like Fritz Lang, Marlene Dietrich, and Max Reinhardt, to flee into exile. Book burnings became common, and the beautiful works of Paul Klee, Max Beckmann, and Jacques Lipschitz were removed from art museums. In their place were hung kitschy portrayals of nude Aryan milkmaids and overstuffed Wagnerian heroes.

Oskar Fischinger had been under the eye of the Gestapo, since he had drawn ads for left-wing political groups during the late Weimar Republic. He had been picked up by police and questioned on two occasions. Once for refusing to put the swastika flag

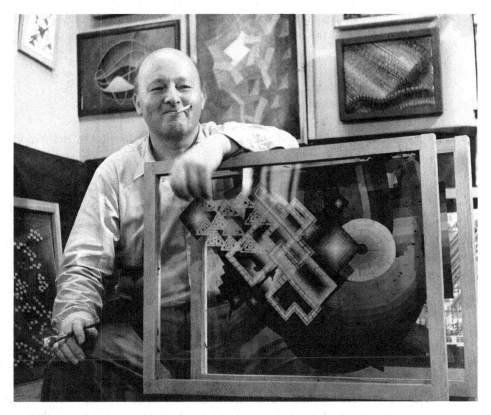

Figure 2.1
Oskar Fischinger with panels of his *Motion Painting #1*.
© The Fischinger Trust, courtesy of the Center for Visual Music.

out on his windowsill when some local Nazi party hack was due to drive by. Another time when an informer overheard him say to a friend about the Nazi newspaper, the *Völkischer Beobachter*, "You don't really believe that bullshit, do you?" When the friend warned him he must be more careful and even dissemble if he expected to survive, Oskar replied, "I'm not sure I can. I open my mouth and the truth just comes out."

Luckily, another friend had sent films like his *Composition in Blue* (1935) to the United States, and they wound up at the offices of famed German expatriate director Ernst Lubitsch on the Paramount Studios lot. The brightly colored cubes and tubes dancing to the music of Otto Nicolai's *Merry Wives of Windsor* charmed him. Lubitsch and his fellow émigrés had set up the European Film Fund, an organization that served as a pipeline to smuggle artists and intellectuals out of the Third Reich. That day in 1936 Oskar and Elfriede waited by their phone. Their agent had sneaked a message to them to expect a phone call from America. From Hollywood, no less!

Abruptly, the tension was broken by the shrill ring of the phone. Oskar picked up and heard through the overseas static a man speaking *auf Deutsch,* but with a heavy American accent.

"Oskar Fischinger?"

"Yes," he replied.

"Are you THE Fischinger who did *Die Kompozition in Blau?*"

"Yes."

"Well, Herr Lubitsch would like to hire you to work for him in Hollywood. Would you be willing to leave Germany?"

Oskar looked at Elfriede and smiled. "Yes."

And so Oskar and Elfriede Fischinger took a ship to America.

For many refugees from the Nazi terror, even New York City was too close for comfort. The sunny, silly, never-never land of Los Angeles was about as far away as one could get from Hitler without your hat floating. And besides, Hollywood paid good money to have European luminaries in their stables. MGM Studios' advertising boasted, "More stars than there are in Heaven!" That meant imported celebrities as well. Oskar and Elfriede joined the European expatriate community, and Oskar became friends with composer Arnold Schoenberg.

Yet despite the excitement of coming to Hollywood to work for the great Ernst Lubitsch, he and Fischinger never actually collaborated. Between the time of Fischinger's hiring and his arrival, Lubitsch had stepped down from his executive producer position at Paramount so he could focus on directing. The studio first wanted to use Fischinger to create animation for one of their Big Broadcast films. These were popular anthology series that featured many of the top radio stars of the day. Fischinger created animation titled "Radio Dynamics," set to a jazz track, for *The Big Broadcast of 1937* with W. C. Fields and Bob Hope. But creative disagreements with the director, Mitchell Leisen, caused him to leave the project. Fischinger went on to MGM. There he created the short *An Optical Poem* (1937), which was a critical success. But he ran afoul of the notorious Hollywood bookkeeping system that hid profits from those expecting a fair share. His attempt to confront a studio accountant grew into an argument so heated that the hapless clerk threatened to throw a typewriter at him. But Fischinger was the one who wound up being arrested for assault.

Today Oskar Fischinger is best remembered in America for his work with Walt Disney. He was hired to create the *Toccata and Fugue* sequence for Disney's concert feature *Fantasia* (1940). He also influenced the interstitial section known as Mr. Soundtrack. His hand-drawn animation for the magic sparkles around the Blue Fairy in *Pinocchio* (1940) established an effects style now affectionately known as "Disney dust."

But Fischinger did not enjoy his time at Disney. He did not take to the freewheeling collaborative technique of the group story conferences Walt espoused. His English

wasn't good enough to hold his own in a debate, and besides, he was the kind of filmmaker who preferred to work alone and not explain himself. Because many did not understand his nonobjective ideas, Walt kept him out of the Story and Art Direction Departments and relegated him to an office in the Effects Department. The more ignorant Disney workers teased the German Fischinger mercilessly. On the day Hitler invaded Poland in 1939 some pranksters even drew swastikas on his door, unaware of what he himself had endured.

There were other European immigrants who worked out fine at the Walt Disney Studios: Swiss visual development artist Gustav Tennegren, Hungarian art director Jules Engel, and Italian background stylist Bianca Marjolie. They even had a janitor who was a full-blooded Italian count. But in the end, Oskar Fischinger just didn't click with the tone of the place. He objected to the kitschy additions Walt and his sequence director insisted on making to the *Toccata and Fugue* sequence. They insisted that the audience needed more than pure abstractions, so they added some narrative structure to the images, like a red coffin shape lumbering to a bass violin solo, changing to the overtopped, heavenly church window-like shapes during the more religious, revelatory sections. It could be interpreted as faith's triumph over the fear of the grave. Fischinger growled that it was "geshmacklos"—tasteless.

Fischinger opened up his heart in a letter to a friend at the time: "I worked on this film [*Fantasia*] for nine months; then through some 'behind the back talks' I was demoted to an entirely different department, and three months later I left Disney. . . . *Toccata & Fugue* is not my work, though my work may be present at some points; rather it is the most inartistic product of a factory."[3] The most Fischingeresque parts of the toccata and fugue sequence are in the opening, like the rolling patterns of color that move like ocean waves.

For many years Fischinger complained that the whole concept for *Fantasia* was his own and that music conductor Leopold Stokowski stole it and gave it to Disney. He claimed he discussed just such a concert collaboration with the great conductor back in 1936.[4] The final record is not clear.

He then went to work for Orson Welles and his Mercury Theater at RKO. Welles paid Oscar under the table since as a German citizen, Oskar was considered an enemy alien. Fischinger was to make an animated sequence for Welles's upcoming film *It's All True*. But everyone knew that Welles, "the Boy Wonder," was reaching the end of his rope at RKO. His films became cinema classics, but at the time the studio considered them bloated, confusing, and self-indulgent. Soon after Fischinger began, production on *It's All True* was stopped and the RKO management fired Welles. They gave his production crew forty-eight hours to vacate the studio property. Along with his last paycheck, Welles let Fischinger have the Mercury Theater canvas bulletin board to paint on; wartime shortages made finding painting canvas a problem.

With supreme irony, once America entered World War II Oskar and Elfriede Fischinger were declared "enemy aliens" by the State Department, and forbidden to work in communications. When Oskar sent the family radio out to be repaired, he was picked up by the FBI and questioned to see if he was a Nazi spy.[5] While Oskar focused on his personal work and applied to arts foundations for grants, they lived on what Elfriede made creating designs for shops like Suzie's Sweaters.

For the rest of his life Oskar Fischinger stayed in Hollywood but remained apart from mainstream studio productions. He became part of the LA art scene, receiving grants from the Museum of Non-Objective Art. He continued to make short films, sold paintings, and created a color organ device called a Lumigraph that could be "played" at art galleries.[6] He even did an occasional commercial for television.[7] Oskar Fischinger died of a heart attack in 1967.

Although Fischinger himself never touched a computer, the example of his dancing pixel-like squares and points of light was cited by many postwar artists as inspiration for what might be done with a computer.

Now, it's not like the world was devoid of experimental filmmakers before Oskar Fischinger. Len Lye and Jean Cocteau were producing abstract films in the early 1930s. Musicians like Joseph Schillinger and Karl Stockhausen, who were trying to break down the structure of music to elaborate mathematical theory, inspired early avant-garde filmmakers. Likewise, Russian composer Alexander Scriabin, who claimed he could "hear colors," composed for them.

The U.S. art film scene of this period can be divided into three distinct groups: one in LA, one in the New York area, and one in the San Francisco Bay Area. One of the top artists of the New York scene was Texan Mary Ellen Bute (1906–1983). She collaborated with Russian avant-garde inventor Leo Theremin on several projects. In 1931 she wrote of her work in a paper titled "The Perimeters of Light and Sound and Their Possible Synchronization," in which she wrote, "This (her work with Theremin) was an early use of electronics for drawing."[9] Bute's abstract film *Synchromy #2* was screened in 1935 at Radio City Music Hall. Her work retained a wonderful, Kandinsky-like intricacy that would have exhausted a traditional animator. In her early films she used common objects like a kitchen hand mixer, crystal bowls, and lilies. These she filmed in deep shadow in extreme close-up detail for their graphic qualities. This was much like the abstractions Man Ray and Eugène Atget were trying then in photography. "For years I have tried to find a method for controlling a source of light to produce images in rhythm," she wrote in 1954.[8] For animation on her *Spook Sport* (1940), set to the music *"Danse Macabre"* by Camille Saint-Saens, she hired a young Scotsman named Norman McLaren.

McLaren (1914–1987) was one of the most important experimental filmmakers of the twentieth century. After working in New York with Bute, he moved to Canada in

Figure 2.2
Mary Ellen Bute working with an oscilloscope.
Courtesy of the Center for Visual Music.

1941 and became one of the founding artists of the National Film Board of Canada. He explored a variety of techniques, including scratching on film, time-lapse, pixilation, and regular animation. He also found that if he painted with ink directly onto the optical stripe of 35 mm film, the blips made sounds. He would "draw" his own music. His films explored not only abstract concepts but also issues of social relevance. His 1952 film *Neighbors* won him an Academy Award. McLaren was considered such a national treasure that when the FBI tried to extend the anticommunist witch hunt of McCarthyism to media people in Canada, McLaren was protected by no less than Prime Minister John Diefenbaker himself.[10]

Another member of the U.S. art film scene was Stan VanDerBeek (1927–1984), an independent filmmaker who began as a Cooper Union Institute dropout working on the animated kiddy TV show *Winky Dink and You*.[11] At night, when everyone else went home, VanDerBeek would talk his way back into the building by telling the

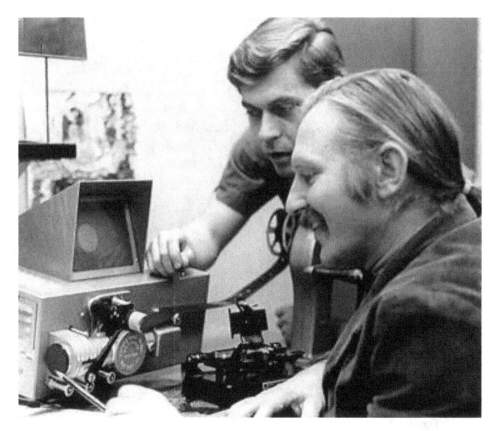

Figure 2.3
Ken Knowlton collaborating with Stan VanDerBeek at Bell Labs (1966).
Courtesy of Ken Knowlton.

guard he needed to complete some leftover work. Then he would spend the night creating his own films using cutouts, collage, and single-frame timed paintings. Months after he had been fired for violating the Screen Cartoonists' union seniority rules, he continued to sneak into the studio to shoot stuff on an Oxberry camera. "The whole commercial cinema of neoreality is fundamentally pornographic," Van-DerBeek claimed, "and does not contribute to one's soul."[12]

VanDerBeek exchanged ideas with Buckminster Fuller, composer John Cage, and choreographer Merce Cunningham. He learned about computers in the mid-1960s and became, in the words of historian Amid Amidi, a computer junkie. "He was willing to travel anywhere for his fix of digital technology and, in his lifetime, he held dozens of artist-in-residencies [Columbia, MIT, CalArts] and teaching positions." His earliest computer film was ten short films titled *Poem Fields, One through Eight* (1966), created

in collaboration with Ken Knowlton of Bell Labs. VanDerBeek's 1972 film *Symetricks* was done with an early electronic light pen and drawing tablet. VanDerBeek and his work at the MIT Center for Advanced Visual Studies were featured in a 1972 documentary, *The Computer Generation*. In it he recognized his role as a teacher who was trying to inform the masses of this mysterious tool known as the computer. Although he had been experimenting for half a decade already, he said, "I frankly don't understand it, and I'm still trying to understand it."[13]

San Francisco after World War II was showing the beginnings of the beatnik culture of North Beach that would become world famous. Jack Kerouac, just discharged from the Merchant Marine, could be seen sitting in the back of coffee shops, smoking cigarettes, digging jazz, listening to people talk, and making notes. Hot topics ranged from discussions of the *Tibetan Book of the Dead* to nihilism, Native American spirituality, the Bomb, espresso, and marijuana. A small, independent group of filmmakers, the West Coast experimental film movement was centered around Frank Stauffacher. The group included Harry Smith, Hy Hirsh, and Jordan Belson.

In October 1946 a landmark film series titled *Art and Cinema* and organized by Stauffacher and Richard Foster began showing at the San Francisco Museum of Art. The October show presented ten programs of the best avant-garde cinema, animated and otherwise. Stauffacher and Foster convinced the Museum of Modern Art in New York to send prints of classics from Georges Méliès, Marcel Duchamp, and Luis Buñuel, as well as *The Cabinet of Dr. Caligari* (1920) and *Ballet Mécanique* (1924). But Stauffacher's real coup was sending painter Harry Smith down to Los Angeles to convince Oskar Fischinger and the famous brother team of experimental filmmakers John and James Whitney to make the trip north to discuss their work.

All those who attended those shows at the War Memorial Center admit they were dazzled by what they saw. Historian Giannalberto Bendazzi said, "The Festival represented the occasion to cross the vast distance separating provincialism from the avant-garde." For many attendees, the high point was talking one-on-one to Fischinger and the Whitney brothers about how they created their unique images. Exiting into the cool night air of the San Francisco Bay Area, many left with new inspiration. Chicago native Jordan Belson (1926–2011) remembered, "I had just graduated from college in painting when I saw Fischinger's films at the festival . . . and that inspired me to start making films instead of just painting canvases." He bought an old X-ray machine and adapted it to film use. His first film with it, *Transmutation* (1947), has been called a "painting in movement" rather than an actual film.[14]

Belson's later films featured bold color patterns, spectrums undulating and reforming themselves "as though you were approaching earth as a god, from cosmic consciousness. You see the same things, but with completely different meaning."[15] In 1983 Belson created some of the special effects for the Philip Kaufman movie *The Right*

Stuff. He imagines what test pilot Chuck Yeager saw as he pushed his jet to the strato-
sphere at the edge of space.

Harry Smith (1923–1991), another of the West Coast experimental filmmakers, was
a wiry-haired musicologist who had helped design the Folkways *Anthology of American
Folk Music*. He roomed for a time with poet Alan Ginsburg, dabbled in Kabbalah and
hashish, and collected Ukrainian painted Easter eggs. Influenced by the War Memorial
show, Smith began experimenting with film, drawing and painting directly onto clear
film stock. He'd take his filmstrips over to an all-night jazz club called Jimbo's Bop
City and project them directly onto the walls while Dizzy Gillespie's band played.
Using a multispeed projector modified by Hy Hirsh, Smith could modulate his images
to fit Gillespie's improvisations.[16] Smith's idea of screening images as part of a live jazz
performance, along with Belson's projections and work in the Vortex Concerts, which
were immersive environments, were cited as a major influence by later San Francisco
light-show makers. First in discotheques and then in rock clubs like the Fillmore.
Bands like Pink Floyd and the Electric Light Orchestra employed a number of experi-
mental filmmakers who later added lasers to increase the feeling of sensory
immersion.

Hy Hirsh (1911–1960), also part of the West Coast movement, lived the life of a
beatnik American artist. He had once been a staff cinematographer and still photog-
rapher for Columbia Pictures in Hollywood. Now, inspired by the new ideas in
avant-garde, he lived hard, drank hard, grew a beard, listened to jazz, and made
nonobjective films in postwar San Francisco, Amsterdam, and Paris. His most famous
work was the 3D stereoscopic *Eneri* (1953). It was named for his then-girlfriend
Irene, spelled backward. But a full account of his filmography is difficult. Hirsh
neglected his works once they were done and re-edited at his whim. Some of his
films were live action, some abstract, some made with an oscilloscope, some creat-
ing by tracing a stick through dense oils to create moving patterns and shot in high
contrast. In 1961 Hirsh died unexpectedly in a car crash on a Paris street. Police
found a bag of hashish on the seat next to him. At his funeral in Père Lachaise
Cemetery a dozen women showed up, each thinking she was the one true love of
his life.[17] Historian Bill Moritz claimed that this incident served as the inspiration
for the Ingmar Bergman film *Now About These Women* (released in the United States
as *All These Women*, 1964).

In 1957 Frank Stauffacher tragically succumbed to a brain hemorrhage at age
thirty-eight. Although the *Art and Cinema* series soldiered a few more years, the unify-
ing force that kept all these artists in touch with one another was gone. Hirsh left
for Europe. Smith moved to New York. Fischinger and the Whitney brothers stayed
down in Los Angeles. The San Francisco experimental animation scene was slowly
absorbed into the blossoming psychedelic subculture of Haight-Ashbury. The atten-
tion of the art world passed to New York, where the new trend was underground

cinema, Andy Warhol, Robert Breer, and the E.AT. Program (Experiments in Art and Technology).[18]

Until 1945 U.S. heavy industry had been producing in a white heat to generate enough materials to win World War II. When the war was over heavy manufacturing centers like Detroit and Pittsburgh switched back to making peacetime products. Junkyards and secondhand stores across the nation filled to their ceilings with discarded military equipment. The army surplus store became a regular feature on every town's main street.

Among the piles of gas masks, tents, helmet liners, and canteens were electronics like oscilloscopes, sonar, and small metal and radar detectors. Bohemians like Hy Hirsh, Mary Ellen Bute, Norman McLaren, and Hank Stockert became intrigued by the qualities of the glowing beams of light, blipping and dancing across their little screens. R. T. Taylor explained, "There was a control button you pushed to photograph the beam as it was on the oscilloscope screen. If you took multiple images, then later re-photographed them as you would 2D animation cels, it would create a kind of movement."[19] Artists began to experiment with taming the oscilloscope and sonar light beams using computers: "When controlling the electron beam of an oscilloscope, electronic signals became visible patterns. Manipulate the signal with a computer and you animate the corresponding forms on the screen."[20]

In 1950, working in a sign-painting shop in Iowa, Ben Laposky devoured magazine articles about futuristic "painting with light." He soon went out to buy some oscilloscopes. Through articulation of the controls he created dazzling electronic abstractions that he photographed directly off the screen with high-speed film. He called these electronic abstractions his *Oscillons*. Like Whitney and Bute, Laposky described the process as being "analogous to the production of music by an orchestra." Laposky's works are arguably the first true computer graphic paintings.[21]

In 1954 Mary Ellen Bute teamed with a scientist from Bell Telephone Laboratories, Dr. Ralph Potter. Potter modified an oscilloscope to her specifications, which she used to create imagery for several of her films, like *Abstronic* (abstract electronics), set to the music of the ballet *Hoe-Down* by Aaron Copeland. Bute noted, "By turning knobs and switches on a control board I can 'draw' with as much freedom as with a brush. . . . I venture to predict that the forms and compositions artists can create on the oscilloscope . . . will not only give esthetic pleasure to all kinds of men and women in all climes . . . but will help theoretical physicists and mathematicians to uncover more secrets of the inanimate world."[22]

Yet despite all the intriguing images created by oscilloscopes, in the end the machine was of limited use. The jittery beam of light just could not be tamed to shape solid forms representing 3D objects. It would fall to the pixel system to do that.

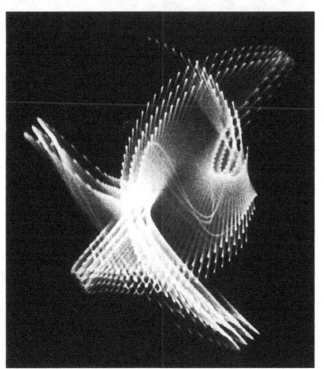

◀ **Figure 2.4**
(top) Ben Laposky's *Oscillons*, 1954.
Collection of the author.
(bottom) James Whitney working in the brothers' garage circa 1945.
Courtesy of the Estate of John and James Whitney.

There was a man back in Los Angeles who was also very interested in the possibilities of combining sound and motion. His name was John Whitney (1917–1995), and today he is called the father of computer graphics. Born in Pasadena, John had attended classes at Pomona and Claremont Colleges and took an interest in the arts, photography, and music. His earliest film was of a solar eclipse, which he shot through a telescope he built himself and connected to an 8mm movie camera. His younger brother James (1921–1982) was equally excited by the possibilities of modern art and filmmaking.

In 1937 the Whitney brothers toured Europe. While James attended classes in England, John went to Paris to study photography and the radical new twelve-tone music, under the noted composer Rene Kollwitz. In the smoky cafés of Montparnasse John came under the influence of artists like László Moholy-Nagy, Marcel Duchamp, and Vladimir Rodchenko. They taught him that just as music is pure, so art does not have to be only narrative or representative. For instance, Beethoven's Fifth is not about anything; it holds you as pure music. Why can't you thrill someone the same way with art? "People call graphic images cold," John said. "A musical note is a graphic image too, and it's not cold."[23] Before he returned to the United States in 1939 John burned with the possibilities of the combination of visuals and music. He called it Digital Harmony.

The Whitney brothers met Oskar Fischinger in 1939 when Fischinger was exhibiting his work at the Art Center College in Pasadena and the Stendhal Gallery on Wilshire Boulevard. In a town like Hollywood, where mass culture is king and high art was the syrupy operettas of Nelson Eddy and Jeanette MacDonald, members of the small highbrow community, with strong ties to Europe, would gravitate to one another. Especially three artists who chose to make abstract film with mechanical processes. As John Whitney described the situation, "We were outsiders inside Hollywood."[24] He referred to Fischinger in his writings, and they exhibited together.

Some maintain that Fischinger's influence on John Whitney was minimal at best. Fischinger preferred to set his work to classical music like Bach, while John, who brother James said "was mad for Schoenberg,"[25] found that music too old fashioned. He felt the heavy symphonic sound overtopped the visuals.

Fischinger had a much closer relationship with James, since they both were painters as well as filmmakers. "[In Fischinger's films] I saw pure moving light," James said,

and "after that, still painting would never be enough for me. I had to make real non-objective imagery in motion."[26] James and Oskar were also kindred spirits in rejecting their traditional Western religious upbringing in favor of exploring Tibetan Buddhism, meditation, and mandala structures. "In 1929, I used a rotating cylinder, driven by a motor . . . to hold my affirmations and denials in steady motion-rotation. Years later I learned about the Buddhist prayer wheel, and discovered existing parallel thoughts in my continuous rotating cylinders and the thousands-of-years old prayer wheel," Fischinger recalled.[27] Similarly, James Whitney said, "Only to a person who had expanded his consciousness is ordinary experience expanded. Art and Science are getting much closer to Eastern Thought."[28]

Whatever their inspiration, John and James Whitney were dedicated to experimental nonnarrative filmmaking. Their modest Altadena garage became a full-time workshop. John's goal was not just to set visuals to music but to create music and visuals simultaneously. He referred to his work as "composing" rather than drawing. To accomplish this, the artist needed to invent his own machinery. His son Michael recalled, "His gift for building devices was a source of pleasure for him. He would often joyfully exclaim out loud when, as he made his way through the garage, he found just the right part to complete construction of a new or improved device."[29] He started by building an optical printer for their 8mm camera. This he used to create a short based on the theme of a circle and rectangle, titled *Twenty-Four Variations on an Original Theme* (1940). He then built a twelve-foot Foucault's pendulum connected to a motion picture optical printer, which captured light rather than images as it emitted sounds. He called it an "audio-visual instrument." It was an amazingly complex analog machine, with twenty-nine separate shutter speeds. "Whitney invented a whole class of special effects techniques that became the standard of the industry, what is now called Motion Control camera work. As useful as motion control became to the film industry, its original purpose was Art."[30]

All through the war years, from 1941 to 1945, they scavenged and experimented, even while John worked the graveyard shift at the Lockheed Aircraft plant in Burbank.[31] James worked as a technical draftsman at Caltech. By the end of this period the brothers completed an abstract film titled *Five Abstract Film Exercises* (1945).[32] The film won a prize at the First International Experimental Film Competition, held in Belgium in 1949.

The film's growing acclaim also won the brothers a Guggenheim Fellowship to study the relationship of music to graphics. James Whitney traveled to New York to meet Solomon Guggenheim and screen the film at the Museum of Modern Art. When the film began the sounds in it were so strange that they prompted Guggenheim's curator, Baroness Hilla Rebay, to leap up and run back to the projection booth, shouting, "What is wrong with the projector? Shut off that horrible noise!" James tried to

explain that it was experimental music made for the film, but she replied, "Nonsense! That is no music!"[33]

By 1945 James had struck out on his own to explore his personal work. James's approach was much more internalized than that of his older brother. While John was exploring the abstract language of visuals and music, to James filmmaking was not an end in itself but a means to visualize what he was experiencing in his own spiritual growth. John would grumble at the time it took to develop sound and picture, while James would spend long periods meditating and reading the Indian Vedas, which was what he called a "white wait." James could spend up to five years making one film.

In 1943 James had visited the Frank Lloyd Wright's Hollyhock House on Olive Hill.[34] There he met and soon befriended the photographer Edmund Teske, who was artist-in-residence at one of the studios on the grounds. James moved into one of the other studios. From some old prefabricated plywood he built an enclosed garden in his studio in order to better see the changing of the seasons, in the Japanese tradition. Visitors used to wander in to observe and comment on the works in progress. One of them was retired Hollywood film director D. W. Griffith.[35] The old movie pioneer left the studio shaking his head at the unusual images he saw being created.

By the time of his death in 1982, James Whitney had made only six films, among them *Yantra* (1957), *Dwi-Ja* (1976), *Wu Ming* (1977), and *Kang Jing Xiang* (1982). But they are acknowledged masterpieces, offering a light into his inner soul. Gene Youngblood described *Lapis* (1966) as "hypnotically turning mandala wheels of color, thousands of small lights gathering around a center."[36]

Although the fame was gratifying, John Whitney still had to make a living and provide for his family. He had married an abstract painter, Jacqueline Helen Blum, and they were soon raising three sons: John Jr., Michael, and Mark. After the grant monies ran out, John spent the 1950s dividing his time between personal experimentation and commercial work. In 1952 he directed several technical films for Douglas Aircraft on guided missiles, did some early television commercials, and joined the commercial animation house United Productions of America (UPA). In 1955–1956 he was a sequence director on *The Gerald McBoing-Boing Show* with Ernie Pintoff, animated by Fred Crippen.[37] The show was a collection of shorts that showcased differing styles of animation. Ernie Pintoff and John Whitney outdid the others with designed abstract sequences that challenged even the progressive spirit of UPA. Amid Amidi said that the shorts "were wildly uneven in terms of entertainment value, but fascinating for the sheer variety of artistic styles used."[38] When *The Gerald McBoing-Boing Show* premiered in 1956 it was a great hit with critics, but it may have been a bit too "out-there" for the TV audience that wanted entertainment like Uncle Miltie. The show also ran way over budget and was unable to land a sponsor. Despite CBS's original commitment to a seven-year contract, the initial ratings were so poor that *The Gerald McBoing-Boing Show* was yanked off the air after only three months.

Figure 2.5
John Whitney working on his cam machine.
Courtesy of the Estate of John and James Whitney.

In 1958 John was ready to take his work to the next level in technical development. Rejoined for a time by his brother James, he began to experiment with an early analog computer. "My work with the digital computer is the culmination of all my interests since the 1940's because I found myself forced into . . . the mechanisms of cinema," he explained. "I got to work with the digital computer thanks to the fact that I had developed my analog equipment to the point I had." His equipment was an army Mark 5 antiaircraft gun sight that he had purchased as war surplus. This device was originally intended to aid a plane spotter on the ground in tracking enemy aircraft and to sync several antiaircraft guns to fire on the same moving target. John soon bought an updated Mark 7 and cannibalized it for parts, the intricate wiring completed by his teenage son John Jr. A mechanism of cams, gears, and servomotors, it directed the movement of artwork beneath an animation camera. He called it his Analog Cam Machine. Although still an analog device, today it is recognized as a true early computer. "As I continued to develop the machine I realized it was really a mechanical model of an electronic computer," John said.[39]

In 1958 motion picture graphic designer Saul Bass contacted John.[40] Bass was the artist behind the creation of many of the unique visual effects for director Alfred

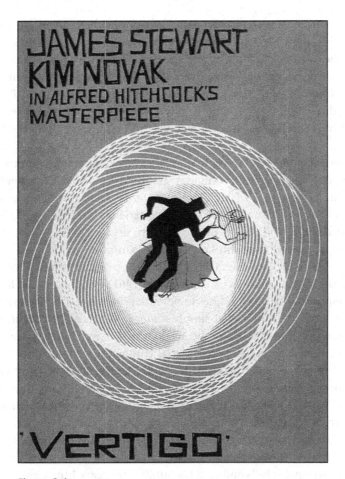

Figure 2.6
Poster for Alfred Hitchcock's film *Vertigo* (1958). Design by Saul Bass, featuring the animated spirals produced by John Whitney.
Copyright Paramount Pictures. Courtesy of The Margaret Herrick Library Collection, The Academy of Motion Picture Arts & Sciences.

Hitchcock's suspense films. Bass had been experimenting with Lissajous images for some time, and for the new Hitchcock film *Vertigo* (1958) he wanted to make these images move. So he contracted John to create the effect, using his Analog Cam computer. The opening credits of *Vertigo* are complicated graphics that spiral out from still photos of actress Kim Novak's eyes, all set to the eerie music of Bernard Hermann. The credits count as the earliest computer images ever to appear in a major motion picture. John himself was blasé about this job, saying, "I did the swirly things."[41]

Beyond being an inventor and conceptual artist, John Whitney became the first great philosopher and champion of computer graphics. He wrote extensively on the subject, published books like *Digital Harmony: On the Complementarity of Music and Visual Art* (1980), and was quoted in extensive interviews in Gene Youngblood's seminal book *Expanded Cinema* (1970). For the first two decades of CG, you couldn't think of computer graphics without thinking of John Whitney.

After doing more work for Saul Bass (titles for Bob Hope's and Dinah Shore's TV shows), John started his own commercial company in 1961, which he called Motion Graphics Inc. To demonstrate his techniques to potential clients he compiled his most recent experiments into a film he called simply *Catalog* (1961). At first John didn't really consider *Catalog* a film, but everyone he screened it for found it stunning. *Catalog* won him still more grants and commercial contracts, but most importantly, it caught the attention of Dr. Jack Citron of IBM. IBM, or Big Blue as it was called, was then the foremost private developer of computers in the world. "One thing I was interested in doing," Citron said, "was to set up the kind of instrument which would buffer the computer user from the technical details."[42]

In 1966 John Whitney was wooed to IBM by being named their first-ever artist in residence. From this point on John could be free to work on his research without worrying about how to pay his bills and feed his family. They gave him a big IBM 360 mainframe with a 2250 graphic display console to work on. Citron wrote an original program, called GRAF (Graphic Additions to Fortran), for Whitney to use. Citron was given formal responsibility for aiding Whitney and as such could be called the first tech director.

Interestingly enough, Citron later mentioned that the other IBM technicians dreaded when Whitney would use the 360. Despite the august corporate setting, the inveterate tinkerer in him occasionally reemerged. Whenever the computer was not doing exactly what he wanted, Whitney would just remove its back panel and rewire it. Engineers returning to the 360 to share time on it had to maddeningly restore all their original settings.[43]

With the IBM equipment Whitney was able to create what many call his masterpiece, *Arabesque* (1975). *Arabesque* is a beautiful meditation on the complex geometric patterns of Moorish-Arabian art. Cylindrical and ever moving, like the patterns and

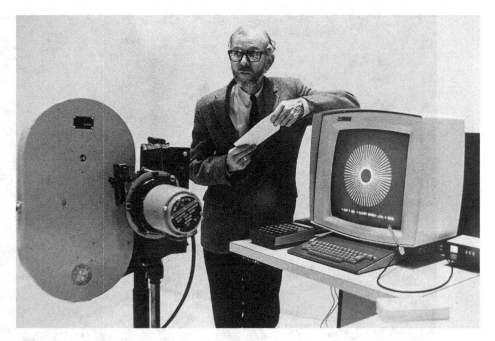

Figure 2.7
John Whitney with IBM 2250 Display (1968).
Courtesy of the Estate of John and James Whitney.

music of the Alhambra, it is a triumph of vector graphics and oscillation. Larry Cuba did the programming for that film. Cuba said that at this time the senior Whitney was "scattered and distracted, like a funny old professor, but in an endearing way. Giving an address at a computer conference he'd say to us, 'You see these large mainframes? Someday they'll all be able to fit on your wrist!' At the time we thought he was crazy."[44]

Into the late 1980s, after he left IBM, Whitney continued to devote himself to developing a computer on which one could compose visuals and music simultaneously in real time. With engineer Jerry Reed he created the Whitney-Reed RDTD (radius differential theta differential). Whitney believed that strong emotion could flow from a direct matching of tonal action with graphic action, saying, "I've struggled to define my vision; the union of color and tone is a very special gift of computer technologies."[45] Yet he remained hampered in his efforts as much of his philanthropic support dried up. John Jr. recalled, "Dad's last fifteen years were very frustrating for him. He was unable to get support for new projects."[46] Ironically, as he lay dying he received an invitation from a large Japanese university to come be a resident fellow. They would provide him with a complete, state-of-the-art computer

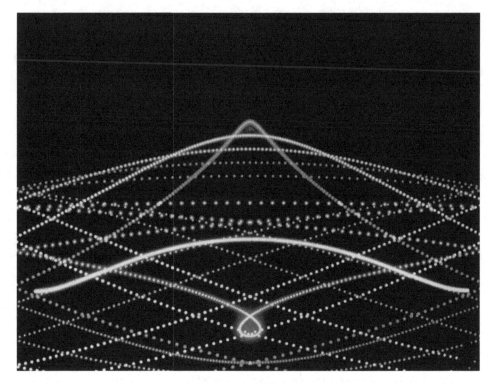

Figure 2.8
Arabesque (1975) by John Whitney.
Courtesy of the Estate of John and James Whitney.

lab and full-time staff. Good news, but too late. John Whitney Sr. died September 22, 1995.

In the summer of 1960 seventeen-year-old John Stehura sat in a heavy oak chair in the sunlit study hall of USC's Doheny Library. Like John Whitney Jr., Stehura had grown up in Los Angeles among the movie community, but he had no interest in that type of work. He recalled, "I was considering what I could do with so many years at some university, and then I imagined that I might possibly develop something new and useful, and then I thought why not a new form of motion pictures using computers? . . . Of course everyone knew that the universities were using very large computers for various research projects in physics, medicine and economics. However none of those computers had any form of graphic device associated with them."[47] Stehura transferred to UCLA, where the Computer Club offered time on their IBM 7094, which had graphics capability and an early film recorder.

"At that time, the discoveries of Watson & Crick were changing how everyone was considering biology," Stehura said. "I was intrigued by the extraordinary capabilities of the DNA vocabulary that both preserved and generated such a myriad of living forms; and I also saw the possibility of generating three dimensional forms perhaps in some way similar to how genes may regulate the growth of complex forms. Such an approach would of course also eliminate any need to enter primitive pictures, or anything graphic for that matter." He learned to program in Fortran and spent late nights after classes and part-time jobs in the bowels of Boelter Hall writing and testing algorithms to create images. He called it "metalanguage."[48] His work was not part of any class, and the UCLA computer department under Leonard Kleinrock and Larry Roberts was then more focused on inventing the Internet (see chapter 3). Late at night Stehura would run the IBM computer for several hours, then take the digital tapes down to General Dynamics in San Diego, where they had a Stromberg Carlson 4020 microfilm processor. This he used to create bright colors for his dancing shapes.

The results of all these tests became John Stehura's seminal film *Cibernetik 5.3* (1965–1969). Historian Gene Youngblood enthused, "Complex clusters of geometrical forms whirl, spin and fly in three-dimensional space . . . the solar system fades into a fish-eye image of people's faces and other representational imagery distorted . . . almost to the point of non-objectivity."[49] He called it "reminiscent of *2001* [Kubrick's 1968 film] in the sense that it creates an overwhelming atmosphere of some mysterious transcendental intelligence at work in the universe." At one time John Stehura ran his film *Cibernetik* behind Jimi Hendrix as he performed.

Charles Csuri had an interesting career. A decorated veteran of the Battle of the Bulge and one of the first football stars of the famed Ohio State Buckeyes (captain of the 1941 team, he is honored in the Pro Football Hall of Fame), Csuri was also a serious modern artist. Between 1955 and 1965 he exhibited his paintings in galleries and at the Venice Biennale and was friends with the abstract expressionist artists Roy Lichtenstein, Jackson Pollock, and George Segal. Csuri was the model for Segal's sculpture *The Diner* (1965). He had been teaching in the Department of Art at OSU since 1947. "Before I became involved with the computer," Csuri noted, "I was intrigued with the idea of using devices and strategies to create art." In 1955 Csuri began an eight-year dialog with an engineering professor at the school named Jack Mitten. Over martinis they would discuss the potential of the computer and art. For a long time Csuri didn't act on their discussions because there were no plotters or graphics output devices at hand. "The ideas were interesting, but the practical reality of programming prevented me from taking any serious action."[50]

Then, in 1965, as if by serendipity, Csuri came upon a project done by several engineers led by graduate student J. G. Raudseps. It was a computer picture of a female profile, done on a computerized typewriter device that could strike paper

using ten shades of gray. Printing and re-digitizing the image would simplify the grayscales to achieve a smooth-looking image that would be indistinguishable from a photo. While the final image had not completely achieved the photorealistic quality desired, Csuri immediately grasped the potential and set to work enhancing the computer as an artistic tool. So even though he was already a full professor in OSU's Department of Art, the next week he signed up for a seminar to learn computer programming. By 1967 he had created his first film, *Hummingbird,* which was a play between representation and abstraction (see chapter 12). His next film, *Frog* (1967), explored the aging of the human face and its similarity to that of a frog. The line-drawing images danced, broke apart, and reassembled as something else. "I found out years later that I had been doing something called 'morphing,'" he recalled.[51] As surfacing technology advanced, Csuri moved from vector images to fully shaded raster graphics. He experimented with creating paintings and simple animations as conceptual pieces.

Csuri also did some of the earliest computer sculptures. In 1968 Professor Leslie Miller, his colleague at the Computer Graphics Research Group, wrote code for an IBM 7094 computer that enabled Csuri to use control parameters. He created a virtual sculpture that he took to a local company that had a three-axis numerically controlled milling machine, basically a CADCAM (computer-assisted design camera). With this device Csuri turned his virtual sculpture into a real object, cutting it out from a large piece of wood. For the rest of the twentieth century and into the next, Csuri continued to teach and explore his personal vision of the conceptual world of computer imaging. There will be more to say about Charles Csuri in chapter 4.

By the 1970s a second generation was starting to carry on the work of the founding generations.

At the National Film Board of Canada, Norman McLaren encouraged the development of computer graphics. In 1969 National Research Council of Canada scientist Nestor Burtnyk attended a conference in California where Walt Disney animators described their traditional methods. After he returned to Ottawa, Burtnyk teamed with physicist Marceli Wein to create a 2D keyframing technique that could be used to draw on a digital tablet. The images did not move in the classic sense so much as their component outlines morphed and rearranged themselves from one keypose to another.

This technique intrigued experimental artist Peter Foldes, then working at the National Film Board of Canada (NFB). Foldes was born in Hungary but left prior to the 1956 nationalist rising of Imre Nagy against the Soviets. Foldes spent his time alternately in Paris, London, and Montreal. "I am not capable of standing still," Foldes explained. "I am in constant motion. I always need something new. That's why I chose to use a computer, which is the animators' new frontier."[52] After an initial attempt to incorporate computer imagery into his film *MetaData* (1970), Foldes was successful

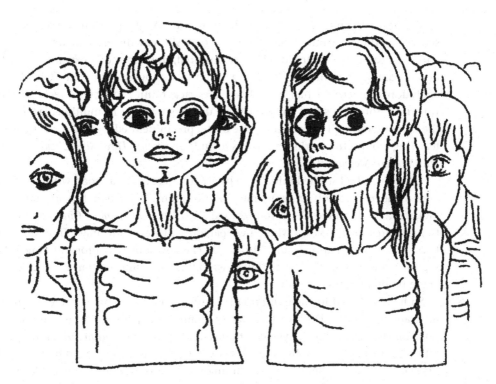

Figure 2.9
Peter Foldes *Hunger* (1974).
© The National Film Board of Canada. Collection of the author.

with his surreal nightmare *Hunger/La faim* (1974). Among its dreamlike images, a selfish rich man engorges himself in sight of starving children until he is himself devoured by the children, morphed into ravenous fiends. The eleven-minute film took one year to complete. *Hunger* became the first computer film ever to be nominated for an Academy Award. It was shown widely around the world and on TV shows in the United States like *The Fantastic Animation Festival* on PBS. *Hunger* inspired a generation of budding computer artists the way Winsor McCay's *Gertie the Dinosaur* (1913) inspired an earlier generation of traditional animators.

Foldes became an unabashed champion of the new medium and defended it vigorously to outraged traditional filmmakers. "In the Middle Ages, stones were dug out, cleaned, pulverized and mixed with glue to make paint. Will anybody claim the Impressionists were not good painters? Yet they bought their colors in tubes, they bought their brushes. . . . I did not make the computer. I did not write the program. I just make movies. The machine does not create anything. It only does what I tell it to. Nothing keeps me from creating."[53]

Vibeke Sorensen came out of Buffalo, New York. While traveling in London in 1971 she visited the Electronic Music Studios. There she saw the early digital music device Spectre, created by Richard Monkhouse. Inspired, she resolved to experiment with this new medium. "The first time I saw a graphics computer I thought, 'Oh, that's just analytical geometry.' I had a math/science background, so I could feel comfortable with it."[54] Sorensen spent the next three decades working in multimedia forms with the computer as well as becoming one of the preeminent educators in the new media, teaching around the world. Her works include *Sanctuary, Three Ring Circuit, Microfishe,* and *Morocco Memory II.*

Larry Cuba had studied initially to be an architect and was good with calculus, but grew to love the abstract experimental short films of Jordan Belson and Norman McLaren. He devoured Gene Youngblood's 1970 book *Expanded Cinema* and desired to make art films. "I saw a whole new paradigm. I wanted to make films about what I knew about math and algebra." He took a class on computer programming at Washington University in St. Louis, "But it was all about using Fortran cards to calculate grade point averages. . . . Boring!"[55]

So he transferred to the California Institute of the Arts. There were two animation programs there, the Disney character program, which trained future animators for traditional work at the Hollywood studios, and the experimental animation program set up by former UPA art director Jules Engel. Cuba was very inspired by Engel, Alison Knowles, and Pat O'Neill. Through animation history teacher William Mortiz, Cuba got to know the work of Oskar Fischinger and was introduced to a then-elderly Elfriede. Cuba called Cecile Starr in New York and asked if Len Lye was still teaching, but she replied that he had died the year before. Undeterred, Cuba pressed on with his own personal work. Since CalArts had no computers of their own yet, Cuba completed his first project, *First Fig* (1974), at NASA's Jet Propulsion Lab (JPL) in nearby Pasadena.

Cuba did some work on George Lucas's first *Star Wars* movie (1977) but then turned his back on Hollywood to focus on his personal work out of his Santa Cruz studio. "I was less concerned with the final result of a film. My purpose was to have a dialogue with the computer."[56] His films include *3/78 Objects and Transformations* (1978), *Two Space* (1979), and *Calculated Movements* (1985). He also devoted a lot of his time to setting up the iotaCenter, where some of the famous works of independent nonobjective filmmaking would be cataloged and preserved.

Another artist toiling away in the rotoscoping department on *Star Wars* was CalArts graduate Adam Beckett, who created beautiful kinesthetic personal films, including *Evolution of the Red Star* (1973), *Flesh Flows* (1974), and *Kitsch In Sync* (1975). Many of the ideas he had for effects imagery were beyond what George Lucas had in mind. One VFX (visual effects) supervisor joked, "I think it was because George had never taken acid." Some of Beckett's only identifiable work on *Star Wars* was the crackling

energy around R2-D2 when he gets short-circuited by the Jawas. Had he not died tragically in a house fire at age twenty-nine, Adam Beckett might have become one of the masters of the emerging CG medium. Other important pioneers to come out of CalArts included Richard Baily, Christine Panushka, Sheila Sofian, and Chris Casady. Los Angeles native Victor Acevedo was introduced to computer graphics while attending Gene Youngblood's survey class at the Art Center in Pasadena. His work focuses on exploring spatial graphical metaphors he calls "applied synergetics." Although he has done some short films, he is best known for his elaborate digital paintings. David Em had a gallery on Market Street in San Francisco, and had worked in conceptual video. "We had gone as far as you could go with video. But I felt I needed some way to control every dot on the screen. One day at a party I met a headhunter scouting electronics for Xerox Parc (see chapter 5). He told me, 'David! Everything is going to go digital. That's the future!'"[57]

CG artists like Vibeke Sorensen and Larry Cuba hold that you can't really understand the evolution of computer animation without acknowledging the work of the earlier analog abstract filmmakers. Cuba said, "Even though older technologies are soon superseded by newer, more advanced technologies, the art itself never becomes obsolete."[58] Artist/filmmaker Rebecca Allen recalled, "We wanted to bring a human quality to computers. Its key development must include the ideas of artists."[59]

This generation of avant-garde artists led the way for CG by showing new ways to view moving images and new ways to create art. The ideas they explored, among them that moving geometry and abstract shapes in and of themselves can be as expressive and entertaining as film, became the model for the next thirty years of CG development.

At John Whitney Sr.'s memorial service, Larry Cuba looked out at the assembled stars of the medium and said, "We here are called the pioneers of CGI, but we are not. We are merely its popularizers. People like John Whitney were the real pioneers."[60]

3 Spook Work: The Government and the Military

I tease my libertarian friends who all think the Internet is the greatest thing. I'm like, yeah, thanks to government funding.
—Marc Andreessen

At times the patronage of a government is as vital to the creation of new technology as the vision of a solitary genius. It seems strangely incongruous that the story of how cartoons or widescreen movie fantasies are made can have anything in common with the technology of war. Yet despite a hagiography of counterculture and social freedom, CG is as much a result of government funding as scratch-resistant lenses or Mylar.

The conflicts of the twentieth century—the world wars of 1914–1918 and 1939–1945 and the Cold War of 1945–1991—were wars of technological attrition fought by centralized economies. The United States, Britain, and their allied democracies prevailed over the fascists and later Soviet Union not only through manpower and industrial output but also through technology. These were wars in which scientists played roles almost as important as the generals.

It was the U.S. government that called atomic weapons into existence, by linking the resources of private think tanks like the Rand Corporation and businesses like IBM and Bell Laboratories with academic institutions like Stanford and MIT. It was early computer pioneer Vannevar Bush of MIT who first proposed organizing this tripartite system of cooperation to President Roosevelt in 1940. They created a circulatory system of cooperation, with the lifeblood of federal tax dollars coursing through its veins. After the war they split off the civilian atomic power industry in the Atoms for Peace Program and the National Science Foundation.

World War II was fought in part with first generation analog computers. The Enigma machine that the Nazi used to encode messages, is today considered a forerunner of the computer. Likewise, the Norden bombsite, which pilots used to drop bombs on cities, was another type of early computer. In Germany in 1941 Konrad Zuse created the first fully automatic electric binary computer, called the Z3 Adder. He also created Plankalkül, the first algorithmic programming language. By 1943 the British had built

a dozen huge computers named Colossus for decoding. One took up the entire basement of the Selfridges department store in London. These various devices were called by various names under the generic term Turing machines, for Dr. Alan Turing. The people who loaded data into them were called *computers*.[1]

When John Whitney began making his first experimental films, he adapted war surplus Mark V and Mark VII antiaircraft gun sights. "I beat their swords into ploughshares," joked Whitney.[2]

MIT had a Servomechanisms Lab funded by the Office of Naval Research. It was established in 1940 in part to develop automatic control systems for battleships to synchronize the firing of all of the ship's massive sixteen-inch guns at once. In 1945 the most advanced computer was Mauchley and Ekert's ENIAC (electronic numerical integrator and calculator), built at the University of Pennsylvania for the army.[3] It had eighteen thousand vacuum tubes, three thousand flip-flop (on/off) switches, and weighted several tons. It was as big as a two-car garage.[4]

For all its sophistication, ENIAC was built exclusively to solve mathematical problems, so it remained, in effect, a big adding machine. It also couldn't store a program, and it had to be painstakingly rewired for each new function. The next model was UNIVAC-1, the first computer offered to the private business market and the first computer that could do more than one task at a time. UNIVAC was advertised as "being able to perform complex calculations in a matter of minutes!" It was used for the occasional public relations stunt, like to calculate the outcome of the 1952 presidential race. UNIVAC's operating language was conceived by Grace Hopper (1909–1992), who became the first woman to achieve the rank of rear admiral in the U.S. Navy. Thanks to her, you can communicate with a computer using words instead of numbers. Hopper is also the person who coined the term *computer bug*, when she discovered a dead moth that had gotten into the circuit board and caused an IBM Mark II computer to crash. She wryly noted it in the computer's log and taped the moth into the book.[5]

Two scientists at MIT, Jim Everett and Ken Olson, began to conceive a bigger computer, capable of performing a variety of tasks, using multiple consoles that all lead to a magnetic memory drum to store data. The project was given the name Whirlwind, and that portion of the MIT lab was renamed the Digital Computer Laboratory. The first-generation computer of Project Whirlwind, the TX-0, went operational December 1, 1951.[6] One of its developers said Whirlwind had "about a quarter of an acre of electronics and 5,000 tubes in it."[7] It introduced several new ideas. Up until then, the way you got data from a computer was via long tickertape printouts or a paper printout like a Teletype machine. But because of the need for rapid response to any emergency, military personnel wanted faster data retrieval and display. So the TX-0 displayed data not in a printout but on a screen, adapted from old, surplus radar systems.[8]

The computer screen was born.

The Whirlwind also sported the earliest known light pen-stylus, so you could point and click to get or move data.

MIT quickly created two more advanced models for Project Whirlwind, the TX-1 and TX-2. The lab soon outgrew its old environs and was moved to the Lincoln Park Facility in Bedford, Massachusetts. MIT then split off the lab as its own corporate entity, called MITRE, for MIT research enterprises. Their original pitch to the navy was for developing an advanced computer to aid in radar tracking of military aircraft. But the scientists quickly began to develop the TX series to do a variety of jobs, including census tabulation, large-scale payroll processing, creating artillery firing tables, and air traffic control. The computers even calculated the exact amount of vanilla icing to stuff into Oreo cookies. Throughout the 1950s the Lincoln TX-2 was the workhorse for advanced multitask computing.

In 1957 the Soviet space program launched Sputnik, the first true orbital satellite. Up to then the United States had been trying hard to get its own satellite up into space, and the Russian success came as a complete surprise. It is hard today to appreciate the trauma this caused the American public. Sputnik's orbit was so low that on clear nights many could see it with the naked eye: the living symbol of the enemy's scientific superiority, seemingly laughing at them overhead. It was as though the moon was suddenly sporting a big red hammer and sickle. It made wild rock-and-roll star Little Richard Penniman drop his music career and become a Pentecostal minister. He thought Sputnik signaled the end of the world.

Oh Little Sputnik, flying high
With made-in-Moscow beep,
You tell the world it's a Commie sky
And Uncle Sam's asleep.[9]
—Michigan governor G. Mennen Williams

The public clamored for Washington to do something. The administration of President Dwight Eisenhower was moved to action. Funding for the U.S. space program was stepped up, and soon Vanguard 1, our own little beeping silver bauble, was shot into orbit. In addition, a new agency was formed, more focused than the National Science Foundation, to marshal the nation's intellectual resources for defense. One of its first directors recalled, "President Eisenhower asked the Defense Department to set up a special agency so we wouldn't get caught with our pants down again."[10] It was called the Advanced Research Projects Agency, or ARPA.[11]

ARPA oversaw the channeling of funds from the air force, navy, NASA, and the CIA into many institutions of higher learning. Insiders called it "150 geniuses and a travel agent." Many times its director was a scientist himself. Director J. C. R. "Lick" Licklider said his philosophy was to "get the best people, ask them what they thought was most

important to do, then give them the funds and let them go to it."[12] Scientists who undertook such top-secret government contracts nicknamed it "spook-work." Initially, no idea was too way-out for consideration. One program was funded to study the swarming characteristics of gnats. Another created a robot-controlled pogo stick.

But more importantly for our topic, most of the major breakthroughs of the 1960s and 1970s—data storage, core memory, graphic displays, networking, virtual reality, and more—were accomplished due to ARPA funding. Many of the top scientists and engineers in computer graphics were sponsored through their careers by ARPA money. Years later former Rand scientist Michael Wahrman summarized, "I took a bunch of technology the Cold War paid for, to make it easier for filmmakers."[13]

Throughout the 1950s scientists and artists had been trying to create films using the light waves flickering through military surplus oscilloscopes and radar screens. These yielded intriguing nonobjective images, but with limited use. In 1957 a scientist working for the laboratory of the National Bureau of Standards named Russell A. Kirsch realized a better system would be a system of pixels, like the printed dot patterns of a newspaper. Using a SEAC (Standards Eastern Automatic Computer or Standards Electronic Automatic Computer) with his newly invented drum scanner, he created the first digital picture, digitizing a snapshot of his three-month-old son. It was 5 x 5 cm and made up of 176 pixels. Without this breakthrough, not only would CG not have been possible, but satellite imagery, CAT scans, bar codes, and desktop publishing would not have been possible either.

In 1956 the U.S. Air Force ordered a radar early warning system to cover all of North America to the North Pole. This new computer project was designated Project SAGE (semiautomatic ground enhancement). This project required a larger version of the TX series, now wholly given over to searching and tracking the Soviet nuclear bombers the public feared were just beyond the horizon. SAGE was a real-time digital computer that had a magnetic core memory. Each system took up twenty thousand square feet of space and weighed 250 tons, all to produce one megabyte of information.

IBM built fifty-six SAGE computers for the Air Force, at a cost of $30 million each. By 1963 there were twenty-four SAGE direction centers and three SAGE combat centers hidden across the United States and Canada. In the major facilities they actually placed two SAGE mainframes back to back. This was in case one system went down, say from a burned-out radio tube; the other would go on immediately without compromising the guardianship of the homeland. SAGE computers had the first modems, so they could talk to one another over telephone lines. Each computer also had a CRT display, keyboard, light gun, and real-time serial data. SAGE data terminals even sported their own built-in cigarette lighter and ashtray for the convenience of those Dr. Strangeloves spending long nights with their eyes glued to the glowing screen, awaiting nuclear Armageddon.[14]

With SAGE operational, the Whirlwind TX series was declared obsolete. The Defense Department ordered them shut down on June 12, 1959. Many on the Whirlwind team felt like they were saying goodbye to an old friend.

I will never forget those pizza-warmed nights,
Filled with the ringing of bells and the flashing of lights.
Oh, 'twas push "START AT 40" and wait there in pain,
With the odds two to one it would hang up again.
And now when its work is almost at end,
I feel like I'm losing a very old friend.
It's an ungrateful world that complains of your core,
"It's too small, you're too old, we've the 704."
—Bert Schafer, 1959[15]

But the scientists back at MIT could still find other uses for them. In 1961 a young student in the ROTC program started doing his PhD work at MIT: Ivan Sutherland, born in Nebraska, the son of an engineer and a mathematics teacher.[16] He had been interested in computers since high school. After earning degrees at Carnegie Mellon and Caltech, Sutherland transferred to MIT because he had heard of their advanced computer program from his brother Bert, who was already there and had helped design the light pen for SAGE and an early computer game. Ivan became a student intern at MIT's Lincoln Lab facility and after a year stuck around as a part-time employee.

At Lincoln Lab he was allowed to dabble with a big TX2 (nicknamed "the Tixo") for his thesis. This was a unique situation for the time. Personal computing was an as yet unheard of luxury, reserved for future generations.[17] The college had already booked the Tixo for another project, leaving the young Sutherland only six months to get all his dissertation work done.

So Ivan Sutherland had his TX-2 alone. It even had an updated light pen for its nine-inch screen. Now, what to do with it? Earlier, a colleague named Charles Adams had experimented by creating an animated bouncing ball. Traditional animators know the bouncing ball is the first basic exercise anyone tries when first learning to make animation. Sutherland liked to say he didn't learn to read until the third grade, but before that he learned to read drawings.[18] Like the artist John Whitney on the West Coast, Sutherland became intrigued by this concept of creating drawings via automation.

Sutherland spent 1962 creating a drawing program for the computer called *Sketchpad*, which he described as "a man-machine graphical communication system." He drew on a tablet with the light pen, and the graphic shape appeared on the monitor screen; the lines could even be made to move. It was the first true computer animation program. "There were some earlier programs involving geometry," the CG pioneer Alvy Ray Smith explained, "but Sutherland's did interactivity."[19] There was no need for any written language, no points to enter. All you did was draw and articulate some

buttons marked "erase" and "move." He developed something called "rubber banding," where you created one point and by moving the pen you stretched a line to another part of the screen, anchoring it as your second point. Also, you could turn objects and the entire wireframe, not just a particular line, would move as one unit. This was the beginning of kinematics, a concept vital to the creation of CG animation. Sutherland demonstrated the graphics capability by drawing an industrial bridge, and he showed the potential for character work by drawing a woman's face copied from a photo and animating her eye winking. The mere fact that he could draw curved lines with Sketchpad marked a major breakthrough. The computer scientist Alan Kay said that contemplating the power of Sketchpad was "like seeing a glimpse of heaven. . . . It had all the things that the computer seemed to promise."[20] Years later Kay asked Sutherland, "How did you invent the first interactive real-time graphic system in less than one year?" Sutherland modestly replied, "I didn't know it was hard."[21]

Figure 3.1
Ivan Sutherland at the TX-2 Whirlwind demonstrating Sketchpad, 1962.
Courtesy of the MIT Museum.

Another idea Sutherland had was to make a film documentary explaining the making and use of Sketchpad. MIT made sure 16 mm copies of the documentary were mailed out to universities all over the United States and Canada. One of those who got excited about Sutherland's film was an electronics professor at Berkeley named David Evans.

After getting his doctorate in 1963, Sutherland entered the army to fulfill his ROTC commitment. By 1964 he was at the National Security Agency, when he was invited to join ARPA as a lieutenant. His brilliance was recognized at ARPA. He was quickly named the director of their infant computer development program.[22] "I felt at the time that it was probably too large a job for me to undertake at that age," he recalled. "I initially said no . . . but they twisted my arm a little harder and I agreed to go." It felt awkward for generals and admirals, cigar-chomping old veterans of Guadalcanal and Inchon, to be working under a lowly twenty-six-year-old lieutenant. "The previous ARPA director (J. C. R. Licklider) had a colonel as a deputy, but it was felt to be improper for the colonel to be my deputy, so the colonel disappeared into the ARPA staff." One of the other departments was led by a Major General Winecki. Sutherland and Winecki would go to staff meetings together and sit side by side on a sofa. "I think the fact that I was a lieutenant was carefully concealed from General Winecki. He always wore his uniform. I never wore mine. He called me Ivan; I called him 'Sir.' It was a very strange assignment . . . but I believe that nobody else would take it."[23]

In 1966 Sutherland left the military to take a post at Harvard. In 1968 he moved to the University of Utah, where he teamed with the Berkeley Sketchpad fan Dave Evans to do Defense Department subcontracting work from ARPA through their own company, Evans & Sutherland.

In 1963, although the U.S. mainland was covered by SAGE, the system had a weakness in that it still relayed information to Washington along commercial telephone wires. After the 1962 Cuban Missile Crisis brought the world within a cat's whisker of a full-on nuclear war, the U.S. Defense Department pondered the problem of how to keep command communications alive if centrally located telephone systems were knocked out. The major cities served as communications centers were also key targets. What if a Soviet first strike took out the Pentagon and the Strategic Air Command headquarters in Cheyenne Mountain, Wyoming? How could the surviving defense elements talk to one another to launch a retaliation? The Pentagon commissioned the Rand Corporation to think about it.

At first Rand researcher Paul Baran proposed a broadcast of special radio signals from local low-frequency AM stations to the surviving missile silos. But on further study that seemed too slipshod. Baran then conceived of an all-digital system. The information would not go out in a steady stream like electric current but be sent in packets, like the DNA contained in a chromosome. These packets would move at

lightning speed around a communications "net," just like the nerve synapses of a human brain.

He first discussed such a system with AT&T, who weren't interested in creating a communications system to rival their own, Ruskie nuclear threat or not. Baran next went to ARPA. Funny you should mention it, ARPA scientists like J. C. R. Licklider, Robert Taylor, Lawrence Roberts, and Ivan Sutherland had been discussing the need for an all-encompassing computer network since 1962. Licklider had called this theoretical system the Intergalactic Computer Network. He theorized that a computer network could help researchers share information and even enable people with common interests to interact "on line."[24] There had been sharing of computer time before. But the computers were all separate on isolated individual mainframes. ARPA scientist Robert Taylor complained that he needed four monitors in his office to talk to four different colleges. Taylor had once studied to be a minister like his father. Now he came to a new type of revelation. There had to be some way to connect them all. Also, they had to devise a way to let users speak to one another like they would with a phone and not just receive, like a television set. While most of the world still thought of computers as overdeveloped electronic brains that James Bond played chess with, these scientists had a vision of the computer as the ultimate means of communication.

Sutherland had ARPA award the contract to design the system to Lawrence G. Roberts at MIT in 1965. Roberts and his colleague Leonard Kleinrock had also come to reject the idea of using a system like circuit-switched phone systems in favor of something else. That turned out to be Baran's idea of packet switching. In 1967 a British team led by Welshman Donald Davies gave ARPA a presentation on the very same concept. Davies was trying to sell Whitehall on a network system with packets of data, but to no avail.[25]

By 1968 Robert Taylor, who had succeeded Sutherland as director at ARPA, presented MIT's system plan. Their paper, titled "The Computer as a Communication Device," started out, "In a few years, men will be able to communicate more effectively through a machine than face to face."[26] ARPA agreed to fund the project to the tune of $3.4 million. "Lick" Licklider had taken a post at UCLA, and Roberts considered his contribution vital. So it was agreed that UCLA would be the first node of the new network.

Soon the big Honeywell mainframe computers, so durable that Honeywell staged demonstrations with a burly construction worker pounding on the computer with a sledgehammer, began to arrive on the Westwood campus from Massachusetts. The second system was set up at the Stanford Research Institute (SRI), more than four hundred miles to the north. There, Taylor's friend Dr. Douglas Engelbart had been trying since 1963 to accomplish a similar link up but had been unsuccessful due to the weakness of the computers he then had access to.

On a hot Indian summer weekend in 1969, in the basement of UCLA's Boelter Hall, the same place where John Stehura created his *Cibernetik* films, Licklider, Vincent Cerf, Robert Kahn, Lawrence Roberts, and Taylor used their computer to make the first call to SRI. "We typed the 'L' and we asked on the phone 'Did you see the "L"'? 'Yes, we see the "L,"' was the response. Then we typed 'O' and asked 'Did you see the "O"?' 'Yes, we see the "O" was the response. Then we typed 'G,' and then the system crashed!" But when they rebooted and the system sprang to life again the people at UCLA were able to type in "LOG," to which the Stanford folks replied "IN." Leonard Kleinrock recalled, "You will find in my logbook, the first breath of the Internet. Oct. 29th, 1969 at 10:00PM—'Talked to SRI. Message received.'"[27]

At one point Kleinrock found himself having to calm the fears of other researchers at UCLA and ARPA, reassuring them that the government was not inventing some new way to tap into and read their personal computer files. Kleinrock had to convince them that this thing was eventually going to be a boon for all.

They called their system ARPANET. By December they had successfully hooked up five computers at five separate universities: UCLA, Stanford, UC Santa Barbara, the University of Utah, and MIT and had begun devising a common language for all to speak. "Like it or not, the ARPANET grew up, and once it was there they loved it," Sutherland said. "I sensed a decrease in the 'Not Invented Here' attitude of groups in the computer science departments at the universities of this country."[28]

While America had its ARPANET, Britain had developed its own system called NPL, and France had CYCLADES. In 1977 Vint Cerf and Robert Kahn linked all three networks and sent the first communication around the globe. In 1990 Tim Berners-Lee and Robert Cailliau announced the World Wide Web, and the first private websites appeared.

Since aviation was introduced as a weapon during the First World War, the U.S. government has attempted to train pilots on flight simulators. The better they could rig a simulation to feel like a real plane, the less likely that pilots would crash their planes into houses and upset the public. The early flight simulators look silly to us now, like an enclosed outhouse on auto springs, flanked with enlisted men at the ends of oars to pitch and yaw them through their motions. During World War II, the Walt Disney Studios built elaborate miniatures of enemy cities for bombardiers to practice on. These were dragged along the ground on ropes by movie prop men under a parked planes bombsite.

Postwar, when aviation advanced to jets and the stratosphere, the margin for error became too great for such primitive techniques. New electronic flight simulators had to be developed to anticipate split-second decision making at supersonic speeds. If only the graphics on a screen could simulate the type of topography the pilot would encounter, and if the topography could turn in real time in response to the pilot's

Figure 3.2
Flight Simulator NASA Space Shuttle program (1978).
© NASA. Courtesy of Richard Weinberg.

controls. . . . In World War II contractors had wasted a lot of money on boondoggle projects like swimming tanks and Howard Hughes's Spruce Goose. Engineers wanted to try out new stratospheric airplane designs in virtual simulation before having to build a costly prototype. NASA also wanted radar-enhanced 3D images of planetary bodies, and oil companies wanted ground surveys. All these needs were addressed by a boom in research on creating virtual reality with a computer.

In the 1950s and 1960s the chief financier of the development of visuals by computer was the military. Such government-sponsored development of CG for military purposes was not limited solely to the United States. In France, Sogitec and Thompson Imaging got the first big contracts for CG simulations from the French military to test new missiles and fighter jets.

William A. Fetter and Walter Bernhardt of the Boeing Aerospace Corporation created 3D simulations of a supersonic plane landing on a carrier bobbing in the sea. They modeled one of the earliest wireframes of a human being to study ergonomic issues

in designing cockpit seats.[29] In 1960, to explain to the funding people what exactly he was doing, Fetter coined a new term, *computer graphics*.

By the late 1960s the U.S. public's growing frustration with the Vietnam War was also shining daylight on the length and breadth of defense expenditures. The military-industrial complex that President Dwight Eisenhower had so gravely warned about in 1961 seemed all too real. Détente under Nixon and Brezhnev made all the Cold War posturing about the Red Menace seem outmoded. Although the progress in computer science with ARPANET was impressive, that project was still classified. All the public saw was a monolithic, self-perpetuating war machine that wrapped both big business and academic institutions in its coils. Its pointless statistics about "kill ratios" and "megadeaths" seemed designed only for self-justification.

The centers of antiwar outrage were the very learning institutions that the Pentagon once relied on. Many young professors and graduate researchers who had been drawing salaries from government agencies had become radicalized. When mobs of shaggy-haired students marched across campus quads loudly demanding that their college administrations stop doing Defense Department research, their professors often were out in front. When Stanford students learned that their school's computer research lab, the SRI, had manufactured a computer simulator called Gamut-H to train combat helicopter pilots, it caused a near-riot on the campus. Former Caltech student Vibeke Sorensen recalled, "Vietnam caused us to want to redirect technology. You either use it or change it. If artists weren't involved, it wouldn't be humanistic."[30]

The CIA's mind-expanding experiments with LSD moved from the research faculty to the student body to spawn the recreational drug culture of the Swinging Sixties. Harvard professor Timothy Leary coined the phrase "turn on, tune in, drop out" following his experiences participating in a CIA-funded study. In 1971 the first e-transaction ever done on the web took place when students at the Stanford Artificial Intelligence Lab (SAIL) used the government's ARPANET to contact their counterparts at MIT to buy some pot.[31]

Incoming Republican president Richard Nixon had to deal not only with a seemingly endless commitment in southeast Asia but also a hostile Democratic Congress. After the shock of the 1968 Tet Offensive, the My Lai Massacre, and the embarrassments revealed in the Pentagon Papers, the leading antiwar senators sought to bring about an end to the Vietnam debacle by using their congressional powers of the purse. By the time of the final moon landings in 1973, the public was tired of the Space Race, a competition that was already won. Why were we still wasting millions of tax dollars just so an astronaut could whack golf balls on the moon? Democratic Senate majority leader Mike Mansfield began to investigate the budget of the Defense Department, to strip away its more outlandish expenditures. And in the era of détente, advanced

computer development to warn against an increasingly unlikely nuclear first strike was high on the senators' hit list.

Over Nixon's objections, the Mansfield Amendment was passed on March 23, 1973. Among many cuts to defense spending, it radically cut down the size and scope of ARPA. It curbed the agency's more exotic research programs and ordered it to stick to those directly germane to national defense. The agency was also renamed DARPA, for Defense Advanced Research Projects Agency.

All these factors resulted in a brain drain of the best and brightest scientific minds from government work into the private sector. No wonder 1973 was the same year the business-machine giant Xerox set up its advanced development arm, called Xerox PARC (Palo Alto Research Center). Robert Taylor from ARPA became its first director. Ivan Sutherland had already left ARPA to continue in academia. The government continued to be active in advanced computer development, but after the Mansfield Amendment the tone changed. The heady, sky's-the-limit era of government research spending was over.

Government sponsorship of CG development had one last hurrah. In 1982 Jim Blinn, a young artist working for NASA, took CG a leap forward in front of a world audience. Blinn had come up from the University of Michigan in Ann Arbor. He majored in computers while being fascinated by astronomy, "ever since I got my first Little Golden Book of Astronomy as a child."[32] While doing his graduate work at the University of Utah under Ivan Sutherland, he created his own computer paint program called Crayon. Blinn did an internship at NYIT in 1976 and befriended Ed Catmull, Alvy Ray Smith, and others who would soon build the computer arm of Lucasfilm. In 1980, at the University of Utah, he expanded on Catmull's concept of texture mapping by creating "bump mapping," a more realistic, irregular skin surface added to a polygon structure.

Blinn worked out of the JPL in Pasadena, normally the place where NASA accumulated and analyzed data from satellites and space probes.[33] Blinn had been so on fire to be at JPL that he would even have accepted a night watchman job. He learned that a JPL official named Bob Holzman had used leftover DARPA funds to purchase a computer graphics hardware system like the one Blinn had been using at the University of Utah. Holzman wasn't quite sure what to do with it, and he needed someone to help him figure it out to justify the purchase. "Just the ticket for me," Blinn thought. So with a recommendation from the omnipresent Ivan Sutherland, Blinn found his niche. His colleague at JPL, artist David Em recalled, "Jim was so excited to get to work that as soon as he received his doctorate at Utah, he took his software codes, stored on a large reel of magnetic tape, off the machine there, and drove straight from Salt Lake to Pasadena (approximately twelve hours).

He went straight to the lab, put his reel up on the machine at JPL, then retired to his rented room to collapse."[34] Now what to do?

Blinn noticed that someone at JPL had already attempted a simple, black and white line-drawing animation of the *Voyager 1* spacecraft as it encountered Jupiter. In 1977 two space probes, *Voyager 1* and *2*, had been launched from Cape Kennedy and sent on a grand tour of the outer planets of our solar system. These were the probes that eventually quadrupled our knowledge of our planetary neighborhood. The Voyagers' historic mission discovered that the gas giants Jupiter and Saturn had many more moons than had ever been observed from Earth, that Jupiter and Neptune had rings like Saturn, and that Europa was frozen and Io was covered with active volcanoes. And in case they encountered any alien civilizations on their journeys, they both carried a solid-gold record of Earth sounds and images selected by Cornell University professor Carl Sagan (1934–1996). Blinn recalled, "When I started, Voyager had already taken off. But it took two years for it to reach anything important."[35]

Blinn guessed that NASA could probably use a film simulation to explain to taxpayers exactly what they were doing, especially if the spacecraft's onboard cameras failed to send back clear images. "I contacted the [JPL] animators, who turned out to be Charley Kohlhase, the chief mission planner for Voyager, and one of his assistants. I got their trajectory-plotting data and set to work making a shaded, colored, and textured version." There was no storyboard. It was the mission plan itself. The unofficial little project at first was merely a moonlighting sideline for Kohlhase, but it was a full-time task for Blinn. "Once we finished the film we sent it to the public information office, and they didn't really know what to do with it. It was only after Charlie showed it to the head administrator of NASA during a pre-encounter briefing that the word came down to make copies and send them out to the news media."[36]

It is intriguing to imagine what these conservative, starched-shirt, pocket-protector-and-horned-rim-glasses-wearing military scientists thought of Blinn. Here in their midst, was this tall, young hippie, with a full, light-brown beard that he let grow down to his belt. He reminded one more of Ted Kaczynski than Robert Oppenheimer. Regardless of what they thought of his appearance, NASA was so impressed with the film that they quickly ordered a larger, more complete film in full color. Blinn called in some friends from his NYIT days who were cooling their heels awaiting roles at George Lucas's Industrial Light & Magic (ILM): Alvy Ray Smith and David DiFrancesco. They also sported longer hair and beards. The trio looked not so much like JPL material as Three Dog Night. But hey, this was California, after all!

What was wonderful about the Voyager flybys was instead of clunky-looking computer graphics with jiggidy-jaggedy surfaces that jerked spasmodically like *Pac-Man* games, these models moved dynamically and with fluidity. The little Voyager satellite twisted and turned its antenna, then dove gracefully through the massive rings of Saturn and swung past its more volatile moons, then up through the vertical axis ring

Figure 3.3
Jim Blinn's *Voyager 2 Flyby* film (1982).
© JPL, courtesy of Dr. Jim Blinn.

of Neptune. All in full color. At one point someone thought to match the film to classical music, and the result was nothing less than a beautiful cosmic ballet. Blinn's masterful rendering of the spacecraft and the planets combined with Smith's handling of the camera. "Alvy freed the camera from its static position; he got it thinking like the satellite itself," Blinn said.[37] This got Smith to thinking, Why can't all camera work be as dynamic and free flowing?

The Voyager flyby films premiered in 1979 and 1983, and clips appeared on network and public TV news programs whenever the two Voyager craft reached another important milestone in their long mission. The onboard cameras did do their work, but the images took weeks to return to Earth and many more weeks to analyze and enhance. Blinn's facsimiles filled in so nicely, most of the public probably thought they were seeing the real thing. Blinn also took the new images of the planets' surfaces as they came in and texture mapped them onto his planets, to increase their realism even more. Each new discovery was announced to the public with a stunning new film by Blinn and his JPL team.

At this time the only way someone who was not a scientist or a fighter pilot could get to see real 3D computer animation would be to go to a film festival like Filmex in Los Angeles and wait for the last short of the evening.[38] But the Voyager flybys were shown every day on mainstream TV news broadcasts. The global public was

getting a taste of good computer animation for free. In this way the Voyager films prepared the way for the high-quality 3D CG films to come. The computer was finally seen by the general public not just as a glorified typewriter but also as a serious medium of art.

Around the time the first Voyager film was showing on the evening news, Blinn heard that Kohlhase had a friend named Gentry Lee who was the business partner of Carl Sagan.[39] Lee was working with the National Academy of Sciences and southern California PBS station KCET to bring Sagan's bestselling book *Cosmos: A Personal Journey* to television. The book was a musing by the award-winning scientist about the nature of human intelligence and our future growth to the stars.

"We all got together for a demo and I was able to convince them [Sagan and the *Cosmos* production team] that I could do some useful stuff with CG," Blinn said.[40] Since Blinn and his team remained full-time employees of JPL, it took some finagling to allow a government-sponsored lab to sign a production contract with a television show, even a public TV one.

Sagan did frequent media appearances; the public liked his persona. Blinn recalled, "Carl Sagan was a nice man, but at times he sounded more pompous than he meant to. The producer did a nice job of editing his more pretentious pronouncements, so he comes off sounding like a down-to-earth guy."[41] It was decided that Sagan would narrate the thirteen episodes as well as be on camera. There had been other "event" documentary series on PBS already: Kenneth Clark's *Civilisation* (1969), and Jacob Bronowski's *The Ascent of Man* (1973). But what made *Cosmos* different was the very advanced CG visual effects.

Sagan would be seen piloting his "Star Ship of the Imagination" through supernovae and gaseous nebulae to the edge of the known universe, set to the music of Greek composer Vangelis. In addition, he took the audience on a walk through a virtual rebuild of the Great Library of Alexandria, destroyed by Julius Caesar two thousand years before in 46 BC. Sagan was actually walking on a green-screen stage. The ancient library was built and turned around by Blinn and his team. It was the first virtual environment the general public had ever seen.

At one point JPL tried to ease the burden on Blinn's overworked team by freelancing some of the work out to a small motion picture effects house in LA called Calico. The artists were assigned to create images that would re-create what the skies looked like in several historical eras. While doing research, they came upon a lot of detailed sky constructs in a publication by the religious sect known as the Rosicrucians. The artists thought they seemed to work, so they used them. But when PBS and Sagan found out, they hit the ceiling. What if the public, specifically the militant New Right, Moral Majority types thought that this secular humanist science show funded with National Education Association tax money was concealing secret messages from the Rosicrucians? Sagan fired the Calico people and quickly had the shots redone.

Cosmos premiered September 28, 1980. As with the Voyager flyby films, the public saw exceptional images done by computer from the comfort of their homes. *Cosmos* was awarded an Emmy and a Peabody Award. It became the most watched PBS series of all time, seen by 600 million people in sixty countries around the world.

When his coworkers Smith and DiFrancesco got their summons to return to ILM, Blinn at first considered leaving with them. ILM certainly seemed like the cutting edge of movie graphics. And JPL's equipment was beginning to date. Smith, in particular, tempted Blinn with the latest goodies Lucas's *Star Wars* earnings could buy. Blinn did go to ILM, bringing with him JPL graphics scientist Pat Cole, the first woman on the Lucas team. But the program directors in Pasadena realized quickly what they had lost and bought him all the updated equipment he needed to stay. Blinn agreed to commute back to JPL to keep things moving there.[42] After a while he came to a decision: "I realized that my first love was really space exploration and science, and it was time for me to commit to that. To collect myself in one place. JPL was for me that place."[43]

Blinn continued to make films and write books for JPL, explaining difficult mathematical concepts in simple graphics. Years later when friends asked why he didn't take a more commercial job, Blinn laughed, "I don't want to sell soap!" Ivan Sutherland paid tribute to Blinn, "There are about a dozen great computer graphics people in the world today, and Jim Blinn is six of them."

Although the emphasis nowadays is not on spook work the way it was during the Cold War, there are still computer graphics artists and engineers working on government projects. There is always a need for new simulations, strategic scenarios, training films, and new promotional films.[44] For instance, in 2004 DARPA began funding a project called The Great Race, challenging engineering graduate students to build robot-guided vehicles. Silicon Graphics computers were vital to the plotting of the human genome, funded by the National Institutes of Health. The military is developing a new generation of simulators inspired by the "holodeck" concept in the *Star Trek: The Next Generation* movies. The user will enter a room that becomes a street in a war-torn town, complete with sounds and smells. There he or she will interact with virtual figures challenging him with a situation.

Today the role of the U.S. government in the development of CG is little known or understood. But those who were CG pioneers back then know the truth: that without the incentives and open-ended funding from the feds, the kind of computer graphics we now take for granted would not have been possible.

4 Academia

I was asked if I wanted to teach. I said sure, I didn't know what else to do. I mean, what does one do with a master's degree?
—Charles Csuri, 1989

There is a story that once, when Socrates was debating philosophy with his students, his wife, Xanthippe, yelled at him for wasting his time when he should have been at his job as a stonecutter. She completed her scolding from her second-story window by pouring the contents of a pisspot on his head. Soaked, Socrates looked at his followers and said, "After such thunder, one should expect some rain."

Society has always profited when it allows a way for great thinkers to work unencumbered by the need to pay bills. Pure research, at times referred to as blue sky research, allows a scientist to think in the abstract, without having to justify how his or her research might be immediately profitable.[1] Much of CG development began in universities with students and researchers allowing their minds to wander about the potential of computers. They had the freedom to fail and to improvise.

By the 1960s many institutions of higher learning worldwide began to offer computer courses. We could easily spend a great amount of time delineating the achievements of each individual university in detail. But we risk someone pouring a pisspot on our heads. So for our specific focus on CG, let us limit ourselves to several major academic centers that provided the launching pad for some of the finest young minds in the field.

The institutions of higher learning that did some of the first work in computer sciences were institutions that were already known for advanced technical development. The Massachusetts Institute of Technology had been doing research in practical technologies since the end of the Civil War. As we saw in the previous chapter, their computer program developed out of their electronics and engineering school, doing direct commissions from the Defense Department to create better guidance and aiming systems for weapons in the world wars. When the project grew too big, it was moved across the Charles River to the Lincoln Campus in Cambridge, Mass. There it spun off

a private company, MITRE, to hold the patents of new discoveries and plow the profits back into the research end.[2]

Vannevar Bush (1890–1974) was dean of engineering at MIT from 1932 to 1938. As early as 1927 he had experimented with Charles Babbage's Victorian concept for a differential engine and had built his own analog computer, which he called a differential analyzer.[3] As we saw, Bush was the architect of the close relationship between government, business, and university research groups during World War II. In a famous article in the July 1945 issue of *The Atlantic* titled "As We May Think," he predicted a future home workstation he called a Memex, with electronic screens that would store a complete library as well as recordings and communications. If you fed it thousands of pages over hundreds of years, you would never fill it up. You would speak to others on your Memex, send documents, and play games on it. Bush's writings inspired many of the computer pioneers of the 1950s and 1960s to realize his predictions.

MIT's Engineering Department was next led by Edward Moreland. Under Moreland's leadership MIT built some of the first multitasking computers and invented the computer screen and light pen or stylus. After a lot of intense lobbying by the Model Railroader students (see chapter 6), MIT offered its first class in computer programming in 1959. It was listed in the catalog as Artificial Intelligence, taught by John McCarthy (1927–2011).[4] McCarthy the previous year had invented the procedural language LISP. LISP quickly became the operational lingua franca of the budding field of AI. In 1962 MIT student Ivan Sutherland created Sketchpad, and Steve Russell and his classmates created the first true computer game, *Spacewar!*[5] In the decades before personal computers were available, allocating computing time on one big mainframe for all these individual projects was a significant problem. In 1961, under the supervision of program director Lick Licklider, MIT researchers Fernando Corbato and Robert Fano invented the concept of time sharing. As Corbato and Fano described it, "time sharing can unite a group of investigators in a cooperative search for the solution to a common problem, or it can serve as a community pool of knowledge and skill on which anyone can draw according to his needs."[6] Time sharing became the standard practice for computer researchers for the next two decades.

Meanwhile, on the other side of the continent, in sunny California stood the great technical research university of the west, Stanford University, established in 1891 by California governor and railroad tycoon Leland Stanford. After World War II, Bush's student Frederick Terman (1900–1982) went out west to be Stanford's dean of engineering. Today he is called one of the fathers of Silicon Valley. He began a program to target leasing the university's land holdings to high-tech startup companies. He also introduced his student William Hewlett to David Packard in 1938 and suggested they might make great partners.

When Stanford set up its computer science programs in the 1960s, they split into two philosophies. The Stanford Research Institute (SRI) set up the Augmented Human Intellect Research Center, headed by Dr. Douglas Engelbart, to explore how computers could be used to expand the limits of the human mind. The rival group, the Stanford Artificial Intelligence Lab (SAIL), was set up by another MIT transplant, John McCarthy. It was McCarthy who coined the term *artificial intelligence*. The goal of SAIL was to increase the ability of computers to think for themselves.

Engelbart has been described as "tall and craggy, with deep-set eyes and a hawk-like nose, he might have been carved from a slab of antediluvian granite."[7] Even though he invented some of the most useful tools of the late twentieth century—the computer mouse, hypertext, and the term *online*—his interests lay not so much in inventing things as in an open-ended search for knowledge. He first read Vannevar Bush's 1945 article "As We May Think" in a Manila military hospital where he was waiting to be sent home from service in World War II. He was inspired to realize Bush's idea of a personal workstation.

After years of development, on December 9, 1968, a cold, gray, drizzly San Francisco day, Engelbart held a grand demonstration at the Brooks Hall Auditorium.[8] The occasion was the fall Joint Computer Conference, a forerunner of SIGGRAPH. Everything was funded by ARPA. Engelbart and his SRI team strung cables and leased microwave beams and antennas to connect the auditorium in San Francisco to the Stanford lab thirty miles away. In front of a thousand people, Engelbart sat down in front of a monitor, keyboard, and wooden mouse. For the next ninety minutes he patiently proceeded to demonstrate how he organized functions on his computer and to communicate with his associate in Menlo Park live on a split screen projected behind him for the audience's benefit. Using his keyboard and mouse, Engelbart opened and closed files just by clicking on a word instead of writing out code. The audience was stunned. One eyewitness said Engelbart was "dealing lightning with both hands." He edited and mixed graphics and described how in the coming year he would be able to do the demonstration on monitors all over the United States. He joked about his manual controller device, "I don't know why we call it a mouse. We just started that way and never changed it."

When Engelbart's demonstration was complete he got a thunderous, standing ovation. All there felt they had been given a glimpse of the future. Until then the computer had been perceived as just a big calculator. Now it had been shown to be a means of human communication, the biggest new advancement since Gutenberg's press.

Many of Engelbart's colleagues and students went on to significant careers in places like Xerox PARC. The young graduate student who manned the cameras at the demonstration, Stuart Brand, became a counterculture hero as editor of the *Whole Earth Catalog*.

While Engelbart was leading his Augmentation Research Center, John McCarthy was setting a different tone at Stanford's SAIL program. Begun in 1964, the program moved in 1966 to the Donald C. Power Building, a ramshackle half-donut structure nestled in the foothills away from the main campus. "Uncle John" McCarthy was a brilliant iconoclast who fit the classic image of an absentminded professor. Stories abound of students asking him a question but receiving no answer. Hours, maybe days, later McCarthy would suddenly walk up to the student and, without any salutation, begin answering the question as though it had just been posed. All agreed that his answer would be brilliant, even if the method of delivery was a bit disconcerting at first.

McCarthy and his director at SAIL, Lee Earnest, had felt the more conservative management style of MIT to be a bit too inflexible. They permitted a relaxed and eclectic atmosphere at Stanford. By then it was the hippie era on college campuses, and the remoteness of the Power Building from the main campus allowed for an unconventional environment. The facility had an ARPA-funded volleyball court and a sauna, and there was skinny dipping in nearby Felt Lake. Lots of dope smoking went on in the dorms. The first alphabet created for SAIL's printer was for Elvish, the language created by J. R. R. Tolkien for his Lord of the Rings series of books. A robot prototype designed by the students rolled on baby-buggy wheels around the building. One day, while all work was stopped for the obligatory watching of the newest episode of *Star Trek*, the robot rolled into the room and paused in front of the TV. Everyone wondered if the machine had suddenly become sentient. In reality, one of the programmers had to work late, so he sent the robot in so he, too, could watch *Star Trek*, via its video camera "eyes."

But it wasn't all just fun and games. Everyone understood what it meant to have such an opportunity with state-of-the-art computers. Stanford scientist Donald Kluth, who wrote *The Art of Computer Programming*, would show up to use SAIL's computers alongside the beginning hackers. Everyone worked long hours through the night, pausing briefly for some Chinese takeout from Louie's and a beer. Scores of the world's best computer scientists began their careers at SAIL. SAIL graduates helped create such Silicon Valley giants as Cisco Systems, SUN Microsystems (Stanford University Networks), Foonly, Imagen, and Xerox PARC.

SAIL's reputation as a welcoming environment for advanced computer experimentation even attracted disaffected high school kids and dropouts, budding geniuses for whom primary school was boring. Two kids who frequently rode their bikes up to the lab were Steve Jobs and Steve Wozniak. Jobs later said the vibes he first felt at SAIL would stay with him his entire life.[9]

At Brown University, Andries van Dam ran the school's graphics program. In the 1960s van Dam sported a wild hairstyle and goatee that gave him a "mad genius" look. With

his colleague the poet/sociologist Ted Nelson he was working on something close to what Douglas Engelbart was doing when he attended Engelbart's 1968 "Mother of All Demos" in San Francisco. At the reception afterward van Dam buttonholed Engelbart and questioned him pointedly, "How much do you actually use this, and how much of it is just a demo?"[10]

The numbers of the undergraduate and graduate students that van Dam touched reach far and wide, from David Salesin, who was part of the ILM group that created the stained glass swordsman in *Young Sherlock Holmes* (1985), to Eben Ostby, who created the short *Beachchair* (1986) at Pixar, to Scott Anderson, who won an Academy Award for the pseudopod in James Cameron's *The Abyss* (1989), to countless others at ILM, Pixar, and Pacific Data Images/Dreamworks. His students ended up not only in entertainment but also creating graphics for medical imaging and other purposes. CG artist Scott Johnston later recalled, "I enjoyed Andries's class, but I didn't officially become part of the Graphics Group. The people who did were amazingly committed to it."[11] There is even a story that the human character Andy in Pixar's *Toy Story* movies is named for Andries van Dam.

In 1975 Rebecca Allen was studying graphic design, but felt, "I gotta make things move." She attended a screening at Brown of Charles Strauss and Tom Banchos's experimental film *Four Dimensional Rotation of Hypercubes* and was enthralled. She proposed an independent study at Brown on computer graphics. "I was interested in hi-res human motion, and as a woman I wanted to do something revolutionary with art," she said. So she created a film manipulating a high-resolution scan of an old 8 mm girlie film of a woman lifting her skirt. "It was a bit shocking for the time, but I wanted to bring a human quality to computers."[12]

Cornell University established its Department of Computer Science in 1965. It trained many who would figure prominently in CG, like Michael Wahrman, Marc Levoy and Richard Weinberg. In the late 1980s Levoy and Weinberg did research into digital paint (see chapter 12). UCLA had its computer center in Boelter Hall where John Stehura did his *Cybernetics* and the Internet sent its first message. After some time working at NYIT among other places, Rebecca Allen became chair of UCLA's department of digital media, and among others hired Bob Abel to the faculty (chap 10).

At Ohio State University Charles Csuri was an abstract expressionist painter who had been intrigued by computers since the mid-1950s. "I became confident that (CG) animation can become a new kind of art form," he recalled. He began to utilize the university's resources to create art on a computer in 1965. "We had one computer for the entire school. . . . As output for the graphics, you received boxes of punch cards." He was already a full professor in the Department of Art, "so I didn't have the nonsense of trying to prove to my peer group that I was doing something valid. . . . In departments where there is not very much sympathy for the computer,

Figure 4.1
A frame from Charles Csuri's *Hummingbird* (1968), the earliest attempt to animate an organic character.
Courtesy of Charles Csuri, ACCAD.

the faculty is very threatened by it."[13] In 1967 Csuri created the groundbreaking film *Hummingbird* (see chapter 12). The film is considered one of the landmarks of CG, because it is the first time someone attempted to move a living thing rather than geometric shapes.

Colleagues at the university suggested Csuri apply for a research grant to expand his studies. Despite not having credentials as a scientist, Csuri applied for funding to the National Science Foundation. "Fortunately, they had a missionary view about the impact of computers upon society, and they felt they had a responsibility to demonstrate the potential for the fine arts." To his surprise, Csuri was awarded a $100,000 grant, the first in a series that eventually amounted to $6 million. He realized that in order to develop the resources he needed, he had to shift from personal art to basic research. That one of their most acclaimed faculty members should resign

his post to give himself wholly over to science shocked the dons of the Department of Art.

In 1968 Csuri founded the Advanced Computing Center for the Arts and Design (ACCAD) at Ohio State, employing twenty full-time staff. In 1971 Csuri added an adjunct group to focus on computer animation called the Computer Graphics Research Group (CGRC). His teaching philosophy was simple: "With computer graphics you can end up doing what every traditional painter has ever done, or what photographers do. I think it is a more interesting challenge really to do things that one would not ordinarily think of. I ask myself a question, 'Can I do this with conventional means?' If so, then I'm on the wrong track."[14] Soon ACCAD rivaled the Buckeyes' football team as one of the highlights of life at OSU. Frank Crow, of the teachers Csuri brought over from the University of Utah, did groundbreaking work on CG shadows and developed a software package for editing called Scene Assembler, which gained wide use in the CG industry. Some of OSU's more well-known students were Wayne Carlson, Tom DeFanti, and Joan Stately.

Chris Wedge was a stop-motion animator from upstate New York who had heard about computers from a chance meeting with independent filmmaker Stan VanDer-Beek. Wedge had worked on *Tron* (1982) at MAGI/Synthavision, helping input data the animators sent in from the West Coast. "And it was just an arcane, tedious inter-face. You could only type things in. There was no way to interact with the images at all. . . . And I was thinking at that time that . . . if I were to be an animator in the future, I'd have to know how to program computers. Some of the people at Magi were able to make cool pictures with textures and lighting. But, as far as programming, I knew nothing about that." Then, while serving on a panel at SIGGRAPH 1983, he met Csuri. "I told him I was interested in the animation they were creating there. And he said, 'Well here! I'll teach you how to program. Come to OSU. I'll give you a TA [teach-ing assistant] stipend and you can do a degree in Computer Graphics.'"[15]

So Wedge moved his growing family out to Columbus, Ohio, and enrolled in the program. He enjoyed the free exchange of ideas with the other students, both artists and computer scientists. "We sat around and collaborated with the computer science students. Someone would say, 'This would be a cool tool.' And they would say, 'Well, what if it did this?' And then you'd counter, 'What if it did that?' Then you'd actually develop something and use it. Make a short film out of it. . . . I just told myself, 'Look! Here are the principles of animation! Let's just apply them to a computer, to computer graphics.' . . . We were some of the first to experiment with physical models, assigning weight, gravity, and spring tensions to computer-generated objects."[16]

Wedge created the short *Tuber's Two Step* (1985) for his graduate thesis film. It was one of the first CG shorts to employ a full range of squash-and-stretch techniques, the kind of organic plasticity seen only in hand-drawn animated cartoons. The little figures bopped to a jazz track like in the old Max Fleischer cartoons of the 1930s.

Wedge went on to win an Oscar for his short *Bunny* (1998) and cofound Blue Sky Studios (see chapter 12).

In 1973 at the University of Illinois at Chicago Circle (UICC), vice chancellor Joseph Lipson wanted to stimulate undergraduate education by utilizing interactive computer graphics on video. To do this he brought two scholars on board. One was Dan Sandin, who studied at the University of Wisconsin and had developed an analog video synthesizer he called the Sandin Image Processor. He was part of UICC's faculty, teaching students how to make their own electronically based kinetic sculptures. The other scholar was Tom DeFanti. He had come from Ohio State University, where he studied under Csuri.[17]

The UICC program was first called Circle Graphics Habitat, then renamed the Electronic Visualization Laboratory (EVL). Although the effort was conceived as a collaboration between the School of Engineering and the School of Art and Design, its first home was in the chemistry department. That was because that department had a PDP-11 mainframe with graphics, which they were trying to use to create visuals to aid in the study of chemical compounds.

For his dissertation, DeFanti had created an advanced graphics language called GRASS, for Graphics Symbiosis System. At Illinois he developed more advanced versions of GRASS and one called ZGRASS. "While most were pushing to achieve photorealism, he wanted to create a program that was easier for artists to use," CG artist Larry Cuba explained.[18] In 1977 George Lucas commissioned Cuba to create the animated schematics for the Death Star in *Star Wars*. Seeing that the computer systems around him in California were inadequate to the task he needed to do, Cuba brought the all the elements, including the models of the Death Star trench, to Illinois to use DeFanti's programs and the PDP mainframe. "GRASS was thirty years ahead of its time," Cuba said.[19] Even so, the black-and-white Death Star schematic took two weeks to render. Cuba also used the UICC system to create his short film *3/78 Objects and Transformations* (1978). ZGRASS also proved very useful to developers of interactive games.

Other than Larry Cuba's *Star Wars* work, the output of the Chicago Circle was predominantly focused on fine arts. Starting in 1973 the EVL held a series of events, usually in the rotunda of the science and engineering school. Students and faculty created performance pieces with music and images manipulated in real time, using GRASS and Sandin's image processor. By the end of the 1970s the EVL sessions grew less frequent as raster graphics replaced their calligraphic systems.

At the same time, Bruce Artwick was attending the University of Illinois at Urbana-Champaign, where he was developing software based on his experience as a pilot (see chapter 8). Artwick was the creator of the first nonmilitary CG flight simulator software. He founded the company subLOGIC while still a student and released the first

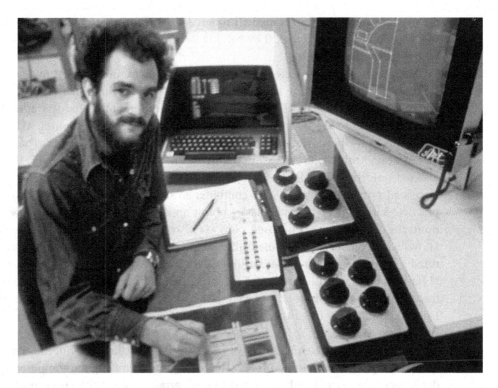

Figure 4.2
Larry Cuba working on *Star Wars* at the University of Illinois, Chicago Circle, 1977.
Photo by Clark Dodsworth. Courtesy of Larry Cuba.

version of Flight Simulator the following year. His original Apple II software was pur-
chased by Microsoft and eventually became the game *Microsoft Flight Simulato*r in
1979.

After completing his graduate and postgraduate work in physics at the University of
Utah, David Evans spent the much of the 1950s at the Bendix Corporation in Cali-
fornia as a project manager. There he headed the teams that designed the G-15 and
the G-20 computers, some of the first mass-produced computers in the world.[20] But
by 1961 Evans came to the conclusion that Bendix was not going to succeed in the
computer world (they sold their computer division to Control Data Corporation in
1963). So he accepted a position in the computer science department at Berkeley. There
he became director of the division that worked with government agencies like ARPA
(see chapter 3). One day Evans saw a promotional MIT documentary about the Sketch-
pad system created by Ivan Sutherland. "I got excited about it, but I didn't immediately

do anything about it," he recalled. Through ARPA, Evans got to meet Sutherland. As the two did business together, they became fast friends. They were equally fascinated by the computer's potential.

When Sutherland completed his military commitment, he left ARPA to take a position at Harvard as associate professor of electrical engineering. There he led a team working on "virtual reality." The user put on a head-mounted harness and looked through goggles to see a virtual room, done as simple wireframe graphics. As the user turned his or her head, the logic of the room's dimensions compensated. The harness was so heavy with cables and relays that it had to be suspended from the ceiling and lowered onto the user's head. Students called it "The Sword of Damocles." The air force had provided a large PDP-1 computer to use. Following Defense Department practice, Sutherland had to regularly submit an expense report showing how many hours the computer was being used. Now as CG artist David Em explained, "Everybody knows with computers, the stuff really got started at night."[21] Sutherland had instituted a system of twenty-four-hour time-sharing. Students called it the Yen List, as in "I have a yen to use the computer." When Sutherland submitted his report to the air force showing twenty-four-hour, seven-days-a-week usage, a colonel remarked, "Ivan! Jeez, you don't have to go that far!" The colonel obviously was new to the world of computers.

In 1965 James Fletcher, President of the University of Utah, convinced Dave Evans to leave Berkeley and return to his alma mater to grow their fledgling computer science department. Evans not only accepted but, he arranged an ARPA endowment of $5 million a year for three years.[22]

Evans telephoned Sutherland and asked for his advice on how he should set up the program, saying, "We cannot do all things, our department is too small." Sutherland responded, "Just focus on one thing and do it really well."[23] They agreed that that one thing would be graphics. It would set Utah, called the U locally, apart from the rest of academia at the time. And it would definitely aid the Defense Department's need for better flight simulators (sims) for its more advanced aircraft training programs. Professors in other departments of the university harrumphed, but Evans paid them no mind. He established a program of pure research. Student Ed Catmull recalled, "We constantly had to defend ourselves from other departments. Chemistry and Physics professors would say "You're spending valuable grant money on making pictures? Isn't there something more 'significant' you could be doing?"

Three years later, in 1968, Evans and Sutherland found themselves together during summer break, doing some private consulting work for General Electric. Over a dinner in Phoenix, Sutherland told Evans about his plans to form a private company to make mainframe computers. He wanted Evans to leave Salt Lake and move to Massachusetts to partner with him. After all, weren't all the big computer companies like IBM along Route 128 in Boston?

Evans agreed to go in on a partnership with Sutherland in his company while they both continued to teach. The only problem, as Evans's wife, Joy, pointed out, was that the Sutherlands had two children, while the Evans had a big Mormon brood of seven children, all placed in various schools around Salt Lake City. Wouldn't it be more convenient for the Sutherlands to move west, instead of the Evans family having to pull up stakes to relocate to Massachusetts? Besides, it was the height of the student-led anti–Vietnam War protests. Many large colleges, like Harvard, were wracked with sit-ins, teargas, hardhat riots, and bomb threats. At MIT a mob of protesters had tried to storm the school's computer lab. Had the lab administrator not reinforced the doors and windows with deadbolt locks and steel plates, the radicals might have destroyed its PDP-6 with sledgehammers. Conservative Utah, where 70 percent of the student body were LDS (Latter-Day Saints), offered a much more tranquil atmosphere in which to do research, especially research that was funded by the much-maligned military-industrial complex. So Sutherland consented. He resigned his tenured professorship at Harvard to take up an adjunct post on the faculty of the University of Utah.

Once together, Evans and Sutherland drew to the University of Utah the best faculty appropriate to the study and development of CG. People like Tom Stockham, Hank Christiansen, Jeff Raskin, and Marvin Minsky. When accepting students, Evans and Sutherland were looking for those who had fire in their belly to do CG research. Garland Stern had been rejected by Stanford and MIT but "I saw a copy of *Scientific American* with an article about Ivan Sutherland and Utah U, and that was it. I had to go."[24] Similarly, Alan Kay had already been rejected from several colleges, so he was amazed to see he had been accepted by Utah. "I discovered later that Evans never even looked at my grades," Kay recalled. "He didn't believe in them. You had to send him a resume, which was all he ever looked at."[25] The first time Kay appeared in Evans's doorway, the professor tossed him a copy of Sutherland's 1963 doctoral thesis *Sketchpad* and said, "Take this and read it." Evans believed Sutherland's paper was the best introduction yet to CG computing. "Basically, you had to understand that [Sketchpad], before you were a real person at Utah," Kay said.[26]

Sutherland recalled, "There was a flowering of technology at the University of Utah, and his [Evans's] students took these ideas and ran with them. . . . Evans had a way to make advanced research happen in relaxed and pleasant way."[27] He gave students a lot of autonomy and treated them as professionals. Sutherland brought from Harvard his personal institution of the volleyball game. After class students and faculty gathered in a lot behind the Merrill-Lynch building to play volleyball and converse until the sun went down. Formalities and pretense dropped, allowing a free-flow of ideas in a casual atmosphere. But it wasn't all play. After being accepted, students found that the curriculum was tough, the pace was fast, and the dropout rate was high. Some students were afraid of Sutherland. "He could be quite unforgiving with students who didn't get it," Stern said.[28]

The department's emphasis was on advanced research. No idea, no matter how far out, if conscientiously pursued, was ever dismissed out of hand. At one point Sutherland let the students paint digitizing points all over his Volkswagen beetle in the parking lot. Evans happened to be walking by, and he exclaimed, "Is this a class? Or are you all playing a prank?" This incident later resulted in an advanced 3D model of the Volkswagen, the earliest example of a real-life 3D object being digitized.

One of the big problems many students wanted to attack was how to put a solid surface on objects in the computers. At that time computer images were glowing wireframes on a black or green screen. They looked like a glowing Erector Set. How could they make images that looked real, as if they existed in a natural setting, subject to light and shadow?

In 1972 PhD student Ed Catmull made a mold of his hand by using plaster of Paris. "No one had told me that you need to coat your hand in Vaseline first before applying the plaster, otherwise it pulls the hairs off your hand," he said. "So it was quite painful in getting the mold off."[29] He used the mold to create a model of his hand in which he meticulously noted the plane breaks of the surface using polygons and triangles. These he digitized to create a virtual image of his hand. His finished graduate film, *A Computer Animated Hand* (1972), showed a computer-rendered hand articulating in space. The fingers moved, and the camera even went under and inside the hand. Added to this, his fellow student Fred Parke put salient points on his wife's face to create a working model of a face articulating. Both the hand and face were shown as vector wireframes but then also as surfaced images. They are probably the first 3D-rendered images, or raster images, ever seen on film. Catmull worked on creating three-dimensional curves that could be smoother than an assemblage of polygons, which was still a collection of small, straight lines. He also created "texture mapping" and an early "hidden surface algorithm," which would tell the computer that an image of a solid object should not show the construct lines at the back of the object. Frank Crow worked on anti-aliasing, so that lines didn't have that vector look known as "jaggies." Even the opening titles for *A Computer Animated Hand* were groundbreaking. The original title card was hand-written, but shortly after, Robert Ingebretsen designed titles of the names of Ed Catmull and Fred Parke. They appear as 3D block letters and then rotate 180 degrees to read "University of Utah." This may be the first ever example of "flying logos," the animating technique that would become the bill-paying trick of CG studios for the next twenty years.

Future motion picture visual effects designer Richard Taylor was then an undergraduate in painting and drawing at the U. He recalled, "There were these guys over in the engineering department . . . that were starting to do these things where they were creating a dimensional image, where they had made a computer imitate the effect of light hitting a solid object and bouncing it to a theoretical camera. There already was all this vector stuff . . . wireframes . . . but a computer doing raster

Figure 4.3
A Computer Animated Hand (1972). Ed Catmull and Fred Parkes graduate film created at the University of Utah.
© Pixar. Courtesy of Pixar.

graphics . . . that was new."[30] As word spread about what they were trying to do, the University of Utah computer science department attracted more and more fine young minds from around the world.

Frenchman Henri Gouraud did his graduate work by developing a way to shade three-dimensional objects. Bui Tuong Phong was born in Hanoi, Vietnam, but came to America to study at the U. In June 1975 he created Phong Shading, a way to give solid, textured objects realistic-looking light and shadow. Having battled advancing tuberculosis for years, he died soon after publication of his dissertation. Jim Blinn created the concept of "bump-mapping." It was a way of wrapping a solid texture around an object that wasn't a smooth shape, like a sphere, but had an irregular surface, like a pineapple or a rock face.

In 1974 Englishman Martin Newell was considering what object to use to demonstrate his own ideas for 3D surfacing. His wife suggested he digitize and render their humble Melitta teapot. Newell liked the idea because of its singularly recognizable shape, its smooth, curved surface with some sharp edges, and the way that it made shadows on itself. He sketched out the teapot on graph paper and calculated the necessary mathematics to create the teapot in the computer as a virtual image. When teaching, he'd use the teapot as his standard test subject. Blinn, Gouraud and Phong seized on the idea of demonstrating their own ideas using the teapot. For the next twenty years, the Utah teapot, also called the Newell teapot, became one of the best-loved inside jokes of the CG community. Anyone with a new idea about rendering and lighting would announce it by first trying it out on a teapot. We saw the teapot rendered as if made of alabaster, red brick, leopard skin, and animal fur. SIGGRAPH would work a teapot into the cover art of its publications. Loren Carpenter's 1979 short *Vol Libre* opens and closes with a cameo of the teapot. When Newell spoke at a SIGGRAPH conference in the late 1980s, he jokingly confessed that of all the things he has done for the world of 3D graphics, the only thing he will be remembered for is "that damned teapot."[31]

Even after ARPA's initial three year grant ran out, the University of Utah computer graphics program's funding still relied in part on grants from the Department of Defense. Evans worried if they ever would be called upon to present some real results with a military application. Graduate student Lance Williams quipped, "We have yet to create a fatal cartoon."[32]

Yet despite never having created a lethal cartoon, the graduates coming out of the U continued to be a who's who of CG pioneers: Alan Ashton, the founder of WordPerfect; Nolan Bushnell, the founder of Atari Games; Jim Blinn of JPL; John Warnock, cofounder of Adobe Systems; Ed Catmull, the future head of Pixar and Walt Disney Studios; Jim Clark, the founder of Silicon Graphics and Netscape, the first company to successfully commercialize the World Wide Web browser; Frank Crow, who created software for shadows and editing; Garland Stern, who wrote the first software to scan

2D animation art for digital painting; and Jeff Raskin (1943–2005), the developer of Apple's Macintosh personal computer.[33]

Another University of Utah graduate, Hank Christiansen, went over to cross-town rival Brigham Young University and helped set up their CG program. His specialty was scientific visualization of computer graphics. There, with Tom Sederberg, he developed MOVIE.BYU, an animation software package. In 1976 Christiansen started selling MOVIE.BYU commercially; it was the first "off the shelf" software of its type. He sold about four thousand copies of MOVIE.BYU and was a leading evangelizer of computer graphics, giving hundreds of lectures and training courses around the world and offering many people their first introduction to what computer graphics could do. MOVIE.BYU was popular with a number of film studios, from Walt Disney to Electronic Image (EI) in London.

The University of Utah's computer graphics program during the year between 1968 and 1977 became a legend in the CGI community. Historian Isaac Kerlow called it "a primordial force," the incubator of the digital revolution in the United States. Even the most technically inclined must resort to hyperbole when they try to describe its importance: a CG Athens in the time of Pericles, not unlike Lorenzo de' Medici's sculpture garden group, and so on. Ed Catmull said, "There was very little equipment. But magic happened at that time. A lot of good ideas just kept rolling forth."[34]

In 1974 Ivan Sutherland moved to the California Institute of Technology to organize their computer graphics program. Caltech had also John Whitney Sr. giving classes in his CG technique. Among their graduates was visual effects wizard Gary Demos and Vibeke Sorensen.

At the University of Montreal, the department of computer science had the use of two supercomputers. In the early 1980s Philippe Bergeron and Daniel Langlois were studying there for their bachelor's degree. "I went into computer science because my parents did not want me in cinema," Bergeron said.[35] The young French Canadians traveled to Dallas for the 1981 SIGGRAPH conference, where the featured short was *Adam Powers, The Juggler,* by Triple-I (see chapter 9). It was the first character piece that featured raster graphics and believable human movement. Bergeron and Langlois looked at one another—inspiration! They went back to Montreal determined to create something as great. Their group—Pierre Lachapelle and Pierre Robidoux as well as Bergeron and Langlois—decided to attempt full-on 3D human character animation, which no one had successfully done yet. They would tell a story about a fading nightclub singer named Tony de Peltrie, who sat at his piano and reminisced about his salad days.

They knew they would never get permission from the department to undertake an eight-minute project so ambitious. So they decided to do the entire film undercover while they were doing their regular classwork. "Others in the Computer Science Department thought we were freaks," Bergeron said. "Running in and out of the

Figure 4.4
Tony De Peltrie (1985).
Courtesy of Philippe Bergeron.

building at all hours, never going to other classes or events. People working with the computers during the day wondered why their programs ran so slow. They were unaware that night after night we would sneak in and render all night." They kept the piano player seated, so they didn't have to make him walk. He played the piano with his hands and fingers rising and falling, which involved the team developing some of the earliest inverse kinematics used in a film. "We didn't know how difficult it would be because we really didn't know anything at all. So we did it," Bergeron said.[36] They called the software they created to animate TAARNA, after the sexy woman warrior in the 2D animated Canadian film *Heavy Metal* (1981). By today's standards the images from *Tony de Peltrie* seem crude, but for 1985, it was a breakthrough. Tony de Peltrie was acting, thinking, fleshy, not mechanical. He expressed real emotions.

Produced by Lachapelle, and directed by Lachapelle, Bergeron, Robidoux, and Langlois, *Tony de Peltrie* premiered as the closing film at SIGGRAPH 1985 in San Francisco. "We came in right between *Andre and Wally B* [shown at SIGGRAPH 1984] and *Luxo Jr.* [1986]."[37] But in 1985, the big news was *Tony de Peltrie.* When it ended, the SIGGRAPH audience went wild with cheers. *Time* magazine wrote, "But the biggest ovations last week were reserved for . . . *Tony de Peltrie.* Created by a design team from the University of Montreal, it depicts a once famous musician . . . tinkling the keys

and tapping his white leather shoes to the beat of his memories. . . . De Peltrie looks and acts human; his fingers and facial expressions are soft, lifelike and wonderfully appealing. In creating De Peltrie, the Montreal team may have achieved a breakthrough: a digitized character with whom a human audience can identify."[38] The University of Montreal dean did not hear about the film until he read about it in *Time*.

Bergeron went on to a successful career in Hollywood as a director and character actor and experimenting with digital landscapes, a kind of animated trompe l'oeil. Langlois went on to codevelop the crucial animation software Softimage and in 1997 founded the Daniel Langlois Foundation, to encourage theater arts and technology. Lachapelle created another short, *The Boxer* (1995). It featured advances in 3D paint and animated multicharacter scenes.

And they did all get their degrees.

In the late 1980s, because the Canadian commercial film industry was too small to support film production on a scale to compete with Hollywood, some of the higher-quality learning institutions shifted their focus to the development of software. Most notable of these was the University of Waterloo in Ontario. We can follow the evolution of off-the-shelf animation software from the New York Institute of Technology's Computer Graphics Lab with their BBop programs as they were taken north and added to by commercial studio Omnibus. After that company's decline, the engineers took their animation package and settled in at Waterloo, which had a reputation as a great school for mathematics. The computer science program was started by mathematics head Wesley Graham and associate professors John Beatty and Kelly Booth. They had worked previously at Lawrence Livermore National Laboratory in the San Francisco Bay Area. Eugene Fiume, who got his undergraduate degree at Waterloo, recalled, "They [Beatty and Booth] were theoreticians who developed a slow but sure appreciation of graphics. They were theoreticians who had a very broad notion of what CG could be. While there, I had almost the free run of the lab. I later realized this was because they gave people an awful lot of rope to hang themselves with."[39] Bill Cowan was also there, researching color perception and interaction. It was also at Waterloo that Pierre Langlois took what he learned from making *Tony de Peltrie* and developed the program Softimage. Some of the earliest work into fractals was done there by Bill Reeves, who took what he learned with him to Lucasfilm Graphics Group and later to Pixar.

Meanwhile, professors Ronald Baecker and Alain Fournier at the University of Toronto created a CG group within their program called the Dynamic Graphics Project (DGP). Their program ran parallel to Waterloo's and was an almost complementary fit. The DGP built programs to define the modeling of natural phenomena and did films like *Sorting out Sorting* (1980), the first CG film to teach by visualizing a complex math concept. Fiume recalled, "Both groups [Waterloo and Toronto] were inspired by the National Film Board [of Canada] work, and especially the pioneering software of

Nestor Burtnyk and Marceli Wein, who created the first interactive animation software in 1973 that allowed NFB artist Peter Foldes to do his landmark film *Hunger*. Waterloo was an undergraduate program, more industrially focused, while U of Toronto was a graduate program more academic and about the traditions of the artist."[40]

Over the next twenty years graduates of the universities of Waterloo and Toronto would fan out across Canada and establish computer graphics programs at the University of British Columbia (UBC), Calgary, and McGill University.

By the 1980s, as computers and software began to move out of the laboratory and into the mainstream, the art departments of many universities began to take CG art seriously and establish their own curricula. The California Institute of the Arts (CalArts) was one of the premier institutions in the United States for learning classic animation. With a character animation program directly funded by the Walt Disney Company, CalArts also had a film graphics (then called Experimental Animation) program organized by the legendary UPA designer Jules Engel. Engel spent his life encouraging his students to be iconoclasts and push the edge of the avant-garde. In 1984 Dean Ed Emshwiller hired Vibeke Sorensen, who was already teaching at Caltech, to teach the first class in computer graphics. "We bought Cubicomps and a Silicon Graphics Machine, and then made a deal with Wavefront to develop software for them in exchange for a lower price," Vibeke Sorensen said. "We made the first 'morph' program, naming it and putting it out there and it ran on the Cubicomp. Cubicomp was really only solid modeling and had no animation features when we first got it. We (CalArts faculty and students) added animation to it, and morphing."[41] John Whitney Jr. and Gary Demos of Digital Productions Inc. allowed them to render on their Cray supercomputer at night.

Sorensen recalled, "My first class were all faculty, Christine Panushka, Mike Scroggins, Don Levy, Myron Emery, and Jules [Engel] . . . although nobody did the homework!"[42] Filmmaker Joanna Priestley recalled that after the seminar concluded, Engel rubbed his hands gleefully and announced, "Well, now, how can we do this differently?"[43] Sorensen concurred that Engel then said, "I'm just interested in making mistakes, because that is where you find the limits." Sorensen went on to teach CG at various colleges around the world. She was the founding chair of the Division of Animation and Digital Arts at the University of Southern California (USC) in 1995, and she also formed a program at the Nanyang Technological University in Singapore.

France pursued a drive toward CG education in the 1980s. In 1982 the Atelier d'Image et d'Informatique (AII) section of the École nationale supérieure des Arts Décoratifs (ENSAD) created the first courses in computer animation. In 1985 computer animation training began at the Gobelins School in Paris. Students worked on a Comparetti animation system. In 1988, in the town of Valenciennes, Supinfocom was founded

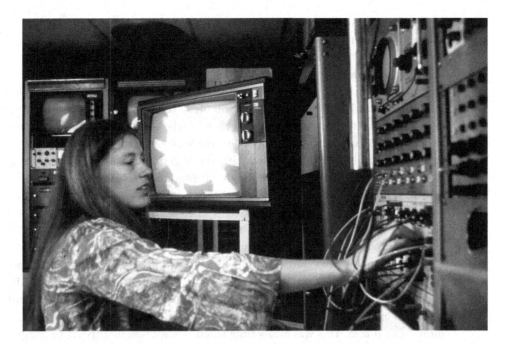

Figure 4.5
Vibeke Sorensen in 1978.
Courtesy of Vibeke Sorensen.

(the name is an acronym taken from École supérieure d'Informatique de Communication). The school created a strong program of CG development.

Across the Channel in England, former architect John Lansdown had fallen in love with computer graphics in the early 1960s. In 1968 he convinced the Royal College of Art to begin experimenting with CG, and with Alan Sutcliffe and George Mallen he formed the Computer Arts Society. When Lansdown retired in 1995, he held the title of emeritus professor of computer-aided art and design and head of the Centre for Advanced Studies in Computer-Aided Art and Design at Middlesex University. The Lansdown Centre for Electronic Arts at Middlesex University was named in his honor. Lansdown's efforts would ensure that London would be a major center of CG, as it had been a center of traditional filmmaking and animation.[44]

The Mathematical Sciences Department at the University of Bath began to experiment with computer imagery in the mid-1970s. Originally focused on flight simulator work, it soon expanded into creating tools to make visual effects for commercials and motion pictures.

The University of Bournemouth established the National Centre for Computer Animation in 1989. It offered both undergraduate and graduate programs, and many

of the CG artists who would contribute to the making of the Harry Potter series of films got their first training there.

Speaking of students in the 1960s and 1970s, one factor in the history of CG that is rarely mentioned above a red-faced whisper is the influence of hallucinogenic drugs during this era. The development of computers, then, was seen as another means to expand the limits of the human mind and free the imagination. As such, computers were accepted as part of the Personal Growth Movement that spun off from the more mainstream sociopolitical trends of the youth counterculture. That culture sought expansion of the imagination through meditation, Vaishnavism, Ramayana Buddhism, various gestalt theories, and sometimes drugs.

Many of the elder titans of computer science were once young geniuses who conceived the basic tools of computer graphics in the age of the psychedelic drug culture. Tune in, turn on, drop out. They may have been brilliant at abstract mathematics and conceptual engineering, but they still liked their long hair, their hippie beads and bell-bottom jeans, and their rock-and-roll. What the public didn't know then but has been revealed by now, was how the CIA utilized major universities to experiment with the mind-expanding qualities of various drugs like mescaline, peyote, and LSD, commonly called acid. This was also a time when science was first trying to comprehend the functioning of the human brain and reaching for alternate ways to expand consciousness. Scientists were measuring brainwaves with oscilloscopes, the same tool early CG pioneers used. The U.S. military eventually stopped funding these programs when their results proved untenable and prolonged drug use proved debilitating to some.

The U.S. government officially banned LSD in 1966, but by then the recreational use of narcotics had filtered down through research professors like Berkeley's Dr. Timothy Leary (1920–1996) to students and had become quite the fashion. Leary spoke for all when he wrote, "A psychedelic experience is a journey to new realms of consciousness. The scope and content of the experience is limitless, but its characteristic features are the transcendence of verbal concepts, of space-time dimensions, and of the ego or identity. . . . Most recently they have become available through the ingestion of psychedelic drugs. . . . Of course, the drug does not produce the transcendent experience. It merely acts as a chemical key—it opens the mind, frees the nervous system of its ordinary patterns and structures."[45]

More than a few CG pioneers admitted that after "tripping" on LSD, they were inspired to try to re-create by electronic means what they saw in their minds.[46] CalArts graduate and independent filmmaker Adam Beckett said, "I want to make films that make you feel high."[47] Leary wrote papers on CG, produced interactive games like *Mindscape* and *Neuromancer* (see chapter 7), and was a regular at SIGGRAPH functions. He once declared, "Computer graphics will be the drug of the 1990s!"

5 Xerox PARC and Corporate Culture

The only problem with PARC was a law of physics. A star that bright eventually has to blow up.
—Charles Simonyi

When we speak of the achievements of American civilization, we don't speak of pharaohs or dynasties as much as we do of great companies. You could say America from its beginning was a financial venture, set up by corporations like the East India Company. Colonies were financed by shareholders who expected to see dividends from their investment. John Adams's negotiating a loan for the American rebels from the Dutch was as important as winning on the battlefield. America is the only nation on earth whose very DNA is based on capitalist free enterprise. So it is only natural that in the development of CG animation many large companies led the way.

I cannot describe here in detail the story of every company that ever did computer development in the twentieth century: Raytheon, Honeywell, Bendix, Motorola, Phillips, Bolt, Beranek and Newman, Chrysler, and so on. That would take another book in itself. But I would like to highlight a few whose work had an impact on the development of computer graphics.

For most of the twentieth century, when you thought of a computer, you thought of IBM—International Business Machines, or "Big Blue," founded by Herman Hollerith as the Tabulating Machine Company. They began by making a primitive punch card/calculator to aid in counting the U.S. Census of 1890.[1] During World War II they developed the Norden bombsight, considered today an analog ancestor of the computer. Under the guidance of CEOs Thomas Watson Sr. (1874–1956) and Jr. (1914–1993), they created the IBM 360 series of mainframe computers. In 1954 they created the first disk drive. Their computers became standard for government and went to the moon in the Apollo Lunar Lander. In 1966 Big Blue employed John Whitney Sr. to create art on their computers. Ivan Sutherland was a student intern there.

IBM's competitors were called the BUNCH: Burroughs, UNIVAC, NCR, Control Data Corporation, and Honeywell. They were also called IBM and the Seven Dwarves,

Figure 5.1
The *Harmon-Knowlton Nude* (1967). A picture created at Bell Labs out of small electronic symbols for transistors and resistors. It was the first nude ever printed in the New York Times.
Courtesy of Ken Knowlton.

because all these companies grouped together didn't possess the market share of IBM. From 1960 to 1970, while the BUNCH lost a combined $167 million, IBM racked up profits of $3.5 billion and controlled three-quarters of the entire world's computer market.[2] Its hold over the industry through zealous enforcement of its patents was so absolute that the federal government finally launched an antitrust investigation against them. In a 1973 decision titled *Honeywell v. Sperry Rand,* a federal court ruled that IBM had, via its 1956 patent-sharing agreement with Sperry-Rand, constituted a monopoly in violation of the Sherman Antitrust Act. That decision invalidated the 1964 patent for ENIAC, the world's first general-purpose electronic digital computer, thus putting the concept of the digital computer into the public domain. The government dropped the remainder of its antitrust suit against Big Blue in 1982.

The second-largest player in the electronics industry in the 1960s was the utility AT&T, also known as Bell Telephone. Ma Bell's research lab was centered in Murray Hill, New Jersey. K. C. "Ken" Knowlton from MIT, who worked there recalled, "Bell Telephone Laboratories, as my colleagues and I experienced it during the 1960s and 1970s, was a beehive of scientific and technological scurrying. Practitioners within, tethered on long leashes if at all, were earnestly seeking enigmatic solutions to arcane puzzles. What happened there would have baffled millions of telephone subscribers who, knowingly or not, agreeably or not, supported the quiet circus."[3] The lab is famous for the invention of the transistor in 1947, the first fax machine, and in 1972 Ken Thompson and Dennis Ritchie developed "C", one of the most widely used computer procedural languages. Scientists at Bell Labs experimenting with synthetically creating a human voice taught their IBM 7094 computer to sing the song "Daisy."

This impressed science fiction writer Arthur C. Clarke so much that he used that idea for the HAL 9000 in his screenplay for *2001: A Space Odyssey* (1968).

Bell Labs also encouraged experimentation with computer graphics. In 1954 Bell Labs sponsored May Ellen Bute's experiments with making images via a modified oscilloscope (see chapter 2). In 1962, while Ivan Sutherland was still writing his Sketchpad thesis at MIT, Bell chief scientist Max Matthews was given the go-ahead to bring in artists and filmmakers to explore the potential of computer graphics. Bell scientist Ed Zajac created what might be considered one of the earliest CG animated films, *A Two-Gyro Gravity Gradient Altitude Control System* (1961). This film demonstrated how a telecommunications satellite could orbit the Earth while keeping one side stable and constantly facing the planet, so it could receive and transmit radio signals. Between 1962 and 1966 Ken Knowlton and Michael Noll worked on a system that could pair digital processing with film recording to produce a high-resolution image. Knowlton became interested in animation. "I soon wrote a memo to department head Tom Crowley, suggesting the possibility of [developing] a 'computer language' for making animated movies; his two-part response launched my career in raster graphics: 'It sounds rather ambitious, but why don't you see what you can do?'"[4]

In a year Knowlton had created one of the earliest computer graphics programs, called BEFLIX, for a Bell Flick. The program was contained on stacks of computer punch cards, which Knowlton usually carried in a shoebox. After the program was loaded into the 7094, the artist would "draw" images directly on the cathode-ray tube via a light pen, similar to Sketchpad. The finished work was stored on a reel of data tape. In 1966 Bell Labs sponsored a collaboration of ten artists and thirty engineers that would be a forerunner of the E.A.T. program. Knowlton and BEFLIX were paired with experimental filmmakers like Stan VanDerBeek, Frank Sinden, and Lillian Schwartz. Schwartz's 1973 film *Permutations* is an abstract blending of colors and shapes that evoke Oskar Fischinger's work. VanDerBeek created a dozen short films called *Poem Field* (1964–1967) and experimented with holographic 3D imagery. Recalling a press conference Bell Labs once held to display their new discoveries, Knowlton said, "I remember in particular one reporter who badgered me about the possibility of someday resurrecting Rock Hudson and Doris Day, by computer, to star in posthumous movies. I argued that nothing like that would ever happen: it was too complicated, and certainly not worth the effort; computers were for serious scientific movies, for example about atoms, whose cavorting could be scripted by vectors and equations. Unswayed, his newspaper the next day printed a story about computer animation that featured Rock Hudson and Doris Day."[5]

The Bell System held absolute control over all U.S. telephone communication until antitrust litigation in 1982 broke the system into smaller, independent companies, the Baby Bells. The lab was reorganized in a reduced state as AT&T Bell Lab and in the 1990s merged with a French company to become Lucent Technologies.

Figure 5.2
Loading data on punch cards at Bell Labs (1964).
Courtesy of Ken Knowlton.

The Control Data Corporation (CDC) was formed in Burlington, Massachusetts, in 1957 by several engineers who left Sperry Rand. In 1964 H. Phillip Peterson used a CDC 3200 to recreate Da Vinci's famed painting, the *Mona Lisa*. A black-and-white image was digitized using a flying spot scanner, similar to the way a television camera takes an image and breaks it down into thousands of tiny bytes. These bytes were then converted to numbers and arranged to make up shapes and gray scales. After fourteen hours of slow scanning, *Mona by the Numbers* was done.

The top computer designer at CDC was Seymour Cray (1925–1996). Cray was a genius who, it was said, could design a mainframe computer in just three weeks. He was also a tad eccentric. He said his best thinking was done while digging tunnels under his Colorado home. There, he said, the elves came to speak to him. With the aid of elfin magic or not, in 1964, Cray led the team that created the CDC 6600, ten times faster than any other computer of the time, the world's first supercomputer. IBM chief Thomas Watson Jr. complained, "How can this little company of 34 people, including the janitor, manage to beat us, when we have thousands?" To which Cray replied, "You just answered your own question."[6] In the 1970s Cray left CDC, whose fortunes immediately sank, and formed Cray Research, Inc. There he focused on making supercomputers that were large enough for complex CG graphics to be rendered and composited. The Cray-1 was introduced in 1975. In the 1980s a Cray X-MP became the mainstay of Hollywood's Digital Productions Inc, used to create visual effects in the films *The Last Starfighter* (1984), *Labyrinth* (1986), and Peter Hyams's *2010* (1984).

The year 1971 saw the development of the microprocessor, a single, small silicon chip incorporating all the basic capabilities of a large computer. Work on such a device was begun by Texas Instruments (TI) in 1968 to fit a computer on board an F-4 Tomcat fighter plane. TI agreed to share with Intel its discovery of a new generation of chip, and then Motorola got in on the action. Motorola developed the world's first 8-bit microprocessor. It was the basis for the "Mark-8" computer kit advertised in the magazine *Radio-Electronics* in 1974.

The computer manufacturer Symbolics grew out of the research done at MIT to develop the computer language LISP. Based in Cambridge, Massachusetts, in 1983 they introduced the 3600 series of computer. Founder Russell Noftsker was a compact, blue-eyed man who so disliked people smoking near him, he carried a can of pure oxygen. Shooting it at a lit cigarette caused it to burst into flame. On March 15, 1985, they registered the world's first privately owned domain name "symbolics.com." Symbolics produced high-end computer mainframes and their graphics division SGD in California created breakthroughs in behavior animation and movie visual effects. Their systems were twice as expensive as their competitors, about $350,000 each. As CG artist Matt Elson recalled, "Apple was focusing on making Volkswagens, at Symbolics we made Lamborghinis." But the company was too slow to wake up to the need for faster processing power to suit their elegant software. Their large mainframe approach

was not able to keep up a performance advantage over special-purpose graphics work-stations. Also, their LISP equipment was a "closed system," incompatible with other companies' infrastructure running UNIX and C. As one engineer said, "People like cars they can tinker with, not cars with the hood welded shut." Noftsker was ousted by his exec board in 1988, and by the 1990s they were gone.

Nor was the advancement of the technology necessary for CG to progress limited to America alone. At this time in France the labs of the Renault automobile company perfected a way to approach the solid modeling of a curved surface. The innovation was called Bézier curves for engineer Pierre Bézier (1910–1999), although the curves were actually developed in 1959 by Paul de Casteljau. Bézier publicized them to the world in 1962. Although Bézier was primarily interesting in the curves for computer modeling of automobile fenders (using CAD/CAM), the principle greatly aided in the building of curved images in CG. In 1974 another French company, named Benson, tried to copyright its CAD/CAM and simulator-type vector system under the name Infographie. It failed to pursue the claim, but the name Infographie became the common term in French for CG.

In 1968, while America was consumed with Vietnam, Black Power, Flower Power, and puzzling over the ending of *2001: A Space Odyssey*, two college professors in Salt Lake City were going into business for themselves.

Dave Evans and Ivan Sutherland had put together an advanced computer graphics program at the University of Utah. Many of the major players of the digital revolution were hatched from their incubator. Now Evans now stepped down as department chair and took an adjunct teaching post like Sutherland, so he could devote more of his time to their new computer company, Evans & Sutherland. The University of Utah granted them use of a beat-up old barracks building on the Fort Douglas end of the campus for a monthly rent of one dollar. Beyond that the two men wanted no other aid from the campus, to avoid any charge of conflict of interest. The company was fully funded by private investors. University of Utah faculty member Hank Christian-sen recalled, "I had a little money saved for investing. About $10,000. I wondered if I should invest it in E&S or cattle feed. I wound up investing in the cattle feed, and all the cattle died. Years later I mentioned this to Dave Evans. He told me, 'Let me tell you two things. First, we really could have used your $10,000. And if you had invested in us, the payoff would have been a hundred to one!'"[7]

Their goal was to retail mainframes for computer graphics. This did not mean that Evans & Sutherland intended to compete with heavyweights like IBM. Rather, they worked on the idea of creating modular sections of mainframes. This way, instead of hand-creating a massive mainframe every time, the modules could be customized to suit a company's specific purpose. These became the graphic supercomputers of their day, requiring racks of equipment that could generate real-time computer-animated

Figure 5.3
Hank Christiansen's raster image film created at The University of Utah for the US Navy's Undersea Center. *Pressure Patterns—Forced Vibrations of a Submerged Sonar Transducer* (1971). Courtesy of Hank Christiansen.

images. USC CG Dept Chair Richard Weinberg recalled, "This led to the implementation of graphics algorithms in hardware, not software, to be fast enough to support real-time, fast image generation for display in flight simulator cockpits. These were the precursors of today's graphic chips and add-on boards."[8] They had as working student interns the future founders of Silicon Graphics (Jim Clark) and Adobe (John Warnock).

Their first retail graphics computer was called Line Drawing System-1, or LDS-1. Sutherland noted dryly that is was appropriate for Salt Lake City, as it could also stand for Latter-Day Saints. He asked Evans (a devout Mormon) if he was offended by the pun. Evans said no. Later he told his wife, "I think they were testing me." Evans & Sutherland was begun with ARPA money, but as Evans told his team, "ARPA only likes to start things, so ARPA is going away someday. We need to bring in more projects."[9] Among their many contracts, they created some of the first CG films for the military in the early 1970s. NASA hired them to create an advanced computer simulator to help train pilots of the space shuttle, which was still being built at the time. The company also created vector simulator of the New York Harbor area for the coast guard to train harbor pilots to maneuver the new generation of supertankers and a film for

the national laboratories about the arming device of an atomic weapon. In a few years 80 percent of all pilots in the world had trained on an E&S simulator. NASA's Space Shuttle pilots trained in a simulator built like the front of the Shuttle's controls, but with two E&S computer screens for windows. Ed Catmull's team at Lucasfilm used an E&S PS-300 to do the Genesis effect in *Star Trek II: The Wrath of Khan* (1982). Christiansen remembered, "Dave sent me to the FBI in Washington. I brought Fred Parke and Henri Gouraud's student films of animated faces. I told them if they funded us, in a few years we would have an advanced system of facial recognition and cataloging. But the FBI couldn't see it."[10]

To demonstrate what they had accomplished in terms of hidden surface algorithms, in 1973 Evans & Sutherland created a raster computer image that was an exact model of the nuclear-powered aircraft carrier USS *Enterprise*. They wanted to add an airplane for scale, and for a laugh the researcher used the cartoon character Snoopy in his Sopwith Camel. The Peanuts characters were very popular at that time, and a novelty song about Snoopy's battles with the Red Baron was high on the pop charts. But the sight of a cartoon character taking off from the deck of the *Enterprise* fell flat with the big brass, who were expecting to see an F-16 Tomcat. "I showed it to a number of admirals at the Pentagon," Sutherland smiled. "They didn't think it was nearly as funny as I did."[11]

Originally Sutherland was to run the day-to-day business at Evans & Sutherland while Evans focused on the university program. But Sutherland's well known lack of patience did not put him in good standing with business types who expected to be coddled. Christiansen recalled, "After a while, not many wanted to work with Ivan, so I ran E&S from 1968 to 1972."[12] Sutherland left Evans & Sutherland in 1974. "It had become so large," he said, "I could not learn everyone's names. You see, I'm a small group kind of guy."[13] Eventually, when silicon chips and faster and cheaper Silicon Graphics Imaging computers (SGIs) replaced the Evans & Sutherland PS-300 mainframes, the company pulled back and refocused on making military simulators and equipment for planetarium shows.

As Sutherland was leaving Evans & Sutherland, two thousand miles away on the East Coast a young New York University professor lay in a hospital encased in a full-body plaster cast, reevaluating his life.

Texas-born Alvy Ray Smith had a lifelong love of painting and art but didn't think he could make a career of it. So he picked up on computer science at New Mexico State University and did his graduate work at Stanford in electrical engineering. There he was heavily influenced by Marvin Minsky's writings on artificial intelligence. Despite his comparative youth he won a tenured professorship at New York University to teach a computer science course titled *Cellular Automata: The Mathematics of Self-Reproducing Machines*. But despite his status, Smith felt restless. Then one day in 1973, while skiing in New Hampshire, his headgear slipped over his eyes momentarily and

he crashed into another skier. This accident laid him up for three months in an uncomfortable body cast.

"This turned out to be the most wonderful break in my life!" he later said. While in the hospital, Smith had time to meditate on his career choices thus far. He hated that he was in a field where only a handful of people even understood what he was talking about. And he wasn't painting, and the idea that his work was aiding the military-industrial complex bothered him. At Stanford in 1968 Smith had embraced the youth rebellion and the antiwar movement. He had grown a full beard and shoulder-length hair, the very image of every establishment square's nightmare. Lying in his New York hospital bed, his final conclusion was, "Fuck it! I need to get back to California!"[14]

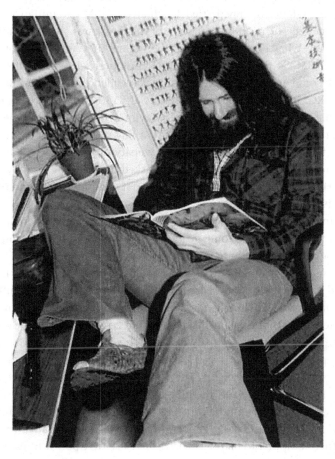

Figure 5.4
Alvy Ray Smith in the 1970s.
Courtesy of Alvy Ray Smith.

So when he got out of the hospital, Smith resigned his professorship at New York University, loaded what belongings he had into his Ford Grand Torino, and drove across the country. He settled in Berkeley and, living on a shoestring for months, waited for something good to happen. One day he wanted to use Stanford University's library. So he drove the fifty-odd miles down the East Bay and crashed for the night at the Palo Alto pad of his friend Dick Shoup (pronounced like *shout*). "I met Dick a few years earlier, and he was one of the few people I could talk to who knew everything I knew about subatomic particles," Smith said.[15] Shoup just happened to be working for Xerox, the photocopier people.[16]

Ever since 1935, when Chester Carlson invented the photocopier with an amateur chemistry set in the back of a beauty parlor, the Xerox Corporation had grown to be the preeminent supplier of photocopiers. The name Xerox became synonymous with copiers. In 1970, Xerox fancied they'd tried to challenge IBM's dominance of the growing computer market. The push-button office of the future was coming, and while they weren't quite sure what it would involve, they knew they wanted to own the technology ahead of IBM. So they set up a group of computer scientists in their own lab to see what they come up with. The new facility was called the Palo Alto Research Center, or Xerox PARC. It officially opened its doors at 3180 Porter Drive on July 1, 1970. Among the first scientists hired were Robert Taylor, who had just left the directorship of the government's ARPA program, and Alan Kay, a graduate of Evans's and Sutherland's computer graphics program at the University of Utah. When Kay interviewed with Xerox for the position, the interviewer asked him, "What would you like to work on here?" He said, "I want to create the personal computer." The interviewer responded, "What is that?"[17]

Taylor had convinced Xerox that instead of being near the company headquarters in Stamford, Connecticut, the new lab should be located out west in Palo Alto, California. He said this would be a better location to avail themselves of the pool of excellent computer engineers being let go from NASA's Ames Research Center, the Defense Department, and Stanford's government contracts due to Mansfield Amendment cutbacks. What this also did was give the lab independence from the stuffy office environment of older corporate America. In that time, at IBM you would be reprimanded for wearing anything other than a pressed white shirt and dark tie. The dresscode at PARC was long hair, tie-dye tank tops, love beads, torn jeans, and sandals. One conference room was filled with nothing but large beanbag chairs. The office librarian was instructed to order all the books in the *Whole Earth Catalog*, the hippies' bible. Scientists could be seen on any given day riding bicycles through the carpeted hallways, playing table tennis, and downing beers. Taylor ordered cases of Dr. Pepper shipped out from his native Texas. He programmed his office computer to blare "The Eyes of Texas Are Upon You" every time he got an e-mail message. Kay's special projects unit would go on regular retreats to a secluded beach south of Santa Cruz called Pajaro Dunes to relax and think.

On December 7, 1972, the rock-and-roll magazine *Rolling Stone*, not *Popular Electronics*, published an article about the scientists at Xerox PARC, complete with photographs by Annie Leibovitz. When the senior board members of Xerox saw their employees out west revealed to the world as wild hippies lying around labs that looked like college dorm rooms, they just about died of shock. Generations since then have grown up accustomed to the casual climate of the modern high-tech office. But for the corporate community of 1970, this permissiveness was all still quite unorthodox. What the directors of PARC were trying to accomplish with this work environment was to get their people to loosen up their expectations and think outside of the box about just what a computer was capable of. They didn't just want computers to be smart. They wanted computers to be fun. And the first thing to do was to have fun, knock the computers around, and try to make them do things they were not built to do.

Years later the denizens of Xerox PARC would missionize this work environment concept around the nascent CG world. Alvy Ray Smith took it to NYIT, where he found it fit in nicely with Ed Catmull's thinking, which he learned from Dave Evans at the University of Utah. Bob Abel would cite Xerox PARC as the best way to run a CG studio.

Still, this concept was a difficult sell to the more conventional minds back at Xerox. The lab's second director, Robert Spinrad, said he felt like Clark Kent on his regular weekly flights back to corporate headquarters in Connecticut. Shortly before landing he would duck into the plane's lavatory and change into a suit and tie, emerging a proper executive type.

Beyond their dress code, the scientists of PARC started out almost immediately by offending the Xerox management. It happened when, in selecting what mainframe computers they intended to work with, the team enthusiastically chose the PDP-10 computer, built by the Digital Equipment Corporation (DEC). That it was the best seemed to them a no-brainer. The only problem was that Xerox had its own division that built mainframes, SDS, and it was an insult that the team went with an outsider. "We upset the apple cart and didn't realize yet how badly," Taylor later said.[18]

Alan Kay was assigned to lead the Special Projects Lab, the spear point of Xerox's computer research. Kay was a brilliant, even-tempered, thirty-something man who loved to laugh and could play Bach on the pipe organ beautifully. Curiously, one game he never like to play was charades, a game his wife, Bonnie, enjoyed. Kay explained that it reminded him too much of his work. Every day, all day people would throw him problems and he would have to think of a way to solve them.

Despite their initial missteps, Xerox PARC became one of the great incubators of computer creativity. Many things we now take for granted were first conceived and developed there. Robert Taylor expanded his previous work on the ARPANET networking system for office computers, by developing the Ethernet. The lab developed a means to point and click on graphic symbols, called a graphic user interface or GUI, instead of using binary code instructions. Butler Lampson and Charles Simonyi created

the first WYSIWYG (What You See Is What You Get) system. The name came was from a popular joke on the *Flip Wilson* Show, a TV comedy. For a computer it means that the way you see something graphically on the computer screen would be exactly the way it would print out on paper. PARC scientists took Doug Engelbart's idea of a computer mouse and created a more efficient mode that interfaced perfectly with the data screen. The laser printer was also invented there.

Kay conceived of a computer small enough to carry around in your attaché case. He called it a Dynabook. While beginning working on the film *Tron* in 1980, animator Bill Kroyer recalled a conversation he had with Kay, who was advising on the film:

At the time Alan Kay was fixated on this idea he had for a notebook-sized computer, where you would open the lid and the lid was the screen and the base was the keyboard. He later indeed became the developer of the laptop computer. We asked him, Is this possible yet? And he replied, Well, no, not right now. All this stuff has to be invented, but the way you do this is to assume someone will invent this all on a timeline. Someone will invent the flat screen, and the proper battery and size of the memory chip. And you just conceptualize what is needed and how it will work, and you send that out into the industry, and you assume that when you need it, someone will have invented it, and you put it in. And indeed, eight years after this conversation, we all had laptop computers.[19]

As Bill Kovacs put it, "Getting from the theoretical to the actual was merely a matter of time."[20]

What the lab became most famous for occurred on April 19, 1973, when Xerox PARC booted up the Alto, the first commercially viable desktop computer. Only four scant years after Douglas Engelbart demonstrated that desktop computing might be possible, Bob Taylor's team made it a reality. The Alto had a microcomputer, monitor screen, keyboard, mouse, and printer. The first image to appear on its screen was Cookie Monster from *Sesame Street*. Remember, at this time Steve Jobs was sleeping in friends' rooms and bumming free meals from the local Hare Krishna temple. Bill Gates was a congressional page at the U.S. House of Representatives. Apple, Microsoft, Commodore, and Intel did not yet exist. Xerox had it all alone.

For the purposes of the CG story, however, the important part was what Shoup's team was doing. Richard Shoup was a long-haired, red-mustached engineer from Carnegie Mellon University who had worked for a time at the Berkeley Computer Company before he was invited to join PARC. Taylor offered him a year to consider what kind of problem he wished to tackle. But Shoup settled fairly quickly on the issue of color surfacing of CG objects.

Until then computer graphics were contour line structures called vector graphics. To get computer images beyond the glowing wireframe structures to believable three-dimensional objects, one needed to work out how to add surface color and make it stick. This problem was the focus of many of the students in Evans's and Sutherland's CG program at the University of Utah. Shoup hired two of Utah's graduates, Bob Flegal and Jim Currey, precisely because of their focus.

Shoup realized that a lot more memory was needed to store images in color, so that when a single frame is called back all the original color pixels come back in exactly the order in which they were arranged. This process needed to be performed for tens of thousands of pixels coming back in a millisecond for the tens of thousands of individual frames needed to make a moving CG work. He created a device to store such large amounts of data. It was called a frame buffer. Until the end of the twentieth century frame buffers were the standard way for computers to store external data; after that, the growth of memory storage capacity and more advanced hard drives rendered them obsolete. But for now, frame buffers became essential. When he connected the buffer to a computer, Shoup found he could rearrange the color bits according to any algorithm one could devise. He called his program Superpaint. It could grab a frame from a video or directly off the TV and pull it, stretch it, and change its colors. The equipment was the size of a refrigerator and required two monitors, one showing the image being worked on and the other the menu of paintbrushes that could be used to alter color or pattern. "No question, it was a big hunk of hardware," Shoup recalled.[21]

With Flegal, Curry, and a French graphics expert named Patrick Baudelaire assisting, Superpaint was booted up for the first time on April 10, 1973. The first image was a photograph of Shoup holding up a sign that read, "It works, sort of."

What Shoup had created was the beginnings of the first complete digital paint system. But unfortunately, it didn't quite fit in with Xerox's master plan to create the "Office of the Future." Lab manager Taylor, who conceived of his team as all working together toward a common goal, was ambivalent about the concept of color visuals. Why would an office need color images? He felt Shoup was going out on his own into nowhere and not pulling in the same direction as everyone else. Shoup paid Taylor no mind. He liked to show his system off to anyone interested. "Dick liked to blow people's minds."[22]

One mind he did succeed in blowing belonged to his hippie friend Alvy Ray Smith, who had been camping out on his couch. "You gotta see what I'm doing," Shoup said. He brought Smith down to PARC and demonstrated the Superpaint program. For Smith it was love at first sight. "Art and computers, I was in heaven! This is what I came back to California for!" Smith begged Shoup to help him join the PARC team. Shoup didn't have the budget allowance to hire Smith as a full-time employee, so they wrote out a purchase order for him, as though he was a piece of furniture. "I didn't care how they did it. I didn't want a title or salary or anything. I just wanted access to that equipment," Smith said.[23]

While Shoup was most interested in sampling existing video images and altering them, Smith focused on how to apply Superpaint to geometric shapes, the building blocks of future original images. He designed new controls for hue, saturation, and value, so artists could more easily blend colors.

Smith quickly became a fixture at PARC. He brought in other artists to help flesh out the program: Fritz Fischer, David DiFrancesco, and David Em. They did

all-night jam sessions on the computers, pushing the system to its limit. David Em recalled his first image made on a computer. "I made it on January 6, 1975, around 3:30 AM. . . . It was the first time in my life I'd been in a room with a computer. After a few hours of working with the PARC system, I was sold on the concept that digital imaging was the next big step in the evolution of art." Added to the late nights and the cramped work space, a constant concern with computers then was overheating. So the room's air conditioning had to be kept down at a constant 50 degrees. "It was always cold. I had to work in a jacket and wearing wool gloves with the fingertips cut off. But I loved it. PARC changed my paradigm of artist to studio," David Em recalled.

Figure 5.5
"PARC." An animating color cycle done by David Em with Superpaint, at Xerox PARC, circa 1975. Courtesy of David Em.

But Smith's unabashed exuberance managed to offend Taylor once too often. Taylor once came up behind him and said, "Don't you find this too hard to use?" To which Alvy enthused, "Don't you get it? This machine is revolutionary!" Taylor, who had overseen so many breakthroughs in his time, walked off annoyed at the idea of being dismissed as reactionary.[24] Other scientists at PARC began to complain that developing color was a waste of time and resources, because for the present no one would be able to afford the amount of memory needed to drive a color frame buffer. Shoup defended his team by arguing that it would be cheap in five or ten years' time. "I was looking at the bigger picture, pixel based imaging in general. . . . It was not just the technologies behind some cartoon, but the foundations of a new type of computer graphics."[25] It was too early yet for people to have faith in Moore's Law, that as computers got more powerful, they would get smaller and the price would drop.

At one point Smith and Shoup created a video montage, titled *Supervisions*, of all of their best work to show on a Los Angeles PBS program about the video avant-garde. Smith thought Xerox would be flattered to have their logo credited on each piece. But the idea backfired. Xerox leaders were not amused and did not want the company's name on it. Taylor sat at the monitor with Smith and made him erase every logo from the tape, one by one.

Finally, a few weeks later, on August 18, 1974, a corporate spokesman named Jerry Elkind arrived from Connecticut. He announced to the team, "This project is over. We've decided to go with black and white." Smith protested, "Don't you see? You guys [Xerox] own COLOR! You're crazy! It's going to be color from here on out, and you guys already own it all!" Elkind responded coolly, "Well, it's a corporate decision."

Alvy recalled later, "They never actually fired me. They just canceled my purchase order."[26] Dick Shoup had his lab taken away and left PARC a year later to form his own company, Aurora Systems. There he created, among other things, the first color-processed images from weather satellites. In 1983 Shoup won an Emmy for the Superpaint system, which he had to share with Xerox.

Smith took what he learned at Xerox PARC with him to the New York Institute of Technology, where with Ed Catmull he developed the BigPaint system for their animated projects. This work later evolved into the Pixar Image Computer, the RenderMan system, and Disney's CAPS system, earning Smith an Oscar. Smith's NYIT paint system also influenced the Ampex Video Art, or AVA, system that Tom Porter and Glen Entis developed at Ampex, which artist Leroy Neiman demonstrated on TV during Super Bowl XII, and the paint software Mark Lavoy and Don Greenberg developed at Cornell University, which became the cartoon studio Hanna-Barbera's digital paint system.

With the Alto, Xerox PARC had realized the home station prophesized by Vannevar Bush in 1945 and demonstrated by Douglas Engelbart in 1968. In 1976 an Alto became the first personal computer installed in the White House, by President Jimmy Carter.

Yet Xerox didn't know what to do with them; it was in the copier business. The Altos were initially offered at $23,000 each, which was cost-prohibitive to most. The mouse alone cost over $300. So sales were poor. Xerox lowered the price to $16,500, but sales did not improve.[27] At that time, PARC scientist Nick Tesla came back from a Homebrew Computer Club meeting with news of the MITS Altair 8800 personal home computer. At first no one in the lab thought it was a serious threat. Yet, by the end of the 1970s, with Altairs, Apple IIs, and Commodores beginning to expand the market, Xerox had still not decided what to do with its Alto.

One day in December 1979 a group from Apple, led by Steve Jobs visited Xerox PARC. This meeting has gone down as legend in CG annals. But the story was more complicated than one group lifting ideas and Xerox being too dumb to understand what was being lost. Apple had already gone into a deal with Xerox, and Xerox had invested in Apple ahead of its first IPO. Jobs referred to it as "I'll let you invest a million dollars in Apple stock at $10 a share, if you open the kimono a bit at PARC."[28] So the kids from Cupertino were given carte blanche around the lab. One of the briefers, Adele Goldberg, was appalled. "It was incredible, nuts, completely stupid, and I fought to prevent giving Jobs much of anything!"[29] But it could also be said that some of the scientists at PARC were so fed up with the company that they let Jobs see everything in hopes that *someone* would finally do something proactive with their discoveries. Remember, the iconic Silicon Valley billionaire did not exist yet. Most research scientists still made a modest salary. It was the hacker's ethic at work. And Xerox did make $17 million dollars on the deal when Apple shares went public.

Jobs and the Apple group were not just inspired by all they were shown at Xerox PARC. They went back to Apple and put what they learned into the development of their Lisa and MacIntosh computers. The innovations pioneered by PARC enabled Apple's greatest selling point, the graphic simplicity of getting to a program just by point-and-click. To boot up an Apple you didn't need any knowledge of code or programming. You just plugged it in and turned it on. In 1981 IBM and Commodore put out personal computers with similar operating systems, printers, keyboards, and mice.

In 1983 Robert Taylor resigned under pressure from the front office. Most of the remaining pioneering scientists left with him. By then Kay had already moved on. Xerox PARC continued to function, but the glory days seemed to have ended. Xerox did gain much success from its development of laser printing. Yet despite its amazing head start, it never did manage to own the "Office of the Future."

By the 1980s innovations in CG had progressed from corporate titans like IBM, Bell, and Xerox to market-driven independent companies like Adobe, Alias, and Pixar. The era of companies toying with graphic imaging demos as a fringe pursuit were pretty much over. If a company required such programs, off-the-shelf software was good enough to accomplish its purposes. The office of the future had arrived.

6 Hackers

Computing should be a right for everyone!
—Hacker's Manifesto

The world of computers began as a buttoned-down corporate culture of scientists and engineers. Oh sure, on the periphery there were a handful of beatnik artists and non-conformists who experimented with electronics in their basements. But for CG's first decades, the white lab coat crowd was on the front line of advanced development. Crew-cut hair, horn-rimmed glasses, cherry-wood Billiard pipe clenched firmly in teeth, they clocked in, then worked on huge government contracts and research programs for corporations like IBM, Bell Labs, Boeing, and Honeywell. Then they clocked out and drove home to suburbia for a TV dinner while watching Ed Sullivan with the family.

By the 1960s a new type of computer user began to appear on the fringes of the electronics world. The *hacker*. To the modern public, the term hacker has come to mean someone who illegally breaks into encrypted or confidential sites on the Internet, as in to hack into someone's website. In modern game-player slang it is a derogatory appellation. But in the early days of computing, the term *hacker* was considered a badge of honor. The pure hacker was an amateur computer enthusiast. No degree, t-shirts instead of starched shirts. Hackers were more likely to get their latest information from magazines like *Popular Electronics* than from reading papers by PhDs. "The Computer Bum," as Alan Kay once said to *Rolling Stone*, ". . . was someone who looked as straight as you'd expect hot-rodders to look. He's a person who loves to stay up all night, he and the machine in a love-hate relationship. The hacker as rebel: not an undernourished weirdo, merely someone not very interested in conventional goals."[1]

The only thing they had in common with the more orthodox scientists at IBM was a passionate belief in the potential of computers. Some were so intensely focused that, even when working for a salary at a company, they had to be reminded by their supervisor to go cash the paychecks sitting in a pile on their desks. MIT hacker Pete Samson said, "We did it twenty-five to thirty percent for the sake of doing it, because it was something we could do and do well, and sixty percent for the sake of having

something which was in its metaphorical way alive, our offspring, which would do things on its own when we were finished. . . . Like Aladdin's Lamp, you could get it to do your bidding."[2] In his seminal 1984 book *Hackers: Heroes of the Computer Revolution,* writer Steven Levy defined the hacker ethic: "It was a philosophy of sharing, openness, decentralization, and getting your hands on machines at any cost to improve the machines and to improve the world. . . . A culture that would be the impolite, unsanctioned soul of computerdom."[3]

In the entire history of computer graphics, there never was a master plan like NASA's race to the moon. No one made a corporate strategy for CG. No one ever wrote out a mission statement.

CG was born of the inspiration of hundreds of people of different backgrounds and abilities who shared a common dream—that of wanting to create art with a computer. Despite the naysayers, this tribe of talented bohemians wandered the world looking for outlets for their craving. Many hackers began as home enthusiasts. In the 1920s they sent away in the mail for "build your own crystal radio" kits or, later, "build your own shortwave receiver." In the 1940s came the Heathkit home-built television sets. In the late 1970s the first microcomputers, like the MITS Altair 8800, the Commodore 64, and the Apple I sold as mail-order kits.

This spirit of unofficial improvisation became a key element in the growth of computer graphics. CG artist Michael Disa said, "Most of the history of computer development consists of one or two nerds who get hold of a computer and re-rig it to do something it was never meant to do."[4]

What they intended was at first outside of the mainstream of orthodox science. To the mainstream science community, moving pictures and games on a computer were merely trifles, demonstrations to amuse visitors on lab open house days. The real business of computer science should be physics, missile trajectories, plotting DNA genomes, and such. No credible journals or organizations would take CG seriously. If I could only put out there what I have been doing, maybe someone can take what I have done up to this point and add the missing element I can't see. All that matters is that the idea will move forward. So CG people had to depend on one another to disseminate information about new breakthroughs. Hackers formed their own associations to share discoveries and indulge their mutual interests.

One of the earliest of these groups was an association of engineering students at MIT. They called themselves the Tech Model Railroad Club (TMRC, or "TeeMerck"). A collection of slide rule–carrying nerds who wouldn't make it on any varsity sports team, the TMRC formed in 1946 to enjoy their common hobby of collecting model trains. While one group of students focused on restoring classic trains, others began to think of new ways to apply what they were learning about technology to the railroad switches and signals. In 1948, the TMRC was given a third-floor room in the E-wing of MIT's Building 20. The old building was nicknamed the Plywood Palace. It housed

a grab bag of MIT's interests, including the Radar Lab, MIT Press, stroboscopic flash-photography experiments, and the office of radical political theoretician Noam Chomsky. The "TMRC Gang" set up their HO scale Lionel trains on a huge table and developed newer and more exotic ways to automate the track-switching and signaling systems. While other school groups enjoyed a trip to the zoo or a museum, the Model Railroaders loved to tour the regional Bell Telephone exchange. There they would grill the engineers about packet switching and automatic relays. In late fall 1958, club members led by a wiry redhead named Pete Samson went down to the basement of the building and hacked into the circuitry of the school's IBM 407 electromechanical keypunch machine, in order to run programs on the school's IBM 704 mainframe computer. It may be one of the first computer hacks ever recorded.[5]

The TMRC gang developed a language of slang terms all their own to describe what they were doing. So trash became *cruft*, a rolling chair to get to the wiring under the

Figure 6.1
Member of M.I.T.'s Tech Model Railroad Club at work. Circa 1958.
Courtesy of the MIT Museum.

train table was a *bunky*, and to *gronk* something was to smash it or disassemble it. Model Railroader Pete Samson, who was one of the inventors of the first true interactive game, *Spacewar!*, recorded the terms and later published them as "The Hacker's Dictionary." He defined a *hack* as "an article or project without constructive end" and a *hacker* as "one who hacks, or makes them."[6] For instance, one of the first programs created by Samson was one that turned Arabic numerals into Roman numerals. It was considered clever, and utterly worthless—in other words, a brilliant hack. But the Model Railroaders did create some things that had lasting value: The first videogame *Spacewar!*, and the programming language LISP.

We have previously touched on the great upheaval in politics and culture that was the 1960s. The post–World War II baby boomers, as they attained maturity, found they would inherit a world locked in middle class conformity and overshadowed by the inevitable nuclear Armageddon anticipated as a result of the Cold War. This created a societal break with their parents' generation. Young people espoused a spirit of rebellion that is today collectively called the Counterculture. This generation, symbolized by the hippie, declared their refusal to play by their parents' rules, join their institutions, or fight in their wars. Steve Jobs recalled, "We wanted to more richly experience why we were alive, not just to make a better life. . . . The great thing that came from that time was to realize that there was definitely more to life than the materialism of the late fifties and early sixties. We were going in search of something deeper."[7] It was much more than slogans like Sex, Drugs, and Rock-and-Roll. It was about a search for alternatives. Hippies experimented with new religions like Buddhism and Native American spiritualism, with new societal structures, new philosophies, back-to-the-land movements. Young, urban hippies moved out to the country and lived together in communes, grew their own food, and shared property in common. Some of the lasting trends left behind by the counterculture include organic foods, ecology, and a healthy skepticism of all authority.

Coincidentally, the computer was coming of age just as the counterculture was encouraging people to expand their minds. At first the hippies thought the computer was an impersonal death machine created by The Establishment to further oppress the masses. Many socially conscious hackers strove to change people's minds about what computers were good for. The idea that average people could use a computer for positive things began to take hold as an extension of the Personal Growth movement. Government research on computers had been top secret. Work done by corporations was protected as trade secrets and sealed under patent and copyright laws. Sharing computer files and programs communally seemed heretical in the extreme. That suited the hippies just fine, thank you. As Steve Wozniak explained, "Our first computers were born not out of greed or ego, but in the revolutionary spirit of helping the common people rise above the most powerful institutions."[8]

In 1969 Stuart Brand began publishing the *Whole Earth Catalog* after studying computer science under Douglas Engelbart at Stanford's SRI lab.[9] The catalog was an early example of desktop publishing. The first issue was just a few mimeographed pages created with an IBM Selectric (more a glorified calculator than a computer) and a Polaroid MP-3 camera. Opening with a quote from Buckminster Fuller and ending with one from the *I Ching,* it had the look of a Sears mail-order catalog. A crazy quilt of lists of recreational equipment, farm tools, Indian teepees, and tantric art. Steve Jobs called it a Google in paperback form. But importantly for our subject, it had reviews of some early computers and a review of Norbert Weiner's book *Cybernetics.* Published sporadically between 1969 and 1972 (there were no more than thirty-five editions), the catalog was the first source to put forward to the general public the idea that a computer could be as much a part of an average household as a can opener or washing machine. Its communal ethos of outlaw culture fit in perfectly with the hackers' ethic. Dog-eared copies of the *Whole Earth Catalog* sat on workstation shelves from Hewlett-Packard (HP) to Xerox PARC.

The counterculture spawned early experiments in computing communally. Bob Albrecht and George Firedrake created the People's Computer Company (PCC) in a Menlo Park shopping center. Their first newsletter proudly declared, "Computers are mostly used against people instead of for people; used to control people instead of to free them. Time to change all that—we need a . . . People's Computer Company."[10] Anyone could walk in and program or play games on terminals connected to a computer time-sharing service. Companies like HP and Ed Fredkins's Triple-I donated funding and equipment. The computers were primitive in the extreme, but they were interactive, and that opened a world of possibilities to young minds. And watching children and teenagers use the equipment in turn inspired scientists to consider how they might make their computers "user friendly."

By the mid-1970s the PCC began to splinter due to personality conflicts. It spawned new, informal groupings like the People's Computer Center and The Homebrew Computer Club. The latter began in engineer Gordon French's Menlo Park garage on a rainy night in March 1975. Their motto was Give Help to Others. The new Altair 8800 had just come out, and programmer Steve Moore invited people to come try it out and discuss it. "It was just all these guys standing around and looking at a computer on a table," said club member and engineer Lee Felsenstein.[11] Subsequent meetings were held at Stanford's SAIL facility, up in the foothills, and at the Stanford Linear Accelerator Lab. Some mainstream computer scientists were skeptical. Alan Kay joked that many hobbyists hoped their computer would break, because at least fixing it was something they could actually do with it. But regardless, the Homebrew Club became a valuable neutral ground where engineers and enthusiasts alike could come, learn, and share ideas. One colorful character who called himself Cap'n Crunch (his real name was John Draper) created a blue box that emitted a tone that, when played into

a telephone receiver, enabled him to hack into the phone company's long-distance lines to make free phone calls. For that he was wanted by the FBI. At the club he taught his tricks to two kids named Steve Wozniak and Steve Jobs. Bill Gates also began as a habitué of the Homebrew Computer Club. He wrote a famous plea to the Homebrew hackers to please respect the proprietary rights of his first Altair BASIC software and not share it, since he and Paul Allen were trying to make a living off it.

The Homebrew Computer Club soon spun off a satellite club of people who wanted to focus on computer graphics, the Graphic Gathering. "Although the GG held meetings all over the Palo Alto area, most meetings and group activities took place at the Palo Alto Community Center at Middlefield and Embarcadero in Palo Alto. Monthly meetings usually had one or more presenters—John Whitney Sr. came one time, Larry Cuba, Scott Kim, etc., plus some show and tell and lots of time for people to get to know each other."[12] On one such evening Stanford graduate Carl Rosendahl made friends with Glen Entis and Richard Chuang. Entis was then working at Ampex, developing the AVA digital paint system, and Chuang was at Hewlett-Packard. Rosendahl had just started his own CG studio and invited them to join him. Together they created Pacific Data Images (PDI). Chuang recalled, "We had no real plan other than we thought it would be cool to make pictures with a computer."[13] PDI became one of the longest-lasting, most successful CG animation studios ever.

There were many other clubs of hackers around the world during that time, including the Hobby Computer Club in Holland and Computer Chaos in Germany. In 1968 in England, Alan Sutcliffe, George Mallen, and John Lansdown formed the Computer Arts Society (CAS) as an association dedicated to the development of computers in the arts. But Silicon Valley had the advantage of a huge concentration of talent and companies, without being dominated by one entity, like an IBM.

As the revolution in computing grew, hackers who were focused specifically in the field of graphic imaging began to see the need to form a larger organization to represent their particular needs.

Andries van Dam had helped create hypertext and had built up the computer science program at Brown University. Sam Matsa was a computer scientist at IBM in New York. Together in the mid-1960s they did a touring lecture on computer graphics that drew standing-room-only crowds throughout the United States, Britain, France, and Germany.

In 1967 Matsa and van Dam gathered thirty computer hackers from across the United States to sign a petition to start a computer graphics group. They used the petition to convince the Association for Computer Machinery (ACM) to endorse a new group. "I had to convince the ACM board that graphics was an important activity and that there was enough people interested in graphics—to set it up as a committee," Matsa recalled. "Like anything else, it was partially political. I was on the Board, so I had some influence as to what committees would approve. However, the first reaction

was not positive. . . . I will never forget the question that one of the Board members asked me. He said 'Are you really serious? Do you want to start a section of the NY Academy of the Sciences on using a desk calculator?'"[14] Despite their reservations, the board finally assented. And so the Special Interest Group on Computer Graphics, SIGGRAPH, was born. A small annual dues fee was charged, and a regular newsletter was published. Occasional seminars were given.

Despite some rapid initial growth, for its first few years the group remained small, with irregular and informal activities. A conference on computer graphics in medicine was held in 1972. The group also organized meetings for CG users at the larger National Computer Conference, held annually. Chairman Bob Dunn said, "SIGGRAPH was the only organization that can effectively serve as a nationwide focus for computer graphics." In 1974 Jon "The Troll" Meads and Bob Shiffman decided that SIGGRAPH needed a place for members to gather and exchange information and ideas about the newest developments. Since the hackers were scattered across the North American continent and overseas, the concept of a single headquarters in a single city seemed impractical. An organized annual convention, moving from city to city, would be a better solution——a "moveable feast" of the latest in computer knowledge. The first SIGGRAPH was planned for Boulder, Colorado. It occurred at the same time as a National Sciences Foundation workshop on computer graphics. The organizers initially expected only a few dozen attendees, but they were pleasantly surprised when six hundred showed up. SIGGRAPH today boasts a worldwide membership of over thirty thousand.[15]

In the 1980s, as the number of independent computer graphics houses mushroomed, some felt SIGGRAPH remained too academic-centered to represent their needs. This group split off and called themselves the National Computer Graphics Association (NCGA). They sought to focus specifically on the commercial CG industry. For a time they gave SIGGRAPH some serious competition, but by the 1990s most had come back into the fold. The dons of SIGGRAPH got the message and modified the event to be more inclusive of commercial work.

SIGGRAPH became the premier forum for the worldwide CG community. Employers new to CG came to understand that no matter how tight their project deadlines, there was just no stopping their computer tech people from dropping everything to attend SIGGRAPH for the week. It was the hackers' Holy Week of Obligation. Like the old HomeBrew Club, SIGGRAPH was neutral ground, with none of the proprietary secrecy of the corporate world. When someone made a discovery he published a paper there. Richard Weinberg recalled, "The early SIGGRAPH conferences became a driving force in the development of the field. Each year there was a pre-scheduled scramble for researchers to come up with new results, animated shorts and new products to reveal at the annual SIGGRAPH conference, which then inspired the next annual round of developments."[16] Scientists and engineers came to plan their completion deadlines with the upcoming SIGGRAPH conference in mind. A paper presented at SIGGRAPH could qualify a professor for tenure at his or her university. An idea would

Figure 6.2
A flyer for SIGGRAPH '82 Boston. Created at NYIT by Ephraim Cohen.
Courtesy of Michael Lehman.

not be accepted by the mainstream industry without being presented first at a SIG-GRAPH conference.

In the beginning SIGGRAPH was all about the research papers and conferences, papers on surfacing, raster graphics, translucence. Programmers would write out code for each other on small notepads and tear off the page: "Here. Have you tried this?" In 1987 John Lasseter of Pixar presented a memorable paper in which he spelled out the twelve basic principles of character animation for the CG industry.[17] "It wasn't until 1989 that you could actually sell things there," CG artist Scott Johnston recalled.[18] Small companies would take the opportunity to show off their newest discovery. Because there was so little real film being presented, one feature was an open projector night, when anyone was invited to show what they had done. If there was not enough CG footage to run and somebody had a 16 mm of a Betty Boop cartoon, or something else, that was run, too. Slowly, as more and more film was being done, TV logos and demos were added and the screenings, called the Electronic Theater, became the highlight of the conventions. Bill Kroyer reminisced, "The first night of the Electronic Theater was like Christmas morning. All the most significant work was first revealed to the world there."[19]

Side Effects Software president Kim Davidson remembered, "There was so little work then, you could see what animator or what studio had done what. You could recognize their style."[20] Animator Tina Price recalled, "You'd sit in this dark theater, and up on the screen would appear a pumpkin, center screen and rotating 360 degrees with light shining from its carved openings for a minute, and the audience would jump up and cheer like it was a touchdown at the Super Bowl!"[21] They all understood that each one of these was a technological breakthrough. CG animator Jim Hillin said at a SIGGRAPH conference in 1987, "80 percent of what you see here will be just the same old flying bricks. But every year there is just one thing, one breakthrough that becomes the talk of the convention. And that one step is enough to get everyone excited and so advance the entire medium."

Many breakthrough shorts got their first public viewing at the Electronic Theater: NYIT's *The Works* (1982), Pixar's *Luxo Jr.* (1986), Steve Goldberg's *Locomotion* (1989), Philippe Bergeron and Daniel Langlois's *Tony de Peltrie* (1985), and more.

SIGGRAPH became the place where you could network and make contacts with your CG peers from all over the world. Ed Catmull hired John Lasseter based on their chance meeting at a SIGGRAPH. Chris Wedge was a stop-motion animator who went to a SIGGRAPH on the East Coast in 1983. There he met pioneering CG filmmakers Stan VanDerBeek and Charles Csuri. These chance encounters inspired Wedge to make CG his career.

Loren Carpenter had been an engineer in computer design at the Boeing Aerospace factory in Seattle. He was drawn to graphics and 3D design. On his days off he liked to go over to the engineering library at the University of Washington. "Something to keep my mind going. . . . I'm a tinkerer." There he had read about the first SIGGRAPH,

Figure 6.3
Loren Carpenter's *Vol Libre* (1980), featuring a cameo by the Newell Teapot.
Courtesy of Loren Carpenter.

in 1974. He was impressed reading the papers presented there by Ed Catmull and Jim Blinn. After attending SIGGRAPH 1978 in Atlanta, Carpenter thought, "I can do this." He used his spare time and money to generate his own short film, *Vol Libre*, on Boeing's VAX11/780. A coworker said to him, "What are you making pictures for? We already have an art department."[22]

In *Vol Libre* Carpenter developed his own way of modeling 3D images using fractals. They made the images look more organic and less geometric and blocky than standard models. The film takes viewers on a flight above surreal mountain ranges to end at Newell's famous teapot, the classic SIGGRAPH joke. As he was completing *Vol Libre*, Carpenter read in the trades that Ed Catmull and his NYIT team had left NYIT for Lucasfilm. So he used the opportunity of SIGGRAPH 1980 to show *Vol Libre* to Catmull and Alvy Ray Smith. It got him hired immediately, and Carpenter went on to become one of the founders of Pixar.

SIGGRAPH conventions also provided the opportunity for hackers to raise a little hell with their fellow travelers. The official reason for hosting the events was to give studio recruiters an opportunity to engage the top prospects in the business. But for computer nerds, who lived an isolated existence and endured the blank stare of dates and relatives, they offered a chance to celebrate with their own kind. The parties held at SIGGRAPH came to be as famous as the official events. All the more fun if you could crash one uninvited.

Many SIGGRAPHs began with a customary Japanese Sake barrel opening, hosted by CG abstract filmmaker Yoichiro Kawaguchi. Symbolics animator Ken Cope reminisced, "I remember in 1982 dancing with Joan Collins [president of the SIGGRAPH

Los Angeles Chapter] to music provided live by Steve Roach and his bank of synths, while Jim Blinn presented a slide show of what Saturn-rise from the lip of the Death Star crater on the satellite Mimas would look like."[23] "Dweezil Zappa and Adam Ant played at a Digital Domain party while James Cameron and Linda Hamilton cut up the dance floor; at other DD parties CEO Scott Ross would 'hire' a bunch of beautiful women to show up in order to balance out the mostly male 'geek' attendees. Bands like Big Bad Voodoo Daddy, Beck, Rob Zombie; every party was designed to top the previous year's."[24] When SIGGRAPH was held in Las Vegas, John Lasseter threw a party in his hotel room, choosing an outrageously pimped-out honeymoon suite with mirrored ceilings and indoor hot tub. A score of computer nerds bounced joyfully on the huge, round, pink bed. When it was in Los Angeles, Philippe Bergeron threw a party at his Forest of Mirrors, a fantasy glade like something based on a book by Greg and Tim Hildebrandt that he created in his suburban San Fernando backyard. SIGGRAPH printed a free underground newspaper just to review the coolest parties.

For SIGGRAPH 1995 representatives of ILM and SGI approached the very conservative Richard Nixon Presidential Library and Birthplace in very conservative Orange

Figure 6.4
PDI Animators Tim Johnson and Glenn McQueen, 1992.
Courtesy of Rex Grignon.

County, California, to be the site of a late-night party.[25] The directors of the library probably thought, What could be the harm, with such a prestigious, high-profile company like ILM vouching for the event? The party was entitled *Nailed: An Evening on the Cultural Frontier.*

What they got was a thousand wild, drunken old hippies, rockers, and techno nerds slam dancing into the wee hours. Scantily clad Brazilian Carnival dancers, Japanese Taiko drummers, sword swallowers, and tattooed snake charmers festooned the grounds. Top rock bands the Red Hot Chili Peppers and Fishbone pounded away on the music. Oscar-winning lighter Ben Snow recalled, "There was a killer party at the Nixon Library organized by Steve 'Spaz' Williams and Mark Dippé—they had Timothy Leary talking—and it was like—Oh my god—this is Hollywood!"[26] One inventor said, "I felt deeply, spiritually fulfilled by being able to smoke a joint by the reflecting pool at Richard Nixon's library," adding contentedly, "it's the balancing of opposites over time." Many piled into the library's gift shop just as their high was hitting them. Eyewitnesses doubt this much Richard Nixon memorabilia could have ever been sold after 1:00 a.m. "It's wonderful," enthused Lynn Finch, visiting head of Orlando's SIGGRAPH chapter, clutching a set of presidential spoons in the gift shop, "because I doubt that in any time, place or context, Nixon would've appreciated any of this."[27] LSD guru Timothy Leary held a mock exorcism over the birthplace. After 2:00 a.m. the Red Hot Chili Peppers ended their last set by urinating on the floor as a political statement. The staid, conservative directors of the museum were unavailable for comment, but one can imagine their reaction.

ACM SIGGRAPH also formed a history panel to preserve documentation of the early days of CG and sponsored a number of documentaries and special shows highlighting the finest in state-of-the-art computer graphics. In 1984 SIGGRAPH cochairs Dick Mueller of Control Data Corporation and Richard Weinberg of Cray Research produced an all-CG showcase in the Omnimax large-screen format. Called *The Magic Egg*, it appeared in science centers around the world and featured pieces done by Nelson Max, Vibeke Sorensen, and the mechanical ant from NYIT's *The Works.*

As the years rolled on and more and more large corporations and Hollywood film studios became invested in CG, SIGGRAPH took on more and more of the look of an industrial trade show. Microsoft, Apple, and HP filled convention centers with huge displays and legions of recruiters. There was less and less sharing of information as more work became proprietary. As the Internet has made the dissemination of information more general, attendance at SIGGRAPH has been down in recent years. SIGGRAPH's initial neglect of the booming games community caused them to go off and mount their own conventions, like the annual E3. Yet the old hacker's ethic can still be felt. The outlaw spirit of the TMRC and Homebrew Computer Club lives on in every new innovation. Without the hacker, CG could never have grown from a weak, glowing vector line on an old oscilloscope to today's slick digital spectacle.

7 Nolan Bushnell and the Games People Play

No one can deny that the ubiquitous invasion of computers into the home was started by the videogame console. If not for videogames and their enthusiasts . . . advanced computer graphics would perhaps still be found only in the exclusive domain of universities and the high-tech world.

—Ralph Baer

August 31, 1966. New York City. At the east side bus terminal Ralph Baer, head of the Equipment Design Division of New Hampshire defense contractor Sanders Associates, sat waiting for the express bus to Boston to begin boarding. It was a hot, sticky summer day in New York. Sweaty bus drivers grunted as they pulled hard at the steering wheel of their great, gray behemoths. A dispatcher barked a few indecipherable destinations through a staticky loudspeaker. The air reeked of diesel smoke and the low roar of the engines. People waited patiently, reading newspapers, smoking cigarettes, and periodically dabbing at their perspiration.

Baer sat lost in thought. He contemplated an ad on the yellowish tile wall for *TV Guide* magazine. "TV, . . . hmph. Never anything good on. I wonder what else can you do with a TV set, other than tuning in channels you don't want?" Then an idea hit him. Why can't you play a game on your TV set? Something that shouldn't cost too much, say $19.95. This concept had occurred to him once before, fifteen years ago, as a young engineer. But now it seemed the more he thought about it, the more it seemed doable. "I'm a division manager now. I have a seven or eight million dollar direct payroll. I can put a couple of guys on a bench who could work on something. Nobody needs to know. It won't even ripple my overhead." Baer boarded his bus with his mind aflame with possibilities.[1]

CG games began as a novelty to allow scientists to demonstrate the calculating power of their early computers. In early 1948 the English computer pioneer Alan Turing worked on a program for an electronic game of chess. But what he was attempting was beyond the calculating power of the analog computer he was then

using. He worked at Britain's National Physical Laboratory to create a more advanced machine, called the Automatic Computing Engine (ACE). After being continually disappointed by government red tape holding up his progress, Turing gave up on the idea. In 1951 Christopher Strachey took Turing's ACE and attempted a program that could play a game of drafts (checkers). In 1952 A. S. Douglas at Cambridge University, in order to illustrate his thesis on the potential of human–computer interaction, created OXO, a computer game of tic-tac-toe, using an EDSAC vacuum tube computer.

In 1958, at the Brookhaven National Laboratory nuclear facility in Upton, New York, Willy Higginbotham, a chain-smoking, fun-loving scientist who had once worked on the atomic bomb at the Manhattan Project, was trying to create a novel exhibit for visitors to the lab. Brookhaven's autumn open house was coming up, and he felt they needed something more entertaining than just the same old Geiger counters and charts on radiation half-lives. He was also a self-confessed pinball machine fan. He reprogrammed an army oscilloscope to play a simple tennis game. It could be seen as a side view only, with a little line representing the net. You controlled it with a button and a knob. He called it *Tennis for Two*. Higginbotham didn't think he had created anything special, so he did nothing further with it. "I considered the whole idea so obvious that it never occurred to me to think about a patent."[2]

In 1962, in MIT's Plywood Palace, Model Railroad Club members Alan Kotok and John McCarthy were given the assignment to write a chess program for the college's IBM 709 computer, aka the Hulking Giant. They had easier access to the Tixo, the old Whirlwind TX-2, and a few doors down at the Kluge office was a new PDP-1 computer, recently donated by the Digital Equipment Corporation. For a laugh, Kotok and McCarthy decided to load the same chess program into the TX-2 and the PDP-1 and link up the two machines. They did this via a large cable run along the floor between the offices. Then they hailed two fellow students who fancied themselves chess experts and invited them to try out a new chess program. One went to the TX-2 and the other to the PDP-1. The students were unaware of each other. They had been told that they would be playing the computer, but in reality they were playing against each other. After a while the chessboards fell out of sync and some arguing ensued. Then one student noticed the big cable extending out the door and down the hallway. As he stood up to investigate, Kotok sent a quick e-message to McCarthy at the other computer: "RUN FOR IT!"[3]

A few years later McCarthy was head of Stanford's Artificial Intelligence Lab (SAIL). In 1965 he traveled to the Soviet Union and discovered the Russians were developing a computer chess program much like the one he was working on back home. Their program was being developed under Professor Alexander Kronrod at the Institute of Theoretical and Experimental Physics. Kronrod challenged the American computer team to a match. Over the next year four games were played between the computer

in Moscow and the one in California. Because there was no such thing as an Internet yet, the players' moves had to be relayed each day by telegraph. The Russian team won every match.[4]

Back in Cambridge, the MIT crew developed some simple games for their Tixo: a mouse in a maze and tic-tac-toe. All the news around them was about the first astronauts going into orbit. This gave a Model Railroader named Steve "Slug" Russell an idea for a game: "My colleague Marvin Minsky had made a program where dots moved around, but [it] didn't do much more. I thought, well, stories about space travel are very popular right now. But most people don't understand how a rocket ship really works, they think it maneuvers like an airplane." Russell and his friends Peter Samson and Alan Kotok were fans of E. E. "Doc" Smith's *Lensman* science fiction books, full of shoot-'em-up action. So they went to their faculty supervisor, Ed Rifkin, and got the go-ahead to do a computer game involving dueling spacecraft.

They created two torpedo-firing rocket ships with a star in the background. They calculated into the program how the gravity of that star would affect the rocket ships' maneuvering. Kotok and Bob Sanders came up with a way to make operating the game ergonomically easier. The scrounged parts from other Model Railroader projects and invented a separate remote controller that they wired into the PDP-1 mainframe, the first joystick console. A problem that arose was when people wanted to win, they could simply fire an endless cloud of torpedoes. So Slug created a way for the other ship to jump into hyperspace and escape. But then people used that too often, so he had to create a three-escape maximum.

Finally the last of the twenty-seven pages of assembly-language code was entered on the paper tape memory. Samson originally wanted to call it *Shoot Out at the El-Cassiopeia*. But Russell and Kotok prevailed and dubbed the game *Spacewar!* It was the first true interactive game. Russell joked, "For two years, *Spacewar!* was the most popular computer game in the world, because it was the only one!"[5]

Although the game was a big hit around the MIT campus, Russell and the gang never profited from their creation. They never copyrighted it. They were hackers who wanted to do it to show their friends they could do it. "We thought about ways we could make money off it for two or three days, but concluded it couldn't be done."[6] So they shared the source code with anyone who asked for it. Russell followed John McCarthy to Stanford, then dropped out before graduation to work at the Digital Equipment Company, the originator of the PDP computer. He took *Spacewar!* with him. DEC offered it as a free demo accessory to any company purchasing their mainframes. In many a university and research lab, if you entered the computer room around 2:00 a.m. you inevitably would find someone playing *Spacewar!*. In this way the game began to spread out of the university lab into the private sector.

Years later, at a small computer company in Seattle, Russell ran an after-school program that would bring in kids and let them bang away on keyboards to see who

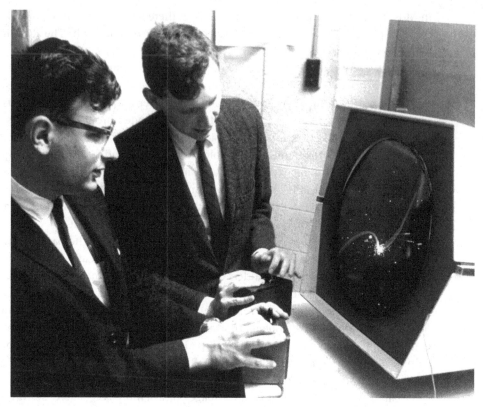

Figure 7.1
MIT model railroaders Dan Edwards and Peter Samson playing *Spacewars*, on a PDP-1 (1962). Courtesy of the MIT Museum.

could crash the computer. There was only one little boy who could crash them no matter what. His name was Bill Gates.[7]

Turning back to Ralph Baer and his bus trip back to Nashua, New Hampshire: During his ride he scribbled out notes for a four-page outline of what he wanted to create. He called into his office his friend Bill Harrison, a former radar specialist in the air force who had become one of Sanders Associates' top technicians. "He [Baer] showed me a TV set with just a little white spot on it [the screen], that he could control a little bit," Harrison said. "He said he wanted to play games on a standard television set, and would I work on this project with him?"[8] Harrison agreed to pitch in. The following year they were joined by Bill Rusch, who brought what he had picked up about external remote consoles during his days as a MIT hacker.

They started with a two-player game called *Chase,* where you tried to catch a flying dot with your spots. The spots soon evolved into paddles. "We had a respectable ping-pong game going, and it wasn't long before it we called it a hockey game. Just remove the center net, and put a light blue background in, and it became hockey."[9] Together they added extra games like volleyball, football, and target shooting to their console, using a light gun. All in all, the console contained twelve games. They nicknamed it the Brown Box, because it was covered in faux wood-grain contact paper. It had simple graphics, black and white, no sound. But it did not need a big mainframe computer to run, it could be plugged into any TV and could accommodate up to four players.

Eventually Baer's superiors at Sanders Associates wondered just what he was doing. His vice president would stop him in the hallway and ask, "Baer, are you still screwing around with that stuff?" Baer and his team finally had a showdown with the company's executive board, including founder Royton Sanders. They were impressed by their work but wanted no more time and money spent on it. The company was a defense contractor, not a toy company. If Baer wanted to continue to pursue this project, he should go shop it around. Perhaps some TV manufacturer? So Baer began a round of demo meetings. GE, Sylvania, and Zenith all passed. They feared the device would damage their TV sets. Finally Magnavox picked it up. They retooled the Brown Box into a sleek, space-age plastic console and renamed it the Magnavox Odyssey 1TL200.[10] Magnavox first introduced the Odyssey to the public at a reception at New York's Tavern on the Green restaurant on April 22, 1972. Ralph Baer sat in the back on a metal folding chair, watching dealers and reporters go wild with excitement. "I got pretty excited and was hard-pressed to keep my mouth shut and restrain myself from jumping up on the stage and yelling: 'That's my baby!'"[11]

But in the months afterward, waiting for the Magnavox-Sanders deal to close and the Christmas buying season to begin, Baer sank into depression. Business was bad for defense industries as the Vietnam War drew to a close. Many of his friends at Sanders were being laid off. Payroll dropped from eleven thousand employees to only four thousand. Baer started to give in to feelings of guilt, like maybe it had been a mistake to waste his company's dwindling resources on a silly game. Then one day, while he was at home recovering from back surgery, his first royalty check arrived from Magnavox. It was for $100,000.

The earliest network multiplayer game began in 1974 when some government scientists working on ARPANET, led by Steve Colley, made their own first-person shooter game. They called it *MazeWar* or simply *Maze.* A player ran through a black-and-white vector maze while shooting it out with others online. Unfortunately, everything the scientists were doing, even playing games, was then considered top secret. Online capabilities such as those they were using would not be available to the general

Figure 7.2
Ralph Baer in 1972 with the Magnavox Odyssey, the first home video game.
Courtesy of Ralph Baer.

public for years to come. Colley took the lessons he learned about first-person optics and used them in the developing the Mars Rover vehicular probe for NASA.

Spacewar!, *Maze*, and the Odyssey may have been the first breakthroughs, but more was needed to get computer games into the mainstream. Russell's game played only on big, expensive mainframe computers, the kind that large companies or universities used on a time-share basis for up to $500 an hour. Magnavox's Odyssey was poorly advertised and priced too high. Instead of charging $19.95, as Baer had wanted, Magnavox charged $100, plus another $25 for the better light gun. Magnavox also didn't discourage the misconception that the Odyssey could play only on Magnavox TV sets, which further limited demand. Cal Poly graduate Hugh Tuck and Stanford University computer science graduate Bill Pitts designed a commercial update of *Spacewar!* and called it *Galaxy Game*, but it still needed a PDP-11 to run. The game table, placed in Stanford's Tresidder Union coffeehouse, had cables that went through the coffeehouse, out the back, and upstairs to the mainframe computer in the music room. It had one of the earliest joystick controls.[12] But it didn't generate much excitement beyond the coffeehouse habitués.

Then, in 1972, a new force emerged that would storm into the public consciousness.

Walt Disney (1901–1966) did not invent animation, but no one would dispute that he was the greatest exponent of the art form. If anyone could claim to be the Walt Disney of electronic games, it would be Nolan Bushnell.

Raised in the small Utah town of Clearfield, Bushnell grew into a tall man with a deep baritone voice and a big, bright smile. The young Mormon adopted habits not usually accepted by his elders. For one thing, he smoked, and for another, he blew his college tuition in a poker game. Through serendipity rather than intention, Bushnell found himself attending undergraduate classes at the University of Utah, home of the prestigious computer graphics program of Evans and Sutherland. Even though the most advanced classes of their CG lab were not available for undergraduates, Bushnell ingratiated himself with some of the graduate students and soon became a regular, working late into the night. However, losing the ability to pay your tuition could pose a problem for even the most promising young entrepreneur. So he took a job at Lagoon Amusement Park, repairing electronic pinball machines.

This made him begin to think about ways to combine his two creative passions, computer graphics and pinball. At the U, Bushnell was introduced to the *Spacewar!* game. Though members of his graduating class had invented several games of their own, *Spacewar!* was Bushnell's favorite. He played it constantly, trying to familiarize himself with every component.

After graduating in 1968, Bushnell got a job at the Ampex Corporation in Northern California. They made the magnetic recording tape that had replaced paper tape for

storing computer data. But the idea of making computerized games still obsessed him. While MIT engineers like John McCarthy and Slugg Russell wanted to use games to demonstrate the sophistication of research computers and Ralph Baer wanted to create games you could use at home on a TV set, Bushnell dreamed of ways to make computer pinball consoles—big, cathode-ray tube (CRT) monitors in brightly colored cabinets that would stand in arcades and amusement parks, right next to the skeeball and penny stampers.

For several months, while his two-year-old daughter, Britta, slept in the living room, Bushnell turned her bedroom into a workshop. Trying to build a version of *Spacewar!*, Bushnell realized he couldn't build his own, $120,000 PDP-1 mainframe to run it on. But the new solid-state transistor chips introduced in 1970 were making complex computation more manageable. Plus the PDP was a multipurpose machine, while all he wanted was enough computing power to play his game. So, using spare parts he "borrowed" from his day job at Ampex, Bushnell devised a specialized micro-computer that was capable only of running his game. He had to boil down miles of electronic spaghetti wiring and dozens of transistor boards into a housing smaller than a common dishwasher. He went to a Goodwill store and bought an old black-and-white TV set for a monitor, then rigged a coin operation to it that dropped quarters into an empty paint can. Although his graphics were not as good as *Spacewar!*'s, he managed to re-create all the basic player moves. Everyone who saw it said it was a brilliant hack.

In 1971 Bushnell and circuit board engineer Ted Dabney quit Ampex to focus exclusively on further developing the game, now called *Computer Space*. They named their new company Syzygy. They partnered with a traditional pinball company called Nutting Associates to create a gaudy, futuristic fiberglass box to house the monitor and circuitry and a more conventional coin box operation than a paint can. They eventually marketed fifteen hundred units. Sales of *Computer Space* topped $3 million, but it was considered a commercial failure. For one thing, the instructions were too complicated. "Nobody wants to read an encyclopedia to play a game," Bushnell confessed.[13] He also felt Nutting had not done enough to market the product. About the only lasting contribution *Computer Space* made was as a prop in the dystopian futuristic fantasy film *Soylent Green* (1974). At this time Bushnell also learned that his company name, Syzygy, was already trademarked by a Mendocino hippie commune that sold hand-dipped, scented candles through the mail.

So in 1972 Bushnell and Dabney broke off with Nutting Associates and adopted a new look and a new name. On July 27, 1972, the twenty-seven-year-old Bushnell, Dabney, and Larry Bryan each chipped in $250 to file for incorporation of their new company, Atari. Bushnell named the new company after a move in the Japanese board game Go. Saying *atari* is similar to saying *check* in chess. They set up an office in Sunnyvale, California, near Stanford University, in the heart of Silicon Valley, and

bought an old station wagon to be their company car. Bushnell immediately broke with the traditional white-collar companies of the time by insisting his employees have no dress code to adhere to. Visitors described the group as "a bunch of Led Zeppelin–loving, herb-smoking hippies."[14]

Among other ideas, Bushnell recalled once trying out a colleague's experimental prototype of a computer tennis game (which may have been Baer's Odyssey). He told Alan Alcorn, one of his newly hired engineers from Ampex, that he had just landed a big contract with General Electric to create an arcade game based on ping-pong. "The game should be simple," he said, "one ball, two paddles and the score." In reality, Bushnell had no such deal with GE. He merely wanted Alcorn to be motivated to do his best on the simplest game concept he could think of. Then he'd be ready for some of the more complex ideas Bushnell had in mind. Alcorn came up with *PONG*. It's a simple, real-time ping-pong game, black and white, that Alcorn ran through a seventy-five- dollar Hitachi black-and-white television set he bought at a Payless discount store. Instead of a thick pack of printed instructions, all it said on the cabinet was, "Avoid missing ball for high score." You could play *PONG* with one hand while hold a beer

Figure 7.3
Nolan Bushnell posing with a Pong game.
Corbis Images, Inc.

in the other. Perfect for bars and pubs. Bushnell had asked for sound effects like audience cheers at a professional tennis match, but Alcorn stuck with simple computerized "bleeps and blups." When Bushnell tried the game he had so much fun he forgot all about his other project ideas.

To test out their new creation, in late September 1972 Bushnell put the *PONG* prototype on top of a wine barrel in Andy Capps, a tavern on El Camino Real Boulevard in Sunnyvale. There already were some pinball machines and a *Computer Space* game there. But with the addition of *PONG* the bar quickly became a madhouse. After two days the bartender called Alcorn to complain that the game was broken, saying, "Get that fucking thing out of here!" But upon inspection, Alcorn saw its coin box was so choked with quarters that it had jammed. By the end of the week, when the bartender opened in the morning, people were already lined up just to play *PONG*. The machine was pulling in $300 a week in quarters, six times more than their pinball machine. No one had ever seen anything like it.

PONG is now considered one of the great breakthroughs in motion graphics. Before *PONG*, all computer activity was text-based. You typed in code for everything. *PONG* was the first to use real-time images to communicate a graphic idea. You didn't need a science degree or pages of detailed instructions. Just plug it in, and anybody could play *PONG* in minutes.

PONG took the American public by storm. Within a few years of *PONG*'s introduction, Atari went from its little $750 investment to a $2 billion "wondercompany." Sales in arcades skyrocketed, and Atari soon produced a home console version. Magnavox sued, claiming Bushnell stole the ping-pong idea from the Odyssey. Magnavox won, and Atari released the console version exclusively through Magnavox. Atari and other companies did pay some royalties, but only on home console games, not on arcade games. Baer's original company, Sanders Associates, and Magnavox made millions on the patent. Also, Atari did not register a trademark in time to protect the name *PONG*, so soon a lot of others jumped on the bandwagon with *PONG* knockoffs, capturing a big share of the profits. By 1978 more advanced versions of *PONG*, as well as *Asteroids*, *Breakout*, *Tank*, *Centipede*, and *Grand Track* became popular with the general public.

Around the same time, in 1976, Bruce Artwick graduated from the University of Illinois with a degree in computer electronics. His thesis was on 3D graphics for flight simulation, and he got his pilot's license while he was completing the thesis. While working for Hughes Aircraft, he wrote some magazine articles in which he postulated that one could run dynamic graphics of a military-type flight simulator on the newer, faster microcomputers, like the 6800 from Motorola. So many readers asked him where they could buy his software that he started his own company, called subLOGIC. He created the first flight-simulator game, called, coincidentally, *Flight Simulator*, for the Apple II. Later Artwick went to Microsoft, and *Microsoft Flight Simulator 1.0* (1982) was

the first game launched on the new IBM PC. At the same time, Atari went to George Lucas's ILM and, using simulator programs and some of Larry Cuba's original vector models of the Death Star trench flight, created the *Star Wars* arcade game. Steven Spielberg became addicted to it between working sessions on preproduction for *Indiana Jones and the Temple of Doom*.

The period between 1976 and 1983 was the golden age of arcade games. "We treated programmers like mini-gods," Bushnell said. "We gave the best ones private offices. We set up a hot tub in the engineering building. We hired the best-looking secretaries for that department."[15] Atari was trying to introduce a new game a month. Teenage dropouts Steve Jobs and Steve Wozniak were, for a time, employees of Atari. They even offered their prototype Apple I to Bushnell. But for once, Nolan the entrepreneur wasn't interested. So Jobs and Wozniak were forced to strike out on their own.

When Atari's cash flow ebbed at one point, Bushnell agreed to a merger with the mighty Warner Communications media empire, parent company of Warner Bros. Studios and *Time* magazine. Bushnell's freewheeling style didn't quite fit their corporate structure. Unlike most of the executives now filling up plush offices in Atari's "Mahogany Row," Bushnell actually loved video games and played them often himself. Dispirited, he began to lose interest in the company and take longer and longer vacations. So Bushnell was replaced as head of his own company by producer Ray "The Czar" Kassar. Also nicknamed the Sock King because his previous job was at Burlington textiles, Kassar moved Atari's focus away from developing new games and more toward sales and marketing. This annoyed Bushnell. He became so detached from the daily goings-on of Atari, that for a time he used Steve Jobs to keep him informed about what was happening. The showdown came in November 1978. "Guys, we have to do things the way I want, or I'm out of here," he said. "Nolan, you're out of here," was Warner's response. Bushnell's philosophy was always that business was a game. Now at Atari, it was game over. Without even pausing for breath, Nolan Bushnell started another games company, Sente. While Atari took its name from a call in the Japanese game Go that was the equivalent of "check" in chess, *sente* meant "checkmate."

Bushnell considered video games the medium in which the new novels and classics would be written. He had become a great fan of William Gibson's seminal cyberpunk novel *Neuromancer* (1984). The idea of making the story into a game was proposed to him by the old sixties LSD guru Timothy Leary, who owned the rights to make it a game. Leary had already coproduced a game called *Mindmaster*.

Bushnell convinced Atari to take on the game's creation. They brought in NYIT computer vets Rebecca Allen and Kevin Bjorke to build the game, while Leary attracted other celebrities from the "artsy set" to explore this new medium of expression. Photographer Helmut Newton and writer William S. Burroughs as well as the author William Gibson all volunteered to help. Bjorke recalled, "The project was big on hype, but it was hard to get anyone to do anything. We just got a lot of scruffy bits and

pieces. Artist Keith Haring sent a floppy disc of drawings of his for use in the game. But I felt like I was the only one who was actually doing any work!"[16] Like many beautiful people collaborations, all the different artistic directions and egos collided and ended in stasis. Allen left the project and was replaced by a hard-nosed games producer. After looking over all that had been done, he called Bjorke and his crew together and said, "Can you run this thing on a Commodore 64?" Bjorke answered, "No, it's high end." The Atari exec replied, "No, you're all fired!" He subcontracted the game to a small group in Orange County, California, called Interplay Productions.[17] Ironically, Interplay was made up of disgruntled Atari programmers who had gone out on their own because of Kassar. They made *Neuromancer* a simple pursuit combat game that could run on all Amigas, Commodores, and Apple IIs. In the end, *Neuromancer* did well with players and critics.[18]

While he was still part of Atari, people noticed that Bushnell kept on a mannequin in his office a costume of a large mouse character. People in neighboring offices thought it was more like a weird-looking rat. They wondered what he could possibly be planning with such an outfit?

The 1980s was the age of Reagan, an era that tried to be as conservative in outlook as the 1960s had been liberal. Among the reformist movements of the New Right, a lot of American popular media was scrutinized for its effect on children. Parents' groups raised concerns that the video game craze drew minors into hours of addictive distraction in the unwholesome atmosphere of cheap video arcades. Truth be told, many places, like Playland in New York's Times Square, and the arcades on Hollywood Boulevard and in the Tenderloin District of San Francisco, could indeed be unsavory hangouts after dark, populated by junkies and prostitutes.

So, much as Peggy Charen and Action for Children's Television (ACT) made the lives of Saturday morning cartoon animators miserable, a mother from Long Island named Ronnie Lamb launched a very effective grassroots campaign against video games. She was all over television, accusing video games of undermining American youth and making children numb to violence. Conservative president Ronald Reagan's equally conservative surgeon general, Dr. C. Everett Koop, declared that "video games were evil entities that produced aberrations in childhood behavior."[19] Connecticut senator Joseph Lieberman made great hay in the press out of a yearly video game report card, outlining what he felt was offensive in video game content.

Bushnell reacted to this public relations problem by conceiving of a chain of franchise restaurants where kids could play video games in a safe, wholesome, family environment. He thought, "What kind of food would a family wait patiently for, no matter how long it took?" Why, a custom pizza, of course. And while the family waited for their order, the kids would play his video games. To make the restaurant appealing to kids, he themed it on a mouse character he called Chuck E. Cheese. Warner Communications didn't seem interested in his idea, so it allowed him to go on with it

uncontested. Bushnell purchased an old Dean Whitter stock brokerage in an outdoor mall in San Jose, California, and there he built the first Chuck E. Cheese Pizzatime Theater. The restaurant idea took off, and franchises were soon sprouting like mushrooms, with pepperoni and extra cheese, across the United States and Canada.

The Japanese video game industry began with a company called SEGA. The company's story opens in 1951, when New York–born David Rosen left the air force after serving in the Korean War and settled in Japan.[20] He started a portrait-painting business, but he soon realized there were better opportunities in arcade games and coin-operated photo booths. He recalled, "When I was a youngster, I went to Coney Island. Like everybody else in New York City, I played the games in the penny arcades. That was really my total knowledge of the business."[21] In 1956 Rosen spent $200,000 importing electromechanical games to Japan and hit it rich. In 1964 he merged his Rosen Enterprises with his biggest Japanese competitor, Service Games, also begun by two Americans, Raymond Lemaire and Richard Stuart.[22] The partners called their new company SEGA, taken from the initial letters in Service Games. Their first big success in 1966 was *Periscope,* a submarine game where you looked through a periscope and fired little electric blip torpedoes to sink 2D ships. Its asking price of a quarter a play became the industry standard for years to come.

Japanese companies had become players in various electronics fields, but until the 1980s few had penetrated the American games market. Some preferred to go through American pinball distributors like Midway or Bally. In 1978 the Japanese company Taito released through Midway a game called *Space Invaders.* The player tried to fight back an advancing phalanx of little alien spacecraft that slowly filled the screen. *Space Invaders* was such a hit in Japan that at one point the government was compelled to deal with a coin shortage. They had to rush into production a new minting of hundred-yen coins. And it became an equally huge hit overseas. *Space Invaders* became such a success in the United States that fast-food franchises and pharmacies set up monitors in their stores. Even funeral parlors put them in their waiting rooms.

Designer Toru Iwatami worked for a company named Namco. He noticed that most video games were oriented to young males. Lots of shooting, exploding, and killing. He wondered if he could make a game that would appeal to women. He thought about making a game where the little character eats things rather than killing them. Sitting in a restaurant, he ordered a pizza. After taking one slice out of the pizza, he noticed that the simple round shape with the slice removed resembled a face with an open mouth. It inspired him to make his character a disc that eats things. He named his game after the Japanese slang *paku paku taberu*—literally, *munchy-munchy eating.* He chose the English name *Puck-Man,* but when it got to the United States in July 1980, the execs at Bally were worried about how easily vandals could change the *P* to an *F,* making it into the English-speaking world's favorite expletive. So they changed it to *Pac-Man. Pac-Man*

became one of the most successful video games in history. Namco/Bally sold over a hundred thousand video arcade consoles. The ubiquitous *Pac-Man* disc came to be the symbol of the 1980s, the way the peace sign symbolized the 1960s. There were best-selling books on *Pac-Man* strategy. *Pac-Man*'s pizza-shaped head made the cover of *Time* magazine, and a *Pac-Man* console became one of three video games to be placed in the collection of American popular culture at the Smithsonian Institution.[23]

Another Japanese company that desired to get into the world market was Nintendo. In 1889 Fusajiyo Yamauchi started a company named Marutuku. They produced Hanafuda, brightly decorated playing cards that were prized among the Yakuza, the Japanese mafia. They transitioned to electronics in 1956 to get in on the average Japanese citizen's passion for electronic Pokeno, a gambling game that is a cross between pinball, poker, and slot machines. At that time they changed their company name to Nintendo, which means "leave luck to Heaven."[24] In 1976 Nintendo agreed to become the distributor of *PONG* in Japan. Seeing the big profits to be made, Nintendo president Hiroshi Yamauchi, a descendent of the original founder, set up an American office under the leadership of Minoru Arakawa and put his game designers to work.

They first came up with arcade games called *Radarscope* and *Heavy Fire.* Although they sold well in Japan, they did not make much of a splash in America. Then, in 1977, Nintendo hired a creative young designer just out of college named Shigeru Miyamoto. Miyamoto was a brilliant nonconformist who liked to think while playing bluegrass music on his banjo.

Yamauchi asked Miyamoto to rework *Radarscope* so that they could use the unsold games. Miyamoto felt he first had to create an interesting plot for the game's action. He had always liked the American cartoon characters Popeye, Olive Oyl, and Bluto as well as the 1946 Jean Cocteau film *Beauty and the Beast.*[25] Seeking a similar triangle of pursuit, he created a big gorilla, like Bluto, who was always more comical than deadly. He made up a story about a gorilla that escapes from his master, a little carpenter, and carries off his girlfriend. As the carpenter chases the gorilla through a construction site, he must dodge barrels and other obstacles hurled at him. Yamauchi insisted that the new game have a catchy American name. Miyamoto spoke no English, so he consulted a dictionary. He looked up *stubborn* and *gorilla. Gorilla* in Japanese is *kong,* and he noticed that a synonym for *stubborn* is *donkey.* So Miyamoto dubbed his creation *Donkey Kong.* The carpenter was first called JumpMan. But in America, his name was changed to Mario, after the Seattle landlord who once let the American distributor slide on his rent.

When Nintendo's American distributors, based in Seattle, first heard about the new game, they were more than skeptical "None of these games have been great. And now the final blow is a game called *Donkey Kong*, which even my lawyer can't understand!" said one of the distributors.[26] They demanded that Nintendo change the name, but the company refused.

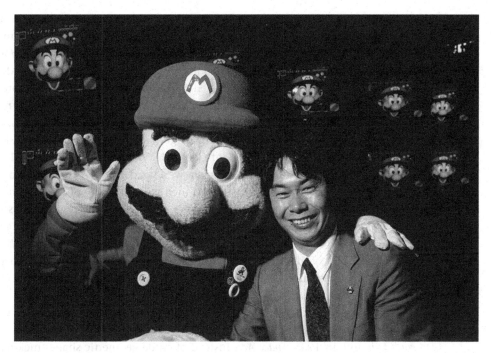

Figure 7.4
Shigeru Miyamoto, Nintendo's designer of *Donkey Kong, Mario, Legend of Zelda*, and *Pokemon*.
Corbis Images, Inc.

Just as Nolan Bushnell tested *PONG* in a local California bar, so Nintendo's American CEO Minoru Arakawa placed *Donkey Kong* in two bars in Seattle, the Spot Tavern and Goldies, near the University of Washington. The two games quickly pulled in so much cash that the proprietors begged for additional game consoles. *Donkey Kong* was officially launched in 1981 and quickly became the most popular game in America. It spawned other games, like *Donkey Kong Jr., Mario*, and *Super Mario Brothers*. All of this made Nintendo a major player in the U.S. games industry. In 1985 Nintendo of America was sued by Universal movie studios, who owned the rights to the 1933 film version of *King Kong*. But Nintendo's American lawyer Howard Lincoln proved you could not copyright the Japanese word for *gorilla*. Coleco had licensed a King Kong game with Universal that seemed derivative of *Donkey Kong*, and it wound up paying royalties to Nintendo.

By 1982 the computer-game industry reached critical mass with *Pac-Man* and *Ms. Pac-Man, Donkey Kong, Battlezone, Centipede*, and *Q*bert*. Every home with children had to have a game console, and the arcades in malls were packed with eager patrons. Large, venerable electronics firms like Texas Instruments, RCA, and Phillips Electronics

now made room in their back areas for teen hackers newly out of school, and they touted them as their "Games Division." In 1979 Mattel had introduced the Intellivision game console, and Coleco released ColecoVision.[27] Milton Bradley, the *Monopoly* and *Chutes and Ladders* company, released an early handheld system called Microvision. By 1981 U.S. arcade revenues reached $5 billion. Americans spent more than seventy-five thousand man-hours annually playing video games.[28] Warner Communications reported that two-thirds of its earnings were coming from Atari games. Nolan Bushnell built a hot tub in his office, sailed a large yacht named *Pong*, and would lend his private executive jet to Vice President George H. W. Bush when he needed it. The sky seemed the limit. The mainstream media wondered whether traditional old toys like Silly Putty, G.I. Joe, and Barbie were destined to go the way of the dinosaurs.

Up to this point, the graphic picture quality of all these video games was pretty primitive. Most of the video games of the time used *sprites*—simple graphic shapes, little more than bitmaps—moving in a rudimentary way. Little money was allocated for quality graphics, animation, or artists. Computers did not have enough power and memory to move more than simple graphics through all the possible scenarios anyway.

This state of affairs changed in June 1983 when veteran Walt Disney animation director Don Bluth partnered with Taito and Cinematronics to create the games *Dragon's Lair* and, in 1985, *Space Ace*. Instead of crude geometric shapes nick-nacking across the screen, Bluth and his team created full-on, Disney-quality cartoon animation. All the variants' moves and all plots possible within the game were stored on a Pioneer LDV1000 laserdisc. The sumptuous graphics were something never seen before in a game. And a secondary attraction of the game was the visceral enjoyment of seeing cutesy Disney-type figures being blasted, chopped up, and fried when they failed. Even the beautiful princesses in the game were a bit sexier for a more hip, teen audience. *Dragon's Lair* was the number-one game in America for a time. It was the only video game that attracted an audience when being played. *Dragon's Lair* cost fifty cents for three plays, so a lot of people did not play it as much as they watched others play. Yet it was so successful that many consoles would break from the wear of being played too much.

But by the fall of 1982 the video game market reached saturation point. The general public tired of the glut of lookalike games that all blipped and beeped. There were too many, and because of the hot rivalry among electronics giants and prevalence of cheap, bootleg knock-offs, most games systems were not compatible with one another. And they tied up the family TV set, to the frustration of parents. Kids turned back to noncomputerized action figures like He-Man, G.I. Joe, Jem, and Rainbow Bright. They were simple figurines that did not need an instruction manual or a lot of electronic rewiring. You took He-Man, the good guy, and Skeletor, the bad guy, and you made up your own adventures.

RePlay magazine publisher Eddie Adlum recalled this time as the Great Video Games Collapse: "People stopped playing them, and operators stopped buying them. And that pall lasted for many, many years and nobody's been able to figure out why."[29] Truth be told, a sizable portion of the public still liked arcade games, but the rush of companies pushing inferior knock-offs created overnight caused a glut that ignited a major shakeout in the market. Even Steven Spielberg's licensing of the characters from his 1982 blockbuster movie *E.T.* for a game flopped. Atari spent most of its budget on securing the rights, then threw the game together so haphazardly that most critics agreed with the public that it was awful. The bottom fell out of the industry and everything crashed as rapidly as it had grown. Large game suppliers, overstocked with product and weighed down with debt, collapsed like houses of cards. Arcades closed and truckloads of unwanted videocassettes were buried in landfills. Atari alone lost half a billion dollars that year. Warner Communications stock dropped 33 percent in a single day because of Atari. Ray Kassar, the Warner exec who replaced Nolan Bushnell, reacted to the news that Atari was $356 million in debt by dumping all his stock before being forced to resign on December 7, 1982. A week later he was under investigation for insider trading (charges that were settled out of court). Electronics firms that had hired up to fifteen hundred employees at once to create games laid them all off just as fast. Employees held pink-slip parties at their favorite watering holes to cry in their lite beer.

But while smaller companies went under, American giants like Motorola and RCA simply turned to other pursuits. After his electronics partners went bankrupt, Don Bluth returned to making animated theatrical films. Gulf and Western unloaded SEGA. Coleco saved itself by selling Cabbage Patch Kids dolls. Warner Communications sold Atari to Commodore Computers founder Jack Trammel. When Trammell began slashing the top-heavy staff of Atari ("Jack dislikes large corporate structures"), execs streamed out the back entrance with their personal computers in hand like rodents fleeing a sinking ship. Just a few weeks before, Atari had announced its slogan for the 1984 Computer Electronics Show: "June 3, 1983: The Day the Future Began." Now the workers grimly joked about making a commemorative t-shirt reading, "July 3, 1984: The Day the Future Ended."[30]

But the Japanese companies weren't willing to concede defeat. The dynamic Japanese economy of the 1980s, their conservative investment strategy, and their growing domination of the electronics field enabled them to survive the burst of the gaming bubble. After 1985 Japanese companies became the dominant force in video game manufacturing.

In 1985 Nintendo began a campaign to restart the comatose home game market in the United States. Instead of trying to resurrect the arcade console trade, they realized the future was in creating games for the growing home computer market and in

upping the quality of the game play and graphics. Howard Lincoln, the attorney and now CEO of Nintendo of America, summed it up: "We weren't convinced that video games had a long life. We knew that if the market was flooded again with poor-quality video games, it would blow up again overnight."[31] Nintendo began by creating a more sophisticated eight- and sixteen-bit home console using raster graphics. They called it the Family Computer or Famicom in Japan but released around the world as the Nintendo Entertainment System. It featured a multitude of new game cartridges, including the new *Super Mario Brothers* and *Mike Tyson's Punchout*. Shigeru Miyamoto, who created *Donkey Kong*, added a complete one-person role-playing game titled *The Legend of Zelda*. He made up his own fairy tale about rescuing a princess and defeating a monster named Ganon. Drawing on his love of spelunking, he designed intricate caves and deep forests to explore. These systems sold millions. By 1990, in the minds of the public the name Nintendo was synonymous with video games. But such success attracted new competitors. SEGA marketed its own rival console system. After going through several big conglomerate mergers—with Gulf and Western in 1967 and Esco Trading in 1979—SEGA was bought by the Japanese conglomerate CSK in 1986. Isao Okawa, a friend of SEGA founder David Rosen, became its CEO.

SEGA had declared itself the alternative to Nintendo. The Ninten-Don't. In 1986 it marketed a console called first Master-System, then the following year the MegaDrive, then Genesis. Genesis featured SEGA's signature character *Sonic the Hedgehog* (1991). Atari bounced back with its 7800 game console. SEGA tried a relationship with electronics giant Sony, but when that arrangement soured, Sony decided to get into the market itself with the Sony PlayStation. Microsoft opened a console games division and introduced the Xbox. The 1990s became known to gamers as the era of the console wars. SEGA wrested control of the U.S. market from Nintendo in 1992, then Nintendo took it back again in 1994. Parents' groups again raged about wasted youth corrupted by games, and congressmen threatened hearings. All to no avail.

In 1984, in Soviet Russia, Alexey Pajitnov, a twenty-nine-year-old mathematician working at the computer center at Moscow's Academy of Sciences, invented his own video game on an Electronica 60, the Russian equivalent of a PDP-11 computer. It was a simple puzzle game with geometric blocks that fall slowly and have to be quickly sorted into proper order before more fall. He called it *Tetris* after the Greek number tetra and tennis, Pajitnov's favorite sport. After the game spread throughout the Iron Curtain countries, in 1986 a British company named Andromeda discovered it being played at a Budapest electronics show and brought it to the West. It caught on almost immediately. Its graphic nature gave it international appeal. Adults came to love *Tetris* more than kids, and it could be played in almost any format. Since 2005, 100 million copies have been sold for cell phones alone. One American enthusiast wrote, "I forgive them [the Soviets] the whole Cold War thing, because they gave us *Tetris*."[32]

There was a scramble over the copyright for *Tetris*. This usually happened when Soviet bureaucrats tried to cut deals with the bourgeois capitalists of the West. After a dozen companies tried and failed to lock the rights down, Nintendo emerged the sole victor. And unlike Dr. Erno Rubik of Rubik's Cube fame, Alexey Pajitnov actually saw some money from his creation. In 1996, he regained his rights from the Russian government and started his own company, Tetris, Inc.

In 1989 Nintendo chief scientist Gunpei Yokoi revisited Milton Bradley's 1979 idea of a portable handheld game. Yokoi described himself as "a cartoonist who understood movements in the world and created abstractions from them."[33] He created an efficient, lightweight, stereo sound game player with a liquid crystal display that was the size of a pocket calculator. Gunpei saw that it was impractical to try to create a tiny joystick control, so he designed a cross-shaped directional fingerpad that could move things in four directions. He made the individual game cartridges the size of a book of matches. He called it the Game Boy. And in an inspired maneuver, Minoru Arakawa decided to load *Tetris* on them. The Game Boy idea took off and helped make *Tetris* into one of the most played games of all time. On commuter trains and omnibuses from Beijing to Buenos Aires you used to see rush-hour commuters doing newspaper crossword puzzles. Now you saw many of them playing games.

In 1990 *Donkey Kong* creator Miyamoto urged Nintendo to accept the idea of his friend Satohsi Taijiri for a game called *Pokémon*. As a child Taijiri liked catching insects and tadpoles. He created a role-playing competition with simple designs. A player needed to catch 151 different characters to become a *Pokémon* master. Nintendo launched *Pokémon* on Game Boys on February 27, 1996, and followed it up with manga comic books, collector cards, an animated TV series, and feature films. Soon after *Pokémon*, similar crazes, like *Digimon* and *Yu-Gi-Oh,* hit the stores. They were a huge hit domestically, but what they did outside Japan and especially in the United States was nothing short of remarkable.

For many decades, conventional wisdom on Madison Avenue was that the more-ethnocentric characters of Japanese manga/anime pop culture were too exotic to ever interest the average American. In the 1960s Japanese TV imports like *Astro Boy* were banished to the remotest time slots, like a Sunday morning opposite *Sermonette* and high school basketball. A video store may have had one Kurosawa movie in its foreign section. But in the 1990s the growing hip-hop, pluralistic culture embraced Japanese cultural forms as an alternative to western iconography, creating an international street cyberpunk. Kung fu masters, samurai, and ninjas were no longer archaic historical artifacts, but cool modern conventions. Starting with Katsuhiro Otomo's cyberpunk classic film *Akira* (1988), Japanese anime features and TV shows began to build a loyal following in the United States. Stores now had whole sections of anime films, and bookstore shelves bulged with stacks of translations of the latest Bandai manga graphic novels. Mamoru Oshii, in his classic film *Ghost in the Shell* (1995) reinterpreted

the lone Ronin samurai as a futuristic android cop, who battled not a clan warlord but a living cyber-entity that existed in the Internet. The Game Boy came at just the right time to take advantage this cultural shift and became a mainstay of the cyber-punk/anime craze.

Pokémon was just the gentler, more child-friendly part of it. Warner Bros. eagerly bought all six *Pokémon* anime features for the U.S. market sight unseen. The first release in the United States, *Pokémon: The First Movie*, in December 1999 was for a short time the highest-grossing animated film opening of all time.

One other realm that Nintendo, SEGA, and American producers like Electronic Arts competed for was the role-playing game. Multiple-player strategy games had been around since the card game bridge. In the psychedelic sixties, there was a great interest in sword and fantasy literature. J. R. R. Tolkien's Lord of the Rings series and Lloyd Alexander's Chronicles of Prydain were very popular on college campuses. In 1974 two strategy board-game creators, Gary Gygax and David Arneson, designed the first great networking multiple-role-playing game, *Dungeons and Dragons*. Each player was assigned a character with certain powers to role-play, overseen by a dungeon master who acted like an umpire. At its peak, *Dungeons and Dragons* had 20 million fans around the world and made billions in related sales. Fans held conventions and dressed in costumes like the characters they represented. Many of the young engineers and programmers at MIT and Stanford's Artificial Intelligence Lab were *D&D* fans. But it was still basically a card game. How to create a networking experience on computers?

In 1981 two students from Cornell, Andrew Greenberg and Robert Woodhead, created a dungeon-crawl game titled *Wizardry*. They designed it for an Apple II. Nintendo game designers saw the idea at a games conference in San Francisco in 1983, and resolved to create something similar. They developed *Dragon Quest* in 1986. That same year an early networking game called *Habitat* was invented at Lucasfilm. Consoles offered two to four joysticks to competing players, but such multiple-player games needed the freedom of the Internet to achieve their full potential. After the Telecommunications Act of 1991 opened up the World Wide Web, role-playing games such as *Dragon Quest, Final Fantasy*, and *World of Warcraft* became popular.

In 1991, the first-person shooter game reentered the digital age with *Catacomb Abyss 3D*, in which you are a wizard, hurling plasma blasts at ghouls popping out from behind graves. It was followed by *Wolfenstein 3D* (1992), where you shot your way into a Nazi prison to free their victims. The soldiers you blasted to bloody bits were Nazi torturers, so for once, no conservative parents' groups seemed to mind.[34] In 1993 British designer Toby Gard, working at Core Design in the city of Derby, began to create a game featuring a beautiful, butt-kicking female hero in the mold of Hewlett and Martin's comic book *Tank Girl*. He called her first Laura Cruz, then changed it to Lara Croft and titled the game *Tomb Raider*. From a simple shooter game, Gard and the British interactive company Eidos expanded her backstory to make her an aristo-

cratic heiress who goes on Indiana Jones–style hunts for ancient treasure. Solving the puzzles in the plot was as important as racking up multiple kills. After the game was introduced on a PlayStation in 1996, Lara Croft became the most recognized figure in interactive gaming, with a series of *Tomb Raider* games, a loyal fan base, and successful movie spinoffs. As popular with women as with men, she was the first virtual "synthespian" to grace the cover of fashion magazines.

And so the Console Wars continued. From eight to sixteen to sixty-four bits in power. On September 29, 1996, the first Nintendo 64-bit game system debuted in the United States. It sold five hundred thousand units the first day, and eager purchasers had camped out at stores the night before. That year Nintendo's worldwide sales of game cartridges passed the 1 billion mark. In 2006 Shigeru Miyamoto's team at Nintendo launched the Wii, a seventh-generation console with a wireless control and hand-pointing device. It could also download new games directly from the Internet, without the need of cartridges, CDs or MP3 devices.

As the audience of millenials raised on electronic games, grew to maturity, the games grew with them in sophistication. Adult games like *Street Fighter*, *Grand Theft Auto*, *Mortal Kombat*, and *Medal of Honor* appeared. Vector graphics yielded to raster graphics and flat staging yielded to three-point, in-depth perspective. Audiences demanded more story to the games and more realistic movement, so cinematics began to be added to games.[35] Best-selling authors like Tom Clancy, Michael Crichton, and Douglas Adams wrote storylines. Veteran Hollywood movie directors Martin Scorcese and Spike Lee created cinematics. The budgets rose to the level of those allocated for major motion pictures, as did the salaries paid to artists and engineers.

In 2003 the total sales of video games surpassed the total box office of the movie industry for the first time. Major schools like the University of Southern California began to offer entire curricula for an undergraduate degree in interactive games studies. In 2011 the National Endowment for the Humanities declared interactive games to officially be an art form.

Another devastating collapse like the Great Video Game Crash of 1983 was now unlikely, because at that time video games were a novelty and computers were still scarce. Since then, entire generations have been raised online with interactive entertainment. There are now adults who never watched movies like *The Wizard of Oz* or *The Godfather* but can rattle off in detail the evolution of the characters in *Final Fantasy*.

In 2010 Nolan Bushnell was invited back to the board of directors of his original company, Atari. After decades spent building twenty companies, his dark hair was silver and his energy had slowed a bit. But what remained undiminished was his boundless enthusiasm for future of interactive games. "There's some shitty parts to running a business," he says. "But at the same time, creating stuff is neat."[36]

8 To Dream the Impossible Dream: The New York Institute of Technology, 1974–1986

We are creating a new art form from the ground up, but first we have to build the ground.
—Bil Maher, production designer, NYIT CGL team

Westbury, New York. Summer 1974. Take the Long Island Rail Road from Grand Central Station out to Nassau County, Long Island. Soon the heat, bustle, and congestion of the inner city yield to cool green lawns, dotted by white church steeples, woodlands echoing with cuckoos, and the fresh country air of the town of Old Westbury. Since the Gilded Age this suburb had been a bedroom community for the old money of New York City. The Whitneys, Du Ponts, Guggenheims, and Vanderbilts rubbed shoulders on weekends. Even President Teddy Roosevelt and his family were often seen riding by in their buggy on the way to Sagamore Hill. But for ten years, from 1976 to 1986, Westbury gained a new kind of notoriety. For it was the site of one of the most uniquely audacious experiments in the history of cinema. It is where the most advanced team of scientists and engineers in the world attempted to create a feature-length motion picture entirely by computer.

In its first century of development the art of animation was moved forward by larger-than-life personalities, messianic creators who directed small armies of artists to make ink and paint fantasies for the masses. Individuals such as Max Fleischer, Chuck Jones, and most importantly, Walt Disney. Occasionally the medium had been moved forward by outside entrepreneurs, people who had a desire to emulate "Uncle Walt" Disney. Everyone from Western novelist Zane Grey to celebrities like Julie Andrews, Paul McCartney, Tommy Smothers, Todd Rundgren, and Tom Hanks has at one time had a go at producing animated films.

In 1974 no mainstream animation studios had yet worked with computers seriously. Judson Rosebush was doing small projects on his own in the Syracuse, New York, area. The pioneering animation artists, like John Whitney and Stan VanDerBeek, had moved into academia. Computer development was still the realm of engineers and military/aerospace subcontractors. Every now and then at a film festival the last

film of the evening, started as most of the audience slipped out for a nightcap, would be some strange avant-garde short, like Peter Foldes's *Hunger/La faim.*

Then there was Dr. Schure.

Although Alexander Schure (pronounced *shore*) was a PhD who surrounded himself with other PhDs, most of them fell into the habit of calling him Dr. Schure. No one was ever quite sure how he came by his fortune. After New York City College and military service, he earned doctoral degrees in engineering and education from New York University. As a young man he won $10,000 on the NBC TV game show *Jeopardy.* His best topic was animation. Some said he grew his fortune from the sale and resale of surplus electronics from World War II. Another story is that his firm had something to do with the original land deal to build the Lincoln Center for the Performing Arts on the Upper West Side of Manhattan. He was friends with the powerful Rockefeller family and with Professor Alexander de Seversky, the Russian aviation theorist whose ideas Walt Disney featured in his 1943 film *Victory through Air Power.*

The diminutive businessman has been described in many ways by those whose lives he touched. Ebullient, eccentric, moody. Megalomaniacal to some, a romantic to others. "I'm not trying to be Walt Disney, but . . . ," he would say, or "Our goal is to speed up time, and eventually eliminate it."[1] He always seemed to be thinking faster than he spoke, producing a nonstop stream of words, sometimes using phrases only he seemed to understand. His employees called it Dr. Schure's Word Salad. "Alex Schure came into our room at all hours, and then without any opening small talk, his free-flowing stream of words would commence. You could never interrupt Alex, you had to try to spot an opening and merge into his stream to get your thought in. And after awhile, you heard your own words coming out of his mouth back at you, and you thought, oh well, I guess that idea transferred."[2] People might tease about his eccentricity, but no one doubted his sincerity.

One thing all agreed on was that he was a man who liked to dream big.

After the Korean War ended in 1953 Schure saw opportunities in helping returning veterans train for the burgeoning field of electronics. At 500 Pacific Street in downtown Brooklyn he started a correspondence school with just nine students. By 1958 he had bought the old Pythian Temple in Manhattan and moved his base there. In 1960 his school received its accreditation from the state as the New York Institute of Technology (NYIT). Some derisively labeled it a "second-rate diploma-mill." The school advertised in the back of comic books alongside ads for sea monkeys and amazing x-ray specs. The college's store sold auto parts next to the required textbooks. But Dr. Schure built up NYIT from a simple mail-order academy into a serious educational institution. Here was an electronics college that supplied you with the electronic equipment to work on. During the Vietnam War the school benefited from a clause in U.S. Selective Service regulations that exempted you from the military draft if you were in college. Kids who weren't exactly "college material" signed up at NYIT in

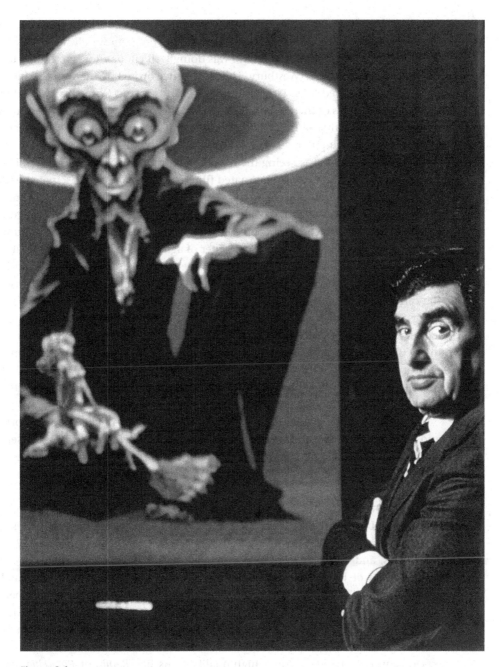

Figure 8.1
Dr. Alexander Schure of the New York Institute of Technology.
Courtesy of Leslie Iwerks.

droves, as well as veterans leaving the service and seeking to learn a trade.³ Schure took it upon himself to create a remedial academic program for all these students.

By 1963 Schure's Manhattan school was doing well enough for him to buy up four stately old manors in Old Westbury. They were once owned by titans of the Industrial Revolution like Alfred I. Du Pont, William C. Whitney, and Cornelius Vanderbilt. All seven hundred acres of these grounds he labeled the Westbury Campus.⁴ The buildings were ready for the first of thirty-five hundred students in 1965. That same year NYIT acquired its first computer.

In the early 1970s, after seeing the results of turning one of his math texts first into a comic book and then into an animated film, Dr. Schure became fascinated with the educational possibilities of cartoons. Believing that complex mathematical problems could be made understandable to all via the metaphor of simple graphics, he resolved to create new feature-length cartoons. Remember, at this time Walt Disney Studios in Burbank had become a moribund backwater of aging masters who churned out a film every few years between sets of golf. Walt Disney, Max Fleischer, Paul Terry, and Leon Schlesinger were long dead and gone. So there was certainly room for expansion in the cartoon mogul business.

Dr. Schure quickly rounded up a crew of 150 artists and chose his topic—a feature-length adaptation of "Tubby the Tuba." The story began as a popular children's recording by Paul Tripp in 1942. It had been animated once before, in 1947, by Hungarian puppet master George Pal, as part of his classic Puppetoons series. Dr. Schure secured the rights, got Paul Tripp himself to write the screenplay, and lined up celebrities like Pearl Bailey, Jack Gilford, and Dick Van Dyke to record the voice tracks.

At this time American cartoon animation was centered chiefly in New York City and Hollywood. Max and Dave Fleischer had ruined themselves trying to set up a studio in faraway Miami, Florida. The San Francisco Bay Area was better suited to be the setting for noir crime movies like the *Maltese Falcon* than a place to launch the next Bugs Bunny.

Wanting to do *Tubby the Tuba* on the East Coast instead of Hollywood, Dr. Schure ran into problems securing talent. The animation industry in New York City seemed run down by the 1970s. The old studios, like Max Fleischer, Paramount East (Popeye), Terrytoons, and UPA East were but distant memories. The famed independent film-making team of John and Faith Hubley deliberately kept their operation small for economy's sake. Then John died unexpectedly from a burst aorta during an operation in 1977. A recession after the Vietnam War had depleted the once-thriving Madison Avenue advertising scene, causing many cartoon studios dependent on commercial work to go bankrupt.

Dr. Schure dreamed of doing high-quality films like *Bambi* or *Pinocchio,* but the older, veteran talent that could accomplish that kind of quality work was in short supply. Many had already retired or else followed the work out to California. The old-

timers on both coasts had only lately begun to train a new generation in their heretofore neglected skills.[5] In addition, a rival film project being undertaken in Manhattan competed for artists. The electronics giant ITT created a studio for famed London animation director Richard Williams to animate a Broadway musical, *Raggedy Ann and Andy: A Musical Adventure.* ITT owned Bobbs-Merrill publishers, who owned the rights to the classic Johnny Gruelle rag doll stories. Joe Raposo, the award-winning composer of the *Sesame Street* theme, wrote the score. The opportunity to work for an Academy Award–winning director flanked by past animation masters like Art Babbitt, the creator of Goofy, and Jerry Chiniquy, the animator of Yosemite Sam, soon made *Tubby* seem the second-tier project.

Dr. Schure gathered what old Paramount and Terrytoon animators he could find. One of them was Wayne Boring, a legendary Superman comic book artist who created the Bizarro World.[6] Another was Al Brodax, who produced the Beatles' *Yellow Submarine* (1968). Schure combined this core group of senior artists with an eager phalanx of young beginners. In doing so he clashed frequently with Gerry Salvio, the gruff union representative of New York's Screen Cartoonists Local 841, IATSE. To crew up, Schure tried to skirt union seniority rules and overtime minimums. The cartoonists' union contract had a very strict time structure that called for a thirty-five hour work week, with time-and-a-half pay after seven hours. Schure also battled with his film's animation director, Sam Singer, who had created low-budget TV shows like *Bat Fink, Milton the Monster,* and *Courageous Cat and Minute Mouse.* After a few contentious months, Singer got fed up and quit. Schure decided to direct the film himself, backed up by a veteran animator named Milt Stein.

Filmmaker Michael Sporn, who graduated from NYIT in 1967 and worked on *Tubby,* recalled, "I had to go see Schure to quit, since he had just decided that he was directing the film that was in progress for about a year. I told him that I felt the project was in chaos and if there were an experienced director around to pull it out, the film might work. But I didn't trust it'd happen, so I had to leave. He told me that he would make a great movie and it'd be dumb for me to leave. I did."[7] Sporn became a department supervisor on the *Raggedy Ann* project and later opened his own animation studio.

Members of the Rockefeller family sat on the board of NYIT as well as on the board of the Salt Lake City–based Evans & Sutherland. At this time Evans & Sutherland was a premier supplier of mainframe graphics computers to government and industry. While pencils scratched and electronic sharpeners whirred making *Tubby the Tuba* come to life, a computer salesman from Evans & Sutherland got a chance to meet Schure. He showed him a demonstration reel that contained Ed Catmull's and Fred Parkes's digital animation for their thesis film, *A Computer Animated Hand* (1972).

Dr. Schure had a revelation. Computer animation! Here was a way to combine his two chief passions, art and electronics. For the first time, he clearly saw what his mission should be. NYIT would be the first computer animation studio. His ultimate

goal would be creating feature-length cartoons like *Tubby*, but using a computer. This was a little more than ten years since Ivan Sutherland drew the first line digitally and John Whitney did his spirals. At a time when the glowing blips on Luke Skywalker's target screen were seen as the best computers could do, the idea of animating an entire feature-length 3D cartoon with believable, lifelike characters was audacious, to say the least. It was the vision of an unapologetic dreamer.

Dr. Schure first consulted the Rockefellers about how he should begin. They advised him to go and talk to Evans & Sutherland. So Schure flew out to Utah.

When Dr. Schure arrived at Evans & Sutherland, he toured the premises, then turned to Ivan Sutherland and said, "I want one of everything you've got here!" When he was shown a frame buffer that would cost $80,000, he unhesitatingly reacted: "So give me one of those!" Dave Evans didn't think he was being serious.

Dr. Schure then asked Ivan Sutherland who could potentially run his proposed new lab. "Who is your most gifted student?" They replied that it was the newly graduated Ed Catmull. A Utah native, Catmull had always been inspired by Walt Disney's work. But realizing his drawing skills would never be on par with those of the fabled Disney cartoonists, he turned to his second passion, physics. In his 1974 doctoral thesis, which focused on texture-mapping and rendering curved surfaces, the soft-spoken twenty-nine year old had already broken new ground.[8] But after graduating, he fruitlessly looked around Salt Lake City for work. Finally he had to move his family to Boston after landing a job as a programmer in an unrelated electronics firm named Applicon. Dr. Schure immediately went to Boston to speak to him. Catmull had been desperate to apply his skills to making computer animation, so Schure's offer seemed to be an answer to all his prayers. During the conversation, when Catmull asked Schure what kind of equipment he had purchased from Evans & Sutherland, the good doctor shrugged. "I dunno, just one of everything."[9] Catmull's jaw dropped.

Catmull quickly accepted Schure's offer to move to New York, along with his fellow graduate Malcolm Blanchard. Once at NYIT, Catmull began the job of pulling a team together. Because he didn't want to jeopardize NYIT's academic tax standing by accepting commercial projects, Schure formed the computer group as a separate entity from the school and called it the Computer Graphics Lab (CGL).[10]

Meanwhile, on the West Coast, Alvy Ray Smith and David DiFrancesco sat trying to decide their next move. After Xerox suspended their computer research program at PARC, they needed to find where real computer graphics were being done. They piled their meager belongings into Smith's old Ford Grand Torino, which he jokingly called his Turino machine.[11] They headed first for Salt Lake City, because they had heard of the reputation of the University of Utah computer graphics program. But once there, it didn't really seem to offer anything for them. Martin Newell (he of the famous teapot) mentioned to them that an oddball millionaire from Long Island had just come through and bought up everything in sight. That the guy intended to start his

own digital movie studio.[12] So Smith and DiFrancesco spent the last of their savings on plane tickets to New York City. After they left, Newell phoned Catmull and said, "Hey Ed, I'm sending two hippies your way . . ."

Landing at New York's JFK airport in a winter snowstorm, Smith and DiFrancesco immediately borrowed a car from DiFrancesco's dad and slogged out to Old Westbury. Once they arrived, they were immediately ushered into Dr. Schure's mansion for dinner. While servants scurried about the huge, oak-vaulted dining room, a loud voice boomed, "Welcome, California!" Dr. Schure took to Smith and DiFrancesco immediately, even though to the wealthy New Yorker the two looked more like they should be in Woodstock than Westbury. It turned out that DiFrancesco had a distant family tie to Schure, so thereafter they referred to him as "Uncle Alex."

The sprawling grounds of the Westbury campus consisted of a collection of lush, baronial manors with fountains and intermittent marble Greek columns that the CG folk dubbed Great Gatsby Land. One house even boasted a bear pit in the back. Squawking peacocks wandered the grounds. A software engineer once had his dinner interrupted by billionaire David Rockefeller's private helicopter landing in his backyard.

The *Tubby the Tuba* animators living in Brooklyn or Queens had to get up at five in the morning just to catch the train to get to work on time.[13] Jim Blinn recalled, "There were no apartments or hotels in Old Westbury, because it was then chiefly a suburban bedroom community. The institute had to put people up in dorms on campus or at the nearby campus of C. W. Post [of Long Island University]."[14] Smith, DiFrancesco, and Garland Stern found themselves rooms in the luxuriously restored Wyndam House mansion. No one gave them permission to squat there, but Dr. Schure's holdings were so vast, no one seemed to notice. Catmull moved his growing family into a nice suburban home a few minutes away in the town of Glen Cove. All the computers were moved into a carriage house adjacent to a pink mansion called the Kerry House, with the computer geniuses working upstairs in what was once the chauffeur's quarters. Smith remarked, "We were born in a garage, but it was a six-car garage!"[15]

In his enthusiasm, Dr. Schure was so convinced that he was helping to give birth to a new art form that he began experimenting with the titles for the new job categories. Smith was poking around in a storage space when he came upon a draft production chart festooned with Schure's bizarre new job titles. Smith noted with glee that his own title was to be "Information Quanta."[16]

The conservative inhabitants of Old Westbury were not used to people like the exotic-looking computer types now in their midst. Memories then were still fresh with the depredations of Charles Manson, and Patty Hearst was still with the Symbionese Liberation Army. Student intern Jim Blinn (chapter 3) had a habit of going on long walks to think. Tall, with shoulder-length hair and a large beard, he cut quite a figure

Figure 8.2
NY Tech Computer Lab in "the Pink Building."
Courtesy of Mike Lehman.

wandering suburban streets where almost no one was ever seen walking. The Nassau County Police actually stopped him one night. They were about to arrest him, but as luck would have it, Dr. Schure happened to be driving by. He immediately vouched for Blinn to the skeptical peace officers.

CGL's initial effort would be to create a short titled *Clyde in the Cockpit*. The idea was later expanded to a feature-length film called *The Works*. The plot was about a robot, Clyde, and his girlfriend, T-Square, and was set in a future where computerized robots dominated the world. The word *robot* comes from the Czech word *roboti*, which means "worker," and the title *The Works* derived from that meaning.[17] CGL also started a separate division to do commercials in CG, and Dr. Schure hoped to eventually produce cartoons for the lucrative Saturday morning TV market. And since they were guests of a school after all, Catmull and Smith would also teach some classes in computer graphics.

As CGL's projects progressed, the problems inherent in this new way of making film began to manifest themselves. Dr. Schure constantly upgraded their computers. NYIT equipped Kerry House with the most powerful hardware and software then avail-

able. The equipment came from Evans & Sutherland and the Digital Equipment Corporation (DEC), including the very first commercial VAX, a "minicomputer" that was the size of a massive double freezer.

Ironically, the VAX was almost destroyed before its installation. DEC's delivery truck and an NYIT truck were parked back-to-back outside of the Kerry House. The $250,000 VAX computer was about to be pushed from Digital's truck into NYIT's when the driverless NYIT truck started to slowly roll away. Smith leaped into the NYIT truck and stomped on the brake pedal just in time to save the delicate machinery of the VAX from smashing on the ground.

Whenever someone requested something like an additional buffer, Dr. Schure would buy three extra. Catmull recalled, "Alex only ordered one frame buffer the first time. Since it was 8 bit, it only had 256 colors. After we arrived, we convinced Alex that we needed full color, which was 8 bits for each color, or three frame buffers. But we would need two full-color frame buffers, which was six of their frame buffer products. So Alex bought five more to add to the one we had, at $50,000 . . . each."[18] It was great to have the money and the new equipment, but constantly changing noncompatible systems meant relearning each operation again and again, which slowed things down.

Because they were working without any experience of any kind of animation production structure, Catmull was given a free hand to create the work environment. At the time traditional filmmaking, including animation, was pretty regimented, with specified job categories. Catmull kept the NYIT studio structure loose, more like the research lab atmosphere he knew at the University of Utah. Smith seconded him, based on his experience back at Xerox PARC. And Dr. Schure himself set the tone, as engineer Garland Stern remembered: "Alex Schure was the total tech. He would go from desk to desk saying, 'You can do this?' or 'Why not do this?'"[19] They encouraged people to move around and help where they were needed, look over each other's shoulders, and creatively explore without waiting for direction from above. It was the advent of multitasking. Your job was whatever you thought was important, so long as you were filling in a piece of the computer animation puzzle.[20] Unlike traditional production line animators who went home at five, the scientists were accustomed to all-night computer time-sharing. So they thought it nothing to stay at their terminals into the wee hours. Having a family, Catmull kept regular hours, but he was the exception. Smith estimated that he regularly worked on a twenty-six-hour cycle.

Over the next three years the NYIT CGL team began to rack up an impressive list of achievements. They created systems and language to build the first 3D character models and the first RGB (red-green-blue) 24-bit computer graphics. In fact, they made the first RGB anything, because they had the first RGB frame buffers in the world. Smith built on what he had learned from working with Schoup at Xerox PARC and created the first scan and paint system, called Paint, later Big Paint. They created the first pixel dissolve and the first raster-graphic TV commercial. Lance Williams

developed mipmapping, an early form of texture mapping. Another artist created the first real-time digitization of a video signal.

Garland Stern had overheard Dr. Schure asking Ed Catmull whether he could create a way for traditional animation drawings to be digitized directly into the computer for inbetweening and painting. Catmull was busy with other matters, so Stern decided to solve this problem himself. He mounted a video scanner on a simple animation downshooter rig and, with Smith solving the tint-fill issue (gray shades), he invented the first 2D animation scanner. Now computer images did not have to be created inside the system. The whole world of hand-drawn animation of the past now had a way to interface with the digital future.

Another issue that needed attention was how to combine various pictorial elements into one image without transparency or confusion of visual planes, so characters wouldn't walk through one another or through walls. At that time each animating element was created on a separate level, which in computer talk was referred to as a channel. Smith created software to combine all the elements logically, calling it the Alpha Channel, from the Greek word for one.

Working from the pioneering efforts of Canadian software engineers Dr. Nestor Burtnyk and Dr. Marceli Wein, Catmull developed systems to automatically create the inbetween drawings between keyframe poses of the characters, called *Tweening,* and the first computer-controlled video editing.[21] Fred Parke continued the work he had done on facial animation at the University of Utah. With Bil Maher and Robert McDermott they created characters called User Friendly and Dot Matrix, a robot girl who did some of the first-ever CG lip-sync animation. Bil Maher recalled, "We used two techniques—for User Friendly the character was modeled with a blank space where the mouth would be, then I recorded his lines [while] lashed to an easel to keep my head still. The resulting video frames were cropped, then texture-mapped in place frame by frame. Naturally the sync was perfect and the effect was surprisingly good. For Dot Matrix we wanted to compare the mapping technique to real 3D animation, something Fred Parke had already been doing in early speech-modeling experiments."[22] Christie Barton created a way to connect all the lab's computers in a network, at the time a luxury used only in top-secret government systems. Said Smith, "Thanks to Christie, we rolled our own."[23] The growing departments—an audio group, video/ postproduction, and computer science—moved into different mansions. Smith later recalled that once he started to list all the technical achievements developed at NYIT, and his list ran for over four pages!

Up to this point digital animation was being attempted by avant-garde filmmakers and scientists with an amateur's grasp of the technique at best. They may have attended a lecture or picked up the Walter T. Foster workbook *Animation,* by Preston Blair, in an art-supply store.[24] But at CGL, for the first time, scientists had actual hands-on collaboration with classically trained professional animators. NYIT retained the services of

three veteran animators: John Gentilella, Earl James, and Dante Barbetta. They became working consultants to the CGL. These men had spent twenty or more years in the New York studios, creating characters like Baby Huey and Heckle and Jekyll. When Catmull hit a snag figuring out his Tweening program, a professional assistant animator named Jamie Davis sat down with him over lunch, took a pencil, and drew the inbetween in question, adding timing, drag, and pull. He explained that an inbetween is not just putting lines between lines but positioning logical shapes between shapes.

The breakthroughs achieved at this out-of-the-way Long Island campus would influence the art of animation for decades to come. Smith recalled, "It was the first time where people were seeing real characters, not polygons. And it was like, wow, we finally got it."[25] As they presented their breakthroughs at the annual SIGGRAPH conferences, NYIT quickly became the talk of the nascent CG world.

One day Dr. Schure played host to veteran animation director Shamus Culhane. Culhane began his career in silent film and later drew animation for classic films like *Snow White and the Seven Dwarves* (1937), *Gulliver's Travels* (1939), and *Pinocchio* (1940). After forming his own studio in New York City, Culhane had been one of the first to see the potential in the new medium of television. He created the first animated TV commercials, for Muriel Cigars, in 1948. Now, touring the NYIT/CGL facility, Culhane was amazed by what he saw. "I watched Paul Xander create a background," he said. "First he presses a button and on his computer a line of brushes appear from one inch thick down to a hairline. After he selects his brush size, Xander dips his brush into a row of colors on the bottom of the screen, and starts to paint a background. After finishing a desert scene, Xander shows me how he could change it from a day to night shot by the touch of a button."[22] Xander was a traditional cartoon painter, doing a lot of TV animation, like the Filmation cartoon version of *Star Trek*. Now he would become one of the first traditional animators to retrain as a digital artist.

The seventy-five-year-old Culhane concluded, "I was a link with the primitive past, before sound, color or tape. I had been permitted to live long enough to see and use the greatest tools for artists that were ever invented. I am convinced computer animation will produce beautiful works of art—beautiful beyond our most fantastic dreams."[26] Another time claymation artist Art Clokey came to NYIT and experimented with a CG model of his most famous creation, Gumby, running from a huge CG hand modeled from Catmull's wife's hand.

Yet despite the input of some of the cartoon animators, the relationship between the scientists and the traditional artists at NYIT was strained. Especially when Schure proudly announced to the artists that the computer guys were inventing stuff that would soon put them all out of work forever! Catmull recalled, "They [the traditional animators] wanted us to fail. When we said we could help them with their Tubby the Tuba film, they sent us designs of the main character and said, 'Here, make Tubby dance.' Then they called after only one day and complained, 'What? Aren't you done

yet?'" Truth be told, even the best pencil-and-paper animator could not accomplish that type of task so quickly. The collection of long-haired professors with PhDs in computer science and mathematics had little in common with the traditional animators. Most animation artists at that time, after completing a rudimentary BFA, learned much of their craft by apprenticing to master animators on the job. That was their version of graduate school. Staying in school for more degrees seemed like a waste of time. Walt Disney and Ralph Bakshi didn't need PhDs. After work animators drank, watched cartoons, and collected comic books, while most computer graphics engineers relaxed by drinking, publishing research papers, reading Buckminster Fuller, and, uh, collecting comic books, too.

Still, the computer whizzes amused themselves as they became immersed in cartoon culture. "Every week we'd all pile into Alvy's car, because he knew the city well, and drive into Manhattan," Catmull recalled.[27] At the New School for Social Research in Greenwich Village, a young, black-bearded professor named Leonard Maltin hosted an evening class on the history of American animation. In the age before DVDs or downloads, it was the only chance to see classic Hollywood cartoons projected on the big screen in glorious 35 mm. Among the many animators in the audience were future Academy Award winners like John Canemaker and future Disney animators like Eric Goldberg; the future director of *The Simpsons*, David Silverman; and me, your author. Suddenly this group of wild-haired people, looking more like the cast of the musical *Godspell* than research scientists, would fill up a row in the theater and laugh and talk among themselves. Many years later I mentioned to Leonard Maltin just how many important people were in that New School auditorium to watch his cartoon show. He said, "Gee, now I wish I had brought a camera and taken a picture of that audience!"

The beginning of the end of NYIT CGL's dream came one evening in 1977. At a large screening room in Black Rock, the CBS headquarters building in midtown Manhattan, Schure premiered his completed traditionally animated feature *Tubby the Tuba*. It was so awful that many, like Alvy Ray Smith and Ralph Guggenheim, covered their eyes. Ed Catmull recalled, "I kept looking, I can't close my eyes while experiencing a train wreck in progress."[28] Some fell asleep. One young animator cried out, "I've just wasted two years of my life!" *Tubby the Tuba* was never able to earn a release with a major film distributor, and it was quickly buried. Uncle Alex could do many things, but obviously directing a film was not one of them.

Now, there's an old saying in the cartoon business, "Animation can do anything, except save a bad idea."[29] The computer nerds, so focused on getting the technology of animation right, now came to the realization that no amount of technical wizardry could make up for a lack of storytelling. Ted Baehr observed, "I don't think anybody [in the computer lab] was thinking in terms of plot. . . . In the beginning it was just, we want to make a movie."

Soon *The Works* became mired in the same kind of story problems that beset *Tubby the Tuba*. Everyone started to feel like the unit was just spinning its wheels. Garland Stern remembered, "We had artists and scientists, but one thing we didn't have was an experienced motion picture production manager who could tell us what we were doing wrong. The problem with the research facility model was no one was sitting on you to finish your work. The attitude of the studio was to leave the scientists alone and they'll have something when they are ready. No one ever finished a film like that."[30]

After the *Tubby the Tuba* disaster, Catmull and Smith sullenly sat down together and tried to work out just how big an undertaking they were on in making this CG feature. "Ed and I did our back-of-the-envelope calculations, and realized it couldn't be done," Smith said.[31] Even though they were wowing the greater computer community, nothing on the feature seemed to be getting done. Catmull recalled, "It was clear to us early on that Alex had no idea how to make a film and was not interested in finding out how to make one. This presented a dilemma for us—how do we support the person who is making the investment, and how do we succeed at making films? Normally this would not be a dilemma, but with Alex, it was." At the same time they were reading about guys like John Whitney Jr. and Gary Demos at Triple-I making great new advances in digital imaging. Catmull and Smith wondered if their fate was to be diddling with this futile project for the rest of their days, like some kind of Flying Dutchmen of digital.

The traditional animation crew was let go, and the CGL soldiered on. Schure went out into the market and brought in smaller, money-making projects to do. These included the first computerized TV commercial spots, sports promos, and logo titles for CBS, the PBS show *NOVA*, Volkswagen, and *Live from Lincoln Center*. CG Animator Rex Grignon recalled, "The opening titles for *ABC Monday Night Football* featured two football players who slam into one another. I think that was some of the first CG character animation ever seen on TV."[32] More young animators, like Glen McQueen, Glen Entis, and Grignon joined the CGL ranks. The difference being that these animators were not traditionally trained but had come to Westbury with the sole intention of doing CG.

They were also joined by the Hugo Award–winning artist and filmmaker Ed Emshwiller. "His [Emshwiller's] proposal to us, that he use his new Guggenheim grant, to make a 3-hour computer graphics movie, sent us into gales of laughter, much to his consternation (after all, he was trying to talk his way into our facility)," Smith said. "We explained that he would be lucky, in his 6-month timeframe, to make a 3-minute film, considering the state of the technology."[33] At NYIT Emshwiller created an exciting conceptual short film titled *Sunstone* (1979). An enigmatic face on the sun goes through various abstract phases while beautiful color images swirl on an open cube design. The striking images were completed in collaboration with Smith, Lance Williams, and Stern.

Figure 8.3
Alvy Ray Smith and Ed Emschwiller working on Sunstone at NYIT. The ghost image was created when someone kicked the camera tripod.
Courtesy of Alvy Ray Smith.

But while everyone in the lab was busy, behind the scenes Catmull and Smith were now irrevocable committed to "working on their tunnel"—that is, trying to find a way out. Catmull told Dr. Schure that he would be vacationing in Florida, and Smith told him he planned to relax in San Francisco. Instead, Catmull and Smith rendezvoused in Burbank, California, to pitch their CG concepts to the only deep-pocketed movie studio they knew that might listen, Walt Disney. But while Walt Disney himself was a great believer in innovation, he was long gone. The administrators now in his place were uninterested in spending millions for something that might promise something unique but only many years down the road.

And then came *Star Wars*.

By 1979 George Lucas had made kazillions of dollars in profits from his blockbuster film *Star Wars* (1977). He used the money to build his own dream VFX unit, called Industrial Light & Magic (ILM).[34] He moved his base of operations out of Hollywood, up to an industrial suburb just north of the Golden Gate Bridge called San Rafael. *Star Wars* had been done with traditional motion picture visual effects and a little CG done by Larry Cuba. Some of the more complex effects scenes took months to create. George Lucas, like his friend Francis Ford Coppola, was a big believer in new technologies.

He wanted to use computers to streamline the production process and create the film-making of the future.

An invitation came to Alvy Ray Smith to attend a three-day new media conference at Coppola's San Francisco house.[35] Lucas would be present as well. Coverage of the event in *Variety* and the *New York Times* quoted Coppola predicting the unimaginable idea that computers would completely revolutionize filmmaking. Film itself would one day be a thing of the past. After three days of drinking Napa Valley wine, smoking Humboldt County pot, and talking intense tech talk, the "Interface Conference" was declared a success. Smith flew back to Long Island. The Westbury campus inmates shuffled quietly across moonlit snow to gather in the pink garage office to hear his report. Smith told them that the Coppola-Lucas bunch on the West Coast had the money and the mojo with the major studios, and most importantly, they seemed to be people who finally shared their vision: to make digital filmmaking a reality.

The CGL computer team was sorely tempted, but they didn't seriously think Lucas would ever ask them to join him. They also felt conflicted about the idea of abandoning Schure, who, after all, had done so much for their cause. But it soon turned out that Lucas was very much interested in them. He had been sending out people to troll the field and gather the best computer engineers for his planned Lucasfilm Graphics Group. One of these scouts for Lucas, a real estate purchasing agent named Bob Gindy, had heard from the University of Utah people about one of the Westbury gnomes named Ralph Guggenheim. Gindy cold-called him at his desk and asked if he would be interested in setting up ILM's computer lab. Guggenheim stammered that he did not feel he was qualified for such a task, but he knew of those who were. After he hung up the phone, Guggenheim ran into Catmull and Smith's office and announced, "Hey, guys, guess who I just got a call from? GEORGE LUCAS wants me to set up a research group . . ." Catmull and Smith practically leaped out of their chairs: "Sshh!! Shut the door!"[36]

Their fear of being overheard was well founded. As the fortunes of NYIT and CGL faltered, Schure became increasingly paranoid about his holdings. He had been reading in the trade magazines that the dynamic Japanese electronics giants Sony and Matsushita (Panasonic) were moving into computer graphics. This made Schure fear that someone might try to co-opt his lab's breakthroughs for their own use and take all the credit. He assigned one of the lab insiders to regularly monitor the letters, phone calls, and e-mail[37] of his top CGL personnel.

Jim Clark, another University of Utah alumnus, had been hired by Catmull to work on virtual reality projects. "Jim and Alex Schure were like two bulls," Smith recalled. "You could see right away it wouldn't end well."[38] Sure enough, one day Dr. Schure burst into the graphics lab waving aloft printed transcripts of several e-mails from Clark, scouting a potential teaching position at Berkeley. Schure pushed them in Clark's face, and after a loud, ugly confrontation, Clark stormed off, with Schure yelling that he was fired. The incident severely rattled the morale of the lab.

In this tense atmosphere, Catmull and Smith didn't want to give Dr. Schure any more reasons to blow his top. Any further communication with the Lucas people would have to be done in secret. Smith jokingly called it their own little *Escape from New York*, referring to the John Carpenter movie of the same name. Sometimes the only time they could talk freely out loud on the NYIT campus was when playing racketball. So "playing racketball" became their code for talking about going to Lucas. After the Clark debacle, they didn't write any e-mails that could be intercepted and read. When they needed to write a letter of introduction to Lucasfilm, Catmull went to a neighborhood junk shop and bought an old, used manual typewriter. Tap-tap-tap . . . "Dear Mister George Lucas. . . ." Tap, tap, zzzipp, ding!

A week after he read Catmull's letter, Lucas sent one of his top ILM people, Richard Edlund, to interview the wizards of Westbury and inspect their facility.[39] Catmull hoped to keep this visit a secret, despite Edlund showing up at the door sporting a large, silver, Western-style belt buckle with the name LUCASFILM written on it in big letters. Later Catmull himself flew to San Rafael and met with Lucas on the set of *The Empire Strikes Back*.

Upon returning to Westbury, Catmull and his crew discussed how best to extricate themselves from NYIT and get to ILM with a minimum of fuss. If Dr. Schure saw Catmull simply detach half the research staff and take them to California, he wouldn't just be hurt, he might very well sue them. So they planned to leave piecemeal and scatter, to reconvene within a year. Smith and DiFrancesco said, "We were laundering ourselves."[40]

Catmull gave his notice first and relocated his family to California in summer 1979. Smith and DiFrancesco put in their resignations shortly after and went to join their friend Jim Blinn at the Jet Propulsion Lab in Pasadena. There they helped him create the *Voyager* flyby films and the Carl Sagan miniseries *Cosmos*.

Schure's tech team at NYIT was seen as the rock stars of the infant medium. So their jumping ship was big news throughout the business. "Catmull's leaving for Lucas caused a great disturbance in the Force," Pixar cofounder Loren Carpenter joked.[41]

The depleted NYIT lab endeavored to soldier on, despite losing their core group of scientists. Dr. Schure's son, Louis, a former tennis pro, took the reins as CGL director, and Lance Williams completely rewrote the script for *The Works*. A talented artist named Bil Maher from Detroit was brought in to revamp the storyboards with future Disney director Francis Glebas, then an NYIT graduate. Rebecca Allen came over from MIT. She recalled, "The real hardcore 3D began after Ed and Alvy left. Dr. Schure shifted the emphasis from supporting 2D to purely 3D animation."[42] The unfinished reel of *The Works* caused a sensation at the 1982 and 1984 SIGGRAPH conventions. Clyde the robot, in the cockpit of an enormous mechanical ant, marched his six-legged contraption to a construction site and lifted huge sections of girders to be welded in place by a hopping robot. But despite all the good word of mouth generated, *The Works* was fated to never be completed.

Figure 8.4
Production designs for *The Works* by Bil Maher.
Courtesy of Rebecca Allen.

CGL continued to tour around celebrities like Terry Gilliam and Henry Kissinger. TV commercials and show titles continued to trickle in. Allen won an Emmy Award for the opening titles of the CBS show *Walter Cronkite's Universe*, the first ever for a CG film. But big opportunities were also lost. In 1982, when Dr. Schure stepped down as president of NYIT, the Walt Disney Studios was farming out lots of computer graphics work to complete its film project *Tron* (chapter 9). It was being touted the first CG feature, even though some of the work was still done traditionally. To complete this project, the normally insular Disney studio had reached out to distant New York to utilize the local computer houses MAGI/Synthavision and Judson Rosebush's Digital Effects. But alas, not NYIT. "NYIT was one of the only computer houses that didn't work on *Tron*," Lance Williams recalled, "because Alex and Disney couldn't arrive at a deal."[43]

Bil Maher and a few of the team recut some of *The Works* footage with other elements and created a short entitled *3DV*, an acronym for DynaDigiDatavac. It was conceived as a teaser-trailer for an imaginary all-CG network of the future. Its six minutes were packed with many of the techniques CGL pioneered. They had hoped to sell it to some of the nascent cable networks, like HBO and Z Channel. It caused another sensation when shown at SIGGRAPH 1984, but it failed to reel in a cable network client. "Having witnessed many visitors watching previous demos, I came to realize that the style was so new that viewers really weren't sure what they were looking at—it obviously wasn't drawings but it wasn't stop-motion either," Maher said.[44] Something similar to their character User Friendly popped up in 1985 as the character Max Headroom.[45] Although Max Headroom looked like a computer graphic, it actually was actor Matt Frewer in heavy latex makeup filmed with digitally edited skips and distortions to give the appearance of CG. The character appeared in some MTV intros and some commercials for New Coke before starring in a cult British TV action show. And yes, it ran on a cable channel (Cinemax). But that was cold comfort to the folks back at NYIT.

Focus at the CGL now shifted to one last hope. Al Brodax, one of the original producers of the Beatles animated feature *Yellow Submarine* (1968), had closed a deal with two companies, Vestron and ICT, who claimed to have secured the rights to the Beatles' song catalog. They meant to produce a new animated film based on Beatles music titled *Strawberry Fields*. Work would be done in LA and New York. Once again, this project was touted as the first true computer-animated feature film. But then it emerged that ICT had not secured the rights to the Beatles' songbook (pop star Michael Jackson had). So the project never got further than some development art.

Maher recalled, "By '83, I felt we just weren't getting anywhere. . . . I soon realized the feature was a carrot to bring in more top scientists. For the scientists it was okay, because they had no real desire to complete anything. They just enjoyed the research and development."[46] Just like Catmull and Smith had done five years earlier, researcher Ned Greene did some calculations and projected that, using the technology they then had, their feature film would take seven years just to render! "We really didn't want

Figure 8.5
Dot Matix and *UserFriendly*. Some of the earliest lipsync attempted by a CG character.
Courtesy of Rebecca Allen.

to know it couldn't be done," Maher recalled. By 1987 the *Strawberry Fields* project too was shelved.

After the loss of Catmull, Smith, and their teammates, Schure became convinced that his lab's hard-earned breakthroughs would leak out for others to exploit. "When Schure learned Mark Lavoy at Cornell was being funded by Hanna-Barbera to develop an ink and paint system for cartoons similar to New York Tech's, Schure went all-out on a spree of patent applications," Garland Stern said.[47] Schure attempted to take out patents on CG keyframe real-time animation. In this way he was emulating animator John Randolph Bray, who in 1913 patented traditional animation techniques like key drawings, inbetweens, and arcs. Bray had designed the first animation production pipeline, and he made everyone, even Walt Disney, pay for the rights to use it, until his death in 1977 at age 107. Had Schure applied for his patents in the mid-1970s, he would have owned computer animation and would have become been rich beyond measure. But delaying such a move until the 1980s proved problematic. After one year it can become impossible to apply for a patent. In addition, many of the innovations created by the wizards of NYIT had already been presented publicly in papers and demonstrations at computer events like SIGGRAPH, making enforcement of a patent unlikely. By 1986 Microsoft teamed up with CG companies Pixar and Digital Effects to defeat all of Schure's efforts to secure patents in court. The secrets of CG were destined not to be the exclusive property of one man.

NYIT did succeed in retailing out its animation system in a package called BBOP, created by Garland Stern. One of the first purchasers was the German company TDI (Thompson Digital Imagery). The young animators Ken Wesley and Rex Grignon followed the system to Frankfurt. Another major buyer was John Pennie of the Canadian company Omnibus. Omnibus would become a major player in the CG scene of the 1980s.

The CGL staff kept drifting away from Westbury for other, bigger projects. Rebecca Allen went off on her own and produced breakthrough rock videos for musicians like Peter Gabriel and Kraftwerk. In 1981, using BBOP, Allen created distinctive projected imagery for modern dance choreographer Twyla Tharp and David Byrne's *The Catherine Wheel*. Lance Williams left to join Wyndam Hardaway in Colorado, where he designed medical scan cyberware, then moved on to Apple. Bil Maher joined Nolan Bushnell, making computer arcade games for Sente. Jim Clark founded first the Silicon Graphics Company (SGI) and later Netscape. Ed Emshwiller left to be dean of the School of Film/Video at the California Institute of the Arts. Tom Duff left to join the Mark Williams Company in Chicago and then went to ILM/Pixar. Carter Burwell went on to become a successful composer for such films as *Blood Simple* (1984), *Raising Arizona* (1987), and *No Country for Old Men* (2007). The old Paramount animators Johnny Gentilella and Dante Barbetta retired.

Only Garland Stern remained. "My wife and I didn't want to move to California because it might fall into the sea, and besides, there were too many good new video-games in the student lounge. So I stayed. I guess I was the last to turn off the lights

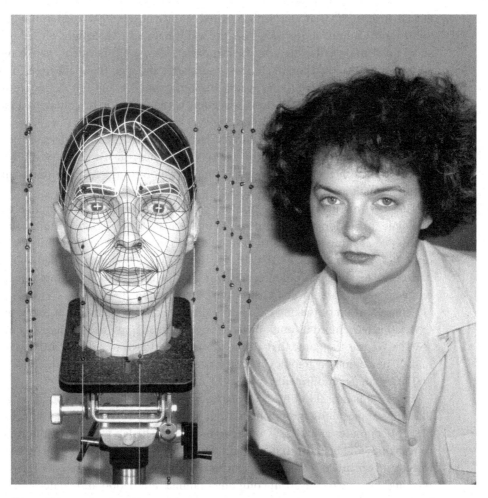

Figure 8.6
Rebecca Allen with a digitizing cast for a bandmember of Kraftwerk.
Courtesy of Rebecca Allen.

at CGL in 1991."[48] That year Schure retired. At SIGGRAPH 1991, held in the Bay Area, Smith and Catmull did a panel on the early days of CG. Schure didn't normally show up at these gatherings, but he came that year. Smith recalled, "While he never addressed us directly, I could tell he was still bitter about all that happened." But later, when they toured him around Pixar, Schure became his old self again. He hopped from workstation to workstation, engaging the engineers with comments like "You can do this . . . but couldn't you do this?"

In his final years Dr. Schure suffered terribly from Alzheimer's disease. He passed away on October 29, 2009, at the age of eighty-nine. In his obituary the *New York Times* erroneously reported that he had "produced one of the first computer-animated films, *Tubby the Tuba*."[49]

The New York Institute of Technology continues on and today is a highly respected academic institution, proud of its place in the history of CG. But Schure's audacious dream of a creating a full-length animated cartoon feature film would not be realized until 1995, when Pixar did it with *Toy Story*. Alvy Ray Smith recalled, "Of all the patrons we ever had, considering all the money he invested, Alex Schure was the only one who never really profited from the CG revolution."[50]

Schure's dream of making CG feature films was never realized, but today his NYIT CGL lab is recognized as one of the key figures in shaping the modern CG industry. "NYIT CGL was the flame that all the moths were drawn to," digital artist Matt Elson said. "The computer graphics industry would not exist in its current form without NYIT's original commitment."[51]

Lance Williams said of his NYIT experience, "George Lucas got computer graphics like a ripe apple falling into his hands, but Alex Schure truly inspired and nurtured the birth of computer graphics."[52] Fred Parke added, "The lab was one of the first places to recognize and benefit from the tight coupling of art and science. NYIT CGL was an eclectic mix of artists, computer scientists, animators and musicians, all of whom were pushing the state of the art in computer graphics, animation and related topics."[53]

Before NYIT, many computer scientists and engineers worked on creating digital graphics while being isolated from graphic artists. At the same time, graphic artists and filmmakers who experimented with computers did so isolated from the science community. NYIT proved the best results would occur when artists and scientists were put together to collaborate. Rebecca Allen said, "A fine artist's mentality suited that of the research scientist. A creative person produced ideas that would fit into the constraints of the technology [in order] to emulate . . . human motion."[54] While others were still improvising their CG systems, NYIT not only built some of the first off-the-shelf 3D animation tools, they conceived the first studio production pipeline for creating CG films.

Maybe that was Dr. Schure's greatest legacy.

9 Motion Picture Visual Effects and *Tron*

I think computer graphics will enter the film industry through the back door of special effects.
—Charles Gibson, vice president of Rhythm & Hues Studios

Fundamentally, visual effects is a crappy business.
—James Cameron

Paris, Saturday night, December 28, 1895. 14 Boulevard des Capucines.

Parisians scampered quickly through a raw winter rain, dodging the passing horse-drawn carriages and motorcars to gain refuge in the Grande Café des Capucines. They paid one franc, then descended the steps to a smoky basement room decorated in the current fashion as a *salon indien*. There they saw the first public demonstration of a new invention by two brothers from Lyon named Louis and Auguste Lumière. The brothers had improved on the American inventor Thomas Edison's kinetoscope by combining it with a magic lantern projector to create a true theatrical experience. They called it a *cinématographe*. Back in America, Edison was skeptical. He doubted people would sit still in a dark room for very long. But for one of the few times in his life, the Wizard of Menlo Park miscalculated. The audiences laughed and thrilled to the ten little films that made up the twenty-minute show. When the film of a train coming into a station came on the screen, people in the front rows leaped out of the way. Soon there were lines of eager customers waiting to see the moving-picture show. By the end of the year cinema shows were popping up like champignons across the City of Light.

Toward the rear of the theater on one of those inaugural nights stood a tall, well-dressed man with a closely cropped beard and elegantly waxed mustache. His name was Georges Méliès. He was the proprietor of the Theater Robert-Houdin and a professional magician whose tricks of prestidigitation had amazed many an audience.[1] Always on the lookout for new things to add to his act, Méliès had heard about this new mechanical marvel. Now, as he watched the images dance across the screen, his waxed mustache twitched. He immediately grasped the potential. The next day Méliès rushed over to the office of the Lumières' father, Antoine, to buy one of these

Cinématographe machines. He was surprised when the elder Lumière refused him: "Young man, you should thank me. This invention is not for sale, but if it were, it would ruin you. It can be exploited for awhile as a scientific curiosity; beyond that it has no real commercial value."[2]

Méliès was not deterred by this initial rebuff. Soon he had procured similar film-making equipment from a London inventor named R. W. Paul. By that April he was making his first films. Originally he intended to place them as one sequence in an evening's bill of magic tricks and spectacle. But soon his film work supplanted all other efforts to become his primary interest.

The essence of magic acts at that time was creating seemingly supernatural visual tricks using some mechanical aids to the sleight of hand. Méliès discovered that when you stopped the camera, made an actor step off the set, and then restarted the camera, the actor seemed to magically disappear. Accent the effect with the addition of a flash bomb and presto! Movie magic. Méliès adapted his magician's bag of tricks to the new medium. He invented the matte, in which several strips of film are combined, allowing you, for example, to put a full-size human next to a toy model city; the camera dissolve, where one scene fades into another or someone seems to fade away; and the jump cut, when the camera pops to another, unrelated, angle for dramatic or comedic effect.[3] His films, like the 1902 *Le voyage dans la lune* (A trip to the moon), became an early classics. Mermaids and moon monsters danced with pretty Folies Bergère chorus girls, then disappeared in hand-tinted puffs of smoke. Méliès himself occasionally jumped in the front of the camera to twirl his mustache and caper about.

After a very successful run, by the 1920s the audience had grown tired of Méliès's stale tricks and began to look elsewhere for more substantive films. Films with narrative. As the old Lumière père predicted, Méliès did eventually lose his fortune. By 1934 he was reduced to selling chocolates in a Paris railway kiosk owned by his wife. By the time of his death in 1938 he had almost been forgotten, but film history would come to honor him as the father of motion picture visual effects.[4]

In the years after Georges Méliès's first efforts, the seeds the magician planted sprang forth. Motion picture visual effects became a central ingredient of the magic of movies. Special effects brought dinosaurs back to life in *The Lost World* (1926), put King Kong on top of New York's Empire State Building (1933), put actors safely under an erupting Mt. Vesuvius in *The Last Days of Pompeii* (1935), made a tornado blow Dorothy's house up into the sky (*The Wizard of Oz*, 1939), and parted the Red Sea for Cecil B. DeMille— twice (*The Ten Commandments*, 1923, remade 1956).[5]

So, when did computers first come into this movie-making process?

While research into computer imaging slowly evolved in places like Stanford, MIT, IBM, and Bell Laboratories, the mainstream Hollywood film community ignored it. Throughout the 1960s and 1970s studio executives would occasionally have to humor

their stockholders by feigning interest in new media. They'd grant an audience to a nerdy engineer with obligatory pocket protector. Soon they would be rolling their eyes and leaving hints for their secretary to call them away for a fictional important phone call; anything to stop the techie from going on and on about the future potential of inverse kinematics, fractals, and wireframe removal. The low-resolution green florescent CRT monitors were too weak to even appear on a film; if used at all, they had to be matted in later. It all seemed too far off, too limited, too time consuming, and above all too expensive to be applicable to serious filmmaking.

Every year computer pioneers like Ivan Sutherland and John Whitney did the studio rounds, with the zeal of missionaries preaching the gospel of the coming era of digital filmmaking. Ed Catmull recalled, "When we spoke with film studios, our work was completely irrelevant to them. Even if they saw the pictures—which were somewhat crude, I admit—they couldn't project what computer animation might be. The concept of funding R&D never even entered their heads."[6] Computer scientists who worked for the government understood that research may not always lead where you originally intended, but the end results could be just as important. For instance, spending millions to design a computerized, self-propelled pogo stick may seem crazy to a layman, but it demonstrates the possibility for automated space probes with self-compensating gyros to maintain balance while navigating the irregular terrain of a planet like Mars. Pure research was great for defense and aerospace contractors, but the idea was arch-heresy to corporately owned Hollywood studios, obsessed about budgets and the bottom line.

Normally sound comes after light, but in film the first computer effects were heard long before they were seen, in MGM Pictures' forward-looking science fiction classic *Forbidden Planet* (1955). The score was created by Louis and Bebe Baron, a husband-and-wife team of conceptual artists who lived a beatnik lifestyle in a Greenwich Village loft choked with analog electronic equipment. Given a tape recorder for a wedding gift in 1951, the Barons experimented with making tonal effects. Their neighbor, composer John Cage, was the first to tell them that what they were doing, in effect, was making music. When MGM expressed interested in using their work as sound effects, they quickly expanded their role to create a complete soundtrack for the film, without using a single traditional musical instrument.[7] *Forbidden Planet* was a big hit, and critics singled out the soundtrack of unearthly beeps and clicks for high praise.

We noted in chapter two that John Whitney Sr. was hired by Saul Bass to use his techniques on the distinctive opening titles to Alfred Hitchcock's classic thriller *Vertigo* (1958). The swirling, graphic patterns emanating from the eyes of actress Kim Novak, set to Bernard Herman's haunting score. This can arguably be called the first CG in a movie, even though the device Whitney used was not a true digital computer as we would recognize one today. Around the time Whitney accepted the post as artist-in-residence at IBM, in 1963, he also started his own visual effects company, Motion

Graphics, Inc. He continued to make the rounds of the studios, hoping to drum up more commercial work.

In 1965 director Stanley Kubrick formed an effects team to plan how to make a widescreen science fiction project. He was working with author Arthur C. Clarke on the script and screenplay, and the new film was first going to be called *How the Solar System was Won*, then *Journey Beyond the Stars*, and finally *2001: A Space Odyssey*.

While *2001* was still in its conceptual stages, Whitney dropped in and gave them a presentation. He showed them his film *Catalog* and offered to do all the effects and music in the film by computer. It had been barely three years since Sutherland developed his Sketchpad, so this was an audacious claim. Whitney suggested that the alien Monolith found on the Moon could be done as a wireframe vector effect instead of a solid object. Kubrick, Douglas Trumbull, Tom Howard, Con Pederson, and Wally Veevers heard him out. "We were trying to figure out a way to get him [Whitney] to work on it, because he had worked on a show I did in New York," explained Pederson.[8] They were polite, but Kubrick just couldn't see it.[9] Whitney seemed to be really focused on electronic music tracks at the time. But Kubrick had other plans for that, too.

Later Trumbull started thinking about the principle of Whitney's slit-scan camera technique. He also recalled that there were some shots with side-lateral movement in an NFB documentary, *Universe*, that Kubrick liked. He jumped up and ran down the hall to Kubrick's office: "I think I know how we can do the Star Gate!" The famous finale when the astronaut is introduced to an alien civilization was made utilizing a variation of Whitney's slit-scan.[10] The Star Gate sequence made cinema history and is still admired for its beautiful ambiguity. Other than that, *2001: A Space Odyssey* (1968), this most forward-looking of science fiction movies, was done with very old-fashioned handmade effects, such as traveling mattes and students spattering stars on black backdrops with toothbrushes dipped in white paint. Kubrick even asked for techniques that had been used in silent film, tricks old Georges Méliès would recognize.[11]

The shot of the astronauts Dr. Bowman and Dr. Poole studying a computer schematic of the Discovery's malfunctioning antenna dish looked like a complex computer wireframe image. The truth was it really was made of wire. A sculptor created a miniature of the dish using wire, spray-painted it white, mounted it on a record turntable, and shot it high-contrast against a blue cloth. That footage was then optically printed into the computer screen with added video flicker to give the illusion it was a real, computer-generated data readout.[12]

While all this was going on, Arthur C. Clarke stood watching. After the script is done, screenwriters have little to do on a movie set other than wait for rewrites. To pass the time, Clarke made small talk with the craft-service boy. Clarke told him that someday all the power of this sophisticated computer technology he saw would fit onto a tiny chip the size of a fingernail. The boy couldn't fathom what Clarke was talking about.[13] *2001: A Space Odyssey* went on to become one of the most iconic films in history and inspired a generation of science fiction writers and filmmakers.

While 3D effects were still being incubated in research labs, a variation on 2D video distortion came in vogue. In 1969 Lee Harrison III, founder of a Denver company called Computer Image, created a system called Scanimate.[14] It still required artwork be done traditionally and photographed by a downshooter camera, which was common in traditional animation. Then, by turning various knobs on an analog computer, Scanimate warped and pulled the video images, giving the illusion of motion. One of the earliest patrons of the system was TV celebrity Tommy Smothers, who featured some Scanimate images in his *Smothers Brothers Comedy Hour* (1969). Probably the most well-known use of Scanimate was for *Willie Wonka and the Chocolate Factory* (1971). The brightly colored lettering floating in and out of the Oompa-Loompa songs—BRAT/CAT/SHAME/BLAME—contributed to the unique look of the film.

When the program was pre-wired Scanimate could do moving images in real time, and because it was attached to a videotape, it had the advantage of immediate playback. A client could come into the studio with an idea for a graphic, sit in a room while the animator worked (clients paid $1,500 an hour for a Scanimate session), and leave with the finished product.[15] In its heyday in the early 1970s, Scanimate systems were being used in Australia, Japan, London, and New York. Celebrities like Ringo

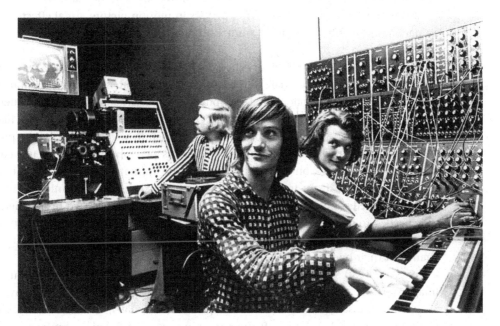

Figure 9.1
At Dolphin Productions in 1971. Andy Warhol's composer Gino Piserchio at a Moog Synthesizer cross-connected with one of the earliest scanimate systems, called an Animac. In the rear, running the system is Dennis Kolehmainen, one of the first Scanimate animators.
Courtesy of David Sieg. www.scanimate.com.

Starr and Todd Rundgren flew to Denver to invest in one of these electronic marvels. In 1972 Harrison was awarded an Emmy for his technical achievements.

In 1975, with the backing of Tommy Smothers, Harrison moved from Denver to try to establish a presence in Hollywood.[16] He set up a Scanimate service on Highland Boulevard and called it Image West. But it soon became apparent to the company's investors that these technical folk didn't know how to market themselves. Finally their bank forced them to sell Image West to their largest customer, a Canadian company called Omnibus. Cliff Browne, who had been working for Omnibus through his own design company in Toronto, was convinced to move down to LA and become Image West's CEO. Dave Sieg was chief engineer. Roy Weinstock moved out from Denver to animate. Harrison managed to retain control of his Computer Image Company in Denver. "This left Lee and the CI guys angry at them, because not only had they lost Image West, they lost their biggest customer [Omnibus]. So anything IW wanted from CI in the way of tech support or new upgrades was priced prohibitively," Sieg said.[17] The animosity increased as Image West's success began to take work way from Computer Image. The mid-1970s was a great time for Image West. They created a futuristic force-field effect in the film *Logan's Run* (1976) as well as a host of successful flying logos for television shows and commercials. By 1976 Image West was one of the most sought-after players in motion picture visual effects. It held a quarter of the entire computer animation market and accrued yearly assets of $10 million.

But Hollywood Boulevard is not called the Boulevard of Broken Dreams for nothing. After a few years the Scanimate system began to look dated. While the public marveled at the new personal digital computers, Scanimate was a big old behemoth covered with knobs, switches, and wires. One big flaw was that Scanimate had no memory to repeat a previous job. It had to be custom wired for each new project, sometimes using up to two hundred patch cords per job. If a client returned and wanted a simple tweak on an existing project, the animator would have to re-create the entire job over again from memory. Canadian partner John Pennie was increasingly concerned about the digital systems he saw coming. He warned his partners that they needed to rethink their loyalty to Scanimate. The solution to their faltering business might be a major retool. But Cliff Browne and the others were resistant to a sea change in their operation.

After the 1980 SIGGRAPH conference in Seattle, Pennie broke off Omnibus from Image West. In a parting shot, Pennie hired away Image West's chief tech guy, Dave Sieg, "maybe just to annoy Browne," Sieg related.[18] Finally, the bank foreclosed on Image West in 1982 and sold off the remaining assets to Pennie, who formed a new digital CG company in Toronto named Omnibus Video. He also kept a presence in LA on the Paramount lot. This new entity would utilize the new digital systems coming out of NYIT, like Ed Catmull's Tweening and Garland Stern's BBOP, and some of the

first SGI stations. With Image West gone, Scanimate was soon forgotten. The last commercial Scanimate work was done in 1986.

Many who entered the media industry in the 1970s first heard about computers at a place called MAGI (Mathematics Application Group, Inc.). Every time you opened a *Filmmaker's* Newsletter or Milimeter magazine, there was a full-page ad for MAGI.

MAGI was founded in 1966 by the "Three Wise Men," Phil Mittleman and two of his colleagues at the United Nuclear Corporation.[19] The company originally paid the bills by creating databases for direct mail services and some government spookwork. MAGI's small Synthavision division was founded in upstate New York in 1972 by Robert Goldstein and Bo Gehring. Using IBM 360 mainframes, MAGI/Synthavision was a pioneer in ray-tracing and outputting high-resolution computer graphics directly to film. Its Celco film recorder was the second model to be produced. Carl Ludwig and Dr. Eugene Troubetzkoy did much of the key research work. In 1977 MAGI created graphics for a sci-fi horror movie titled *Demon Seed,* about a sentient but kinky computer that planned to propagate with its inventor's unwilling wife. MAGI would go on to create digital imagery for *Tron* (1982), David Cronenburg's *The Fly* (1986), and a number of other projects.

Around 1970 a young man from Wooster, Ohio, named Judson Rosebush was completing his undergraduate work at Syracuse University. "I thought they had classes in radio production there, because I wanted to have a career in radio broadcasting. But they only had TV courses, so I got into them." He created public service radio spots and directed shorts for the U.S. Department of Education. But his restless mind became intrigued after witnessing a demonstration at Syracuse of graphics created by Don Weiner and Woody Anderson on an IBM 360. He soon wrote a program for Syracuse's Calcomp plotter. He began to do commercial radio work in the day to finance his passion for learning computer graphics at night. "I found I could write a program, and it would fail. Then I would write it again, and it would fail differently. But soon I was crafting images, and that suited me perfectly." Beginning in 1972 Rosebush created imagery on a computer to market to the small local metromedia stations in and around western New York. "In 1972 I traveled all around the country touring the places that were doing CG work: University of Utah, met [Bob] Abel, [Bill] Kovacs, [Ed] Catmull. Everyone was nice, but no one would give me work or accept me into a program."[20]

In 1978 Rosebush moved to New York City and started Digital Effects with partners Jeff Kleiser, Don Leich, David Cox, Jan Printz, Moses Weitzman, and Bob Hoffman. It was the first CG animation house in Manhattan itself. "We took a broom closet at 321 West Forty-Fourth Street in Midtown. A representative of the union [Motion Picture Screen Cartoonists, Local 841, IATSE] came in yelling and smashed some of our furniture. He was unsuccessful in organizing us."[21] Digital Effects created many early

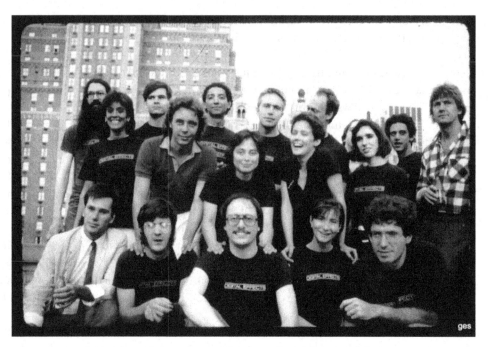

Figure 9.2
The staff of Digital Effects Inc. NYC, 1970s. Jeff Kleiser (gray jacket) and Judson Rosebush (sideburns) are to the lower left.
Courtesy of Judson Rosebush.

flying logo displays for television as well as spots for *Scientific American* and automated animation for the giant billboards of Times Square.

They started with a Tectronics 4013 computer and a dial-up modem connection to an Amdahl V6 in Bethesda, Maryland. Their machines refreshed one polygon per second, then had to be output onto nine-track magnetic tape, then sent to Los Angeles for film recording, then back to New York to be interlaced on high-contrast film and put in an optical printer, which was finally processed by Technicolor NY. "Total time to see a color image: one week, tops," said Jeff Kleiser.[22] In 1980 they bought a $300,000 Dicomed film recorder that had been sitting in a garage in Annapolis, Maryland. "It had been a gift from a rich Washington-type to his mistress, who had ambitions for a career in media," Judson recalled. "We sent a truck down for it after I agreed to assume the remaining payments on the machine. Considerably less than the $300,000 it originally came for. Jeff bought a used Mitchell full-color 24-bit camera with a magnetic tape drive on it. That alleviated some of our film-recording problems."

Meanwhile, back in Hollywood, MGM scored a hit in 1973 with a movie based on the Michael Crichton story *Westworld*, in which a futuristic theme park's android

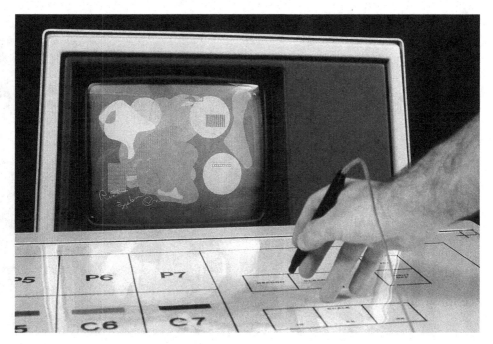

Figure 9.3
The hand of Judson Rosebush drawing on the Digital Effects Inc. Video Palette I, July 1979. The first Digital Effects Paint system used a separated monitor, tablet, and pen and predates the fusion of the mouse and on-screen menus in the Video Palette II.
Courtesy of Judson Rosebush.

workers go haywire and turn on their patrons. Crichton wanted shots showing how the computerized androids saw people. For this he went to a company called Information International Inc., or Triple-I.[23] Founder Ed Fredkin (1934–) had dropped out of Caltech to become a fighter pilot. In 1956 the air force assigned him to MIT, "where they promptly forgot I was there." His genius for computer design contributed the development of the workhorse mainframe computer the PDP-1. He founded Triple-I in 1962. In charge of his VFX division were two artists he picked up from John Whitney's Motion Graphics, Gary Demos and John Whitney Jr.[24] Together they created a digitally processed image of the live action, so the audience could see star Richard Benjamin pixilated through the eyes of the android gunfighter played by Yul Brynner. Each frame of film took over eight hours to render, but it was very convincing. Although this was not yet true graphics or animation, it can be called the first digital imagery in a motion picture, distinct from the imagery in *Vertigo* and Scanimate graphics, which used analog technology.

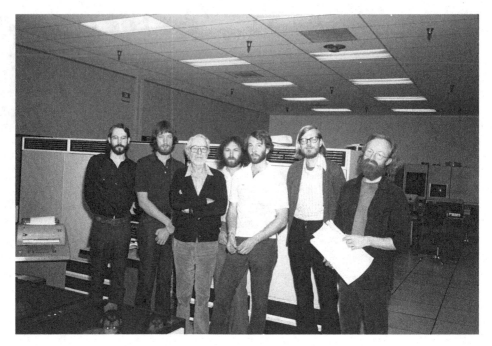

Figure 9.4
"The Beard Squad" aka The Triple I team in 1977 during a visit by John Whitney. L–R, Gary Demos, Art Durinski, John Whitney Sr., Karol Brandt, John Whitney Jr., Jim Blinn, Frank Crow. Courtesy of John Whitney Jr.

For the sequel in 1976, *Futureworld*, the filmmakers wanted to show the advanced planning of the scientists building the cyborg denizens of the theme park. As stated earlier, around this time Ivan Sutherland visited the studios with a young Ed Catmull hoping for an assignment. The producers decided they didn't need them, but they would buy Catmull's student film *A Computer Animated Hand* and Fred Parke's face animation to add to the realism of their make-believe on-camera computers. They also contacted Triple-I and ordered a scan and wireframe model of the face of star Peter Fonda. "We made up Peter all white," Demos recalled, "and we placed black fiduciary dots and crosses all over his face and body, to provide multi-camera registration points. . . . The final data for Peter's head was about 4000 polygons."[25]

Whitney and Demos continued their effects specialization in 1981 for another Michael Crichton film, called *Looker*. It was about a sinister high-tech company that digitized beautiful fashion models for commercials, then killed them. Crichton was inspired to write the story after a conversation in which John Whitney Jr., told him that CG images would one day be so realistic as to be indistinguishable from flesh and blood beings. One memorable scene showed the nude body of actress Susan Dey being scanned, while a complete wireframe image was shown as a turnaround on a

lab computer screen. It was the first CG character animation on the big screen and the first raster image that had true surface skin and lighting, not just a glowing wireframe, as was the norm then. Art director Richard Taylor recalled,

We used a body double to create the wireframe. She was an artist's model with no qualms about nudity. I told the programmers to go in and draw the scanning dots all over her body. A moment later I noticed these men hesitating. They began to blush and tremble! I suddenly realized they never were in drawing classes, where the excitement about nakedness wears off quickly as you work. So the concept of nudity still rattled them. I grabbed the pencil and quickly drew points around her nipple. She was blasé; I then tossed them the pencil and said, "There! Now get to work!"[26]

And then came *Star Wars*.

The story of George Lucas and his 1977 blockbuster film sensation has been told in great detail elsewhere. Suffice it to say that the saga of Luke Skywalker and his battle with the evil Darth Vader hit Hollywood like a 9.0 earthquake. That summer it was like there were no other films out. Director William Friedkin grumbled, "It's like when McDonald's got a foothold, the taste for good food disappeared."[27] But out in the Los Angeles suburb of Brea, California, a truck driver named James Cameron saw *Star Wars* and was so inspired, he quit his job and resolved to get into movie effects. Con Pederson recalled, "Stanley Kubrick called me just after he'd seen *Star Wars*, . . . and he said, 'It's a comic book! It's a comic book!' and I said, 'Stanley, it is making a fortune.' And he says, 'Well, think of what we could do now. You got all these computers now. Think of what we could do. You got any ideas?'"[28]

After Kubrick's *2001: A Space Odyssey*, movie studios had ignored science fiction for a decade in favor of gritty social commentary. Now, as if overnight, every studio needed to make mega-blockbuster science fiction melodramas with the latest technological bells and whistles. The new trend was confirmed when, at the end of that same year, Steven Spielberg's *Close Encounters of the Third Kind* also astonished audiences. Paramount Pictures realized the dearest wish of Trekkie fans and dusted off plans to revive their canceled *Star Trek* franchise. In England, Ridley Scott's sci-fi thriller *Alien* (1979) used John Lansdown's CG house, Systems Simulation Ltd., to create a computer monitor sequence of a terrain flyover, rendering wireframe images of mountains and valleys. New World quickly produced an Italian *Star Wars* knockoff called *Starcrash* (1979), featuring Christopher Plummer, David Hasselhoff, and an Italian model named Stella Star who fought aliens in a bikini that looked like it was made out of electrical tape. This all spawned a visual effects arms race. And it made George Lucas and his effects team a powerful force in movies.

For all its technical breakthroughs, that first *Star Wars*, now called *Star Wars IV: A New Hope* contained few CG scenes: some targeting diagram screens on the X-wing and TIE fighters, computer motion controls on the miniatures, a Scanimate image of the planet Alderan emerging, the go-motion controls on the models, and the Rebel

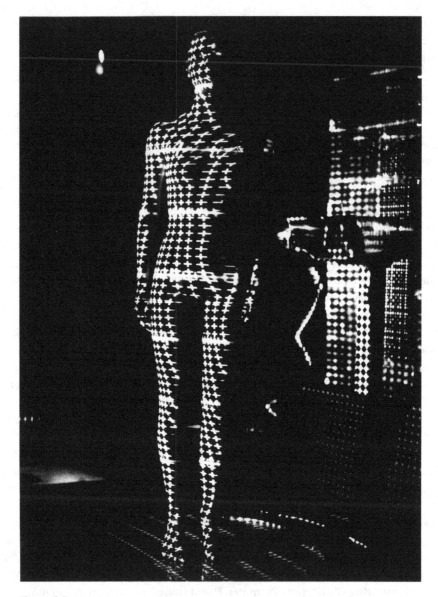

Figure 9.5
Actress Susan Dey being "scanned" in the Michael Crichton thriller *Looker* (1981).
© Warner Bros. Collection of the author.

Alliance briefing schematic of how Luke Skywalker's bomb needed to get into the intake duct of the Death Star to bring about its destruction. As with Stanley Kubrick a decade earlier, when production began in 1975, one of George Lucas's first callers was the indefatigable apostle of CG, John Whitney. Once again Whitney proposed doing all of the special effects in the film by computer. And like Kubrick a decade earlier, Lucas was impressed, but not enough to risk that much of his production on something so untried. Triple-I and MAGI/Synthavision also put in bids on some of the shots, but effects supervisor John Dykstra and producer Gary Kurtz were convinced by a short film they caught called *First Fig*. It was done at JPL by a young independent filmmaker named Larry Cuba.[29] Cuba had worked as a programmer with Whitney *père et fils* on *Arabesque*. Now he was in business for himself. "George [Lucas] saw me for about 5 minutes," Cuba recalled. "He listened to my plans, nodded, harrumphed, and walked on. And that was that. I had the job."[30]

Cuba was given molds of the Death Star trench to digitize by hand. "I had to take all the models and elements to the Circle Graphics Habitat at the University of Illinois." His friend there, Tom DeFanti, who had studied under Charles Csuri at Ohio State University, had developed an advanced language called GRASS (Graphic Symbiosis Systems). "We did the Death Star shot using GRASS. It was thirty years ahead of its time." Just the rendering took a week on the supercomputer at the university. The completed footage was used as a rear projection during the Rebel Alliance briefing scene. It was output to film, then matted in, the way Méliès would have understood. This was because the visual output of computer CRT screens was still too weak to read on a motion picture without help. The final result was certainly impressive. But Cuba did not remain in the commercial film business. He preferred to follow his first love, creating experimental film. "It was a job. Well, yeah, a chance to work on a feature film."[31]

Lucas took his *Star Wars* success and moved his base of operations out of Hollywood, settling in the Bay Area north of San Francisco. He named his visual effects company Industrial Light and Magic, or ILM for short, and settled it in an innocuous industrial park on a little street called Kerner Boulevard in San Rafael. The name painted on the door read "The Kerner Optical Resource Company," to preserve their privacy. Lucas decided that, like his sound facilities, Skywalker Sound and THX, ILM would be a service house, not just doing work for his films but offering their skills to other studios.

As we saw in chapter 8, Lucas also created an independent computer lab adjunct to his ILM effects operation, the Lucas Digital Lab (LDL, also called the Lucasfilm Graphics Group). In 1979 he hired NYIT director Ed Catmull, and many key members of his CGL staff. Using the power of Lucas's reputation, Catmull quickly assembled one of the finest computer graphics teams in the world, including Alvy Ray Smith, Loren Carpenter, David DiFrancesco, Ralph Guggenheim, Bill Reeves, and Jim Clark. Instead of being located at the main offices in San Rafael, the Graphics Group was

first housed in a small office space above a store in suburban San Anselmo, another suburb of San Francisco.[32] As they grew they were moved to a larger space over a laundromat. Lucas gave them an ambitious plan for technical development. He wanted them to create things like digital editing, digital matte process, and digital film transfer. ILM also saw that the computer guys could field a pretty good softball team when the occasion arose.

It was exciting at first, but after a year Catmull and crew began to notice something strange. No one at ILM proper had asked them to contribute their work to any of the motion picture projects they were doing. At NYIT, Dr. Alex Schure had encouraged Catmull to explore all his ideas about filmmaking. But in the rarefied air of Lucasfilm, all Lucas's people seemed to want out of the CG team were digital solutions to the tools of postproduction: editing, mixing, and optical printing. And despite all his big pronouncements in the press about the digital future of cinema, director Francis Ford Coppola seemed uninterested in financing much beyond some video preview playback systems to use on set (the practice became standard on all movie sets). Back at NYIT with Dr. Schure, money had been no object. Here Catmull had to keep his division to a tight budget and detail in writing the slightest cost overrun. And the ponytailed, universal-tool-on-belt, traditional visual effects artists were just as reluctant to mingle with computer eggheads as the pencil animators back in Old Westbury had been. "We told them [the ILM supervisors], do you have any idea of what we can do with computer graphics? They said no, and that was that," Alvy Ray Smith recalled. "One day George Lucas brought in legendary Japanese film director Akira Kurosawa for a tour. Through a translator they explained to him everything that we could do with digital editing. As they spoke, Kurosawa silently wandered away to examine a lone, unused upright Moviola in a corner of the room. By this way, he had made his preference clear."[33]

In late 1981 Catmull's team finally got their chance. Paramount Pictures had engaged ILM to create the special effects for the second film in the *Star Trek* franchise, *The Wrath of Khan*. One sequence would be a top secret film that explained to Kirk and Spock the Genesis Effect, a device that, when fired at a barren planet, would alter its molecular structure to cover it with forests and streams teeming with new life. The Paramount folks asked the ILM's VFX supervisor Jim Veilleux, "Do you do computer-type films?" He replied, "No, but I think we know the guys who do." Veilleux gave Catmull's Graphics Group the assignment. Smith was elated: "Here was our chance to show what we could do for a movie." The Genesis effect sequence would not just be to wow Paramount, "it was our sixty-second audition to George."[34]

Paramount would have been quite happy if the effect was something as simple as moss growing time-lapse on a rock. But the Lucasfilm Graphics Group was determined to hit them with everything they had. They used Loren Carpenter's fractals to create mountain ranges and volcanoes, Rob Cook and Tom Duff wrote software, and Bill Reeves

created something called "particle systems," allowing for the realistic articulation of random elements like smoke and fire. Jim Blinn popped up from JPL to pitch in.

Alvy Ray Smith recalled, "I saw that George Lucas doesn't look at a film the way you or I do. He is captivated by camera moves. He watches a movie as though he were the camera itself. So the P.O.V. of the shot needed to be extra special. I decided to utilize what I developed working out with Jim [Blinn] on the Voyager satellite films." The perspective would be that of someone in a spaceship approaching the dead planet, then flying over it as it bubbled up with new life, and then moving out into space as we saw the planet's transformation completed. "Six-dimensional splines, a hundred-some odd nodes, we're going to blow George's mind!" DiFrancesco exulted.[35] It was all very labor intensive. While most ILM-ers would go home after six, the computer guys worked round the clock. During one final practice flyby of the effects, it was noticed the camera flew straight through a solid-rock mountain range. Rather than painfully recalibrate the flight path to compensate, Loren Carpenter created a notched pass in the mountain range. It's still in the film today.

The Graphics Group delivered the completed Genesis Effect sequence on time on March 19, 1982. The first in-house screening of the completed film was in a little rented theater in San Rafael where ILM screened new footage. When the effect was seen, the audience gasped. The Paramount people were thrilled. Sherry McKenna, then an executive producer at Digital Productions Inc., summed up the impression the Genesis effect made on the rest of the CG industry: "I cannot tell you how jealous we were at Digital when we saw that come out. Because we [Digital] were all digital, and we wanted to be the first. And then he [Lucas] does that beautiful, beautiful effect . . . and it was like, he put it on the map."[36] It, meaning computer-generated visual effects. The consequences of the screening were also not lost on the traditional effects artists and model-makers of ILM. One recalled, "When the effect ran, there was an audible gasp, and then many looked down at their shoes and mumbled, Aww, shit! There it is. We'll all be out of work soon."[37] As they left the theater, some of these sullen craftsmen crumbled their complimentary posters and threw them in the trash. They understood what they had just seen. The beginning of a new era, one in which their skills would soon be obsolete.

But what about George Lucas? The next day on his regular rounds Lucas leaned into the doorway of Smith's office and murmured laconically, "Uhh . . . great camera shot," and then walked away. Truth be told, Lucas was known for being uncommunicative and cool to praise. This certainly was a different tone from that of the exuberant Dr. Schure. *Star Trek II: The Wrath of Khan* was released in theaters June 4, 1982, and was a big hit. Elements of the Genesis effect were reused in the next two *Star Trek* sequels.

That same year, 1982, there was an animation producer out from Boston named Steven Lisberger, who had opened a studio in Venice, California. He had completed a traditionally animated film titled *Animalympics* that spoofed the Olympic coverage on

TV shows like ABC's *Wide World of Sports*. By a twist of fate, NBC dropped *Animalympics* from its Olympic coverage when President Jimmy Carter ordered an American boycott of the 1980 Moscow games in protest of the Soviet invasion of Afghanistan. It was a terrible disappointment, but the ever-ebullient Lisberger had already moved on to new ideas. He had been shown a demo reel from MAGI and been intrigued by images of the video game *PONG* on it. "I realized that there were these techniques that would be very suitable for bringing video games and computer visuals to the screen. And that was the moment that the whole concept flashed across my mind."[38]

He wrote a treatment for a film titled *Tron*. It was the story of a young programmer named Kevin Flynn, who was suddenly digitized into the video game he was playing. Inside was a high-tech world where humanized avatars acted out the life-and-death struggles their master played on the game above. Lisberger and his business partner, Donald Kushner, pitched the idea around Hollywood. They were turned down by Warner Bros., MGM, and Columbia. Finally Lisberger and Kushner managed to sell the idea to the Walt Disney Studios.

Since the death of Uncle Walt eighteen years earlier, the Disney studio had lapsed into a kind of torpor, like it had itself become the Sleeping Beauty. People were still having creative discussions that began "What would Walt do?" Insiders complained that films like *Star Wars* and *Close Encounters of the Third Kind* were exactly the type of G-rated family entertainment Disney should be making. But some young creative execs, like producer Tom Wilhite, were attempting revitalize the old studio. He greenlit a short film titled *Vincent* (1982), done by a quirky young animator just out of CalArts named Tim Burton. One day the script for *Tron* landed on his desk. Wilhite saw *Tron* as the kind of innovative project the studio should now be doing, a throwback to Disney's earlier technological glory with films like *Twenty Thousand Leagues Under the Sea* (1954) and *Mary Poppins* (1964). And video games were all the rage then, so they could commission a tie-in video game, another new technology Disney needed to be part of. Wilhite put his reputation on the line to coax the conservative dons of the Mouse Factory to make this film, with Steve Lisberger as director and young actor Jeff Bridges as its star.

The original idea was to do *Tron* all hand-animated with back-lit effects. But an early mention of *Tron* in *Variety* caught the eye of Alan Kay, the Xerox PARC scientist and father of the laptop computer. Kay called Lisberger and offered his services as an adviser on the film. From that point on, each Friday Kay would fly down from Silicon Valley to Burbank to meet with the crew to discuss concepts for *Tron*. The meetings with Kay convinced Lisberger that his film about computers had to be created using computers. "I think we can do this," Lisberger said, which was a pretty bold statement for the time, since all of the technology they would need to complete the film really didn't exist yet.[39]

Walt Disney Studios was used to doing all their visual effects work in-house. But now they found themselves unequipped both mechanically and philosophically to

attempt this type of film. Richard Taylor, then at Digital Productions, recalled, "Disney people went to the 1980 SIGGRAPH to see what they were getting into. When the Disney guys saw our demo reel being screened, they realized just how far behind they were in . . . [trying to] seriously attempt a film like *Tron*."[40]

Lisberger's studio had been a traditional animation studio. So, to create the computer-generated effects, Lisberger and Don Kushner engaged several independent CG service houses: Triple-I, MAGI/Synthavision, Digital Effects, and Robert Abel & Associates. Ken Mirman directed the sections for Bob Abel. "On *Tron*, Bob told me I was on my own," Ken recalled. "I think the experience of the first *Star Trek* hurt him [chapter 10]. Doc Bailey did the Mandala Seq in *Tron*." Digital Effects head Judson Rosebush recalled, "I heard about *Tron* at SIGGRAPH 1981 and called Tom Wilhite. I flew out to LA and got shots to do that night."[41] "I had never touched a computer before Lisberger," Bill Kroyer reminisced. "All of us designers—Chris Lane, Peter Lloyd, and Jerry Reese, didn't know the first thing about computers." Animator Randy Cartwright recalled Bill and Jerry Rees being shown a basic motion idea on a monitor by a tech person. The tech then invited them to reboot the computer and try their own idea. After he walked away, Bill and Jerry stared at one another blankly: "What's a reboot?"[42]

Tron engaged the services of famous illustrators Jean Giraud, aka Moebius, and Syd Mead. "Moebius was quite prolific," Kroyer said, "and really set the style for the film with his distinct gray-marker style." Normally a feature film, animated or live action, is storyboarded by a crew of up to a dozen artists, but *Tron* was storyboarded by Jerry Rees, Bill Kroyer, and Moebius. Kroyer remembered,

In storyboarding, sometimes an idea you come by lightly can stick around all the way to the end of the project. I had to do Flynn engaged in a game with another player, that turns out for them to be a game of death for the loser. But no one was specific about what that game should be. I devised the figures standing on a set of concentric rings and throwing a jai alai ball at one another. When the ball touched a ring, it would disappear, and you would have fewer rings to stand on. Until finally the player who lost his last ring would drop to his death. I just kind of drew that out. That not only made it through to the finished movie, it became part of the *Tron* arcade game. What made it frustrating for me, the art director made the rings transparent, which to me blew the whole idea of the rings. I couldn't believe they did that . . . but we were on such a tight deadline, there was no time to change it. I was yelling a lot."[43]

The first day of shooting English actor Michael Warner, as the villain Shark, had to act like he was being zapped by a nonexistent laser ray. He wiggled up and down as best he could, hoping the effects to come would make the concept work. At press conferences the actors often deferred to the CG techs, since they didn't want to admit that they really didn't understand what they were doing.

Kroyer said,

I remember having this symbiotic relationship with the technical guys. We'd conceive an idea, bring them in to ask, "Can you do this yet?" No, not yet. Well, what can you do? Well we can

do this. For instance, interpenetrating shapes. Unless told not to, two shapes created by a computer when intersecting would just pass by one another. So we made a character called the Bit, that went through solid objects, because we thought that was a cool concept.

When it came time to do the key scene where the human being Kevin Flynn [Jeff Bridges] gets laser-scanned into the video game, everyone was trying to conceive of a cool computer way to do it. Today you can achieve the same effect on your laptop. But at the time, they could not even imagine how to make software to do that. So we wound up doing it in the most mundane way. We simply made a photostat of Jeff Bridges and created a negative Kodalith still, in which you literally erase the image a little each frame while superimposing it with back-lit laser beam effects. It was all done on an old-fashioned Oxberry animation camera. You could have done this in 1940.[44]

The scenes where the light cycles res up (rise up) to cover and transform the human players were also hand-animated and shot with bottom light. Animator John Van Vliet recalled, "The light cycles growing around the people is one of the most iconic shots of the film, and I hand-animated it. . . . I still go to SIGGRAPH conventions today and see digital fans with that image silk-screened onto t-shirts!"[45]

Bill Kroyer recalled,

There was no animation software yet in existence when we did *Tron*. The computer companies up till then created things and lighted things and rendered things but . . . had never thought about moving things. So to do *Tron* we had to render every object in a different place in every frame. So in the light cycle sequence you had a scene, say, at two seconds, at forty-eight

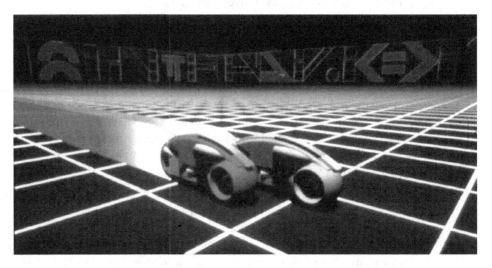

Figure 9.6
The lightcycles race from *Tron* (1982).
© Disney. Courtesy of Bill Kroyer.

Figure 9.7
Bill Kroyer and Jerry Rees (1982). Showing the phoneline dialup Internet connection with studios like MAGI.
Courtesy of Bill Kroyer

frames. You told them, on frame one, put the bike here on X and Y and Z, and on frame two, put the bike on here at X and Y and Z. . . . We wrote out traditional exposure sheets for the XYZ coordinates and the yaw, pitch, and roll tilt for every frame of every bike.[46] Handwritten coordinates for tens of thousands of frames. They also used graph paper to delineate paths of actions.

For some scenes Kroyer ran across the street to the Disney animation building, where one animation camera had a Tondreau motion-control motor. It was developed to calculate complex camera shots for a traditional cartoon. Kroyer would get it to calculate the coordinates to within a hundredth of an inch. But because it couldn't print out its results, Kroyer would have to sit in front of the monitor and painstakingly copy down by hand all the calibrations that were on the screen. "Then you gave it to the computer guys, and they hand-typed those numbers into their rendering scripts," he explained. "You couldn't just build a model and move them around like you do

now. You couldn't do that yet." One of those people patiently typing in those thousands of numbers for Synthavision was future Oscar-winning CG animation director Chris Wedge. "After this was done, everyone would wait weeks for the CG guys to do their stuff, and they sent back vector line tests and rough footage on 70 mm movie film," Van Vliet said. "It wasn't on a Moviola with a foot pedal. We had to watch it in a theater on a 70 mm screen. And that's how we gave our notes."[47]

Background illustrator and matte painter Jesse Silver recalled, "When we did the Solar Sailer scene, the ship built in CG, like any computer image, was built to perfection, while the rig the actors stood on was built by carpenters without a real understanding as to how their construct would match with the computer image. I had to find the images and paint in the points where the actors' feet were not making contact with the ship's surface, frame by frame."[48] Rosebush's team at Digital Effects in New York created the character known as the Bit and the opening shot of the electronic warrior building up. "We had the power to take concrete visual reality and transmogrify it," Rosebush remembered.[49]

It took Bob Abel's group five months to produce a fifty-five-second sequence. Technical director Tim McGovern recalled, "A typical scene took one hundred hours, hundreds of passes on the film. And if one mistake occurred, it was all done over. It was like live performance art under the camera!"[50]

Still, in the heat of production there was always time to relax. "There were full arcade-sized video games right on the set for us to play between setups. Everyone on the crew, from the film's stars to the air-conditioner repairman, played. Jeff Bridges claimed exclusive dibs on *Battlezone*," said publicist Michael Bonifer. One time, Bonifer had gotten to the sixth level of difficulty on the game *Galaga*. A crowd gathered around him, and director Steve Lisberger announced solemnly, "From now on, you have no other job on this film but to get to level seven, so we can all see what the hell is down there!"[51]

The marketing of *Tron* proved difficult. Publicists were not sure who the target audience was for this film. *Playboy Magazine* offered to do a photo spread called "The Girls of *Tron*," featuring nude Playboy models with their naughty parts discreetly covered by circuit boards. This seemed a bit much for the staid Walt Disney Company. The idea was quickly scrapped. In May 1982 Disney produced a science show based on the technology used to make *Tron*, titled "Computers Are People, Too." It was written by Mike Bonifer and L. G. Weaver and narrated by Joseph Campanella.

At that time the feature animation division of Walt Disney Studios was still smarting over the open defection of top animator Don Bluth in September 1979 with a number of key personnel from the animation crew to start his own studio. By publicly humiliating Disney by declaring the studio's output was now "stale," Bluth sparked a blood feud with the Mouse House that lasted twenty years. Early in 1982 Disney marketing strategists learned that Bluth's movie *The Secret of NIMH*, the first fully

animated Disney-quality movie not done at Disney, would be released that July. Disney used a well-known studio strategy of crushing potential competitors by releasing one of its big films the same day as their competitor's and letting brand loyalty do the rest. So, wishing to strike at any potential success for Bluth's first release, Disney chief Ron Miller moved up *Tron*'s release date from Christmas to the first week of July. This would take *Tron* out of the holiday season, where its competition would be smaller, serious, adult dramas vying for Oscars, and place it in among the ferocious competition of the big, summer VFX blockbusters.

That summer of 1982 a string of hit films, like *ET: The Extra-Terrestrial, Star Trek II: The Wrath of Khan, Porky's*, and *Poltergeist* were released. *Tron* got lost in the crush. It opened on July 9 to lukewarm reviews and lackluster box office. In the first few days of its release, computer-game fans lined up in droves in front of theaters on the East and West Coasts. But that enthusiasm faded quickly. Bluth's *The Secret of NIMH* opened July 2. It was critically well received, but it did not do much better. *Tron* was budgeted at $17 million, and its box office take eventually eked up to $33 million worldwide, but not before Walt Disney Studios declared the whole experiment a disappointment. Alan Kay, who met his wife, the film's co-screenwriter Bonnie MacBird, on the project, was philosophical about the results: "We like to say our marriage turned out a lot better than the movie."[52]

Tron's disappointing first run, coupled with the flop of their other fantasy VFX film, *Something Wicked This Way Comes* (1983), soured Disney Studios' upper management on any further unorthodox experiments. Plans were shelved for a *Tron* sequel and for the first all-CG feature cartoon, based on the novel *The Brave Little Toaster*.[53] Producer David Kushner and executive producer Tom Wilhite left Disney and set up their own companies, Kushner Locke and Hyperion Productions, respectively. MAGI/Synthavision of New York had opened an LA office and crewed up in anticipation of doing the CG animation on *The Brave Little Toaster* and an adaptation of *Where the Wild Things Are*. MAGI financed a lot of the preliminary R&D themselves. But when the Mouse cut bait, MAGI was forced to close its LA office and sell off Synthavision. Many of the survivors, including David Brown, Chris Wedge, and Dr. Eugene Troubetzkoy, returned east to the Washington Irving country of the Hudson Valley to found Blue Sky Studios. Digital Effects went back to doing commercial logos for TV. In 1986 the company broke up over personality differences, spawning the Judson Rosebush Company and Omnibus NY. Director Jerry Rees was left to animate *The Brave Little Toaster* as a traditionally drawn and painted film. Most of the work was completed overseas in Taiwan. That winter, when highlights from *Tron* were screened at the Motion Picture Academy for the finalists for the best visual effects Oscar, no one in the audience applauded. Stony silence. The audience were all traditional effects artists.

Steve Lisberger was particularly hurt by the failure of *Tron*. Years later he reflected, "It turns out that people change in [movie] scripts, but in real life they are fearful of

change. The next generation grows up and embraces the innovations that their parents feared. Only in movies do people completely transform in two hours."[54] Walt Disney Studios dropped his next film project, *Einstein,* and Lisberger's development deal along with it. Mike Bonifer said, "He [Lisberger] spent a long time wondering when *Tron* would be recognized for the breakthrough it was."[55]

The impact of *Tron* on the nascent CG industry could not be underestimated, nor could their enthusiasm be diminished by its anemic box office. At last, there had been a big-budget Hollywood movie done in CG. "*Tron* introduced the world to the idea of cyberspace and raster graphics," Richard Taylor said. "It was not the first film to have raster graphics, *Futureworld* and *Looker* came earlier. But *Tron* popularized the idea in the public's mind."[56] All around the world, filmmakers now wanted to try CG, and computer hackers wanted to try filmmaking. Australian animator Peter Greenway recalled, "After seeing *Tron,* for the next few months commercial clients kept asking for effects like they saw in *Tron.* But there were no computer animation setups in Australia. We mimicked the effects with old-fashioned, bottom-lit mattes made with black cardboard paper and colored gels. For a long time black cardboard was hard to find in Australia, because we had used it all up."[57] *Tron* became legendary in the CG world and acquired a cult status among science fiction aficionados. In the early days of home Internet sites, a forty-two-year-old postman from Fairmont, Minnesota, named Jay Maynard created his own *Tron* costume at home. He called himself the *Tron* Guy, and his photos went viral on the Web.

That following spring Lorimar Films greenlit a script by Jonathan R. Betuel called "The Last Starfighter." A young man from a trailer park, whose life seemed to be going nowhere, is selected by an embattled alien race to pilot one of their gunships against an aggressive alien foe. He was chosen by a recruiter who turns out to be a cosmic confidence man. This recruiter had salted the globe with special arcade games to find the best players on Earth. The young champion rises to the challenge to not only defeat the enemy but save Earth and find purpose to his own life. Like *Star Wars,* the story featured a young warrior coming of age and a wise old mentor, but in this case it was American actor Robert Preston.[58] Producer Gary Adelson pitched the project based on Preston's most well-known role: "It's *The Music Man* in outer space!" And that seemed to work. They secured the services of famed fantasy artist Ron Cobb (*Dark Star, Conan the Barbarian*) to do the production designs. The only stipulation was they had to make it with a limited budget of $13 million, what *Star Wars* had cost six years earlier. Adelson, director Nick Castle, and visual effects supervisor Jeffrey Okun agonized over how to accomplish such an effects-heavy film, over three hundred process (effects) shots, with that budget. Okun later said, "If we had used models and miniatures, we never could have done it."[59] This time, when the CG guys dropped in to pitch their services, they got a "yes."

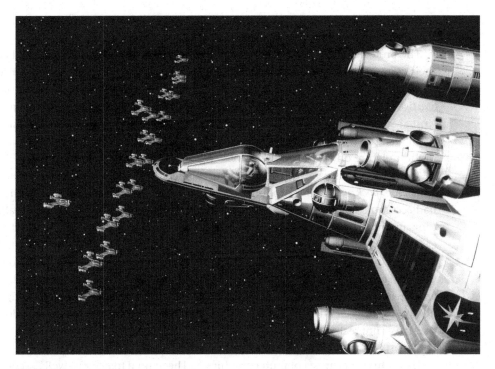

Figure 9.8
The Last Starfighter (1984). The first motion picture to create all its space ships and effects on computer.
© Lorimar Pictures. Courtesy of the collection of Jerry Beck.

The Last Starfighter was the first motion picture where the rocketships and effects were all done entirely by digital animation. No toy models on fishing line, no green felt wrappings, no miniatures, no explosive charges set off in garbage cans. An Atari video game was planned that would reuse many of the movie's assets to offset some of the costs. This work was done by John Whitney Jr. and Gary Demos, who had left Triple-I and formed a new company, Digital Productions, Inc.[60] Whitney attracted some top talent from the *Tron* crew, like Disney-trained animator Bill Kroyer. Demos said, "I used to be an architect, so I hired all my out-of-work architect friends."[61] They had gambled by investing in their own Cray supercomputer to do their rendering (see chapter 10). They also had a table-sized tablet with a dual cursor, a setup normally used in architecture.

When building the spacecraft, they had to address a new aesthetic concept. Unlike the smooth, gleaming spaceships of the 1950s, *Star Wars* had created a trend of showing interstellar craft showing grit and wear and tear.[62] They designed a special program to add grime and oil stains to the ships. "We applied a color-per-vertex

technique using dirty brown tones combined with the normal smooth shading (and coplanar polygons for edges)," Demos said.[63] They called it their "dirtabase."

The production was touch and go for a while. To finish, Digital had to cut back on their commercial work. Visual effects chief Okun had a backup plan to finish the film with miniature models, but Digital came through, and the film was done. *The Last Starfighter* premiered July 13, 1984, and was a solid hit. It grossed $29 million in the United States alone, double their budget. It proved to a skeptical Hollywood establishment that good digital CG was not so expensive that it could be made for a major motion picture on a budget.

Yet some minds were still very slow to change. When the next *Star Trek* film, *The Search for Spock*, was up for production, Digital Productions tried to do for it what they had accomplished with *The Last Starfighter*. Vice President Sherry McKenna recalled, "I took an image of the starship *Enterprise* from the last film and had it re-created identically on computer. Then I brought the Paramount producers in and showed them high-quality printouts. The Paramount people could not tell which was their film and which was the computer image. On the screen I showed the *Enterprise* moving effortlessly in any direction they chose. Then one producer asked, 'Can . . . can I touch it?' I said, 'What do you mean, touch it?' He repeated, 'I would like to hold it.' He did not understand that it was not real, it was a virtual image in the computer. There was nothing to hold."[64] To her astonishment, the producers walked out. They had lost the job.

Up to this time, most computer graphics had been used to portray, well . . . computer graphics. Scientific readouts, the inner point of view of a robot, laser blaster targeting screens, laboratory diagrams, wireframe turnarounds of killer cyborgs or beautiful androids, and so on. But in 1986 we saw the first realistically animated 3D organic character. That year Jim Henson of the Muppets, fantasy designer Brian Froud, and ex–Monty Python writer Terry Jones teamed up to create the film *Labyrinth*. It starred rock star David Bowie and fifteen-year-old actress Jennifer Connolly. The film began with a realistic white owl flying through the opening credits until it transformed into the Goblin King. Bill Kroyer said, "Henson wanted an owl in the titles. He tried to film a real owl, but the thing flew up to the top of the sound stage and refused to come down. He tried a Muppet owl, but it looked silly. So he came to us at Digital Productions."[65]

Kroyer started by renting a stuffed white owl from the Los Angeles Museum of Natural History and studying the aerodynamics of bird flight. "Each feather on the owl's wings was modeled individually and hand painted by guys like Jesse Silver," Kroyer explained. "Not only did they paint front and back but they also added a diffusion matte on each, to make the feathers' edges fade off gently and so not appear spikey. Each feather was then rigged to not just pivot from the base, but it could bend conversely, convexly, and it could twist. When I animated the flight cycles, I was working with vector images, nothing was rendered. So I had to keep turning the image to different angles to make sure the shapes didn't penetrate one another. It was

a mind-blowing animation problem."[66] Jesse Silver recalled, "We had worked so hard, but we couldn't be sure if the whole thing would work until the first shot fully rendered. When it came out with big, soft, photo-realistic-looking feathers, it drew spontaneous cheers from the crew."[67]

The *Labyrinth* owl was also one of the first 3D scans of a maquette statue. Before this, CG model rigs were built with diagrams drawn on big scanning tables. But this owl was an organic shape. For the owl's head Kroyer had Kathy Zielinski (a future Disney animator) sculpt a realistic head out of clay. Then they painted it black and put it on a record player turntable to control the rate of the scanning.

The owl of *Labyrinth* caused a lot of excitement in the CG community because it didn't look mechanical but resembled a flesh and blood owl. Despite this and other innovations, the film itself flopped in its initial run, not making back even half of its costs. Yet it remained a cult film favorite for many years to come.

ILM continued to be the king of visual effects throughout the 1980s, while taking small steps toward CG. They had set up divisions to make CG (Lucasfilm Graphics Group), video games (Lucasfilm Games Group) and digital post (Droid). Like IMAX and Skywalker Sound, they behaved like separate companies. In 1985 Steven Spielberg was producing a fantasy titled *Young Sherlock Holmes,* directed by Barry Levinson and scripted by Chris Columbus. It featured a nightmare in which a medieval knight made of stained glass jumped to life out of a church window to attack an elderly priest. John Lasseter did the animation of the nefarious knight, and the work was rendered by Lucasfilm's newly developed Pixar imaging software. It was some of the tightest combining of CG and live action yet seen. *Young Sherlock Holmes* opened in December 1985 to critical acclaim, but again earned disappointing box office. After the 1987 financial debacle that caused the collapse of three of Hollywood's best known CG effects houses —Digital Productions, Omnibus, and Robert Abel & Associates—a temporary chill came over the VFX industry, causing effects work in features to be cut back. The bloom seemed to be off the CG effects rose. Time to start selling chocolates.

The only relief in this VFX drought came from the Canadian-born director James Cameron. Blunt, blustery, and outspoken to the point of rudeness, Cameron had studied physics and philosophy in college before settling on a career in film. Enamored of special effects films since working for Roger Corman, Cameron's breakout film was his 1984 blockbuster *The Terminator.* It was a sci-fi fantasy he wrote and directed about an android assassin from the future. Since then, each film Cameron has attempted has added an additional page to the breakthroughs in CG film technology.

In 1989 Cameron directed a big-budget fantasy titled *The Abyss.* It was about a deep-sea exploration team and its close encounter with a race of aquatic beings at the bottom of the sea. *The Abyss* featured an amazingly realistic 3D alien character made of water, first called the Water Weenie, later the Pseudopod. It was the first time that

ILM attempted an organic character done in CG that could integrate seamlessly with the live action. Initially animator Jim Hillin at effects house deGraf/Wahrman did a test of the character. They didn't get the job, but it was said that Cameron carried the test tape up to ILM and told them, "I want this!" To create the effect ILM bought Silicon Graphics computers with the new Alias modeling software from Canada and hired Alias's spokesman, animator Steven "Spaz" Williams, for their team.[68] Alias had been developed using some of the old Omnibus people. Williams, with Mark Dippé, Scott Anderson, and Jay Riddle, created a liquid creature that matched believably with the human actors and even morphed into their likenesses. But when touched, it collapsed back into splashing water.

One young ILM motion control assistant watching wire removal being done digitally was John Knoll. He was inspired by what he saw and wondered if it could be done on a smaller scale. Instead of using a $120,000 supercomputer system, could the same-quality work be created on a home terminal? Each night after work he would get together with his brother Thomas, a graduate student at the University of Michigan, to work on a paint program that would run on a home computer system like their Apple Mac Plus. Alvy Ray Smith recalled, "At one point Knoll asked me for my help with his project. But then I was not interested in kits for people's homes, just big movies with big computers. Aargh!"[69] The program John and Thomas Knoll created was purchased by the Adobe Corporation in 1988 and marketed as Photoshop.[70] By 2010 much of Hollywood was drawing, painting, and designing using Photoshop software.

Even after cash-flow issues forced George Lucas to sell off his computer graphics department, which was renamed Pixar, he continued to expand ILM's development of CG to create increasingly lifelike effects for motion pictures. Two veterans of the Lucasfilm Graphics Group, Doug Kay (no relation to Alan Kay) and George Joblove, had remained with Lucasfilm. They coordinated with the Games Division to develop new digital tools.[71] First they automated their old Andersen optical printer to make the 2D animated characters in *Who Framed Roger Rabbit?* (1988) match seamlessly with the flesh and blood actors. Then they achieved a further breakthrough with digital mattes on films like *Death Becomes Her* (1992). Their technique replaced the black, hand-painted, optically printed mattes in use since Georges Méliès's trick films of a century earlier. Robert Zemeckis's *Forrest Gump* (1994) also explored ways of adding characters to archival footage without the use of mattes.

As the decade of the 1990s dawned, throughout Hollywood there was a palpable feeling in the air that the digital revolution was about to change forever the way we made movies.

The old magician standing in the back of the theater smiled.

10 Bob Abel, Whitney-Demos, and the Eighties: The Wild West of CG

These technical people . . . they're really, really strange . . .
—Sherry McKenna, 2010

Generally speaking, when people think of the beginnings of CG, they think of the 1980s. It was the decade when CG emerged from the lab and went retail. When the 1980s began there were one or two boutique studios doing CG exclusively. But by 1990 the great media centers of the world were peppered with small digital houses providing effects for film and TV: Metrolight, Centropolis, Xaos, Lamb and Associates, Bo Gehring Aviation, deGraf/Wahrman, R. Greenberg, and many more. It was like the Old West, a digital boomtown populated with geniuses, hucksters, artists, craftsmen, and card sharks, all hawking pixilated perfection.

As we saw in the last chapter, the 1980s began with San Francisco's "Interface Conference." Francis Ford Coppola and George Lucas dreamt out loud about the coming Era of Digital Filmmaking over barbeque. Coppola predicted celluloid film itself would become a thing of the past, an amazing heresy at the time. Then came Triple III's short demo of a juggler entitled *Adam Powers, The Juggler* (1980) done by Gary Demos, John Whitney Jr., Craig Reynolds, and Richard Taylor. Motion-capturing the live action of a real juggler named Ken Rosenthal, they animated a man in a tuxedo juggling, and doing back flips, as shapes and landscapes change around him. The juggler is not a wire frame, but he has flesh and clothing and a light source—an organic character moving in an organic environment. When *Adam Powers* screened at SIG-GRAPH '81 in Dallas, it brought the audience to its feet. The following year *The Works* demo by NYIT caused a similar sensation. These films declared the final triumph of raster images over vector wire frames. Soon came Carl Sagan's *Cosmos* TV series, Jim Blinn's Voyager Fly-by films, and the arcade videogame mania typified by *Donkey Kong* (1981) and *Dragons Lair* (1983).

In 1981, Quantel Computers of the UK announced Paintbox, the first professional grade off-the-shelf CG system. It featured the first ever pressure-sensitive stylus. In 1985, they followed that with The Harry, an all-in-one effects package. It featured fast

rotoscoping and compositing suitable for 35mm motion picture film. Shortly to follow were Softimage, Alias, Wavefront, Adobe, ImagePro later Photoshop, Cambridge, and more.

In 1981 Ohio State University professor Chuck Csuri approached investor Robert Kanuth of Cranston Securities to apply the computer animation technology created in OSU's Computer Graphics Research Group lab to the commercial world. Their partnership, Cranston/Csuri Productions, did a lot of commercials and flying logo titles before closing in 1988. Outside the United States and Canada there was BUF Compagnie, started in France in 1984 by Pierre Buffin; the Computer Film Company (CFC), started in London in 1984 and later acquired by the Framestore; Thompson Digital Imagery in Germany; and Japan Computer Graphics Lab (JCGL). So what made these quantum leaps in CG development possible?

As the decade of the 1980s opened, more advanced integrated circuits on silicon chips expanded the ability of small computers to store the huge amount of data that moving graphics required. The Intel 4004 chip was a silicon wafer small enough to hold between your thumb and index finger, packed with tens of thousands of microscopic transistors. This made it more powerful than a 1960s-era computer the size of a building. The following year the 8008 series doubled the computing power, and it doubled every year after that. Drum memories, stacks of punch cards, and magnetic tape were no longer needed. "What we didn't realize then was that the integrated circuit would reduce the cost of electronic functions by a factor of a million to one," said Jack Kilby of Intel.

By 1979 Jim Clark, the hotheaded engineer that Dr. Schure kicked out of NYIT, held a non-tenured teaching job at Stanford. He'd never worked with silicon chips before, but he still had the passion to make CG. One of his students recalled, "The first day I went to talk to Jim, he pointed up at a picture of an airplane on his wall. 'I'm going to make that move.'"[1] Taking advantage of an offer from Xerox PARC to work with colleges to develop projects, Clark created a chip with partner Marc Hannah called the Geometry Engine. It greatly increased the speed of computation of graphic images. Clark started a new business to market the chip and called it Silicon Graphics, or SGI. In 1982 SGI began marketing a reasonably priced desktop computer with exceptional graphic potential. It quickly outpaced the older Evans & Sutherland and PDP "Big Iron" mainframes to become the workhorse of Hollywood CG. Everything from *Jurassic Park* (1994) to *Toy Story* (1995) would be completed on SGIs.[2]

The success of movies like *Star Wars* (1977) and *Close Encounters of the Third Kind* (1978) had created a great demand for bottom-lit special effects. Every TV show opening title, every commercial for dishwashing liquid, had to sparkle like Obi-Wan Kenobi's light saber.

Since Georges Méliès's *Le voyage dans la lune* in 1908, optical effects had been done pretty much the same way. Effects were produced by the creative use of an optical printer. Artists painted black mattes on acetate cels. These were placed in exact registration under a downshooter or rostrum animation camera, called an Oxberry in most places, after the designer John Oxberry (1918–1974). Then the film was rewound in the camera and reshot with a bottom-lit second pass, which burned the chemical emulsion on the film. This created the illusion of a glow of energy. Colored gels and diffusion lenses were added to enhance the final look. Then all the separate elements were combined like a sandwich and rephotographed once more in an optical printer. John Whitney invented the concept of a motion-controlled slit-scan—taking the camera and streaking the artwork under its continually open lens. This too was combined on the optical printer. The *Star Wars* craze made the job of optical VFX cameraman a cool career.

One of these visual effects artists was Robert Abel. He began as a commercial art intern doing pasteups under the legendary movie-title artist Saul Bass. One day in 1958, Bass bade him put down his T-square and sent him out to the Los Angeles suburb of Pacific Palisades to check on the progress of one of his subcontractors, John Whitney Sr.. Whitney had been hired to create the special swirling effects for the opening titles of the new Alfred Hitchcock movie *Vertigo*. Stepping into Whitney's machinery-cluttered garage would change Abel's life.[3] He was amazed at what Whitney was attempting and quickly struck up a friendship with the veteran filmmaker. Whitney took Abel on as a graphic designer and had him work things like a print job for Foodmaker Company, the parent company of fast-food chain Jack-in-the-Box. Under Whitney's tutelage Abel learned to use the motion control camera and how to slit-scan, and he made friends with his future industry competitor, John Whitney Jr.

After getting a degree at UCLA, directing documentaries for David Wolper,[4] and completing a stint in Vietnam as a war photographer, in 1971 Abel with old Kubrick alumni Con Pederson started their own boutique service house, Robert Abel & Associates (RA&A). They began with a six-thousand-square-foot space behind an accountant's office at 953 North Highland Boulevard (south of Santa Monica Boulevard) in Hollywood. They had no sign on the door, no phone, no receptionist. But they did have a deal with advertising firm Sullivan and Marks to create a new, modern look for the ABC TV network. RA&A had purchased the leftover slit-scan equipment from *2001: A Space Odyssey*, and they started by doing traditional optical effects.

They won awards for groundbreaking effects in TV spots like the 7UP Bubblicious and Levi's blue jean campaigns ("We put a Little Levis in everything we do . . ."). Each spot was increasingly difficult in the complexity of its opticals. Abel's executive producer Sherry McKenna recalled, "Bob Abel put visual effects for TV commercials on the map. Many think it was George Lucas who did it after *Star Wars*, but we were doing it years before."[5] But Abel wanted more. He wanted to create new digital effects

Figure 10.1
Bob Abel, seated, wearing his tan shirt and white shorts, directing the shoot of a commercial for
TransAmerica "King Kong."
Courtesy of Al DiNoble.

on the computer for commercial spots. He spun off an adjunct business called Abel Image Research to sell the software his team perfected.

Stories abound about Abel being a visionary, a charlatan, a consummate artist, and a consummate bullshitter. But all who knew him agreed he was a charismatic leader with rakish charm and wit. He always seemed to be wearing the same beige shirt and shorts. He wore them so often that at one point he felt compelled to send the staff an e-mail explaining that he owned a dozen pair of the same clothes so he didn't have to decide what to wear each day. Abel was into macrobiotic vitamin diets, and he carried his food around in something resembling a tackle box. RA&A general manager Steve Kasper recalled, "My first production meeting, we had been asked by the client to re-create the type of glowing aliens seen in the Ron Howard movie *Cocoon* [1985]. But Abel wanted to do something different, not just re-create someone else's effect. As the discussion drifted against his idea, I could see he was steaming. Finally, he leaped up onto the conference table and pounded his fists, shouting, 'IT'S MY FUCKING COMPANY AND I WANT IT MY WAY!!'"

In a world of inarticulate tech nerds, Abel was a natural salesman. R. T. Taylor recalled, "Bob was a great schmoozer. Even when an effect didn't come out the way we had hoped, Bob had a way of talking the client into thinking that was the way they wanted it all along."[6] Designer Allen Battino recalled once going to a big meeting with clients from Chrysler, to launch a campaign for their new car the *Laser*. When Battino unzipped his portfolio, he realized to his horror that in his haste, he had left behind all the artwork for the campaign. "There was an awkward pause among the execs, as though someone had passed gas and no one wanted to acknowledge it. Then, without missing a beat, Bob Abel turned to the clients and said, 'No matter. Gentlemen, now picture if you will . . .' and he successfully pitched the campaign to them anyway!"[7]

Animation director Tim Johnson recalled, "Carl [Rosendahl, of Pacific Data Images] complained that Bob Abel was always selling jobs on the basis of things he knew computers couldn't do yet. Carl would be asked by a client about an effect, and he would answer that it really couldn't be done. To which the client would respond, 'Well, Bob Abel said he could do it . . .'"[8] Abel figured his people would rise to the challenge, or they would think of something else when the time came.

RA&A quickly gained a reputation for cutting-edge visual effects that attracted the best and brightest. Abel's motto was, "If you do the best possible work, they will come." Michael Wahrman remembered, "I think at third of the top people who ever were in VFX went through Bob Abel's."[9] Designer Richard Taylor, a University of Utah graduate, had been doing his own laser-light installations with multiple projectors for rock groups like the Grateful Dead. For a time he slept on the floor of the Dead's house in the Haight-Ashbury section of San Francisco. One day, frustrated with his career, he plopped down on a couch and thought to himself, "The next thing I see on TV

that moves me, THAT is what I'll do for a career."[10] And he spotted a Bob Abel commercial. Taylor created a signature look of hot, glowing colors for RA&A, that he labeled "Candy-Apple Neon."

One of Abel's brightest stars was a former architect named Bill Kovacs.[11] Kovacs had studied at Carnegie Mellon and Yale, and by 1978 he was set for a drafting table at the prestigious firm of Skidmore, Owings & Merrill. Then he too spotted what Abel was doing. He became RA&A's chief technology wrangler as they transitioned from a purely optical effects house to a CG house.

Kovacs's protégé Frank Vitz recalled, "Bill was gung-ho about the great potential for CG production. He made everyone read Tom Wolfe's *The Right Stuff*. He saw us as digital astronauts, probing the frontiers of what was possible with computer graphics."[12] Kovacs was an expert at writing the "'glue code' that connected things together."[13] As previously stated, a lot of early CG work involved getting a computer to do something it was not created to do. Kovacs began by adapting military flight-simulator hardware from an Evans & Sutherland Picture System II that Abel had purchased. At that time the computer was used as a previewing tool to manipulate wireframe figures. Then that data was used to program the motion-control cameras for a regular optical shoot. "The E&S Fortran code was primitive, but it had good structure and was bug free . . . so I had a great foundation on which to jam," Kovacs said.[14] He soon tripled the software's functionality.

Late one night he had a realization that changed the way everything was being done up to then. Sitting at the E&S alone, Kovacs marveled at how sharp the images were on the screen. "Suddenly I saw it as a piece of high-contrast artwork. We had a camera set up in front of the screen to shoot our motion tests, so all we'd need to create color graphics was a computer-controlled color filter wheel in front of the camera."[15] Kovacs and Con Pederson pushed the boundaries of vector imaging as far as one could, and then, in 1982, Abel brought in SGI machines and began the transition to raster graphics. "But we didn't say we were doing computer graphics because that scared some people [clients]," Abel recalled. "They thought that meant [industrial] CAD/CAM, which looked cold and phony. We'd just say we could make an idea come alive through an 'animation technique.'"[16]

One open secret then was that many CG houses kept traditional artists on staff as insurance. Abel had a Disney-trained traditional 2D effects animator named Sari Gennis. The team nicknamed her the Evans & Sari. On certain jobs, if the computer systems failed and the deadline was in doubt, Gennis would jump in and traditionally animate the troubled sections, and the client was none the wiser. Animator Chris Bailey also did this kind of work for Abel.

One thing Abel did not seem to know well was business. Much like his contemporary Richard Williams in traditional animation, Abel created the highest-quality work, even if it meant working at a loss. "Bob brought in huge budgets and cash

flow, but he never kept anything for himself. God forbid he'd ever make a dime. That's because he kept putting it back into the company."[17] Once, after they had finished a glitzy commercial for 7UP and showed it to the clients, who were thrilled, Abel had the entire last scene reshot because he thought it could be better. The cost of the retake erased any profit they would have seen for the job. "We dreaded being called into the theater for a staff meeting, because it usually meant we were going on half pay until Bob landed a new contract in to pay the bills," Ken Mirman recalled.[18] John Hughes, then head of technology, liked to relax by sitting at the company's switchboard and working the telephones. When asked why he didn't let the receptionist do that, Hughes answered, "I think she gets paid more than me." RA&A could be notorious at times for putting off paying bills from suppliers and subcontractors. One time a small Japanese woman burst into the studio waving a pistol. She demanded the money she claimed they owed her. A failsafe for the company was that the offices of a high-powered patent attorney named Bernie were in another part of the same building. Bernie just happened to be Abel's stepfather. Whenever RA&A had trouble making its payroll or paying off a bill, Abel would stroll over to ask Bernie to cut him a check. But despite his shortcomings as a businessman, no one disputed Abel's ability to inspire a creative team. General manager Steve Kasper recalled, "Bob knew how to select people and cultivate talent. His people didn't just work for him, they loved him."

In 1979 Abel made a deal with Paramount to do the digital effects for *Star Trek: The Motion Picture* for $6 million. Abel spent the lion's share of Paramount's money on updating and developing new graphic computers. They also did lots of predesigns and storyboards. Richard Taylor recalled, "There was a lot of disagreement among the higher-ups about the direction of the movie. How much it should look like the old TV show, or not. I think Ed Verraux and I storyboarded that film completely over three times."[19] A young Paramount producer named Jeffrey Katzenberg sat on a ladder in their computer room, and kept asking to see "dailies." But there weren't any. In the end RA&A didn't deliver much more to the final film beyond the Wormhole Sequence. But because of the contract Bob got to keep the $6 million anyway. Paramount had to finish the VFX for *Star Trek* under Douglas Trumbull, who quickly pulled back together his crew from the recently completed *Close Encounters of the Third Kind* and augmented them with a traditional animation crew under veteran Disney animator John Kimball. Abel felt bad about the way that deal went down, because he admired *Star Trek* creator Gene Roddenberry. On the other hand, it was said that one sure way you could see Roddenberry lose his temper was to say the name *Bob Abel* to him.

One of Abel's most famous works was a TV commercial for the Aluminum Board titled "Brilliance," now known as the Sexy Robot ad. In 1984 the National Canned Food Information Council came to Abel's CG house in LA with a concept.[20] A lot of beverages and food that used to come in cans were being sold in plastic tubs and liter

bottles. The Aluminum Board made it a mission to prove that getting food in aluminum cans was still cool. So they wanted a commercial where a sexy female robot of the future, all plated in chrome and sounding like actress Kathleen Turner, made the case for buying food in cans. Abel had just appeared on a talk show where he declared that we were still a long way from being able to counterfeit a human being: "We haven't even figured out human motion, which is the basis, and that's years away." Now these people wanted a super-realistic chrome-plated woman! Abel, always up for a challenge, told the clients he needed the weekend to plan whether such a project would be feasible with the technology then at hand.

Abel gathered his crew, which included Con Pederson, Bill Kovacs, Roy Hall, Neil Eskuri, and Charlie Gibson, and spent that entire weekend trying to work out how to make this idea work. "Several of us got into our underwear, we got black adhesive dots, and we put them on our bodies and we would photograph each other with Polaroid cameras, and then we would lay out these Polaroids so we could see how

Figure 10.2
The Aluminum Can Board's 1985 Superbowl TV spot *Brilliance*, also known as The Sexy Robot. Courtesy of Al DiNoble.

they changed from angle to angle," Abel explained.[21] Finally, by Sunday at 3:00 a.m. they hit on a way to create the desired effect. Abel phoned the canned food reps and told them it could be done.

Randy Roberts directed the spot. They hired a female dancer and covered her with black data points made with Magic Markers. They sat her on a rotating stool and photographed her from multiple points of view, then imported all this data into their SGI Iris 1000 system. It was only the second Iris ever made, Lucasfilm getting the first one. They then were able to analyze one frame at a time, measure the difference between joints for each point of view, and combine them all with a series of algorithms that would be used to animate the digital character. At the same time the wireframe model was built and the motion algorithms were applied to all the moving parts. The entire process took four and a half weeks and was completed two days before its delivery date.[22]

The Sexy Robot ad, aired during the 1985 Super Bowl telecast and was a great success. It has since gone down in the CG annals as one of the landmark achievements in the growth of the medium. PDI's Carl Rosendahl recalled, "Sexy Robot had a monumental effect for a commercial. Like *Jurassic Park* in movie effects."[23] Digital artist Jim Hillin at that time was a kid who wanted to be a jazz musician. He recalled, "I was sitting with my brothers in Texas watching the Super Bowl, when suddenly this ad came on. I thought—What is this? How are they doing it? It's this girl all made of chrome, and it's moving beautifully! From then on, I knew I wanted to do that as a living."[24]

The studio lived and worked on a pressurized schedule, twenty-four hours a day, seven days a week. Animator Steve Segal recalled, "They never wanted to repeat themselves. They were always trying to push a new look."[25] Matte artist Jesse Silver said, "On my first job, I think I only slept six to seven hours in a week. . . . It was the only studio I ever saw that had telephones in every toilet stall, so you could always be reached."[26] When Sherry McKenna complained, "Bob, you're working me hundreds of hours. My husband is going to divorce me," Abel's solution was to hire her husband.[27] One artist got so many notes on a scene, he got his coat, walked out of the studio, and went straight to the airport, where he boarded a plane to Hawaii. He never came back.

Some did drugs to keep going, some cracked under the strain. One morning people came in to find a tech director had hanged himself from the ceiling water pipes. Yet despite all this, people kept on because they felt they were on the cutting edge of something important. Sherry McKenna put it bluntly: "Let me be clear on one thing. He [Abel] worked us to the bone; he didn't pay us well; but we idolized him, because for the first time in our lives, and probably the last, we worked for a man who only cared about doing quality work. Nothing else. No money, no politics, no bullshit. You do the best work."[28] Director Michael Patterson recalled, "Bob was absolutely fearless.

On several occasions he bet the farm and won."[29] Ken Mirman said, "Bob's truest gift was as a mentor and muse."[30]

Meanwhile, across the LA freeways on the other side of town stood Digital Productions Inc.[31] The two principal heads were John Whitney Jr. and Gary Demos. Being the son of John Whitney, John Jr. grew up surrounded by abstract art and electronic filmmaking. "As a child, we had private screenings in our home," he recalled. "I sat in my mother's lap to watch abstract experimental films." John Cage, Buckminster Fuller, and Jordan Belson would come over for dinner. Writer Gene Youngblood called the younger Whitney an electronics genius when he was still in high school, at which time he was already assisting his father in rewiring an analog computer in the family's garage. "I never went to college. Mom and Dad gave me a year to make my own films using our electronic analog equipment."[32] His first independent short, *Side Phase Drift* (1965), was a critical success.

From 1966 to 1967, while his dad was at IBM, John, with his brothers Michael and Mark, staged multiscreen abstract environmental shows across the country, including at the 1967 Monterey Pop Festival, a hallmark in rock-and-roll history. At Expo 67 in Montreal he created a computer film of a continuously moving sequential triptych on three screens set to Indian ragas.[33]

Gary Demos became acquainted with the Whitney clan in 1970 while attending classes at Caltech. "John Whitney Sr. as a visiting teacher presented amazing 16 mm movies of dots and lines, moving in time to music. His enthusiasm for experimental filmmaking was contagious, and I began to explore the intricate visual patterns that could be created by computer." He became an apprentice intern at Evans & Sutherland in 1973. There he worked on Ivan Sutherland's hidden-surface algorithm and some of the first commercial frame buffers. He was also permitted to attend talks at the University of Utah's famed computer graphics department. "Through the work with Ivan, I gained substantial expertise in synthetic image rendering technology," he said.[34] He left E&S with Sutherland and some partners to try to start up a new company called the Picture/Design Group in 1974. Although the company was unsuccessful in getting funding, one positive result was that Demos met John Whitney Jr. The two became as famous a team in CG as Hanna and Barbera were in traditional animation.

When the pair first worked for Triple-I, the company had been making equipment for newspaper printers. Whitney and Demos convinced them to convert one of their scanners to motion picture work. They called the process "Digital Scene Simulation." They branched out as a separate division of the company focused exclusively on making motion picture visual effects. Together they created some of the first CG effects for films, working on *Westworld* (1974), *Futureworld* (1976), *Looker* (1981), and *Tron* (1982). They created the aforementioned *Adam Powers, the Juggler* (1980) that was such a landmark in CG.

But as the year 1982 began, Whitney and Demos began to feel that, in order to improve the look of their CG scenes, they needed more computing power than Triple-I had on hand. Although raised in a climate of nonrepresentational abstract filmmaking, Whitney felt that they were on the verge of a new era of image photorealism, indistinguishable from live action. Whitney spoke to the press of re-creating performances of famous actors of the past. Perhaps a modern movie star might have a love scene with a long-dead starlet like Marilyn Monroe! Demos speculated that crowds of simulated characters would one day become an important tool in films. His prediction was realized by the creation of the crowd simulation software Massive, which made the armies in spectacles like *The Lord of the Rings: The Fellowship of the Ring* (2001) possible. In all this they disagreed with the Triple-I management, who were content with the computing power they had on hand.[35]

One group of Triple I artists and techs led by Tom McMahon and Larry Malone had left to form Symbolics Graphics Division (SGD). By becoming the Hollywood effects arm of the giant Symbolics computer company in Boston, SGD could use their custom LISP computer system. Matt Elson recalled, "The Symbolics system could model, animate, paint and render in one package. The first that could do HDTV."[36] SGD would go on to do VFX in movies like Robocop II. Craig Reynolds pioneered group behavioral animation with his software "Boids" and demonstrated its potential in a short, "*Stanley & Stella Breaking the Ice*" (1986). But despite the fierce dedication of the staff for the LISP equipment, it was not compatible with other computer systems, and the sophistication of the software began to outpace the speed of their mainframes. As the fortunes of the mother company back east began to falter, it dragged down the VFX unit. SGD declared bankruptcy in 1992, and their assets sold off to Nichimen Graphics, a Japanese computer games company.

In the spring of 1982, Whitney and Demos also left Triple-I to set up their own place. They lined up financial support from the Control Data Corporation and a frame-buffer maker called Ramtek. They called their new house Digital Productions Inc., even though friends tried to dissuade them, saying no one yet understood what digital meant. Whitney did a lot of the "up-front" duties: sales and meetings to bring in work. Demos focused on technology development.

By then, Sherry McKenna had left RA&A, and was running her own models and miniatures shop. She recalled,

John Whitney called me to come see this new thing that can make commercials with a computer. So I drove over. Digital was on La Cienega Boulevard, right by See's Candy, so we all used to get to smell the candy being made. . . . I saw all these things that looked like television sets, because I had not really seen computers before up close, and John said, "Okay, let me show you something." On one monitor he showed me a Fuji film carton, and with the controls he moved it around the screen in perspective, something that would be a lot of trouble to do stop-motion frame by frame on traditional film. And I said, "I don't get it, how did you do that?" I was in

shock. And then he started showing me what they were doing, and I knew right then, it was over! I went and sold my company. Models and miniatures are over; computer graphics are going to take over the world!"[37]

She became their vice president in charge of commercial spots.

Digital Productions gambled that their ace in this game would be to get computing power by leasing a top-of-the-line Cray X MP supercomputer from the Ramtek company to do their rendering. "Our initial emphasis was on high scene complexity and computational efficiency, since we were preparing for large-scale simulated special effects production," Demos said.[38] Richard Weinberg was then working for Cray Research. He recalled. "It was the fastest sale in Cray history."[39] Freon-cooled and the size of a small truck, the Cray cost $12,000 a month for electricity alone and $50,000 for maintenance. The most powerful computer NYIT ever used was a VAX. Digital Productions needed two VAX 1180s just to talk to the Cray. When you leased a Cray, you didn't

Figure 10.3
Digital Productions in Los Angeles circa 1982. Gary Demos and John Whitney Jr. are seated on the Cray Supercomputer talking with Cray salesman Bill Stamey.
Courtesy of Richard Weinberg.

just get the computer, you got four full-time, white-lab-coat-wearing engineers with it as tech support. Called "the Crayons," the engineers were housed in an office in a trailer in the parking lot behind the studio.

"I was working at NASA on the Evans & Sutherland CT3 flight simulator for the Space Shuttle program while I was a grad student at the University of Minnesota," Richard Weinberg recalled. "Then I went back to Minneapolis to finish my PhD and was hired by Cray Research to establish their computer graphics group. While there, I got a call from John and Gary. So I moved out to LA to support the Cray."[40]

Many industry people at the time felt this solution to computer power was cost-prohibitive; some said it was like using a Boeing 747 to do crop dusting, but Whitney and Demos were committed. It gave them ease and speed in rendering. While other studios used the technique developed by Ed Catmull at NYIT of working out the motion and composition in low resolution, then going to a full render, the Cray enabled artists to draw and render, draw and render, and so provided quicker results. "Their Cray enabled them to create imaging, compositing and film recording in ten seconds. No one else could do that so fast," systems programmer Tim McGovern said.[41]

Digital Productions Inc soon had up to a hundred employees, including animators Bill Kroyer and Chris Bailey to beef up their character animation capabilities, designer Allen Battino, head of production Brad deGraf, and technical leads Larry Yeager and Mike Wahrman. In 1985 Whitney and Demos received an Oscar for scientific and engineering achievement.

Chapter 9 described how, in *The Last Starfighter*, Digital Productions created the first movie with all CG 3D spaceships. It had been only two years since *Tron*, but in *The Last Starfighter* you could see a large step forward in scene complexity and detail. And whereas *Tron* had several CG sequences augmented with some traditional animation disguised to look like CG, *Starfighter* was three hundred shots of pure 3D CG. No one yet had done that much computer work in one film, and it stretched Digital's resources to the limit. Whitney and Demos had to close Digital's successful commercial division for a while to finish the film. Sherry McKenna, who was producing at a profit, was not happy to make the switch. She knew that once you tell clients to get lost for a year, they find other studios to do their work and don't come back. But Whitney explained that the company could go under if she didn't come over to help them finish. After the success of *Starfighter*, three hundred effects shots became an industry standard for CG–live action effects film for some years to come.

In 1985, Digital Productions Inc., was contacted by the people of rock star Mick Jagger. Jagger was taking a break from the Rolling Stones to create his first solo album, *She's the Boss*. Since the cable channel MTV's debut in 1980, music videos of pop songs using innovative experimental filmmaking had become as essential to creating a hit song as the song itself. Michael Jackson's *Thriller*; A-ha's *Take on Me*, created by Mike Patterson; and Mainframe UK's video *Money for Nothing* for Dire Straits spawned a

technological arms race for the most unique looking rock video. Jagger's people wanted the latest computer wizardry for his single *Hard Woman*. By fortuitous coincidence, Bill Kroyer had been experimenting with Digital's hierarchical software to test animate. He made a woman made of blocks dance to the Jagger song "Just Another Night." The test was shown to Jagger's management team, and they were sold. John Whitney Jr. would direct.

Hard Woman was about Jagger having an assignation with a beautiful CG senorita in a sleepy Mexican town during some Day of the Dead celebrations. It would be, for its time, one of the most expensive videos yet produced. Kroyer remembered, "We were expecting a hard-driving rock-and-roll song, and 'Hard Woman' turned out to be a more like a ballad. For the skeletons doing pop-break dancing moves, they brought in a break-dance star named Pop N' Taco [Bruno Falcone III] for us to film and study. I thought, hey, these are easy to do. Smooth human movement is hard, but computers pop figures into poses all the time."

The way character animation had been combined with live action in the past was to film the live action, then print out every frame in registration on enlargement paper for the animator to draw to. Then the completed, painted cels would be shot and matted-in with the live action in an optical printer. For "Hard Woman," they took the live action of Mick Jagger and had a projector on a tripod behind the animator's head, with a beam-splitter that projected the image onto the Evans & Sutherland monitor. Then the animator would take his vector-image woman and scale it to match Jagger. He would set a keyframe, then move the live action six or ten frames to see how Jagger was moving, and then create another keyframe to it, animating "straight ahead." There were no curve editors yet, just B-splines. When Jagger is serenading the computer girl with a guitar, it looks like he was holding a computer vector image. The way they did that was they took a guitar, painted it black, and made outlines with reflective tape. It reflected light back into the camera lens and made it look like the guitar was glowing. The Cray was used to scan Jagger's live action and combine with the animation. No optical camera or film recording needed. It was probably the first digital compositing ever seen and some of the first painted texture maps ever done.

The CG character acting and dancing alongside a world-famous performer like Mick Jagger created another breakthrough for the medium. With "Hard Woman," Whitney won over skeptics who believed computer images could depict only geometric, hard-edged objects.[42] The critic for the *Los Angeles Times* noted, "These figures move with an elegant, realistic grace."[43]

Soon after "Hard Woman," Digital Productions did the visual effects for the collapsing surface of Jupiter for the Peter Hyams film *2010* (1984), using the newest views of Jupiter from JPL. Then they created the animation of a photoreal organic owl in the opening titles of *Labyrinth* (1986).

New innovations followed one after the other. One of the production people at Digital recalled being shown how to write e-mail. It was all inter-office then, because the World Wide Web would not come into existence until the 1990s. The production person was told by the tech, "This is how you talk to people." She replied, "Why do I need this? Why don't I just walk over to them and speak to them? This is the dumbest idea I ever heard of!"

Meanwhile, in Toronto, Canada, there was a man named John Pennie. He headed a company named Omnibus, which had originally formed in the southern Ontario city of London in 1971. His creative director, Dan Phillips, recalled, "John Pennie was a tall, sleepy-eyed businessman in a brown suit who could see the sharply awakened future. He was a dynamic and perceptive person two decades ahead of his and the real time."[44] Another employee recalled that Pennie spoke softly and he had a great poker face. You hardly ever saw his lips moving. He liked it when people confused him with J. C. Penny, the retail bargain-store magnate, and he claimed to have been the first man to introduce microwave ovens to Canada. Like Bob Abel, he was a good salesman for CG.

Omnibus had set up an LA effects house in 1975 called Image West to use the early analog Scanimate system. But by 1981 John Pennie felt the newer digital software for making 3D animation was the way to go, instead of Scanimate. Pennie broke with his Image West partners and founded Omnibus Video, later simply Omnibus, as a CG house in 1982. He began by leasing some of the NYIT software and Scene Assembler software from Ohio State University, and he opened offices in Toronto at Yonge and Eglinton Streets. The company also had a New York City office (Unitel Video) and leased space on the Paramount lot in Hollywood.

The company endured some early growing pains. The software that they bought from NYIT was created by the engineers who had left long ago for the West Coast. Programmer Doug MacMillian recalled, "To learn how to run something, we would get some obscure manual that was written as a college thesis, in a language that on one else could understand." When they managed to contact the original engineers, they were not interested in helping a potential competitor get on their feet. So the crew was told to make do with what they had. Software engineer Will Anielewicz said, "John Pennie was the master of the façade, pretending to have something that he didn't have. . . . My job was to connect the technology and the product."[45] So much early time was spent trying to decode the code. Their mainstay was a Foonly F1 mainframe they bought from Triple-I that had done a lot of the work on *Tron*. It used washing machine–shaped drives that barely held 50mb and crashed at least once a month. One time, while they were working on the Canadian TV series *The Third Wave*, the equipment actually burst into flames.[46]

Like everyone else in CG in the 80s, Omnibus primarily worked on station bumpers, flying logos, and rock videos. Stuff with lots of shiny chrome renders. The crew joked

Figure 10.4
Omnibus's LA crew in 1983—Delores McArdle (secretary), Art Durinski (production designer),
Michiko Suzuki (seated, digitizer), Rick Balabuck (programmer), Jim Rapley (hardware engineer),
Jonathan Leach (intern from CalTech), Dave Sieg (Manager), Doug McMillan (programmer), Dan
Jex (sales).
Courtesy of Dave Sieg.

that it was all about the "chrome factor," because clients were attracted to bright shiny objects.[47] Omnibus did the TV logos for Canada's largest networks, the CBC, CTV, and Global. They also did the opening titles for the show *Hockey Night in Canada*, which was the national sport. Omnibus artists and techs attempted early versions of morphing and ray tracing. Omnibus contributed some scanner effects to the film *Star Trek III: The Search for Spock* (1984) and the ships in the Disney film *Flight of the Navigator* (1986), later hiring its director, Jeff Kleiser. They also did all the CG effects in the science fiction TV series *Captain Power and the Soldiers of the Future* (1987), arguably the earliest commercial TV series that utilized CG animation. On a suggestion from software engineer Kim Davidson, former traditional animator Mark Mayerson articulated a realistic-looking woman for *Marilyn Monrobot*.

Omnibus technology head Dave Sieg recalled,

My worst nightmare was when we were doing the final render for *Explorers*, a long fly-through that could probably be done in real time on a laptop today. The frames were being rendered on the Foonly F1, taking twenty minutes apiece and being printed straight to the film recorder as they were finished. It meant once the render started it had to run all the way through, and it was going to take like a week. Then we had to ship it off to ILM for optical printing into the final film. Of course, there were final tweaks before the run was started just in time to just make our deadline with a tiny bit of breathing room.

Despite the early bumps in the road, by 1986 Omnibus had grown to be Canada's hottest CG company and the first-ever publicly traded CG house. But John Pennie was just beginning. He had conceived a vision of a great CG effects house, an equal of George Lucas's ILM. Pennie would accomplish this dream by merging with the two largest independent VFX houses in the States, Digital Productions and Robert Abel & Associates.

Sieg was skeptical: "I remember hearing that they were looking into taking over Abel and Digital and thinking it was crazy! Here we were losing money left and right, and somehow taking over two other companies that were losing even more money was going to make it right? John kept preaching 'Economies of Scale,' but there weren't any!"[48]

Back down in Hollywood, despite their high-profile successes, Digital Productions had been having trouble staying afloat. Truth be told, most special effects houses were then living hand to mouth. Even ILM was trying to cut costs. At this time commercials were dependably profitable, but Digital found itself curbing more and more of their commercial work to focus on theatrical features. Not long after completing the film *2010*, Digital Productions went looking for a buyer. After considering IBM, they were bought by the Control Data Company. It was not that CDC wanted such a business under their roof, as much as they wanted John Whitney and Gary Demos for what they could do with a Cray. But CDC had been in decline since Seymour Cray's departure. Soon after the merger, CDC, without Whitney or Demos's knowledge, began to

look for a buyer for Digital Productions. What they found was Omnibus and John Pennie.

In June 1986, backed by a number of investors and a big loan from the Royal Bank of Canada, Omnibus spent U.S. $6 million to acquire Digital Productions Inc. Control Data was reluctant at first, until Omnibus agreed to assume all of Digital's accumulated debt. Digital's executive producer, Sherry McKenna, said, "The first I heard of Omnibus, we had been approached by two producers representing Gary Goddard of Landmark Entertainment. They were going to do a movie with Richard Edlund, *Masters of the Universe* [starring Dolf Lundgren]." Since 1983 He-Man and the Masters of the Universe characters had spawned a successful toy line and 120 episodes of traditional TV animation done by Filmation Studios. "Now they wanted us to make twenty half-hour TV episodes in CG." No TV show had yet been done by computer, and this was realistic human characters involved in elaborate battle scenes. "I told them this would cost a fortune . . . that it can't be done. So they go to Omnibus, and Omnibus says they can do it. So they come back to me and say, 'Omnibus says they can do it.' I said, 'We have a Cray, and we can't do it, because there's too much rendering to be done, and they've got what? The Foonly?' I explain rendering and how much work there would be to get it done. I'm sorry, but if they say they can do it, you go do that project with them. John [Whitney] was not happy with me. He said, 'You just turned down a $20 million project.' I said, 'No. I just turned down a project where we would lose ten million dollars.' Technically speaking, not creatively, it was too hard of a project to do back then." When the first animated TV series completely done on computer, the French *Insektors* and Canadian *Reboot* debuted in the 1990s, they were vastly more simple in design than a He-Man series would have been.

McKenna continued,

We kind of knew by then that Control Data wanted out, and John, Gary, and I knew we had to find a buyer. We had done the Mick Jagger thing ["Hard Woman"] and we had been talking to Prince Rupert Loewenstein, who was Mick's business manager, but he was also a zillionaire. We had gone fairly far in talks with him about buying the company. I had no idea that Omnibus was in talks with CDC to buy us. Finally, after the deal was done, I found out when John and Gary found out, and we were devastated. Just devastated. We felt like we had had the rug pulled out from under us.[49]

Whitney and Demos considered the sale, done without their knowledge or consent, to be in violation of their personal service contracts with CDC. They immediately packed up and left.

The new owners flew to LA to meet with the Digital Studios staff. Accompanied by two Brink's guards with shotguns, they introduced themselves. At a signal, the guards plopped a large pile of money on the stage in front of everyone: "We've got money to spend, and we want to spend it here!" The money itself was not real; it was digitally printed reproductions. While the stunt reassured some nervous employees, it had the

reverse effect on many others. "It seemed too contrived and phony to me. Like they were trying too hard to impress," Allen Battino recalled.[50] Then Pennie and his retinue met with the Digital producers. "I met with John Pennie," McKenna recalled. "And he now said I had to run Digital as well as the Omnibus offices in New York and on the Paramount lot. . . . Oh, and that project? [*Masters of the Universe*] Now you are going to do it. I said, 'Oh, so you couldn't do it. Now you need us, and the Cray. Well, I still won't do it.'"[51] So Omnibus sent down a series of executives who had minimal experience with new media; each had to be brought up to speed about state-of-the-art computer graphics, and each ended with mixed results.

Phase one of his plan now complete, Pennie turned his attention toward Robert Abel & Associates. The story told for years since at SIGGRAPH parties was that both Digital and RA&A were bought by Omnibus in hostile takeovers. This was a practice that was common in the business world of the 1980s. But the truth was, by October 1986 everyone at RA&A knew they were in bad shape financially. Bob Abel's stepdad Bernie had died, and his second wife was not interested in being their financial safety net any longer. They began to look for a purchaser. "We called the new heads at Walt Disney Studios, Michael Eisner and Jeffrey Katzenberg," Abel manager Steve Kasper said. "But they were former producers from Paramount who remembered what Bob did to them on *Star Trek*. A friend there said, 'if you even say the words Bob Abel to them, they'll throw you out the window!'"[52] Former Disney CEO Ron Miller expressed an interest in buying the company to give his children something to run, which did not suit Bob Abel at all. Finally a deal was brokered to merge with the New York City–based CG house R. Greenberg and Associates.[53] Greenberg started up in 1981, and their computer wing had been jump-started with the addition of people leaving MAGI/Synthavision in 1985 when no *Tron* sequel was forthcoming. If they merged, Abel's financial problems would be over, and R. Greenberg would have the West Coast presence that they desired.

The R. Greenberg deal was in its final stages when Bob Abel took a meeting at the request of this Canadian named John Pennie. In only one hour Pennie convinced Abel to go with Omnibus instead of Greenberg.[54] Pennie would give Abel complete control of the three combined companies, with resources rivaling the largest visual effects studios in the world. Plus he agreed with Abel about steering the company away from the Cray mainframe way of doing things to Abel's system of developing smaller parallel processing with Sun Microsystems terminals. So the R. Greenberg deal was dead. For the price of $7.3 million, long live Omnibus/Abel, as the new company would be known: the largest CG company in the world, four hundred employees, the finest talent in Hollywood, Toronto, and additional offices in New York and Tokyo.

The merging of the companies proved more difficult than just piling funny money on a table. Dave Sieg recalled, "Three completely different cultures, completely different software systems, different computer operating systems, three competing sales

forces that were not about to work together. There were all these discussions about whose software was better, whose computers were faster, even where we were going to . . . work was up in the air."[55]

From the outset the Californians were disdainful of the older equipment the Canadians used, like the old Foonly. The Canadians thought the merger meant they would have access to the Cray, which never happened. Bob Abel flew to Toronto for talks. "I met him twice, he was a hero of mine. But at this time he was not interested in working with us in Canada. All he seemed interested in was the dollars," lamented Dan Phillips.[56] While back at Abel's Ken Mirman recalled, "We never met John Pennie. He would send a videocassette of himself, speaking to us all like he was Darth Vader."[57] There was no public Internet yet, so Pennie attempted to link up all the studios with e-mail through a satellite. Sieg explained,

Ted Turner in Atlanta had made a big splash in the satellite TV business and John was convinced that somehow satellites had to play a part in tying Omnibus's Toronto, New York, and LA offices together. He printed up glossy annual reports showing diagrams with satellite dishes at all three locations. We finally convinced him that was nonsense and got our systems connected using UUCP and SLIP. I remember how amazed we were that we could grab a frame from a live camera in New York and send it to LA at a blazing 56 Kbits/sec. That was the extent of Omnibus's "Satellite operations."[58]

The ongoing debate as to whether to complete work on the Cray or the smaller, networked Sun microcomputers came to a head early on, at a production meeting of the whole company. Even with Whitney and Demos gone, the remaining Digital people had their arguments ready when the meeting convened. Abel felt ambushed by this new defense, and he was surprised and hurt when Pennie overruled him and decided in favor of the Cray. It proved to him just how much creative control he actually had.

As a company, Omnibus/Abel started out fast, producing a series of opulent commercials for Benson & Hedges cigarettes for the market in Kuala Lumpur. Called "The Wave," it was a surreal assemblage of clowns, carousels, fish, and a jade tiger that gallops through flames to turn gold. "We had no storyboards," Ken Mirman recalled. "We were just told to make something best in the world, that no one has ever seen." Ken himself was the model for the flute player. For the movie *The Boy Who Could Fly* (1986) production designer Jim Bissell and director Nick Castle had Omnibus create a vector setup to plan out their camera moves. It was one of the earliest uses of the previsualization technique, which became a staple of big effects film production in the 2000s.[59] But the costs of integrating the three companies and Digital and RA&A's combined accrued debts acted like a drag anchor, weighing the whole operation down. As Karen Mazurkewich wrote in *Cartoon Capers*, her history of Canadian animation, "Pennie had made the fatal mistake of closing his deal with Abel, a company with a $12 million debt, before assuring that his companies' additional share offering pro-

Figure 10.5
Still from the Benson & Hedges "Gold" spot, done by Digital-Omnibus 1986.
Courtesy of the collection of Jerry Beck.

ceeded as planned. A series of behind the scenes machinations delayed the offering and spooked investors."[60]

After only a few months, by March 1987, Omnibus/Abel was sinking under the weight of U.S. $30 million in debt and was defaulting on all its loan agreements. Pennie's idea for fixing things was to go up to software developers Kim Davidson and Greg Hermanovic and say, "We're going to sell software!" To which they responded, "Huh?" In production you are selling a service. In software, you are selling a product, they tried to explain. But Pennie would not be denied. Getting one more grant from the Canadian government and some help from the software lab at the University of Waterloo, Omnibus/Abel did improve and update the software had modified from the old NYIT animation package. Pennie named their new system PRISMS, Production of Realistic Image Scene Mathematical Simulation.[61]

Manager Steve Kasper explained, "By then we had $50 million U.S. in sales already in house, plus our first feature film, *Millennium*, in development. We were going to do

our first American IPO. We were the hottest thing on the tech market, so it would have solved our money problems. But during the screening process an accountant discovered some discrepancies on the books. The IPO was delayed, and during that time no cash was coming in. This was when the Royal Bank of Canada and the other leading creditor, Crownx, Inc., demanded their paybacks."[62]

Crownx, whose primary business was medical insurance, sent down a trouble-shooter named Bill Sullivan. He sized up the situation and moved swiftly. He removed Pennie from the chairmanship and replaced him with George Hayward and later Ed Johnson. In the next few weeks several people tried to pull the company out of its death spiral. Sullivan closed the New York and Toronto offices of Omnibus. In Toronto, creative director Dan Phillips found this out when he arrived one morning at the studio and saw that the front doors had been chained and padlocked by the sheriff.

But it was not enough. By May, Omnibus/Abel declared bankruptcy. Bob Abel was advised to walk away; Bill Sullivan rang up Abel manager Steve Kasper and said, "I just sent in my resignation. I suggest you do, too." Kasper tried to find out what was going on. "It took me all day to reach the head of Omnibus on the phone. He was in a bar in Toronto, drowning his sorrows."[63] As Dave Sieg remembered that day:

Digital Productions had a semi-quiet bullpen with all the workstations, and an all-glass air lock into the computer room that housed the Cray. As I was walking from the workstation area into the Cray room, I heard myself being paged. There was a phone in the air lock and I picked it up. It was hard to hear in there because of the noise of all the air conditioners for the Cray, and I had to hold a finger over my other ear to hear. It was Kelly Jarmain, chairman of the Omnibus Board. He kept asking me what was going on there. Where was Ed Johnson, had I heard from John Pennie? I kept asking him what was going on there in Toronto, thinking it was bizarre that the chairman of the board was calling me to find out what was going on in LA. Then I realized that I was having to shout to be heard and that all the people in the quiet workstation area could hear every word I was saying and had gathered around the "fishbowl" air lock and were staring at me trying to figure out what was going on. It was a surreal and unforgettable moment![64]

At Bob Abel's Highland Boulevard facility a bank officer stood on a table and gave the crew the bad news. Animator Steve Goldberg had just recently been hired: "I think Candice Chin and I were the last people ever hired at Abel. I had just graduated from CSUN [California State University, Northridge] and I heard this was a cool place to work. I was on as a night-shift modeler on the big E&S machine, when it all suddenly went belly up!"[65] The banks moved in their security people. At the Digital facility one officer actually tried to unplug the Cray supercomputer while it was rendering, like he was some landlord trying to repossess a refrigerator. Designer Allen Battino recalled, "We all adjourned to a nearby tiki bar to drown our sorrows. At one point I looked over and saw Bob Abel sitting by himself with his drink cradled in his lap, lost in thought. I felt so terrible for him then . . ."[66]

Despite threatening to resign at several points, vice president Sherry McKenna was there at the end. "Yeah, I'm a chump. I know. But I couldn't leave all my Digital people." She still had a little work in house, including this one commercial from Buffalo. The client had ordered a commercial for Desenex foot powder. The spot featured an ancient Greek statue coming to life with cracking, burning feet. Desenex put out the fire, which enabled the statue to run the marathon. McKenna felt obligated to the Desenex rep because she had convinced him to use their services, and now they were in bankruptcy, which meant the client would lose his up-front money and have no commercial to show for it. She called the client and told him, "We're going bankrupt, but if you can pay my people two weeks' wages, we'll sleep here, we'll work 24/7. I think we can finish your spot."[67] The Desenex client flew out to LA with his carry-on bag filled with money, like in some crime-caper movie. They paid off the workers, kept the electric, gas, and water on. Then the landlord of the building showed up and said the rent was several weeks in arrears. They needed to vacate immediately.

Figure 10.6
The Desenex Foot powder commercial "Greek Statue," 1987.
Courtesy of the collection of Jerry Beck.

McKenna's foot powder client went to the landlord with his bag o' cash and made him happy, too.

Mario Kamberg directed the spot and Chris Bailey did the animation with Rebecca Marie doing his tech director duties. Bailey recalled, "At Digital we animated using IMI machines. There were three in total, and [they were] always having to be tweaked to run the animation software smoothly, but now there was no one left to maintain them. When one would get buggy, I'd move on to the second machine and load my files . . . when it would get buggy, I'd move on to the third, and when it was buggy, I'd move back to the first, which was by now the best-operating machine again. I did that rotation several times during our last all-nighter."[68] The Desenex ad was completed, the client placated, and the commercial won an award at SIGGRAPH 1987.

After that, the studio shut down for good. "My last paychecks from Omnibus all bounced," said Sherry McKenna and Bill Kroyer. Desks were auctioned off, many with people's personal papers still in them. One animator recalled going to the building to get something he'd left, and as he walked by the offices known as Producers Row, each abandoned office now had an accountant at the desk, tippy-tapping adding machines to tally up the value of what was there. Dave Sieg bought a $35,000 IKonas frame buffer for $50. Kevin Bjorke poked in the trash dumpster outside and rescued an armful of Cleos, Billboards, and other awards that had been unceremoniously trashed. Chris Bailey saved the owl head maquette from *Labyrinth* for Bill Kroyer. Two hundred of the top people in the CG industry were suddenly out of work. For weeks afterward animation studios around LA kept seeing demo reels with that same Benson & Hedges gold tiger jumping through the fire. The only division that survived was Omnibus Tokyo, thanks in part to the robust Japanese economy. For years afterward they continued to use the Omnibus name and logo.

While liquidating the assets, the bankers could not figure out what to do with the Cray. It was sent back to Cray Research, where updates and maintenance to make it resalable cost tens of thousands more. At that year's SIGGRAPH convention you saw cards tacked on the bulletin board, jokingly saying that if anyone wanted a slightly used Cray, they should make an offer.

Employees made grim jokes about the dramatic collapse of the enterprise. They called it the OmniBust and Digital-Omnibus-Abel or DOA, a pun on dead on arrival. The DOA story was reported widely throughout Hollywood. "It had repercussions," matte artist Jesse Silver explained. "For the next few years the CG VFX business was dead in town. It made investors sheepish about putting their money in these types of technologies."[69] Remember, at this time ILM was still doing primarily traditional effects work. Pixar was doing commercials and shorts. With little domestic VFX film production, the Canadian CG industry focused more on software development.

After DOA, Bob Abel went on to become an Apple fellow and was brought on by Rebecca Allen for UCLA's Center for the Digital Arts. He died suddenly from a heart

attack on September 23, 2001, at age sixty-four. His faithful crew gathered once more, to share their memories of Bob. "Your dedication to quality inspired me for life." "You demonstrated what it meant to be a real pioneer." "You saw our gift and believed in us."[70] One recalled later, "After the ceremony, and so many great Bob Abel stories, I was inspired to go back to my office and work. Tell me who else's funeral would make you want to go do that?"

The indefatigable John Whitney Jr. and Gary Demos started yet another company, Whitney-Demos, which operated from 1986 to 1988. They invested in a new generation of supercomputer, the Thinking Machine CM-2, of which a friend said, "It was this huge box with lots of flashing lights that looked exactly like the supercomputer in the movie *War Games* [1983]."[71] In 1988 they went their separate ways. Whitney created USAnimation, and Demos formed DemoGraFX. Bill Kroyer and his animator wife, Sue, started Kroyer Films. In 1987 they used CG with traditional animation to create the Academy Award–nominated short *Technological Threat*, then *Ferngully: The Last Rainforest* (1992). Leaving the Cray Research outpost at Digital Productions, Richard Weinberg went on to found the Computer Graphics Laboratory at the USC School of Cinema-Television.

Omnibus software developers Gregg Hermanovic and Kim Davidson bought the rights to the Omnibus code and opened their own company, called Side Effects Software. They took PRISMS and rewrote it to become the software called Houdini. Though the intercession of visual effects director Kevin Mack, James Cameron's VFX house Digital Domain used Side Effects software extensively in the hit films *The Abyss*, *Terminator 2: Judgment Day* (1991), and *Titanic* (1997). Dan Philips went on to Walt Disney Animation to help create CG effects like the ballroom in *Beauty and the Beast* (1991).

Omnibus New York vets Jeff Kleiser and Diana Walczak founded the Kleiser/Walczak Construction Company. Many DOA survivors joined Metrolight, a new company formed by former Cranston/Csuri alumni James Kristoff, Dobbie Schiff, and Mits Kaneko from Japan Computer Graphics Lab. Gary Colenso ran their render farm. They moved into RA&A's old offices and picked up some additional software from Ohio State University. Metrolight did some great VFX work for movies like *Terminator 2* and *Total Recall* (1990), and developed an early digital paint system for cartoons, called Metrocel, which was used on the TV series *Ren and Stimpy*. But as one former employee recalled, "There seemed to be a disconnect between their management and the 'creatives.' . . . They wouldn't listen to advice and wound up offending some good people." In 1992 former RA&A vet Tim McGovern left Metrolight and helped found Sony Imageworks. Audri Phillips said, "Sony began to slurp everyone up. We called Metrolight 'the College,' because everyone came out of it."[72]

Sherry McKenna went into interactive games with partner Lorne Lanning. In 1997 they put out the hit *Oddworld*, one of the earliest games to use cinematics. The game earned a devoted following and won over a hundred gaming industry awards. McKenna

never received a rubber check again. Another group, including Jim Hillin, Jay Sloat, and Ken Cope, followed Brad deGraf and Mike Wahrman to form deGraf/Wahrman Imaging in 1987. Their building was an old art nouveau studio that was once the office of silent film star Norma Talmadge. Kevin Bjorke wrote glue code to enable them to use Pixar Renderman and even some Symbolics tools with their DWI equipment. They produced high quality effects work on films and the theme park attraction *The Funtastic World of Hanna & Barbera.* "We had a nice place on Laurel Canyon [Boulevard] and did miles and miles of high-rez images on four and a half gigs," Wahrman said.[73] Ken Cope recalled "DWI is still one of the best teams I've ever worked with—everybody there was tremendously talented and generous with what they'd learned and with what they could do."

Bill Kovacs had started a company on the side in 1984 with Larry Barels and Mark Sylvester, named Wavefront Technologies.[74] Originally wanting to run a production facility, they soon focused on producing high-quality software for production companies. Wavefront imaging software served companies from Walt Disney to NASA to forensics labs (failure analysis). In 1993 Wavefront was purchased by SGI, who merged them with the Canadian company Alias, which had a lot of Omnibus vets. Alias/Wavefront came to dominate animation-imaging software with the package called Maya, released in 1998.

One more group of DOA refugees, led by John Hughes and Charles Gibson and bearing source code from RA&A, formed a new CG studio. They started with four other partners—Pauline Ts'o, Keith Goldfarb, Frank Wuts and Cliff Boule—in a former dental office in Culver City, California.[75]

Another DOA alumnus, Neil Eskuri, had come up with the name "Rhythm & Hues" years ago, intending to someday use it himself, but he graciously offered it up.

On April 23, 1987, just after what was left of DOA was turning off the lights, Rhythm & Hues was awarded their first job, a digital rendition of the MGM/UA film logo. This job had been laterally tossed over to them from DOA as the great ship went under. Hughes kept a number of Bob Abel's ideas for managing a company, like the weekly company meeting, but expanded its scope to include subjects such as company financial data, in order to increase management transparency. Rhythm & Hues grew to be one of the more successful CG houses, and artists and techs agreed it was one of the more pleasant places to work.

And what of John Pennie? The day Omnibus/Abel crashed he was already starting a new company named Windrush Entertainment. He also started a chain of health food stores called Racks. Sherry McKenna concluded, "I'd like to say bad things about John Pennie. But he was not a bad man. He just didn't know."[76] Said Dave Sieg, "John was a visionary but way too far removed from reality. He kept talking about 'libraries of digital actors, props, and motions' that could be reused—all of which came to pass and more, but not for decades! This was at a time when we still had to fake shadows

and reflections and frames took hours to render on computers the size of houses that sucked power and ran at 10 MIPS or some even less, and had memory measured in K not Megs, much less Gigs!"[77]

Five years later at a SIGGRAPH convention the veterans of Digital/Omnibus/Abel threw a memorable party at the LA Zoo. It was organized by Ray Feeny. About four hundred people showed up and spent a wonderful evening reminiscing. The team that at first could not work together at long last bonded over their common experience as survivors. "A large screen ran clips of what the DOA employees had done since leaving," Steve Kasper said. "It was amazing! All the top cutting-edge stuff in the business. All the top people of the business. The clip reel ran for three hours without anything ever repeated."[78] For many years after the DOA party at SIGGRAPH was one of the hot events.

Of course, the broad tapestry that was CG animation in the 1980s had many more players than these few companies described here. Carl Rosendahl of PDI said, "We all competed in separate companies, but no one really wanted to see anyone fail. That was because we all believed in the same thing. We all had the same goal about CG. If we lost a bid to another house, we just hoped those guys wouldn't mess up. Because that would have an effect on us all. We were just as happy for every new idea that moved the bar forward as if it had been our own."[79]

Sherry McKenna recalled, "Success is the best revenge, but we didn't get that at Digital. We never had the chance to taste the success that ILM got. Back then it was like pulling teeth to make people understand. I want to run up to them now and say, 'You see? You didn't like the word *digital*. You didn't like the words *computer graphics*. And now look!'"[80]

One of the final consequences of the boom of the 1980s was that CG, which had been developing in a dozen disparate places, like Cambridge, Syracuse, Columbus, Montreal, and Silicon Valley, became centered in Hollywood, that great nexus of the entertainment arts, which had been sucking in the talents of the world since Charlie Chaplin came over from Britain. CG studios had created viable new power centers in the San Francisco and Vancouver areas, but all show biz now looked to Tinseltown to see whither CG was headed.

Hollywood CG pioneers Bob Abel, John Whitney Jr., and Gary Demos achieved many innovations, but probably their most lasting legacy was that they made CG cool.

11 Motion Capture: The Uncanny Hybrid

I'm working on the most unpopular movie in town.
—*Polar Express* animator, 2004

Since humans first began making images, the source of creative "talent" has always proved elusive. Why can some people create pictures, stories, or music effortlessly, while others lack such skills? Why can some conceive of things in the abstract while others cannot? In looking for a biomechanical answer, some scientists have gone so far as to attribute creative talent in an individual to an aberrant gene in their DNA. But in general, the root cause remains inexplicable.

Because CG is at base a means to generate graphic images that speak to our common capacity to communicate via symbols, at a certain point the scientist must step back and yield to the artist. Among the scientists involved in the development of the CG industry, many once dreamed of being artists themselves but soon realized that they didn't possess enough of those aberrant genes to be that kind of visual creator. So, being resourceful, they pondered the problem of whether there is a consistent way to create natural human movement without the aid of artists, with all their variable and inconsistent skills? In addition, is there a way to speed up the slow, painstaking process of traditional animation? You are literally hand-drawing every frame of film, twenty-four pictures for one second. Of course, it seems painstaking only to the people looking at a distance; it's not painstaking for the animators, who love doing it. Live-action directors, used to instant results, chafed at watching animation being made. "Watching you guys work is like watching grass grow!" Was there some way to use a computer to speed up this process? To create realistic movement for synthetic avatars quickly, in real time?

In this quest to mimic natural human movement in CG creations, some computer researchers developed a technique called motion capture—mocap for short. A human actor is covered with sensors that record his or her movement in the computer, so that movement can become the basis for the movement of the CG figure. The problem with nailing down specific dates for the invention of motion capture runs into the

problem of deciding which process we are describing. Is it mocap in real time or used as reference for later animation? In addition, there are different ways of achieving motion capture—electromechanical, acoustic, and optical.

The idea of recording real motion predates cinema itself. Frenchman Étienne-Jules Marey (1830–1904)[1] was an inventor who was a contemporary of English motion scientist Eadweard Muybridge (1830–1904). In 1882 Marey mounted twelve still-frame sequential cameras in a revolving cylinder attached to a gun stock. With this "gun" Marey recorded sequential images of movement, to show, for example, why a cat always lands on its feet. For one of his experiments he put a model in a black leotard

Figure 11.1
Jules Marey's motion studies circa 1882.
Collection of the author.

with white lines and dots painted on the key joints of the arms and legs. When he used his photographic gun to film the model walking, we first saw sequential movement successfully "captured."

Another ancestor of motion capture is the dance notation system known as labanotation. It was developed by Hungarian Count Rudolf von Laban (1879–1958). He created it before World War I as a way for choreographers to record their work for future reference. The system divides the human body into sections and uses symbols to represent speeds and positioning. Labanotation societies would film dancers in tights with the symbols painted on them in order to preserve the intricacies of a star dancer's performance.

The most direct ancestor of motion capture is the rotoscope technique. It was invented in 1917 by brothers Max and Dave Fleischer while working at the New York studio of John Randolph Bray. Max filmed his brother dressed in a clown costume. They then blew up the film frame by frame and projected it into a light box, so a piece of registered paper could be placed over a still frame and traced off. The final result was smooth-flowing animation, unique for that time. The Fleischer brothers called the character they created Koko the Clown and Bray let them go off to set up their own studio.

Koko the Clown became a popular character in the 1920s, and in the 1930s the Fleischers used their rotoscope technique to augment their other cartoons, like Betty Boop and Popeye. They even rotoscoped the iconic movements of jazz legends like Cab Calloway and Louis Armstrong. Their finest use of rotoscoping probably came with their feature film *Gulliver's Travels* (1938) and their series of shorts about the Man of Steel, *Superman*. These realistic human figures required tight handling by the key-frame animators to achieve a subtlety many more-cartoonish characters could not yet attain.

What the Fleischers realized in their development of rotoscoping was that you could not slavishly trace every fold, crease, and wrinkle of a live-action figure as it moved on film. The myriad changing planes on the figure's clothes and hair would be so cacophonous as to be distracting to the audience. The images would "boil" or "fry" in the industry parlance. The rotoscope still required an animator with knowledge of how to control the live action data, where to expand and where to omit extraneous detail.

Yet despite the Fleischers' successes, throughout the first hundred years of traditional animated filmmaking rotoscope techniques played a minor role at best. Some of the finest examples of natural human movement done in Hollywood cartoons are the nameless dancing girl in the Tex Avery MGM shorts *Little Rural Riding Hood* (1943) and Jessica Rabbit in *Who Framed Roger Rabbit?* (1988). These were done by master animation cartoonists with no live-action reference, just a healthy libido. The Walt Disney Studios did film live-action actors for their animated characters, but only as

reference material. The animator might utilize one frame of live action out of every forty-eight to seventy-two frames to be used for drawing guides. So it was not roto-scope in the truest sense. Disney animator Shamus Culhane told me, "You could tell Grim's [Myron Henry Natwick's] work on *Snow White* from the rotoscope because of the hands. The roto-hands looked like pointed claws, while Grim's work was expressive and graceful."[2] Ralph Bakshi used rotoscoping extensively in his films *The Lord of the Rings* (1978). Don Bluth used it for films like *Anastasia* (1997).

Master Disney animator Ollie Johnston (1912–2008) once explained why the more fanciful characters, like the Seven Dwarves, usually seemed more "alive" than realisti-cally proportioned, rotoscoped figures like Snow White and Prince Charming: "Good [Disney] animation is not about 'copying' real life. Good animation is about caricatur-ing real life. It is Life-Plus." It's the reason why attempts to create human movement by digitizing complete human skeletons and muscle systems never result in satisfac-tory movement. When you bend a certain way, the ribcage expands. When running furiously, the foot squashes in a way that does not look natural when seen in time-lapse photos. A human being is simply more than a machine.

As mentioned in chapter 5, the computer scientists who began to experiment with computer rotoscoping methods didn't have access to real studio animators until NYIT's CGL lab was established in the mid-1970s.

For the first use of human movement recorded in real time to create artificial charac-ters, one must go back to the audio-animatronics of Walt Disney. As early as 1950 Walt had been talking about the feasibility of programming robots to act like his animated characters. The first animatronic characters were made in 1963 for the Tiki Room in Disneyland.[3] Earlier exhibits had used characters with moving limbs, like the animals in the Jungle Cruise, but the Tiki Room had the first programmable, auto-mated controls—simple on-off controls for blinking birds' eyes or flapping wings. The controls used compressed air in thin tubes to articulate the appendages.

For the 1964 New York World's Fair, Disney's Imagineers, looked for a way to create lifelike movement with a full-sized automated version of Abraham Lincoln. This figure was later featured in their Hall of Presidents. The first 3D digital keyframing system was built by Disney to program audio-animatrons. Keyframe poses were linearly inter-polated to drive the robot figures. The Imagineers also built a master-slave servo system for recording human movements to program the animatronics. This original device, which made much of the development of motion-capture technology possible, was called the "Waldo suit." It was an electromechanical prosthetic harness of sensors strapped on to an actor's body like the bizarre creation of some quack doctor. It origi-nated with a concept called telefactoring, developed by the scientists of NASA. They had the need to develop mechanical hands to handle dangerous radioactive material. The arms, telemetry, and other anthropomorphic gadgetry were named Waldo after

a 1942 Robert A. Heinlein novella about a disabled scientist named Waldo F. Jones, who built a robot to amplify his limited abilities: "Waldo put his arms into the primary pair before him; all three pairs, including the secondary pair before the machine, came to life. Waldo flexed and extended his fingers gently; the two pairs of waldoes in the screen followed in exact, simultaneous parallelism."[4]

Walt Disney Studios had done so much work for the U.S. government since World War II that it was perhaps no surprise that they would be the first studio to seize the opportunity to use such equipment when the feds declassified it.

The public was first introduced to this technique on an episode of the TV show *Walt Disney's Wonderful World of Color*, "Disneyland Goes to the World's Fair," which aired May 17, 1964. Walt Disney was seen working on an act from the Carousel of Progress exhibit. As Walt explained the audio-animatronics figures, he walked over to his principal audio-animatronics programmer for the fair shows, Wathel Rogers. Rogers was strapped into a Waldo control harness that would be familiar to most who work with modern mocap. As Rogers moved and gestured, so did the audio-animatronic figure; Walt Disney explained, "The operator of the harness has to be a bit of a ham actor."[5] All of Rogers's movements were recorded on Ampex computer tape so the motions could be run again and again. Disney animator Bill Justice advised Wathel on the project. At one point during a preliminary inspection of the exhibit by World's Fair chief engineer/architect Robert Moses, Rogers made Abe Lincoln lean over, extend his hand, and say, "How do you do, Mr. Moses?"[6] By the late 1960s they were recording the actions on a DAX computer. Imagineer Dave Snyder recalled "Bob Nader was the lip sync guy. He had a helmet with a Symbolics mouth action compiler, and he would write out the dialogue on animation exposure sheets. I said "Hey, this is like Labanotation."[7] Eventually all that data had to be transferred to punch cards to feed into the computer.

The wide exposure that the Disney experience garnered, along with articles in scientific journals and papers, made many eager to try their own variation on the Waldo suit. "The Waldo will do to puppetry what the word processor did to the typewriter," predicted puppeteer Rick Lazzarini of The Character Shop.[8]

At the time, Lee Harrison III was building a business based on a computer image manipulation system he called Scanimate. In 1967, in his attic lab in Blue Bell, Pennsylvania, Harrison created a type of Waldo harness for a dancer. He used it to create a simple, glowing image doing an animated dance. He called his film *The Stick Man*.[9]

At the University of Utah, graduate student Fred Parke digitized his wife's face and built the first working render of a human face. It was paired with Ed Catmull's study of his hand articulating for their film *A Computer Animated Hand* (1972). At NYIT in 1983 Bil Maher, Lance Williams, and Rebecca Allen tried to expand on Parke's ideas by creating a spot titled *Helping Handroids* for a 3DV short. As Maher described it:

Figure 11.2
"The Stick Man" Dancer in early Waldo Suit attached to a Scanimate computer (1967).
From Audio Visual Communications Magazine. Courtesy of David Sieg.

An elderly gent sits in a posh-looking chair reading the paper. He calls for his tea and a robot appears and pours (intentionally cold) tea past the extended teacup and squarely into the poor fellow's lap. We shot the video first over at the neighboring De Seversky mansion with myself doing the robot's moves, then animated the robot using the Pepper's Ghost trick—Rebecca had a half-silvered mirror at a 45-degree [angle]in front of her CRT, which reflected the video frames from a nearby monitor, superimposing the image onto her screen. Her animation of the robot was matched to and replaced my moves while closely tracking my hand, so it looked like the CG character was holding the real teapot.[10]

Allen had utilized the same technique to match dancers' movements in the Twyla Tharp/David Byrne ballet *The Catherine Wheel* (1981).

In 1980, at Triple-I, Gary Demos and John Whitney Jr. put juggler Ken Rosenthal in a mocap suit and had him juggle and do a backflip. They called the short demo *Adam Powers, the Juggler*. It was one of the earliest attempts at 3D simulated performance animation. Master creator of the Muppets Jim Henson (1936–1990) had been interested in integrating his hand puppets with real-time CG since he caught the bug while doing the movie *Labyrinth* with Digital in 1986. His team had been experimenting with remove-control techniques on their Muppet movies—for instance, creating

Figure 11.3
Figure from *The Catherine Wheel*, by Rebecca Allen.
Courtesy of Rebecca Allen.

a scene where Kermit was seen full-figure, riding a bicycle. Henson now asked Whitney and Demos to find a way to mocap Kermit the Frog for *The Muppet Movie*. They experimented with a rig to make a vector image of Kermit, but it was never used.

Some historians point to Bob Abel's 1985 commercial spot "Brilliance" (the Sexy Robot) as the first mocap film. But the human model's movement was not recorded in real time. The salient points were recorded by the computer to be used as a reference guide for the animators to later create a vector animation, then build a raster graphic image from that.

Jeff Kleiser and Diana Walczak had been primed to do an effects-heavy feature film for the Canadian firm Omnibus/Abel when that company collapsed. Salvaging what they could, they set up their own company, the Kleiser/Walczak Construction Company. Using the new Wavefront software on motion analysis, they created a video titled *Don't Touch Me* (1989) featuring a realistic-looking, torch-song-singing chanteuse named Dozo. Other Omnibus survivors Brad deGraf and Mike Wahrman remembered their work at Digital on the Kermit the Frog rig. They built on what they had learned to create the demo figure *Mike the Talking Head*, using a motion-capture harness placed on the head of independent animation distributor Mike Gribble (of Spike and Mike's animation festivals). He interacted in real time with the audience at the 1988 SIGGRAPH conference in Atlanta. Metrolight Studios received a special visual effects Oscar for the motion-capture skeletons they animated for the film *Total Recall* (1989).

Carl Rosendahl was a sandy-haired young man with a big bright smile. A Stanford graduate in electrical engineering, in August 1980 he launched Pacific Data Images (PDI) with a loan from his dad, who was in the oil business. Instead of rushing off to Hollywood or New York, Rosendahl decided to stay headquartered in Sunnyvale, in Silicon Valley. He took on two partners he met at the Homebrew Computer Club, Glen Entis and Richard Chuang. In 1982 PDI first gained its first notoriety with a TV commercial spot, *Rede Globo Brazil*. While Entis built the modeling and animation software and Chuang focused on their rendering program, Rosendahl kept the business on a slow and steady growth pattern, avoiding high-risk movie projects or big debts. "We used a whole bunch of small machines instead of one big one," Rex Grignon recalled. "There were maybe around thirty people, everybody did everything. . . . You contacted the client, you worked with them. And Carl kept everything out in the open. . . . Full disclosure on the financials."[11] Animator Patricia Hannaway said, "Everyone loved Carl and loved working there. He had a way of making us all feel like we had a stake in running the company."[12] Entis recalled, "We never took profits out of the company. We just had this rock-solid belief in the future of CG and the future of PDI. We saw other studio heads living it up, and sometimes we thought maybe we were mistaken . . . ?"[13] But PDI emerged from the rough-and-tumble of the

1980s in relatively good shape, with a solid reputation based on award-winning commercial TV spots and logos.

Then, in 1989, the Muppets came calling again. Jim Henson had not given up on the idea of using CG. He had a new TV show called *The Jim Henson Hour*, and he was shopping around for a studio to realize his ideas. PDI had just added a number of motion-capture specialists from NYIT, including Rex Grignon and Paul Heckbert. Rosendahl remembered, "Jim Henson was a brilliant man. At the time he was running three full-time facilities, in London, New York, and LA, yet when he sat down to talk to you, he was always focused on you and the matter at hand. He was soft-spoken and never lost his temper."[14]

Henson had an idea for a little, floating, seal-type cartoon fellow, sporting a bright-red top hat. He did not want the type of animation that was worked on for weeks after recording. He wanted to interact with the character in real time. A lot of the best Muppet humor came through improvisation, without a script. Henson did not want to sacrifice that spontaneity just for the sake of the technology.

Rex Grignon, Graham Walters, and Thad Beier took the character designed by Kirk Thatcher and adapted a Waldo suit left over from a David Byrne rock video. "We realized that SGI had a dial box that had digital pots (eight of them streaming live)," Grignon explained. "We tore one of the dial boxes apart and soldered the pots to the Waldo arm and had a much, much more precise and calibrated setup."[15] This was then strapped on to puppeteer Steve Whitmire. He was a veteran Muppeteer whom Jim Henson trusted enough to take over the handling of Kermit the Frog. This new character would appear on a video screen as a low-resolution figure, because higher resolution couldn't be done in real time. Cameras were stationed so the people working the other puppets could see him as they went through the scene. They had to bring all their equipment to Toronto, Canada, where the show was being taped. Then, after the performance, they rushed it back to California, where it was rendered to full resolution, with secondary actions and overlap added.

The new character was christened Waldo C. Graphic, after the Waldo suit. The *C* is for computer, so Waldo Computer Graphic. Grignon recalled, "I still think this was one of the best uses of motion capture. . . . You can take advantage of the puppeteer's skills, because these guys are masters. It was amazing seeing them put their hand in a puppet and it just comes to life. I just remember Graham [Herbert] and I were both continually astounded with the subtleties that these guys could bring to these characters."[16]

Despite all that came before, because PDI's Waldo C. Graphic was so successful on a widely seen TV show, and not just an industry demo or an experiment, many film historians frequently cite it as the first true motion-capture character. Besides *The Jim Henson Hour*, Waldo C. Graphic was also a feature in the theme park attraction Jim Henson's MuppetVision 3D. PDI did more mocap work for Henson and in movies like

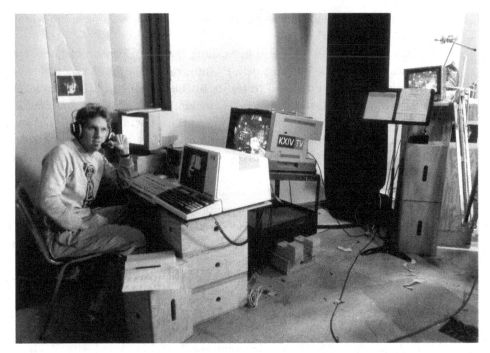

Figure 11.4
Rex Grignon on the set of "The Jim Henson Hour" in Toronto in 1989 (wearing PDI sweatshirt)
Notice "Waldo" armature on the right edge of frame.
Courtesy of Rex Grignon.

Terminator 2 and *Batman and Robin* (1997), but they didn't want their studio to be known solely for motion capture. By the time of their merger with Dreamworks in 1995, a majority of PDI's output was regular keyframe character animation.

No one studio controlled motion-capture technique exclusively. Because the basic concept of the Waldo suit had been out there since NASA declassified it, many entrepreneurs developed their own custom-made systems. Motion capture came into the retail market with a great deal of high-tech hype. All through the 1990s, at every tradeshow, from SMPTE to SIGGRAPH, there were the ubiquitous booths packed with electronic mocap gear. Pretty models in black rubber wetsuits doing pirouettes and kung fu kicks, covered with sensors and cables, looking like the participants of some bizarre techno-dungeon. All the spokespeople with their infomercial headsets carnival-barked their particular system's virtues. The big difference between these companies and the original pioneers was this: to the early hackers, what mattered was advancing the medium of CG through anyone or any way, while to these folks, it was all about

selling their particular system. Every proprietary system developed was patented, promising big retail returns the way THX sound had done for George Lucas.

Traditional animators might harrumph over the hucksters' claims, but businessmen were all ears. Carl Rosendahl said that the reason mocap developed such a bad reputation in the business was because of the false expectations that were built up, that mocap promised instantaneous, cheap results.[17] The technique became a game piece in the ongoing power struggle between creatives and moneymen. Since the Renaissance, businessmen who commissioned the arts have chafed at working with people with creative temperaments, at times moody, at times visionary, at times maddening. But every businessperson understands the concept of retooling and the need for technology upgrades. So to noncreative types mocap was get-able, even if the results fell far behind expectations for the time being. After years of watching simplistic CG images develop, traditional animators remained skeptical about all the claims about this technique. They called it "Satan's rotoscope." Mocap seemed a way to sidestep creative artists and generate CG performance as a dependable commodity.

Animators, actors, and backstage people alike glanced nervously over their shoulders as this hybrid technology grew in sophistication. Stories spread of engineers being worked overtime to figure out how to cut artists completely out the process. "If we just refine the software a little more, we won't need to bring in any animators!" Many proponents in the media predicted the end of movie shoots as we knew them. In 2004, the film *Sky Captain and the World of Tomorrow* was done almost completely on greenscreen sets. Gone would be the days when a movie set looked identical to real life. Everyone would be acting in a Brave New World of green felt backdrops festooned with X marks, with ping-pong balls attached to their nads and wires up their butts. No one but the mocap technicians, the producers, and some movie directors were looking forward to all this. One animator on *Polar Express* privately expressed his anxiety: "I'm working on the most unpopular movie in town!"

As motion capture tried to gain credibility, there were hits and misses. In 1990 Symbolics created a real-time, computer-puppet animated face of actor Tom Noonan for *Robocop II*. In 1992 there was *The Lawnmower Man*, a film loosely based on a story by Stephen King. There was extensive use of motion capture in the film, even the first attempted cybersex scene. At this time the general public was intrigued by a lot of media attention to the idea of virtual reality. But critics felt the film created unrealistic expectations about what virtual reality could be. Despite great visual effects work by a games developer called Angel Studios of Carlsbad, California, the film was not a success.[18] As happened in many CG-effects movies of the 1980s, a weak script undermined groundbreaking visual ideas. Stephen King, disliking how far the plot evolved from his original idea, sued to have his name taken off the film.

In 1993 James Cameron joined with former ILM manager Scott Ross and makeup wizard Stan Winston to found the visual effects house Digital Domain. When they

first set up shop, Cameron wrote a memo to the crew that was in effect his digital manifesto. He predicted that, in some future project, actors would be digitized in a "Digi-Suit" and so create synthetic avatar characters that would not only be unique but be in perfect 3D projection as well. Most of Cameron's predictions would not be realized until his film *Avatar* in 2009.

In 1997 Cameron directed the blockbuster hit *Titanic*. It was one of the first films where complete digital environments and characters mixed seamlessly with the live action and miniatures. Motion-capture "synthespians" were used extensively in place of extras, as the people walking around the deck, climbing into lifeboats, and plummeting to their deaths as the ship sank. *Titanic* and Michael Bay's *Pearl Harbor* (2001) demonstrated that the realistic depiction of human actions that mocap could provide made big-spectacle movies more manageable and cost effective. Peter Jackson's team at Weta Digital in New Zealand added the software program Massive for articulating large masses of figures for their *Lord of the Rings* film trilogy. Massive, combined with motion capture, has made giant wide-screen spectacles possible. Before, filmmakers had to hire nonprofessional historical reenactors or filmed where they could use the idle military of countries like Franco's Spain or the Soviet Union. Then they applied matting and optical techniques to make the crowds seem immense. They had to swallow the humiliation of an occasional accident, like a Roman legionnaire sporting a modern Timex watch.[19] But with programs like Massive, creating the vast armies of Middle Earth, Trojan warriors, and rampaging Mongol hordes was not just possible but cost-effective as well. These motion-capture techniques also worked to give a gritty, realistic human quality to first-person shooter games like *Medal of Honor, Call to Duty, Grand Theft Auto*, and more.

All this worked well for background characters filling the frame and for games. But what about the main characters acting on the big screen? Could they be motion captured as well?

The great Russian playwright Anton Chekhov once said, "On stage, the hardest thing to do is nothing, in character." So long as figures were fighting, or running, or bursting through walls, the motion capture looked terrific. But could a mocap character stand still and act? Could they emote and elicit feelings of empathy from an audience the same way a flesh and blood actor can?

As we have seen, in the 1980s CG animators tried to get closer to expressing realistic emotions with characters like Tony de Peltrie and Dozo. In France in 1995 Alan Guyot of Video Systems wanted to create a novel host for *Cyberflash*, the first daily computer-game show on French TV. So he created a sexy lady named Cleo, who was designed to be a cross between Jessica Rabbit and an ant, and he motion captured her like the Henson work, with the ability to interact with people in real time. Cleo was animated

by Isabelle Landi and Christophe Albertin and was a popular sight on French TV for a number of years.

In that same year, 1995, when Pixar's *Toy Story* was hitting the theaters, executive CEO Jeffrey Katzenberg left Walt Disney and set up his own, competing studio with partners Steven Spielberg and David Geffen called DreamWorks SKG. One of their goals was to build a large animation output and capitalize on the new technologies, the way Disney had done with Pixar. When DreamWorks approached PDI about an acquisition, they were shown an intriguing motion-capture test done by a team of CG techs out of Texas who called themselves Propellerhead Design—J. J. Abrams, Rob Letterman, Loren Soman, and Andy Waisler.[20] They had done a test for a proposed HBO pilot using their own proprietary mocap system. It boasted some impressive, cartoony action of a bulbous character named Harry. The Harry test convinced Katzenberg to try to make a feature film with the technique. He chose a small children's book by popular illustrator William Steig called *Shrek*.

To film *Shrek,* a facility was set up in a Glendale, California, warehouse space with a ten-camera motion-capture stage and a gaggle of SGI computers. A Shrek-proportioned mocap fat suit was designed and fitted on an actor who used to play Big Bird on *Sesame Street*. After a few months the test was finally shown to Katzenberg. But there were problems. The test just couldn't achieve believability of the character. It looked too much like a man in a fat suit. The large feet flapped like those of Bozo the Clown. To give Shrek someone to interact with, a thief character was added to the test. There was no budget to rig a new mocap harness, so it was done keyframe style by animator Donnachada Daly. Daly's work was crisp and focused, and it showed up the meandering mocap. Because of this, Katzenberg dropped the mocap and resolved to do all of *Shrek* as a normal CG animated film.

The same year *Shrek* was released, a Japanese game company named Square Pictures was going for all the marbles by trying to create realistic human animation in a science fiction adventure film titled *Final Fantasy: The Spirits Within* (2001). Building and staffing the studio in Honolulu cost $175 million, and the movie itself cost $137 million to make. The designer of the *Final Fantasy* game, Hironobu Sakaguchi, wrote and directed the film (Moto Sakakibara was codirector). A great deal of painstaking detail was added, such as freckles and blemishes on the characters' skin, and it seemed every hair follicle was plotted out. Some hailed it as the first photorealistic CG film. But it received tepid critical reviews and left most audiences cold. It was made before translucence programs that could make the skin look more natural had been invented. So the human skin tone had a dull, matte quality that made the characters look like dead people. People called it "zombiemation." *Final Fantasy: The Spirits Within* earned $33 million and was a flop, bankrupting the Square Pictures studio.[21]

In the 1980s film director Robert Zemeckis made a name for himself by creating such box office hits as *Romancing the Stone* (1984), *Back to the Future* (1985), and *Who*

Framed Roger Rabbit? (1988). Zemeckis was sensitive to critics who accused him of being more interested in technical gimmickry than emotional content. Still, he was inspired by the promise of digital cinema. In 1997 he formed a company to create films in this way called ImageMovers, later connected to the Walt Disney Studios as ImageMovers Digital. To film the popular children's Christmas book *The Polar Express*, he embraced a technique to make the film completely digital using performance capture. Zemeckis became the most high-profile Hollywood filmmaker to completely tie his reputation to this technology. He went on to produce four more films using performance capture.[22] But none of them had the kind of critical and financial success his earlier live action films did.

Meanwhile, Peter Jackson's *Lord of the Rings* trilogy and James Cameron's *Avatar* were huge successes that set a new standard for motion-capture quality in film. Media buildup drove the perception that the success of the characters' performances was solely due to the skill of the actors in the Waldo suits. London-born actor Andy Serkis became a household name for his performances as Gollum and as the ape Caesar in *Rise of the Planet of the Apes* (2011). With each performance there was talk that Serkis deserved an acting Oscar for his work. This implied that the animators did nothing more than superficial custodial work on the performance. Advocates of performance capture claimed it was a distinct practice, apart from motion capture. While mocap is limited to recording a figure's movement, performance capture is concerned with capturing the creative performance of the actor, whose most subtle movements are being faithfully recorded on screen. Its detractors said the distinction was more about publicity and a way to excuse huge cost overruns, at times double the budget of a conventional CG animated film. A number of other well-known motion picture directors loudly declared in the press that their performance capture was not the same as cartoon animation, as though it would demean them to even be associated with cartoon animation. James Cameron said, "I'm not interested in being an animator. . . . That's what Pixar does. What I do is talk to actors. 'Here's a scene. Let's see what you can come up with,' and when I walk away at the end of the day, it's done in my mind. In the actor's mind, it's done. There may be a whole team of animators to make sure what we've done is preserved, but that's their problem. Their job is to use the actor's performance as an absolute template, without variance, for what comes out the other end."[23]

The fact behind much of the media hype was that these performance-capture shots still required extensive reworking by animation artists. "Mocap gets us 60–70 percent there, but you still need a good animator to bring it in," one animator explained.[24] The old live-action visual effects craftsmen's view of character animation is that it is not a true performance but merely a drawn effect. And thanks to the miracle of motion capture, they believed, animators were no longer necessary. "The implicit sentiment seems to be that even the poorest actor can act better than the best animator. Many

of us [animators] find this offensive, especially those of us who have had to extensively clean up, radically alter, or even throw out a shot performed by a 'real actor.'"[25] Never mind Pinocchio, Bugs Bunny, or Buzz Lightyear, the live action will always better. Animators charged that this idea is as absurd as tracing a line around a photo and declaring that better than anything Norman Rockwell could ever draw.

Some workers on the *Lord of the Rings* films mentioned that the initial results of the Gollum in motion capture were so unsatisfactory, that at one point director Peter Jackson despaired for the film. He declared that if the Gollum was not believable, the entire trilogy of films would fail. So a number of highly skilled character animators were flown down to Wellington New Zealand to repair what was not working.

Gollum was a different shape than Andy Serkis in proportions. And many of my shots were hand-animated with animators acting. That is why the Gollum has humanity and more feeling. . . . The animators cleaned up mocap, animated necks, tails, and creatures like the flying wraiths . . . hmmm . . . where have I seen those before? Hmmm . . . it is 3D rotoscoping . . . like the 2D rotoscoping issues of old . . . from Uncle Walt himself. Movement, but not selective emphasis, which comes from a real character animator. It moves . . . but I don't feel those characters.[26]

Another animator recalled,

Bending over backwards, waaaaay over, I think you could argue that 80 percent of the performance was his [Andy Serkis's], but my gut tells me it was 65-ish . . . and much of that was just first pass, with take two and subsequent takes directed by Peter [Jackson] and Fran [Walsh] and implemented by animators, not by Andy . . . The Fellowship [of the Ring] had five or six Gollum shots, three entirely keyframed, including a long shot by Mike Stevens and two big closeups that Randy Cook animated; a roto of Gollum's hands based on live action with failed makeup, and the book illustration shot of Gollum in the middle of his lake.

Even on James Cameron's film *Avatar*, which has been called a pinnacle of performance capture, a certain amount of redoing had to be done by the character animators. "It is a 1:1 data transfer for the Na'vi [the big, blue natives of Pandora]. . . . the actors' lower faces are indeed the actors' lower faces. Cameron nuked facial capture in the eyes and brows, too . . . the eye moves . . . but the brow is a rock." The crucial scene in *Avatar*, when Jake Sully confesses his real mission to Neytiri, was also heavily reworked by keyframe animators in a way Max Fleischer would have understood. "Facials still remain the Holy Grail of performance capture," said Professor Eric Furie of USC's motion-capture program.[27]

ILM had attempted a full mocap character in *Hulk* (2003), directed by Ang Lee. Despite some great story work on the humans, the film was a letdown because of the lackluster mocap work. Chekhov's rule was in full flower here. The Hulk looked great when he was destroying things, but when he stood still and tried to act, his empty gaze was disappointing. One critic called the Hulk "Shrek in Capri pants"

with "all the realism of a plastic bath toy." The promotional press kit showed footage of director Ang Lee himself trying on the motion-capture suit to create some of the Hulk's movement. Some people on the crew later admitted the reality behind the footage. Lee was so annoyed by the results he was getting that he grabbed the suit, put it on, and gestured, "No! Like this!" Afterward, when he was being applauded for *Brokeback Mountain* (2005), he admitted that *"Hulk* almost made me give up on filmmaking."[28]

For Peter Jackson's remake of *King Kong* (2005), the Weta effects team put great emphasis on the facial acting. In one scene when Kong sits, exhausted, on a ledge after having dispatched a monster, Anne Darrow comes to his side. The camera lingers on the ape's face as we see the rage in his eyes soften to love. This was done with keyframe character animators working over the mocap, much as they had done with Gollum. Yet, as many of the technology's advocates maintain, the mocap performances involving Andy Serkis do have a quality above other similar films.

Since performance capture has become part of mainstream filmmaking, the Short Films and Feature Animation branch of the Motion Picture Academy of Arts and Sciences has struggled year after year to determine how to differentiate between an animated film and a live-action visual effects film. In 2009 they ruled that if a film was 70 percent created with frame-by-frame construction, it could be considered animation. Despite *Avatar* being 80 percent animation, Cameron would not consent to the film being entered in the Academy Awards category for Best Animated Feature. In 2010, after Cameron's declaration about *Avatar*, the academy tried to say that films made using performance capture or motion capture are not animated films because the principal performance was created at film speed, not frame by frame like true animation. As such, these films cannot be considered eligible for the Best Animated Feature Oscar. But then Steven Spielberg's Amblin partner Kathleen Kennedy argued for their film *Tintin: The Secret of the Unicorn* (2011) to be entered in the Oscars as an animated feature, and it won a Golden Globe for best animated film, throwing the debate open once more.

"Animators construct motion out of stills and when the stills are rapidly displayed, they provide the illusion, not the recreation, of motion," animation professor Mike Mayerson of Sheridan College explained. "Motion capture starts with real world motion. Artists may work on it afterwards to clean it up or to enhance it, but the basic motion begins as observable motion. From my perspective, anything done to that motion qualifies as a special effect, but not animation because the major part of the performance comes from real world observable motion."[29] Film director/writer Richard Linklater introduced a completely different idea of trying to achieve photorealism with computer effects. In two of his films, *Waking Life* (2001) and *A Scanner Darkly* (2006), he filmed a live-action story, then used computers to re-color and distort the images in surreal and imaginative ways, so that they looked partly like 2D character anima-

tion.[30] Ultimately these were not considered animated films, because the action was filmed in real time, and not frame by frame.

Famed stop-motion animation director Henry Selick (*Coraline*) noted, "The academy has to come to terms with where [performance capture] goes. Is it animation? Is it a new category? I'm like the academy. I don't know where it fits. I will tell you this, animators have to work very, very, hard with the motion-capture data. After the performance is captured, it's not just plugged into the computer which spits out big blue people. It's a hybrid."[31]

So what is motion capture? Animation or live action? This argument may be resolved in the future as the technology improves to a point where the actor's performance and the synthespian images become indistinguishable. That said, it raises the question of whether the final end of animation is to re-create reality in the first place. PDI director Tim Johnson has said, "Performance capture animation deserves a champion. It deserves a Jim Henson, a visionary, to come along and understand this does not look like character animation."[32] Rex Grignon has said, "Trying to figure out what the aesthetic could be for this new medium is what should drive it. Not the technology."[33]

Is motion capture to be dismissed as merely a gimmick sold to movie execs as a way of replacing artists and actors with digital avatars? Or is it what its proponents claim—a new medium that is neither live action nor animation but uses the best features of both to create a unique cinematic experience? Only time will tell.

12 The Cartoon Animation Industry

The future of the CG business is in character animation.
—Sherry McKenna, producer at Digital Productions, 1986

I don't want to spend the rest of my career staring into a damn TV set!
—Traditional animator, 1978

Burbank, late summer, 1983. "Ron will see you now." The sandy-haired young man shuffled into the office of the president of the Walt Disney Company. Ever since Walt Disney started the practice, it had been company policy to use first names only. So it was not Mr. Miller, or Pres. Ronald Miller, it had to be simply Ron.[1]

As the young man walked through the office, the length of a small bowling alley, he glanced up at the walls, festooned with reminders of the rich legacy left by the Disney artists of the golden age of Hollywood. Framed animation drawings of consummate skill from films whose names trumpeted a bygone era of Disney classics—*Lady and the Tramp* (1955), *Pinocchio* (1940), *The Jungle Book* (1967). To the average person they were things of beauty. But to animators they could be intimidating. For they served as a constant reminder of the standards of quality that the Walt Disney Studio expected would be maintained and, one hoped, excelled.

The young man, John Lasseter, had been at Disney heading a development project to try and use new computer technology, which Lasseter had seen his friends using on the film *Tron*. He spearheaded a small team that included animator Glen Keane and the West Coast unit of Magi/Synthavision. They created a thirty-second test using characters from the classic Maurice Sendak children's book *Where the Wild Things Are*. While Keane supplied the 2D character animation of Max chasing his little dog, Lasseter created a moving perspective shot to allow him to run through the house and down a flight of stairs. If this test worked, he had plans to start on the first ever all-CG animated feature, *The Brave Little Toaster*. But after the poor performance of *Tron* at the box office, Lasseter's producer Tom Wilhite had left the studio and had been given *The Brave Little Toaster* to take with him. Lasseter's future seemed in doubt.

The *Wild Things* test was on the verge of being completed when the telephone rang: "Ron wants to see this test now." So here was Lasseter, three-quarter-inch videotape in hand. He showed it to Miller and explained the approach. Just as he was finishing, Miller cut him off. "Well, uh . . . we don't want to do this." And that was that. No sooner had Lasseter walked back to his desk than his phone rang again. This call was from Ed Hansen, the studios production head. He was known through the company as the man who swung the ax. "So . . . I hear it [*Wild Things*] is not going to be made. . . . And since this is the last day of your contract, I guess we won't be needing your services anymore."[2]

That was it. The ax had fallen. Nothing more to do but box up your stuff and turn in your keys. Lasseter left his office crushed. All he ever wanted to do was be a Disney animator. And here was his beloved Magic Kingdom kicking him out. What now?

For the next few months Lasseter worked around some other animation studios, and then at a SIGGRAPH event he ran into a different Ed.

Ed Catmull.

Animated film is one of the oldest ways of making cinema. It is handcrafted film done frame by frame. Animators would pass their skills from master to apprentice, and they rose through a stratified system of job classifications in place since 1913. For instance, I myself can claim that I was a protégé of Shamus Culhane, who was one of the animators of the Heigh-Ho March in *Snow White and the Seven Dwarves*. He learned animation from Max Fleischer, who learned from James Stuart Blackton, who worked with Thomas Edison and consulted with Eadweard Muybridge. Animators are very proud of their traditions and repeat the lessons of the past masters with an almost religious reverence.

Artists drew storyboards; they pinned them up on large corkboards and "pitched" them to coworkers. Soundtracks were recorded and edited in advance. The sounds were analyzed down to the increment and the fragments of guttural sounds assigned frame numbers on paper, called grays or bar sheets. A layout supervisor planned the continuity behind the staging in a workbook, which the individual layout artists used to design the staging of each shot. The background painter painted the setting on a registered piece of illustration board with gouache or acrylic paints.

The master animators took the layouts and, with the sound-analysis charts, created the keyframes of the movement. Assistant animators then tightened the rough drawings and supervised breakdown and inbetweener artists to draw the remaining frames the animator called for to complete a movement. This stage was then checked against the soundtrack sheets and numbering corrected. The completed drawings were photocopied, one by one, onto sheets of registered acetate called cels. In some cases people still inked the images onto cels with a brush, crow quill, or Rapidograph pen. Another team of artists created the special effects: shadows, smoke, fire. The character and

effects images on the cels were painted on the back side, so the black outline would still be visible on the top. A technician would calibrate the camera moves to within a hundredth of an inch and a twenty-fourth of a second. A final checker then assembled the entire scene with the completed color background and checked everything for registration and mistakes. Then a polisher would remove fingerprints and lint before it went under the camera to be photographed, frame by frame, onto Kodacolor reversal stock film. All these stages were subject to review by an animation director and administered by the individual department heads.

Since 1937, the animators' unions in LA and New York had negotiated basic agreements and policed wage scales and working conditions. Artists in all categories were proud of their positions and professionalism. You could have a full career in support roles as an assistant animator, scene planner, or final checker. Animators didn't just pop willy-nilly out of school; they began on the bottom rungs and worked their way up. There were classifications for first-six-month apprentices, second-six-month apprentices, and journeymen.

It was the legendary Bugs Bunny director Chuck Jones who said, "*Animator* should be a gift word; you are not really an animator until a wiser, older animator says you are."[3] When you finished your apprenticeship and earned the right to the title of animator, you were proud. From then on your work would be compared to that of the greats of the art form, like Bill Tytla, the animator of *Dumbo,* or Milt Kahl, the animator of Shere Khan in Disney's *Jungle Book*. Films like Walt Disney's *The Little Mermaid* (1989) were drawn and painted just as their ancestor *Pinocchio* (1940) had been.

As late as the 1990s it was commonplace for visitors to cartoon studios to exclaim, "You mean you draw every drawing?" Of course, animation studios would welcome any labor-saving innovations, like improved pencil testers. The Max Fleischer studio had steel ball bearings embedded in the drawing tablets so you could rotate your drawing surface more easily. In the early 1960s Hanna-Barbera invented the system of stock cataloged movements for reuse that became the "limited animation" system for TV.

Despite these innovations, however, no one seriously expected the basic system to change all that much.

What many animators drawing away at their desks may not have known was that animation and CG have always been intertwined. When Bill Hewlett and David Packard started their electronics company in a Palo Alto garage in 1937, their first paying customer was Walt Disney. Walt ordered eight Model 200B oscillators (at $71.50 each) for his planned Fantasound stereo surround sound system for his concert film *Fantasia* (1940). John Whitney Sr. worked for a time at United Productions of America (UPA) on the *Gerald McBoing-Boing Show*. Con Pederson drew inbetweens of Pluto for

Disney cartoons. When Canadian engineer Nestor Burtnyk conceived of the software that made the NFB film *Hunger/La faim* (1974) possible, he was inspired by attending a lecture given by Walt Disney animators. Many of the pioneering scientists of CG, like Ed Catmull, Alvy Ray Smith, and Jim Blinn, had once harbored dreams of being Disney animators. George Lucas took a class at the USC film school with animators Bill Melendez (*A Charlie Brown Christmas*, 1965) and Les Novros (*Universe*, 1961). His very first student film, *Look at Life* (1965), was done in animation, as was Bob Abel's first film project at UCLA.

Live-action movie studios had been dabbling with computers since the early 1970s. Yet despite the predictions of old animation masters like John Halas and Shamus Culhane that computer animation would revolutionize the medium, the animation industry was the last branch of media to fully embrace the new technology. Except for a few experimental shorts, commercial animation producers didn't even begin to consider the possibilities of CG until the late 1980s. There were a multitude of reasons for this, the chief one being the economic climate.

The time period when computers first began to emerge from the science lab into commercial business coincided with Hollywood's lean years. The movie moguls of the 1930s could afford to finance an occasional experimental film because they cranked out so many sausage-mill films to make up the costs. After their theatrical monopolies were outlawed by the Supreme Court's 1948 *Paramount* decision and competition from television increased, the large Hollywood movie studios went into a decline.[4] By the 1960s, as old tycoons like L. B. Mayer and Harry Cohn retired or died, studios began to sell off their assets and be acquired by large conglomerates. One of the first things the studios could drop was their animation units. All the kiddies were home now anyway, watching cereal commercials and low-budget Saturday morning cartoons. One by one the theatrical cartoon units of MGM, Paramount, Columbia, Universal, and Warner Bros. wrapped up their last projects and sold off their drawing desks.

Since the death of Walt in 1966, the chief income earner for The Walt Disney Company had become their theme parks. The aging masters of the Disney animation crew would turn out a feature film every few years for their Disney-loving audience, as if on autopilot. The animation staff had shrunk from a 1940s high of 2,000 employees to barely 175 in 1966. It wasn't until the 1970s that anyone in Disney management seriously entertained the notion that they might need to train new artists for the future.

The film and advertising industries' conventional wisdom in the 1970s was that classic animation was good in its time (the 1930s and 1940s), but it had become too expensive and was too labor-intensive to ever again prove profitable.

If the live-action movie studios were initially reluctant to invest in computer development because of scant entrepreneurial liquidity, animation studios had even fewer

resources to commit. The idea that an animation studio could be found to invest millions of dollars in computer-science-style blue sky research that had only a small chance of actually generating what its promoters claimed was highly improbable.

The earliest drawn art created with a computer was the nonobjective abstract films by artists like John and James Whitney (see chapter 2). In 1964 TV producer Fred Patten got hold of some Defense Department films in the public domain and worked them into a low-budget TV show about science called *The Big World of Little Adam*. These clips included some shots of oscilloscope Lissajous patterns. Not much, but a start. The earliest drawn figure to be animated was done by Charles Csuri in 1967 at Ohio State University. Called simply *Hummingbird,* it was a black-and-white line drawing of a hummingbird in flight, morphed and broken up into its component lines. "I thought the technology had possibilities for character animation," Csuri said. "It took many months and thousands upon thousands of computer punch cards to make the film. I can't believe I had the patience to do it."[5]

For years animators had been going to film festivals where they saw short film experiments with computers like Peter Foldes's *Hunger/La faim* (1974) and Lillian Schwartz' *UFO* (1971). Each film listed in its credits a bewildering litany of new job titles and explained what computer was used, as if the computer itself had an agent who'd file a grievance if their client didn't get its proper credit. As the computer equipment got friendlier to people without PhDs, computer data-storage capacity grew to allow storage of complex raster graphics. These were images with surface textures that could be illuminated like a real object, replacing the glowing outline shapes called vector graphics.

As we saw, the earliest attempt at a CG animated feature film was *The Works,* begun by the NYIT CG Lab in 1974 but never completed. In 1986 New York Tech also tried to a launch a feature called *Strawberry Fields*. Ultimately, it, too, was never finished.

With the more powerful software that enabled the 1980s CG gold rush to occur, animation studios began to dabble in CG film ideas. In 1982 Toronto-based animation studio Nelvana created its first feature film *Rock and Rule* (1982). The villain, Mok, voiced by Lou Reed, consulted a computer that spoke to him through a vector avatar. He was looking for a path to an occult dimension that could only be had by possessing the Yensid Key (Disney spelled backward). To create this effect, Norm Stangl and directing animator Keith Ingham leased time on an Evans & Sutherland mainframe. "The Yensid Key was actually a computer motion-controlled slit-scan created on the Mechanical Concepts Animation Stand. The motion-control software was written and designed by Elicon Control Systems," said Stangl. "The three CG attorneys that communicate with Mock and the angular Mock head while he is driving into Ohmtown were vector computer images. The budget was tight, so we built a simple set of 35 mm high-contrast images for each character that were then

manipulated on an optical printer for basic action with color gels providing the color for the individual characters. As I recall, I did the optical work over at Film Opticals in Toronto."[6]

In France, the first CG animated film was a short called *Maison vole* (House flies), by André Martin and Phillippe Quéau for Sogitec INA, completed in 1983. For the WestStar/Mihanan film *Starchasers: The Legend of Orin* in 3D (1985), the character animation was created traditionally by the Steve Hahn studio in Seoul, South Korea, but Digital Productions animator Bill Kroyer created 3D spaceships and turned them in flight using a computer. The Filmation Studio, which had created the *He-Man and the Masters of the Universe* TV show for syndication, started a small CG team led by Jim Hillin (Digital Productions Inc) and Ken Cope (Symbolics). They created spaceships and stagecoaches for *The Legend of BraveStarr* (1986) TV series and theatrical release. As in the film *Tron*, the CG images for all these projects were not direct renders but wireframe schematics printed out on plotters, then painted and photographed like traditional animation.

Starwatcher, a CG feature based on a story by Jean Giraud (Moebius), started at VideoSystem in Paris circa 1991. This film would have included "traditional computer animation as well as real time CGI animation utilizing proprietary software developed by the company sixteen years ahead of such seen in *Avatar.*"[7] It made it through preproduction but had to be abandoned due to the death of the producer and lack of sufficient funding.

Meanwhile, most traditional animators pooh-poohed each CG project as just another attempt to replace them with a cheap, low-quality alternative. In 1977 engineer Dave Wolf attended a screening of Disney's *Sleeping Beauty* at the USC cinema school. "When the old Disney guys asked for questions, I asked if they could see a role for computers. Immediately, I got a lot of ugly looks from everyone."[8] Frank Thomas and Ollie Johnston, perhaps the best known of the Disney animators called the Nine Old Men, initially dismissed CG. Thomas said, "Well, to be an animator you had to be a really solid draftsman. With a computer you don't have to be able to draw your ass."[9] Johnston said, "What you could not put in the 3d animation was the charm and magic achieved through graphic cheats that are only possible in 2D drawing." It seemed foolish to them to spend so much on technology just to re-create what they could already do with a humble pencil. "Old fashioned animation has more control and more freedom, and also offers a greater range of expression."[10]

But even Toontown had a growing digital underground. Young animators like Randy Cartwright, Mike Cedeno, Phil Nibbelink, Tina Price, and Randy Cook, among others, all accepted that computers were something they could work with. Disney animator Randy Cartwright had taken a class in Fortran at Cal State Fullerton in 1971: "I learned some BASIC. You had to know programming then to do anything. I felt like I was in a desert drinking water. I absorbed it all."[11] As the demand for quality

Figure 12.1
Bill Kroyer's Oscar-nominated short *Technological Threat*, where cartoon office workers fear of being replaced by automated workers.
Courtesy of Bill Kroyer.

animation grew in the 1980s, these intrepid toonmeisters began to lobby their respective employers to work CG into the production process.

But how? Since the common perception of computers then was that they were glorified adding machines, the first place animation producers thought they could be useful was in the production offices, to maintain tracking systems.

As anyone who has worked on large film projects knows, no matter how many talented artists you have, films get completed on time and on budget thanks to good infrastructure. A producer and director need to know where every shot is in the production pipeline at any given moment. For a feature film, this means keeping track of over 1,550 individual shots and thousands of feet of film, all being worked on by hundreds of people at various stages. TV series are even more complex, because they involve repeating locations and actions for anywhere from six to sixty-five half-hour episodes. For years, studios improvised their own tracking systems—shooting logs,

continuity specialists, production flowcharts, even the occasional savant with a really good memory.

So the first tabletop computers to appear in animation studios came into the production offices. Some Commodores and Amigas, but mostly the sturdy Macintosh from Apple. Those grey little plastic breadboxes dotted most of the production offices of Toontown. During DreamWorks Animation's first year, when Paul Allen of Microsoft was toured around the studio, he was heard to joke, "What are all these fucking Macs doing here?" Starting with Walt Disney's ATS (Animation Tracking System), proprietary production-tracking systems were given colorful names like Taz (Warner Bros.), Nile (Dreamworks for *The Prince of Egypt*) and FAME (Feature Animation Management Engine, also Disney).

The next place computers were used was to help with testing animation. For the first seventy years of cartoons, animators sent their drawings out to be shot on film downshooter cameras. The artist might have to wait as long as twenty-four hours to see his or her test results. In 1978 a company named Lyon/Lamb marketed a video downshooter with single-frame capacity that quickly became an industry standard. The reel-to-reel videotape was soon replaced by three-quarter-inch video cartridges, then VHS videocassettes. By the early 1990s animation studios were developing custom-made systems using small video-surveillance cameras that stored animation tests digitally. While not providing good enough picture quality to use as final footage, these systems helped with approvals and revisions. In 1998 Animation Toolworks marketed the Video Lunchbox, a retail system so cheap and basic it could be set up at home. It shot single frames and stored the footage as an electronic file, which could be saved onto a videocassette later or simply discarded. This was a great boon to students and freelance animators. Disney animator Randy Cartwright adapted a Finnish pencil test system for Disney animation to use in all their great movie musicals of the 1990s, like *Aladdin* and *The Lion King*. "I had a Mac on my desk and I wanted to create a pencil tester," he explained. "I got the studio to buy a pencil test system for Mac written in BASIC by Jan Eric Nystrom. I got the source code and adapted it to show animation running at twenty-four frames per second."[12]

An additional task for computers was doing the drudge work animators hated to do, namely drawing hard-shaped graphic objects—vehicles, geometric backgrounds, corporate logos. Drawing such things to the exact proportion in perspective freehand was tedious in the extreme. I once had to animate a commercial for AC Delco auto parts where I had to turn the Delco logo in space and morph it into a spark plug. It took me much longer to do that than to do the characters singing around it. In the Richard Williams–directed *The Adventures of Raggedy Ann and Andy* (1977), animator Michael Sporn had to draw an ornate antique cuckoo clock turning 180 degrees in perspective. None of the Roman numerals on the clock face could be seen to tremble when projected in wide screen Panavision. It took weeks of very hard concentration to make it work.

Walt Disney Studios solved this problem by filming toy models on high-contrast exposures and then printing them out as stats to be painted to match the 2D art. Cruella De Vil's sportscar, Stromboli's wagon, Cinderella's pumpkin coach, and Prince Eric's ship in *The Little Mermaid* were all done this way.

Walt Disney Imagineering (WDI) was the arm of the company that focused on designing the amusement parks. They had been experimenting with CG imaging since the late 1960s. Imagineer Dave Snyder recalled: "Around 1972 we had a Honeywell 516 computer, and a calcomp plotter. We tried drawing some Disney characters on it and drew a proposed castle for the center of Epcot Center (the Sphere went there instead). We made some stick figures dance. Disney had the chance to move radically in the area of computer graphics, but they didn't want to do it. The party line with those guys (management) was that computers were good for crunching numbers and payroll, but that was about it. . . ."[13]

In April 1983, shortly before John Lasseter was given his walking papers, Walt Disney Studios purchased two IMI computers with calligraphic display, one megabyte of memory, and ten megabytes of disc space. "The IMI was a box with sixteen knobs on it," animator Steve Segal said.[14] One was given to Imagineering. Scientific Systems Division manager Nick Mansur told his team, "This machine came in. Anyone want to work on it?" A young man named Tad Gielow raised his hand. Recently graduated from Cal State Northridge, Tad had done word processing at a division of Raytheon and had joined Imagineering to work on arcade games for the Future World section of Disneyland. After creating software for architecture previsualization for proposed new buildings for Epcot, he thought, "I'd like to see what this 3D stuff can do with animation." He got into a conversation with some other techs working on the big-budget animated feature *The Black Cauldron* (1985).

The Black Cauldron, based on Lloyd Alexander's *Chronicles of Prydain* novels, had been in production for seven years, going through multiple script treatments.[15] During that time it went through a lot of staff changes and a lot of cooks pulling in different directions. Directors Ted Berman and Richard Rich asked to get the multiplane camera out from storage to create some shots. The multiplane was a device invented at Walt Disney in 1937 to simulate the illusion of depth using 2D flat art. This was done by mounting a camera vertically to shoot down through layers of background art painted on glass, all moving to precise calibrations. The multiplane was expensive to use, and Walt had it mothballed after *Lady and the Tramp* (1955). When they tried to get it running again for *Cauldron*, they discovered hardly anyone remembered how to use it and no one had left behind any written directions. Producer Joe Hale finally reached out to the scientific team at Imagineering. Tad Gielow wrote some code to simulate the same effect: "I sat at a computer screen with a scene planner [a 2D technician who plots incremental camera movement] and previewed with them what the move would

be. If approved, we would then print out the coordinates and the layout positions as a reference guide that would then be done manually."[16] Similarly, Chief Engineer Dave Inglish, now in charge of the team, used their IMI 500 to create simple animation for the cauldron, a boat, and a glowing magic bauble that Princess Eilonwy possessed.

Although ultimately *The Black Cauldron* was a critical and financial disappointment, it had the very first CG work ever done at the Walt Disney animation studios.[17] For Disney's next film, *The Great Mouse Detective* (1986), they moved Inglish's unit with their coffee-table-sized computer to a room that was once the ladies' lounge area in the back of the Ink and Paint Building.[18] "My modeling program was a sheet of graph paper. We were given a four-by-six-foot digitizing tablet," Gielow said.[19] Directing animator Phil Nibbelink became the key creative artist on the project. Randy Cartwright urged production manager Ed Hansen to adopt the new CG techniques to make layout and staging ideas move more smoothly, but Hansen resisted such changes.

Meanwhile, in the executive offices, Roy E. Disney wrested control of the company away from Ron Miller and forced his resignation in 1984, after a celebrated corporate battle.[20] Roy brought in the team of Michael Eisner and Jeffrey Katzenberg over from Paramount. He charged the two with turning around the fortunes of the Mouse Empire, which had sunk to fifteenth in overall box office receipts and were producing flops like *Condorman* (1981). The joke around Hollywood was "some people work at Disney, and some people work in film." Eisner and Katzenberg reformed things with an alacrity that had some of the old Mouseketeers' heads spinning. Within two years Walt Disney was back to number one. One thing Roy Disney was passionate about was what he called the Heart of the Company. "We're getting back in the animation business," he said. Ed Hansen took his cue to retire, along with many of the older production executives. In a place that still relied on hand-crank pencil sharpeners, the gloves were off to develop new technologies. Two Amiga computers were put in for the animation department to use. Animator Tina Price recalled, "I got hooked while we were on a nine-month hiatus awaiting the script approval of *Oliver & Company*. At that same time, Tad Gielow moved from his previous location into the animation department on Flower Street, with one SGI that was named *Minnie*. I was glued at his side, eager to learn more about this new tool."[21]

While others were deciding what the computer crew could do on *The Great Mouse Detective*, layout artist Mike Peraza worked on the idea of a duel between Basil, the hero, and the evil Dr. Ratigan on a huge, life-size chess set. But as the story developed, the location for the climax shifted to inside the giant clock tower of London's Big Ben. Peraza was sent to London with a team to do research for the film. He was given unprecedented access to the clockworks inside Big Ben. The problem was, he had to rush in between chimes and complete all his research notes, sketches, and photos within one hour. If he stayed any longer, the bell would deafen him![22]

Back in Burbank the directors asked the CG team if they could create a convincing clock mechanism that the characters could move around in. They said of course they could. After the directors left, Gielow turned to Dave Inglish and smiled. "Well, Dave, how the hell are we going to do this?"

Before Internet searching was available, getting research on clockworks was not easy. Fortunately they shared their building with a machine shop that serviced the cameras on the studio lot. Upon request, a studio mechanic plopped on Gielow's desk a pile of catalogs that showed dozens of gears and how they interlocked. They made a line test of three interlocking gears and a camera move flying through the teeth. The directors were impressed and gave it the green light. For the next six months the CG team worked with sequence director Phil Nibbelink. "Phil and I would sit together and go through each scene," Gielow recalled. "I would take a pass at the camera move on the IMI. Once it was worked out and approved, I had to transfer the animation info to an HP computer that ran the Fortran rendering software MOVIE.BYU. The scanners would print out the gears as black-and-white line drawings on paper. These were then xeroxed on to acetates, and painted like traditional animation."[23] Animator Dave Bossert recalled, "The initial print quality of the scans were abysmal. Many faint lines breaking up. A number of traditional effects artists needed to redraw over the scans so that they could be painted. Because of the large size of the area to be painted one color, we resorted to using a color card behind it." All these lessons learned proved invaluable to Disney later in developing their hidden line software.

One day disaster struck because of the studio's old policy of frugality. Not realizing the importance of air conditioning for computer circuits, a janitor closed the door to the computer room at the end of the workday, cutting it off from the building's central air conditioning. "Next morning I entered the room to the smell of burned capacitors," Gielow recalled. "Everything had overheated and all the previous day's work was lost. One new circuit board on the IMI cost $10,000 to replace."[24]

Despite these glitches, *The Great Mouse Detective* was a critical and financial hit and was considered an important step on the road to recovery for the House of Mouse. The Big Ben clockwork sequence in particular was signaled out for praise. For *Oliver and Company* (1988), the studio expanded the team to create New York City traffic and subway tunnels. They sent some of their young staff of animators to the Art Center of Pasadena to be tutored in state-of-the-art CG techniques. There they attended lectures by Jim Blinn and Charles Csuri. Another small team of animators was sent to Wavefront in Santa Barbara for training, Tina Price among them. Further training occurred back at the studio, taught by Vibeke Sorensen of CalArts. "I started by saying to them, 'Computers are stupid, you are intelligent. You have to tell computers everything. I am going to explain to you how they work so you don't think they are smarter than you. You won't need to use this information, but you should have it so you know you can understand it if you want or need to. I will also show you how your vision

Figure 12.2
Walt Disney CG designer Tad Gielow working on the Big Ben clock wheels for the climatic scene
of *The Great Mouse Detective* (1986).
© Disney. Courtesy of Tad Geilow.

and ideas can drive the technology and how you can be in the driver's seat, where
you can really use your skills and creativity and where the opportunities are for
improvement.'"[25] One day Randy Cartwright was trying to animate some characters
on his computer when he noticed Michael Eisner standing over him. "What are you
doing?" Eisner asked. "I'm attempting some 3D animation," replied Cartwright. Eisner
responded, "Well, then figure out a way to do without those big glasses. No one likes
wearing them!" Eisner was confusing this type of character work with 3D stereo-optical
filmmaking.[26]

The growing CG unit followed the animation crew from the main lot over to 1420
Flower Street, a series of converted warehouses close to Walt Disney Imagineering.
They were now called Animation Technology.[27] The team was composed of Mark
Kimball, Lem Davis, Dave Inglish, Dylan Kohler, Jim Houston, Bob Lambert, M. J.
Turner, and Don Iwerks (Iwerks left in 1985 to form his own VFX company, Iwerks
Entertainment). They were joined by a team sent down from Pixar to develop the
digital paint system. By now the old IMI computer was replaced by a more advanced
SGI Iris 2400 Turbo, featuring Bill Kovacs's Wavefront imaging software. Kovacs even

lent the source code, so the team could adapt it for a plotter. In return, Kovacs could use what the Disney guys worked out for CADCAM architecture. There was much confusion at this time over "where this new tool" belonged in the animation pipeline. Was it a special effects tool? Was it a system administration tool? No one even knew what to call the department. As more interest and more training ensued, two teams began to form: the animators who used the computers and the technology group. Tina Price represented the former and was promoted to head of the department in 1986. She became an invaluable conduit between the tech people and the artists. She could get through to the crux of any problem and translate one group to the other. Until then, all the CG elements, over a thousand feet of film on *Oliver and Company* alone, was still being printed out on paper and inked and painted the old-fashioned way so that it would blend in artistically with the rest of the film.

While *Oliver and Company* was in production, the suggestion was made to try to create a short film with CG characters, much like John Lasseter had just done with *Andre & Wally B.* CAPS lead architect Lem Davis came up with the idea of boy and girl junkyard dogs who fall in love and are menaced by a monster made of junk. They called it *Oilspot and Lipstick.* Although he was the originator of the project, Davis knew enough to know he did not want to direct the film. Veteran animator Michael Cedeno directed a new group of young animators and technical directors who were inspired to create CG characters. They were nicknamed "the Late Night Crew" because of the long hours they put in. The junk monster was made out of leftover car and truck rigs from *Oliver and Company,* including the rig of the villain Sykes's limousine. Gielow recalled, "I wanted ink lines on the 3D characters, so they would blend in better with a 2D drawn look."[28]

During the early meetings on the story the team was visited by an efficiency expert hired to study company operations. The expert listened for a while, then erupted, "What the hell are we making a short for? There's no money in shorts! This is all just ego-gratification!" Roy Disney, who disliked confrontation, sat quietly in the back of the room, puffing his unfiltered Camel cigarette. After the man's outburst, Roy stood up and quietly left the room. No one knew what was said, but the next day the efficiency expert was gone.[29] *Oilspot and Lipstick* went on to win a number of awards.

Around the same time, another area where Roy Disney wanted particular attention to be paid was the so-called back end of production. On a typical animated movie the largest department was ink and paint, the people who traced or photocopied animators' drawings onto clear acetate cels and painted them. This team was usually twice the size of the animation team. Other studios tried to cut costs by farming out ink and paint work overseas, where the labor was cheap. But the quality of the animation suffered because the overseas artists were paid for the quantity of their footage, rather than the quality. Dave Inglish recalled "Eisner and Katzenberg had originally wanted to send all our (Disney) ink and paint to Korea. (A portion of *The Little Mermaid* was

Figure 12.3
Oilspot and Lipstick.
© Disney. Courtesy of Jerry Beck.

painted in China.) We took some *Cauldron* elements and sent them to be scanned and painted at Pixar using their imaging software. It came back with no degradation of quality. We put together the financials and pitched the concept to the studio. That will allow us to keep everything here."[30] Pixar itself was struggling financially, and many agree that if Roy Disney had not pushed for the formation of a collaboration with them to create a digital paint system, Pixar probably would have gone under.

As early as 1973, Dick Schoup's team at Xerox PARC had developed Superpaint, the first digital paint-texture mapping software. After leaving PARC, Alvy Ray Smith continued the work at NYIT, where he developed Big Paint. These systems were followed the one Mark Lavoy and Donald Greenberg developed at Cornell University. Animation studio Hanna-Barbera, which did as many as twelve series of thirteen half-hour TV shows each year, funded research on the animation paint issue. The system was called Video Synthesis. The first Hanna-Barbera TV show to be painted with it exclusively was the 1987 season of *The Smurfs*. Despite accidents like an electrical storm that once overloaded their circuitry and wiped out their files, it was considered a success. Cambridge Systems UK worked on developing a paint and inbetweening

system. At the same time, Metrolight marketed a paint system that ran on HP systems, called Metrocel. Much of the TV series *Ren and Stimpy* (1991–1992) was painted using Metrocel. John Whitney Jr.'s USAnimation developed its own system, which was used to color the Turner Animation film *Cats Don't Dance* (1997).

Barry Sandrew had been a doctor of neuroscience at Harvard, when his interest in medical 3D reconstruction led him to develop a process to digitally colorize film. He was approached by Sid Luft, the husband of Judy Garland, to use his process to colorize old black and white classic movies. In 1987 he founded American Film Technologies in San Diego. His first effort was the Bing Crosby film *The Bells of Saint Mary's* (1945), which was quite popular.[31] Movie mogul Ted Turner heard about AFT and soon had them colorizing thirty-six movies a year. Future Visual Effects Supervisor Doug Cooper got his first job at their Sorrento Valley offices colorizing movies. "We used an architecture CAD, and moved around a sliding puck digitizer in place of a stylus."[32]

But soon the novelty for colorization of old movies waned. Ted Turner was convinced against further colorization by film directors like Martin Scorcese and Woody Allen. Supposedly, Orson Welles on his deathbed said "Keep Ted Turner and his crayons away from my movies!" Sandrew decided coloring animation was the next logical place AFT could go. Since their colorizing process was vector-based, it could easily be adapted for flat drawings. Shauna Teeven recalled "They did the second season of *Attack of the Killer Tomatoes* (Fox 1991) which before had been done all in Korea. *Tomatoes* was the first cartoon hand drawn on digital tablets into the computer. Barry's plan was to somehow get to point where we could do a hi-rez something. But we got off-track trying to do tests of hi-rez film restoration and hi-rez 2D animated colorization."[33] After producing a short, *Diner* (1992), based on cartoonist Gahan Wilson's designs, AFT focused on animating and scanning in the 2D artwork for the Steven Spielberg–produced *We're Back (1993)* with Amblimation (UK).

But after that film, Amblimation switched first to Softimage-Toonz, from Italy. Then when Amblimation moved to LA and formed the base for the new company Dream-Works Animation, they switched again, this time to the Cambridge System, renamed Animo. DreamWorks redesigned Animo software to become their own in-house system.

By 1989 the Disney system was ready. It was called CAPS (Computer Animation Production System). The team led by Bob Lambert collaborated with the Pixar engineers to adapt the paint system into the regular animation production pipeline.[34] Animator Randy Cartwright served as an artist liaison to help train the veteran painters in CAPS. "Our motto then was, if it's easy for the programmer, then it would be harder on an artist. It eventually got to the point where we had painters come in, and we'd have them painting digitally in an hour." The last shot of *The Little Mermaid* became the first CAPS shot: King Triton and the merpeople waving goodbye to Ariel

and Eric as they sail away. As such, *Little Mermaid* has the distinction of having the first digitally painted scene as well as the last work done by hand-inking—the underwater bubbles. Disney's next animated feature, *Rescuers Down Under* (1990), became the first animated feature where CAPS came on line to fully manage production data and paint the film entirely in the computer. The opening shot of *Rescuers* was a dynamic tracking shot at breakneck speed, skimming across the grasslands of the Australian outback. Its simulated depth totally surpassed anything the old multiplane camera could do, making one of the most difficult shots to achieve in animation one of the easiest. After that, there seemed no turning back.[35]

While all this was taking place, hand-drawn animation was enjoying its own renaissance. Films like *An American Tale* (1986), *Who Framed Roger Rabbit* (1988), *The Little Mermaid* (1989), *Beauty and the Beast* (1991), *FernGully: The Last Rainforest* (1991), and *The Lion King* (1994) packed theaters around the world and sold millions in toys and games. In these films CG played an increasingly important role. From just two people in 1984, Disney Feature Animation's CG Department continued to grow to suit the demands of production. It was augmented by more CG talent to design more-complicated effects in the films: Scott Johnston from Brown University, Jim Hillin from deGraff/Wahrman, Steve Goldberg from PDI, Linda Bell from Omnibus, James Tooley from Florida, and Kiran Joshi from Nepal via Cal State University, Long Beach. Tad Gielow was sent to build Disney Florida's animation unit. Dan Phillips, formerly the creative head of Omnibus, was bought in to manage the group's responsibilities on multiple films.

Walt Disney's classic *Beauty and The Beast* began with an enormous camera pullout from the stained glass into a long shot of the Beast's castle. Dan St. Pierre, the layout artist who designed the shot, would pass my desk. "Crashed the system again . . . ," he would say with a wry smile of satisfaction. One of the big highlights in the film was Belle and the Beast waltzing together to the film's signature song as the ballroom turned around them. The ballroom sequence was the result of months of work building the ballroom and plotting the close sync of the 2D and 3D elements. A lot of incidental dishes and silverware in the "Be Our Guest" number were CG animated also.

CG designer Scott Johnston recalled, "The transition to digital ink and paint and compositing allowed the CG artists to render their work and composite it with the other elements. No longer did the pen plots have to be put onto cels and painted by hand. Plots were still used so that animators could register their drawings with their CG counterparts. Rendering the background opened up a world of possibilities, including the ornate ballroom CG from *Beauty and the Beast*."[36] *Beauty and the Beast* was a huge hit, which made many skeptics in Hollywood begin to look at CG seriously.

Then, for *Aladdin* (1992), the Disney CG department created the talking tiger head and Cave of Wonders with character key poses by Genie creator Eric Goldberg, com-

Figure 12.4
Beauty and the Beast (1991) the Ballroom Sequence.
© Disney. Courtesy of Jerry Beck.

pleted by Steve Goldberg (no relation). The character of the Magic Carpet, drawn by Randy Cartwright and completed in 3D by Tina Price, was conceived as a more purely CG character, worked into the 2D format. He moved like a traditionally animated character but with a complex Persian rug pattern texture mapped onto him. Tina Price recalled, "Upon the film's completion, Ron and John [directors John Musker and Ron Clements] showed the film to Chuck Jones. . . . When the lights came up in the theater the first question Chuck had was, 'What team of clean-up people in Japan did you get to draw the pattern on the carpet?'"[37]

The goal was to seamlessly blend the CG with Disney's classical 2D animation. Jeffrey Katzenberg would overlook the process and goad them: "Nah! That looks too computery!" When he expressed that concern on the talking tiger head cave sequence, the solution was to mask it with a sandstorm. For *The Lion King* (1994), Scott Johnston and Kiran Joshi worked with traditional animator Ruben Aquino to create the film's Wildebeest Stampede sequence. Its use of large crowds of characters presaged the program Massive, used for the Lord of the Rings trilogy seven years later. Pretty good for a studio that in 1961's *One Hundred and One Dalmatians* had an animator who worked for a year just on drawing the spots on the Dalmatians! *The Lion King* became the first animated film to compete with live action films for the Oscar for Best Visual Effects. For the 1999 film *Tarzan,* a CG team created an effect they called Deep Canvas. It was a way to texture map traditionally painted background art to give a feeling of 3D depth and space.

Disney Animation seemed to percolate with new ideas. Studio chiefs Peter Schneider and Tom Schumacher would ask in production meetings, "Are we breaking any new ground here?"

While the Disney CG team did great work, their unit faced a glass ceiling familiar to other CG innovators. Just as George Lucas intended his Lucasfilm Graphics Group limited to improving postproduction, Walt Disney Feature Animation initially preferred using CG primarily to support their traditionally drawn feature films. Something to cover difficult camera moves and offer an expanded choice of colors, but nothing more. With hand-drawn animated features doing so well, management had little interest in doing the type of CG movies that Pixar was doing.

By the end of the 1980s many of the high-flying VFX houses dabbled with the idea of doing an animated feature. The problem was, since the OmniBust downturn in 1987, most studios were living hand to mouth, just breaking even on piecework. ILM was the big exception, because they could command top dollar for their work.

In 1985 Pacific Data Images had set themselves a long-term goal of creating a 3D animated cartoon feature. Carl Rosendahl said, "We knew we couldn't attempt such a project until we had built a tool-base first."[38] They did a lot of VFX work and mastered motion capture and morphing. By 1991, Richard Chuang created a production pipeline. But their goal was still to get to the point where they could create true animated characters. Richard Chuang said, "It wasn't an effect or a morph, but to create a living character who would transfer an idea." Rosendahl recalled, "I always knew we had to go with a major movie studio." Pixar was working with Walt Disney; Digital Domain had a connection through James Cameron to Sony Pictures Entertainment.

The opportunity came in 1995, when Walt Disney studio chief Jeffrey Katzenberg left the company after his acrimonious split with Michael Eisner.[39] While they battled in the law courts, Katzenberg formed the new studio DreamWorks SKG with his friends Steven Spielberg and David Geffen. They prepared to compete on all fronts: feature films, television, interactive media, and animation. A DreamWorks animator came out of an early staff meeting and said, "So what I got out of that meeting was this is a place where we can create as artists, share our dreams, . . . oh, and we also need to kick Disney's ass!"

Katzenberg built a traditional animation unit out of Spielberg's Amblin UK team and talent who joined him from Disney. Their first efforts were with big-budget, high-quality traditionally animated films like *The Prince of Egypt* (1998), *The Road to El Dorado* (2000), *Spirit: Stallion of the Cimarron* (2002), and *Sinbad* (2003). These films earned good critical reviews but generated only moderate enthusiasm with the public. Then the success of Pixar's *Toy Story* in 1995 changed the game. Everyone in Hollywood was suddenly dabbling in the new CG technologies. Glen Entis, one of PDI's founders, had moved on from the Sunnyvale partnership and was hired by Dream-

Figure 12.5
The original PDI character group. L–R, Tim Johnson, Rex Grignon, Dave Walsh, Glenn McQueen, Raman Hui, Carl Rosendahl.
Courtesy of Rex Grignon.

Works to build their interactive division. In October 1995 Entis was having a breakfast meeting with Sandy Rabins, a DreamWorks producer who had followed Katzenberg over from the Mouse House. "Sandy was pumping me for information on key PDI personnel and how we could convince them to jump to DreamWorks. I said that instead of dismantling that studio straw by straw, why not simply buy into it? PDI was about to go public, this would be a good time to form an alliance."[40] DreamWorks had seen PDI's CG Homer Simpson in *The Simpsons* Halloween special. A meeting was soon set up. DreamWorks acquired a 40 percent stake in PDI and two years later bought it outright.[41] In 1997 Carl Rosendahl decided to retire, saying, "I liked growing companies. By now, it was more about managing things, so I decided it was time to go."

Jeffrey Katzenberg offered PDI a choice between two projects: a comedy called *Antz* with a Woody Allen–like character or a project about an ogre, called *Shrek*. At that time *Shrek* was just a little six-page children's book, with much of the film project still undeveloped. PDI decided to go for the *Antz* film. "Two years later we had a feature film done, and the *Shrek* group had a ninety-second test." *Antz* had been conceived as a vehicle for a comedy pairing Woody Allen and Arnold Schwarzenegger.

Schwarzenegger eventually passed on the film, and the character was voiced by Sylvester Stallone. As production began, it was realized that Pixar was creating a similar story set in the insect world, titled *A Bug's Life*. For many years Pixar and PDI had been like sister studios, sharing personnel, socializing, and even cosponsoring SIGGRAPH parties. But now the two studios found themselves caught in the crossfire of the epic duel between Disney CEO Michael Eisner and Jeffrey Katzenberg.[42]

Until then, John Lasseter of Pixar had enjoyed the tough creative exchanges he had with Katzenberg on *Toy Story*. Alvy Ray Smith recalled, "You better believe he [Jeffrey] was a tyrant . . . but his instincts were usually right on."[43] Now Jobs, Lasseter and Catmull were appalled when they realized Katzenberg was maneuvering *Antz* to a theatrical release date calculated to one-up *A Bug's Life* and make Pixar's effort look like an imitation. Lasseter phoned Katzenberg, and tempers flared. Katzenberg coolly responded, "Hey, guy. Nothing personal. Just business . . ."[44] But that wasn't good enough for Jobs, Lasseter or Catmull. Even though both films got their release and made money, the bad feelings remained for some time.[45]

In the 1990s DreamWorks, Pixar, and Disney, as big as they were, were still not as huge as the world's largest media conglomerate, AOL/Time Warner. Yet despite the great tradition and brand loyalty to the Warner Bros. characters Bugs Bunny and Porky Pig, the studio's senior management had an indifferent attitude toward their animation output. Back in the 1940s Chuck Jones had joked that for all the Warner Bros brass knew, they made Mickey Mouse. After shuttering most of their operations in 1964, they had restarted their animation division in 1985 and had success with new TV series like *TinyToon Adventures*, *Tasmania*, and Bruce Timm's *Batman*. One of their animation directors, Russell Calabrese, had gained CG experience from working in the New York studio R. Greenberg and Associates. He began to bring in his own Macintosh to work. "I think I [was] the first person to bring a computer into Warner Bros. [animation]," he recalled. "On *Pinky and the Brain* I was working out layouts in a simple 3D program called Vertus Walkthrough and would print out on plain paper and we'd draw over the printouts or work over them in Photoshop. I also used Photoshop for coloring background keys, turning day scenes into night, and for animating special effects like film burning [when] caught in the projector. I did an airplane landing in perspective in the short *Invasion of the Bunny Snatchers*."[46]

The two bright results of these ventures from Warner was an experimental short film, *Marvin the Martian in the Third Dimension* (1996), directed by Doug McCarthy, and Brad Bird's *The Iron Giant* (1999). The *Marvin the Martian* short was the first 3D stereoscopic short undertaken since Friz Freleng's *Lumberjack Rabbit* in 1953. Warner employed nine different studios, including Metrolight and Santa Barbara Studios.[47] The great stride in CG in *The Iron Giant* was the consummate acting of the CG giant, matching perfectly with the 2D character animation. This was thanks to further development in the 2D shading software by a team led by Disney vets Tad Gielow and Scott

Johnston. This system was further refined on the film *Osmosis Jones* (2001), when the figure of Drix, voiced by David Hyde Pierce, was ably animated in 3D CG to match with the traditional character work of the Chris Rock–voiced Ozzie. Unfortunately, both films suffered weak box office.

Warner management brought in former Disney executive producer Max Howard to build a feature animation unit, as he had built Disney's Orlando studio. But after a few film projects, they scaled back to distribute outside works like George Miller's *Happy Feet* (2006), done in Australia. Likewise, they spent $150 million to build Warner Digital, a CG effects unit to rival Sony Imageworks, then changed course and laid them all off. While their television animation unit operated year-round, for theatrical projects Warner Bros. preferred the live-action model: assembling crews as needed on a project-by-project basis.

At the same time Sony Studios created a feature animation unit adjacent to its Imageworks VFX studio. They produced a number of animated features: *Open Season* (2006), *Surf's Up* (2007), *Cloudy with a Chance of Meatballs* (2009), and *Hotel Transylvania* (2012). Nickelodeon created several feature films based on their successful TV series, like *Jimmy Neutron: Boy Genius* (2001).

By this time, what had made a lot of this CG movie production even possible was the first truly successful CG feature film, Pixar's *Toy Story* (1995). Its genesis is part of the story of the key time period of the digital revolution in media, that of the Conquest of Hollywood.

13 Pixar

Pixar is the single clear lens thru which everything can be seen.
—Glen Entis

Palo Alto, summer 1985. After a convivial vegetarian lunch, two men strolled along a path thickly overgrown with weeds by the Cal Trans commuter rail tracks that snaked down from San Francisco. Hard to believe this lush vegetation was a short distance from the gleaming glass megaoffices of Silicon Valley, the front lines of the information revolution.[1]

One of the men was Steve Jobs. In a few short years the young college dropout had built Apple Computer from a small hobby-kit business to a global empire. He had made himself a millionaire by bringing high-end computing to the masses. He took computers out of the science lab and made them necessary home appliances, and in so doing he established a personality cult rare among the gray-suited denizens of the corporate community. He encouraged his employees by saying that they were not just selling a product, they were "changing the world." By 1982 Jobs was on the cover of every magazine in America. He just missed being *Time* magazine's Man of the Year because the editors decided to pick the less controversial and more generic "the computer" instead. Jobs's more taciturn creative partner, Steve "Woz" Wozniak, had pulled back from the day-to-day razzle-dazzle of running Apple. He preferred other pursuits, like teaching children about computing.[2]

But by 1985 the fortunes of Apple Computer had begun to falter. They faced strong competition from Microsoft, Dell, IBM, and Commodore. The average non-tech-savvy John Q. Public was still trying to figure out why they needed a computer at home in the first place. Remember, private Internet websites and e-mail were still several years in the future. Jobs knew he needed more-seasoned business acumen to manage Apple. So he convinced Pepsi executive John Sculley to take the helm. Sculley was well known as a marketing whiz; he had originated the wildly successful "Take the Pepsi Challenge" campaign. Jobs approached Sculley with his usual utopian flair: "Do you want to spend the rest of your career peddling flavored sugar water? Or do you want to

Figure 13.1
The Pixar executive team, Ed Catmull, Steve Jobs, and John Lasseter.
© Pixar. Courtesy of Pixar.

come with me and change the world?" After settling in at Apple and examining all the problems there, Sculley's solution was to fire Jobs.[3] He and other members of Apple's Executive Board found Jobs's executive style too chaotic, narcissistic, unpredictable, and off-putting. Jobs's old boss at Atari, Nolan Bushnell, recalled, "If he [Jobs] thought you were a dumb shit, he'd treat you like shit. That pissed certain people off."[4] One Apple exec put it bluntly: "Steve Jobs and management is an oxymoron."

So if anybody's world was changed, it was Steve Jobs's. As bitter as Napoleon on Elba, Jobs trudged along the train tracks while he discussed his options with Alan Kay. The two had been friends for years, and Jobs credited Kay in part with sharing the breakthroughs on graphic-user interface that Kay's team had developed at Xerox PARC.

It's interesting how Alan Kay always seemed to appear at just the right moment to influence the development of CG. The man who conceived of the laptop computer had been at Douglas Engelbart's famous demonstration of personal computing in 1968, he attended the University of Utah's computer science program with Evans & Sutherland when the key tools of CG were being conceived, he was at Xerox PARC when they began to develop color imaging. He had advised Steve Lisberger to do the visual effects for *Tron* using CG. In 2008 Jobs gave Kay an iPhone, and Kay said, "Make the screen five inches by eight inches and you will rule the world," inspiring the iPad.[5] And here in 1985 Kay played midwife to the birth of a new company. As they strolled the quiet green pathway, Kay mentioned that his friends at Lucasfilm had told him that George Lucas was intending to sell his computer animation division. Perhaps if Jobs picked that one up, it might be a new venture for him?

Fifty miles to the north was ILM Building C on Kerner Boulevard. Within, the group of former NYIT computer scientists known as the Lucasfilm Graphics Group were aware that Lucas was intent on selling them off.

Despite Lucas's cool reaction to *Star Trek II's* Genesis effect, Ed Catmull and Alvy Ray Smith continued to hope they could convince him of the value of making CG film. Smith and Catmull thought to demonstrate CG's advantages for making a character by creating a bit of classic old-style cartoon animation. Smith created a storyboard for a short about a funny android, titled *My Breakfast with Andre*, in homage to a film they admired, *My Dinner with Andre* (1981). Andre-Android . . . get it? But recalling their bad memories of the *Tubby the Tuba* debacle at NYIT, Smith and Catmull realized they should get a more experienced cartoon animator to give their technology the cinematic polish it deserved.

That element appeared when Catmull went to speak at a computer conference in Long Beach being held on the old ocean liner the *Queen Mary*. There he ran into the young animator John Lasseter, who had been let go by the Mouse House. At one point Catmull excused himself to telephone Smith: "Alvy, guess what. I just saw John Lasseter, and . . . he's not at Disney anymore." Smith erupted exuberantly: "Ed, get off the phone and go hire him. NOW!" Catmull replied, "Yeah, I know . . . just making sure you agreed."[6]

Lasseter had been part of the CalArts Disney trainee program and had learned traditional animation skills from the retiring master animators of Disney's golden age. All his life John Lasseter had wanted to be a Disney animator. But after seeing his friends working on *Tron*, he was intrigued by the potential of computer graphics. Smith said, "A lot of animators were scared to death of computers, but he got it, he could see it."[7] Lasseter decided to commit his lot to making CG. After leaving Disney, he worked for a time with London-based animation master Richard Williams and had hung out at the CG powerhouses Robert Abel & Associates and Whitney and Demos's

Digital Productions. Sherry McKenna recalled, "Bob Abel so wanted to hire him, and John really thought about it. He was so talented. And he was so smart. But then John got this offer to go up north and do whatever he wanted. And budget didn't really matter."[8]

For some time ILM had not placed a big emphasis on character animation. They employed great artists, but no star animators like Glen Keane or Eric Goldberg. They never quite accepted the idea that character animation was anything more special than a particular type of VFX trick. To hide the fact that they were hiring a cartoon animator, Catmull and Smith weren't even allowed to officially call Lasseter an animator. His official title was "Interface Designer." Lasseter immediately went to work and revamped the storyboards, adding the kind of warmth and personality perfected by Disney artists on characters like Pluto and Donald Duck. He changed the name of the short to *The Adventures of Andre and Wally B.* It premiered at SIGGRAPH Minneapolis on December 18, 1984.

The SIGGRAPH audience went wild for *Andre and Wally B.* One programmer said to Lasseter, "That film had such warmth and personality! What software did you use?" As though the computer program, and not Lasseter's skill as a visual artist, was what made the difference. Catmull recalled, "When *Andre and Wally B.* was first screened at SIGGRAPH, we hadn't finished rendering it, so at one point it dropped back into wireframe. The interesting thing I found was that about half the people I talked to didn't notice that we had switched to wireframe. This was the true indicator that they were following the story and that it was more important than the polish."[9]

In front of the SIGGRAPH audience Lucas was gracious toward the filmmakers, but privately he thought *Andre and Wally B.* was a bad story with weak images. He couldn't see that it was another in a series of baby steps toward a great potential. It only confirmed his opinion that computers were good only for automating postproduction tasks.[10]

At that same SIGGRAPH meeting the Lucasfilm Graphics Group also introduced their breakthrough graphics computer, called the Pixar Imaging Computer (PIC). It was an all-in-one scanning/manipulating/filming computer they had been working on for several years. The name was coined one evening when four men gathered around a dinner table at Frank's Country Garden Restaurant in Bel Marin Keys. Smith was joined by software developer Loren Carpenter, hardware consultant Rodney Stock, and their old friend from JPL, Jim Blinn. As they discussed the name for the machine, Smith suggested a variation on a Latin term for image-making, *pixer.* Carpenter then said, "How about Pixar?" Why Pixar? "Because, . . . because it sounds better!" No one had a better idea, so Pixar it was.[11]

In that same year, 1984, ILM started to have serious cash flow problems. The *Star Wars* movies were completed, and no more were planned for the foreseeable future. This meant revenue from *Star Wars*–related toys and games began to dry up. Then

Lucas and his wife, Marcia, divorced, rending asunder the coffers of their empire. Lucas had hoped his fantasy films *Howard the Duck* (1986) and *Willow* (1988) would provide new franchise tent poles like *Star Wars* had been. Unfortunately, they both disappointed at the box office. His attempts to spin off animated TV shows based on Droids and Ewoks from *Star Wars* also fell flat. The independent film projects he and Francis Ford Coppola helped fund, like Akira Kurosawa's *Kagemusha* (1980) and Paul Shrader's *Mishima: A Life in Four Chapters* (1985), won critical acclaim, but they just weren't the kind of money-making blockbusters the public expected from them. One former Lucas executive said, "For ten years, they could do no wrong; then one day the little Box Office Fairy seemed to flitter away, and nothing they did seemed to work." At one point Lucasfilm was down to twenty weeks' cash flow to keep the doors open.

So Lucas called in two executives, named Doug Norby and Doug Johnson, who excelled at turning around the fortunes of ailing leviathans. Called the Two Dougs, and the Two Dweebs by disgruntled employees, they proceeded to cut the fat by selling off various satellite divisions.

Most of 1985 was spent trying to find a buyer for the Graphics Group. Ten months of meetings and entertaining offers from buyers as varied as Seimens, Hallmark, Japanese manga publishers Shogakukan, and the makers of Silly Putty. They were almost bought at one point by a combination of General Motors and Phillips Electronics, but the deal fell apart at the last minute because of an internal fight within GM. Meanwhile, at the Walt Disney Studios, Stan Kinsey, the vice president of new technologies, suggested the Mouse gobble up this new little computer company. But studio creative chief Jeffrey Katzenberg waved off the idea: "I can't waste my time on this stuff. . . . We've got more important things to do."[12] Finally it all came down to Steve Jobs.

When talks with Steve Jobs commenced, on December 9, 1985, papers were filed that were approved in February of 1986 incorporating the Lucasfilm Graphics Group into a new company called Pixar Animation Studios.[13] It was named for their signature retail product, the Pixar Imaging Computer. At first Jobs balked at Lucas's asking price of $15 million. After weeks of negotiation, getting the asking price down to just $5 million, with an additional $5 million in capital investment in the company, Jobs closed the deal on February 3, 1986. Doug Norby admitted later that had this deal not gone through, he had already decided to close Pixar down and fire all of its forty employees.

Jobs started by having the key partners of Pixar over to his Silicon Valley home. He owned a large house in Woodside that was mostly empty except for a grand piano and his motorcycle. He began his address to the assembled group: "This is the only room of people that know what can be done with a hundred megabytes. Someday everyone will have one hundred megabytes on their desk, and I want to be there."[14] As excited as he had been about marketing personal computers, Jobs now dreamt

of a world where every home would want color-rendered moving graphics on their screens.

"We started as a hardware manufacturing company. We made computers," recalled Ed Catmull.[15] Specifically, they made the Pixar Imaging Computer. You could get one for $122,000. Just as Lucas seemed uninterested in developing digital animation and just wanted digital postproduction, at first Jobs was not really as interested in making digital movies as he was in retailing computers. During their only face-to-face meeting about the Pixar handover, Lucas warned Jobs that Catmull and team were "hell-bent" on doing animation.[16] The art department of Pixar then was only four people, including John Lasseter. Jobs may never have entertained the idea that Pixar could make animated films that made a significant profit. Until then, except for Walt Disney, no one could. The age of cartoons making blockbuster profits would not come for another decade. In 1985, if an animated film made its production costs back in domestic box office, that was considered a success. The profits were earned in the toy merchandising and broadcast rights. But that was chump-change compared to the kind of profits Jobs's computer market was used to. But Catmull and his team were determined. Having been research scientists, engineers, and movie effects specialists, they were now embarking on a new profession, that of business mavens. "I read every book on management and business I could get my hands on," recalled Catmull.[17] Realizing they needed additional business experience, Catmull hired Chuck Kolstad to help, and made him vice president of manufacturing.

For the next several years Pixar made headlines in CG-focused magazines like *Computer Imaging* and *Wired*, but it didn't make much of a profit. They struggled to find buyers for their computer systems while animating commercials, and technical and instructional films for oil exploration, doing medical imaging work, and even taking some spook work. Smith recalled,

Our sales rep recommended to Ed, Steve Jobs, and me that we apply for high-level U.S. government security clearances. Because once we had the proper access he could bring in a lot of top-secret government work. So the FBI sent us these applications the size of a small phonebook to fill out. And on one of the first pages it stated, "Please list all the narcotic drugs you have ever taken." We all looked up at each other guiltily. After all, hadn't we all come of age in the psychedelic 60s, and were once hippies? (All except Ed.) Steve Jobs had already been quoted in *Rolling Stone* about his recreational use of LSD. I asked, "Should we tell them the truth?" Steve said, "Go ahead, they'll just find out anyway." So we were honest. Despite this, we all were approved and got our security clearances.[18]

Smith added, "Pixar should have gone under eight different times, but for Steve Jobs writing checks to bail us out. He must have dropped about $50 million between 1986 and 1991." Pixar animator Steve Segal recalled the anxiety in the little studio then was "When is he [Jobs] going to do what every other business guy has done in

the past and give up on animation?"[19] Down in Hollywood at Digital Productions, Sherry McKenna wondered, "Steve Jobs had the vision. . . . None of us could understand, why did he keep doing that? I mean, we were all jealous. Why didn't he fund us, dammit! Pixar was only doing some shorts and a few commercials. Do you really think he saw it was going to be as big as it became?"[20]

But the relationship was not always so cozy. The dynamic Jobs could be as intense as his reputation at Apple indicated. Veteran Apple team members used the discreet term "Steve is going nonlinear" for when Jobs blew his stack. Alvy Ray Smith had some clashes with Jobs, and then grew very ill with a lung infection. After his recovery, he made some significant breakthroughs with his painting software. Smith finally resolved to leave Pixar and form a new company named Altamira. Jobs at first refused to allow him to take any of his research with him, until convinced by Catmull and Lasseter.[21] Steve Jobs asked why were they kept their old NYIT friend David DiFrancesco on salary even though his particular area of expertise was digital film recording. They weren't going to make movies. Other engineers also joined in questioning the reason for paying for an animation crew. Some of the more disillusioned even quit. They had not come there to make cartoons. "The early days of Pixar were very stressful because very little was working to make us a successful business," Catmull recalled.[22] He kept explaining at length that the animated shorts advertised the values of the computers and software and so kept Pixar products in the eyes of potential customers.

It was at this time that animator John Lasseter really came into his own. His genius lay in the fact that he could see clearly the limitations of computer animation at that time. While the scientists around him wanted to immediately attempt full-on human character animation, Lasseter understood that the results would look stiff and mechanical. It would be the Uncanny Valley, in spades.[23] That type of CG was good enough to get a rise out of the computer geeks at a SIGGRAPH, but it would leave the general public cold. So as computer technology slowly improved, Lasseter devised ways to work around the medium's limitations. Computer animation looks hard and mechanical? So make films about toys and bugs. Computer animation has problems portraying weight? Make a film about fish, which float around. It wasn't until *The Incredibles* (2004) that Pixar found the right formula for stylization to do credible human characters that kept the verve and energy of traditional animation. Their solution was not to do eerily photo-real humans like those in *Final Fantasy: The Spirits Within* (2001) but to use the example of the shorthand stylization of humans developed by the Disney animators for films like *The Adventures of Ichabod and Mr. Toad* (1949) and *One Hundred and One Dalmatians* (1961). Jobs also enjoyed Lasseter's artistic mind. It appealed to his interests in design. The two men bonded.

The other innovation that proved vital to Pixar's success was that each department respected the others' specific areas of expertise. Again, recalling what they experienced

at NYIT, Catmull reasoned, "His [Dr. Schure's] view was, the way you become great is you hire really technical people instead of artists, not a view that I shared. In fact, it was the incorrect view. We could see—those of us who were at New York Tech—the need for collaboration between artists and designers and animators and technical people."[24]

Now, at last, they were free to develop their own system. Catmull and Bill Reeves ran the technology and the executive teams but purposely did not involve themselves in the artistic side. Lasseter built his creative teams at first exclusively from traditional animation artists, but they did not meddle with the technology. They were eased into using the computer slowly. The teams reviewed work through a strict peer review. The norm in Hollywood at the time in films, and particularly animated films, was that overbearing creative executives demanded the final word in creative decisions. This was not the case at Pixar. Catmull and Jobs did not tinker or try to play at being Walt Disney. They'd look around and admire the art and maybe give Lasseter some notes but otherwise not say anything and let the crews do their thing. One artist remembered Lasseter jumping up from a story-pitch session to shush Jobs and chase him from the room. Despite his reputation for having a mercurial temper, Jobs meekly complied.

Figure 13.2
Wire frame of *Luxo Jr.*
© 1986 Pixar Animation Studios. Courtesy of Pixar.

Another animator just up from Hollywood recalled "I talked story issues with the story team, and then I thought, 'Wait. Where is the chicken-shit exec that had no experience in my business, come to tell us what to do?' But there was none to be seen . . ., and it was beautiful." Lasseter had been comfortable directing his fellow artists since his senior year at CalArts. Animator Steve Segal recalled, "John was a caring director. Unlike Walt Disney, who had been known to play artists off against each other, he was generous in praising his artists and kept the atmosphere informal."[25]

Early on Lasseter did want to learn how to program and model in the computer. As he was training, he wondered what to do for a film. He hit upon using his own desk lamp as a character. It would also demonstrate to commercial clients Pixar's capacity to create light diffusion. At first he wasn't sure if the idea needed a story. Historian Charles Solomon wrote in Brussels, "Lasseter showed some test footage of the [Luxo] lamp hitting a ball with its shade. Raoul Servais, the noted Belgian animator, was impressed and asked about the story. When Lasseter said the work was 'just a character study,' Servais told him that no matter how short a film was, it should have a story, with a beginning, a middle and an end."[26]

When Lasseter got back to California he began thinking about a story for his lamp character. Inspiration struck when coworker Tom Porter brought in his infant son. He decided to make it about a parent long-necked lamp trying to control a precocious child-lamp playing with a rubber ball. This was the first CG short where the focus was not on the uniqueness of making a computer-generated short but on the characters and the story, which only happened to be animated on a computer.

Luxo Jr. premiered as the opening film for the Electronic Theater at SIGGRAPH Dallas on August 17, 1986. "People stood and cheered for over two minutes," Segal recalled. "I always felt sorry for [Pixar technician] Eben Ostby, because the very next film, *Beachchair* was one he made at Pixar of a beach chair dipping his 'toe' in the ocean to see how cold it was. It was a great film, well animated, but no one in the audience noticed because everyone was still screaming over *Luxo*."[27] After the screening Lasseter saw Jim Blinn coming toward him to ask a question. He feared his grasp of the technical details would not be sufficient to satisfy a mind as powerful as Blinn's. He was relieved when Blinn instead asked, "Is the lamp a Mommy or a Daddy?" The way the adult reacted to the child would be different depending on the gender. Lasseter pondered this question and explained that the adult lamp was an exasperated father trying to control his excited child playing with a toy ball.[28] *Luxo Jr.* quickly became the signature success for the young company. It was the first CG short to ever be nominated for an Academy Award. Film historian Leonard Maltin said *Luxo Jr.* had the same importance for Pixar as *Steamboat Willie* (1928) had for the Walt Disney crew.[29] The iconic Luxo lamp became the mascot of the studio.

Soon after the company was set up, Pixar nixed a proposed feature project for the Japanese manga publisher Shokugan about the fable of the Monkey King. This was

Figure 13.3
Luxo Jr.
© 1986 Pixar Animation Studios. Courtesy of Pixar.

because Catmull, Smith, and Lasseter felt they weren't yet ready to attempt a feature film. In this way they were adopting Walt Disney's Silly Symphony system.[30] That is, Walt didn't rush headlong into a feature project until he felt his crew was ready. So they made sure they refined their technique and tried out new technologies on short films first. Technicolor was first used on the Silly Symphony short *Flowers and Trees* (1932) and the multiplane camera on the short *The Old Mill* (1937). What they learned from these less expensive shorts was then worked into the feature film *Snow White and the Seven Dwarfs* (1937). The Pixar team adopted this strategy. This system of making shorts also benefited the company's commercial efforts, as each short raised the reputation of the company. It also advertised an effect they could use in a commercial or might retail. So cartoon character animation was demonstrated in *The Adventures of Andre and Wally B.* (1984); directed light source and self-shadowing in *Luxo Jr.* (1986); the qualities of their new RenderMan software in *Tin Toy* (1988); facial muscle articulation in *Geri's Game* (1997), and so on.

 Tin Toy (1988) won Pixar its first Academy Award, for Best Short Film. That finally got the last of the naysayers to stop asking the animation division to justify itself. Lasseter recalled, "Steve Jobs was very proud of that film."[31] The multiple awards the

studio was raking in raised its profile in the film business and attracted the attention of client larger than the makers of Scrubbing Bubbles.

Lasseter didn't just get inspiration from Walt Disney for Pixar's long-term success, he adopted many of the Walt Disney Studios' growth strategies. Walt Disney had said, "You can't make these films without story artists." While their rival CG studios focused exclusively on what new computers to use or what software to adapt, Lasseter centered his efforts on building one of the strongest storyboard teams ever seen in Hollywood or Marin County. Only in animation are the storyboard artists as responsible as the screenwriters for the content of the films. Storyboard artists of the past like Dick Heumer, Joe Grant, and Bill Peet wrote the stories of *Dumbo, Lady and the Tramp*, and *101 Dalmatians* as they drew their panels. Thanks to the umbilical to Disney, Lasseter could frequently invite up to the studio veteran artists like Vance Gerry, Dan Jeup, and Floyd Norman to get their advice and input. Many made the "Burbank Shuffle" up to the Bay Area, even the ninety-year-old storyman Joe Grant. Grant had worked closely with Walt Disney since *The Three Little Pigs* (1934). He had been coaxed out of retirement to give advice based on his decades of experience. He was one of the only surviving artists who knew how to give a story that "Disney magic," a universal visual appeal that was at once simple, charming, and entertaining. It was Joe Grant who suggested the name for *Monsters, Inc.* (2001). The project's working title had been "Hidden City."

Lasseter was also able to add to the team someone who turned out to be one of Pixar's greatest secret weapons—Joe Ranft. Ranft had attended the CalArts Disney Character Animation Training Program around the same time as Lasseter. He was schooled by many of the finest storymen of Disney's golden age, and by the time he joined the Pixar team he was already a veteran of a number of feature animated films: *Brave Little Toaster, Who Framed Roger Rabbit?*, and Tim Burton's *A Nightmare Before Christmas*. He brought a skill at visual humor combined with a patience that helped get the crew get through the pressures of a high-stakes Hollywood production. "Trust the process," he'd say to his exasperated trainees as they'd have to redo a sequence for the umpteenth time. Ranft was the final piece in the senior creative group at Pixar nicknamed "the Brain Trust": John Lasseter, Joe Ranft, Pete Docter, and Andrew Stanton.[32]

The Pixar studio at Point Richmond and later Emeryville retained the spirit of a college dorm—CalArts, to be exact. Artists relaxed with foosball, wore Hawaiian shirts to work, and zipped around the building on skateboards. One office alcove was the Love Bar, with overdone 1960s-era kitschy tiki bar cocktail lounge decorations. When Jobs suggested renovating the cubicle area to make it slick in the Silicon Valley high-tech mode, he was surprised when the workers protested.[33] Lasseter had to explain to him that everyone preferred the funky, personalized workspace. A favorite inside joke was the number A113. That was the animation classroom number at CalArts that Lasseter, Brad Bird, and their friends shared. It appears in discreet cameos in several films.

Figure 13.4
The Pixar "Brain Trust" on *Toy Story*. L–R John Lasseter, Joe Ranft, Andrew Stanton, Pete Docter.
© Pixar. Original Toy Story elements © Disney. Courtesy of Pixar.

But despite an old industry canard that you can't get anywhere at Pixar unless you are a CalArts alum, the studio brought in a great number of artists from other sources. Animators Glen McQueen and Rex Grignon came from NYIT, Anthony LaMolinara came from Will Vinton's claymation studio, Steve Segal from Virginia Commonwealth University, where he studied under Vibeke Sorensen, Karen Kaiser had worked on Art Klokey's *Gumby,* and Jan Pinkava studied at the University of Wales in the UK.

When Roy Disney gained control of the Walt Disney Corporation in 1984 he tried to hire Lasseter back to direct a traditional animated feature. Normally, directing a Disney feature cartoon would be any animator's dream come true. But by then Lasseter was too committed to making CG animation at Pixar a reality. Still, despite all the awards and adulation, by the end of each year Steve Jobs still had to open his checkbook to make up for the studio's shortfall.

Pixar's fortunes began to change when they first learned that the new management at Walt Disney Studios was beginning to look for a way to use computers to streamline

the way they painted cartoons. A small CG team was already forming within the Disney animation unit, Whitney/Demos and Wayne Carlson were also bidding for the work. Whitney/Demos were working toward a more 3D look, and the Disney folks were reluctant to go that far, yet. Catmull and Smith reached back to their experience designing CG paint systems for NYIT and wrote out a comprehensive proposal. This did the trick. In 1989 Frank Wells handed Pixar a check for $10 million to work with Disney to develop the CAPS system.

Pixar imaging computers were used to scan animation pencil drawings, color them, and composite them with the background paintings and other elements, such as effects. 72 gigabytes strong, CAPS didn't just replace traditional acetate cels, it greatly expanded the range of the look of animated features. The initial range of colors offered was the palette of *Pinocchio* to the ninth power. Traditional animation couldn't go much past six cel levels; because the 0.003-mm thickness of the acetate layers, to do more would start to blur the background. Now you could do an infinite number of levels. Plus, camera shots like multiplane and rack focus shots that used to be difficult and expensive now became routine. Because of budget restraints, an animated film wouldn't allow much variation in paints past one set of day colors and one of night colors for any character. But CAPS enabled the art director to custom design every shot. The engineers at Pixar collaborated with the engineers at Disney to make the system as easy as possible for the artists to use.

As previously stated, the first all CAPS-painted animated movie was *The Rescuers Down Under* (1990), and its accompanying short film, *Mickey's Prince and the Pauper*, became the last traditionally painted Walt Disney film. All the creators of CAPS were awarded a technical Academy Award in 1991.

Jobs, Catmull, Smith, and Lasseter had been growing Pixar cautiously for several years at this point. Was it time to finally attempt a theatrical feature film? They were aware that the ground was littered with the bodies of companies that had attempted to animate a feature film before they were ready. So they first proposed to Walt Disney doing a half-hour TV special based on their Oscar-winning short *Tin Toy*. But Jeffrey Katzenberg nixed that idea, saying that if they were going to go through all the trouble to build all the models and crew, they might as well make it a feature film. At first Disney Animation chief Peter Schneider was reluctant to have an animated product made outside of his direct supervision in Burbank. But the successful experiment of doing most of *Who Framed Roger Rabbit?* in London, then Tim Burton's *Nightmare Before Christmas*, convinced the studio brass that they could commission animation of the high-quality standards of Disney outside of the Burbank studio.

On May 3, 1991, as *Terminator 2: Judgment Day,* done in part with Pixar's photo-realistic RenderMan software, was thrilling the mainstream media, and the ballroom sequence was being completed on *Beauty and the Beast,* Pixar and the Walt Disney Company reached agreement to make three animated features. When they announced

Figure 13.5
The Pixar crew that created *Toy Story*, 1995.
© Pixar. Courtesy of Pixar.

the deal on July 11, Steve Jobs said, "Working with Disney to make the first full-length computer-animated film had been a dream of ours since we founded the company in 1986. . . . Now our dream is realized and we couldn't be more excited."[27]

As anyone in Hollywood knows, it may say it's a three-picture deal. But that means if the first one is a dud, the studio can find a hundred ways to dump you before the other two ever get started.

For Pixar, it was all down to one big throw of the dice. In July 1991 they began production on the first CG-animated full-length film, *Toy Story*.

I remember how talented people who created computer generated imagery were looked down on—and actually regarded as nonartistic math geeks . . . and then, one day, the whole world just flipped right over.
—Dan Phillips

This revolution is going to surpass the Industrial Revolution, and there is going to be a lot of blood on the floor.
—Phil Tippett

When George Washington defeated Lord Cornwallis at the Battle of Yorktown, everyone understood that the United States was now an independent nation. When Robert E. Lee was turned back at Gettysburg, everyone understood the North would win the Civil War. When Al Jolson sang in the film *The Jazz Singer* (1927), all could see that silent movies were finished. These were key points of transition, events that compelled conventional wisdom to change.

Ever since the 1960s, when pioneers like John Whitney, Ivan Sutherland, Ken Knowlton, and Charles Csuri set out the basic principles, CG technology had been slowly building. The 1970s were about creating the basic tools, and the 1980s mostly about improving the power of these tools and making them user-friendly enough that creative minds could be free to explore. The development of CG had been advanced by governments, scientists, engineers, game makers, architects, motion picture visual effects studios, and university academics. As the 1980s moved into the 1990s, all these diverse strands, operating on heretofore separate tracks, began to merge into one grand convergence. All that was needed now was to show the world.

The Gettyburgs of the CG revolution can be narrowed down to three movies—*Terminator 2* (1991), *Jurassic Park* (1993), and *Toy Story* (1995).

Since leaving his job as a produce-truck driver, James Cameron had chalked up an impressive box office record by directing science fiction action fantasies that pushed

the envelope of what technology could create. From *Terminator* (1984) through *Aliens* (1986) to *The Abyss* (1989), Cameron kept on the cutting edge of visual effects. When in late 1990 he came to ILM with his shooting script and storyboards for *Terminator 2: Judgment Day*, he already knew what kind of effects he wanted to see, and he knew most of those types of effects had not yet been created. That was his challenge to ILM; it was up to them to figure out how to do them. The character of the new, more powerful Terminator assassin from the future, the T-1000, was supposed to be made of "mimetic polyalloy, or liquid metal." He could morph his shape and pour through objects at will.

The ILM effects team began by utilizing many of the tricks they learned from the Pseudopod in *The Abyss*, but now they made the shapes chrome instead of water. The T-1000 was played by actor Robert Patrick. He received his introduction to CG by having to strip to his Jockey shorts and march around a parking lot with digitizing point grids drawn all over his body. In one sequence actress Linda Hamilton blows Patrick's head apart with a shotgun. This was given the title of the Saucehead Test. Even though the T-1000 was a robot, the CG team was going all out to try and create a moving photoreal human. "Everybody was going for human beings," animator Steve "Spaz" Williams recalled.[1]

PDI's Carl Rosendahl remembered, "We bid on the whole project, but Cameron felt more comfortable sticking with ILM for most of the work. I told Cameron, 'Give us some shots. We'll do them, and if you use them, pay us. If you don't, then don't pay us.' He farmed out some invisible effects shots to us. . . . When he needed to flop a shot of a truck, we corrected the street signs so they no longer read backward."[2] One of the more interesting effects PDI did was in the scene where Arnold Schwarzenegger as the Terminator first appears in a blast of energy from the future. "When he stands up, he is nude, and a little too much light was revealing a little too much of him. So we had to do DDR, digital dick removal."[3] Cameron held to his pledge to pay PDI for their work, and the subsequent publicity did a lot to raise PDI's image in the VFX industry. "*T-2* got us a ton of press, and a ton of work," Rosendahl said.[4]

The opening of the film on the Fourth of July weekend, 1991, raked in $54 million dollars and made *Terminator 2: Judgment Day* a bona fide hit. Unlike *Tron*, *Young Sherlock Holmes*, and *Lawnmower Man*, here technological innovation was embraced by the public in a critical and box office blockbuster. The film went on to earn $520 million and to be hailed as one of the best science fiction films ever made.

As 1992 began, the United States was in a recession. President George H. W. Bush's hopes for a second term were challenged by Arkansas governor Bill Clinton, and movie director Steven Spielberg was developing his new movie *Jurassic Park*. The story was based on a Michael Crichton novel about an entrepreneur who cloned dinosaur DNA to create full-size living creatures. The success of the film would depend on how believable these dinosaurs would be. It was Spielberg's vision that the dinosaurs should not

Figure 14.1
Terminator 2: Judgement Day.
© 1991, TriStar Pictures.

be presented as stereotypical monsters but as real animals, like the ones you would see on a nature TV documentary. Animals that breathe, pant, and sweat.

First the effects masters at ILM resorted to the traditional stop-motion techniques of articulating claymation maquettes and photographing them frame by frame. This was the way things had been done since Willis O'Brien made dinosaurs live in the silent film *The Lost World* (1926). The metal skeleton soldiers battling in the War of the Day of Judgment that opened *Terminator 2* were done that way. Although the jerkiness of the stop-motion movement had been much improved by Phil Tippet's go motion blurring technique, Spielberg was unsatisfied by the first tests. "I brought the tests home and kept watching the them over and over. My kids loved the dinosaurs. But as refined and lyrical as the tests were, I still felt they looked too go motionly."[5]

While Spielberg pondered this problem, the CG team at ILM led by supervisor Stefen Fangmeier and Eric Armstrong began a test, animating some Gallimimus dinosaur skeletons galloping as a herd. ILM head Dennis Muren wanted to move cautiously: "No one wanted it more than me, but I had to be responsibly cautious." Animators Steve "Spaz" Williams and Mark Dippé, who had been pushing the envelope on character work since *Casper,* were feeling pretty confident that they could attempt shots of the dinosaurs that looked photoreal. They began to do "guerrilla tests," extra work done after hours so as not to affect their deadlines on other projects.[6] They got a break when Spielberg's production schedule for *Jurassic Park* was pushed back so he could complete his previous film, *Hook* (1991). The extra time allowed them to work out the bugs with the software.

Everyone at ILM watched the progress of both the stop-motion team and the CG artists. Any traditional effects artist or animator who understood trends in the business knew, since *Star Trek II: The Wrath of Khan,* that it was only a matter of time until CG came for their jobs. The oft-stated mantra of CG hackers was, "Computer animation is a year away!" Stop-motion chief Phil Tippett recalled, "Dennis [Muren] kept me informed of the tests' progress, and I thought, Holy shit! Here it comes."[7]

By summer 1992 the animators had completed their CG tests. Dennis Muren brought them down to Spielberg's offices on the Universal Studios lot that, because of their southwestern architecture, were nicknamed the Taco Bell. First was of a flock of dinosaur Gallimimus skeletons that leap off their pedestals and run through a field, like a museum exhibit run amok. When Spielberg saw it, his jaw dropped. "I'd never seen movement this smooth, outside of looking at *National Geographic* documentaries. . . . I wasn't completely convinced until I saw another test of a fully fleshed-out dinosaur in the outside, in the harsh sunlight." Williams and Dippé's test) was of a Tyrannosaurus rex pursuing the now-fleshed-out herd of Gallimimus through a sunlit field. The dappled sunlight fell on the T-rex's leathery skin as he walked under a shade tree, past camera. "I watched this test with Phil [Tippett] and it blew my mind again," Spielberg said. When Spielberg asked Tippett for his reaction, Tippett exclaimed, "I've just become extinct!" Spielberg liked that line so much he wrote it into the movie.[8]

After that, the orders to those on Kerner Boulevard was to put away the clay and beeswax, the dinosaurs would all be CG, at least in the long shots. Stan Winston's Creature Shop would still do the closeups with puppets and animatronics. Some sulky stop-motion guys mounted their little armatures on top of their SGI monitors, to recall their bygone glory. ILM now had the problem of not having enough good computer animators to complete such a huge project. And it is pretty hard to get a dinosaur into a Waldo suit. So ILM head Dennis Muren devised a compromise that allowed them to keep Tippett's stop-motion unit. They created a hybrid process called the Dinosaur Input Device. Tippett's people built an armature of lightweight aluminum, then animated it in much the same way you would a claymation figure. But instead of Sculptee, this armature was covered with sensors that would collect the data of the movement and send it back to the SGI terminals to be rendered by Pixar's RenderMan software. ILM's Brian Knep recalled, "About 30 percent of the dinosaur shots were done using the Dinosaur Input Device. We used it in the sequence where the T-rex breaks out of the paddock and started terrorizing the people in their Jeep, and for the shot where the Raptors are in the kitchen chasing the kids. The rest of the shots were done using more traditional CG animation tools."[9]

Not only were the dinosaurs in *Jurassic Park* done with CG, but the film marked the first time computer screens could be shown on film running in real time. For years you could not film a computer monitor. The CRT resolution was so weak it came out on film looking black, or it froze into staticky black bars. A computer screen image

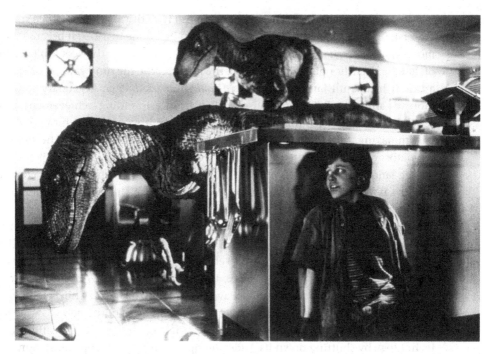

Figure 14.2
Jurassic Park (1994).
© Universal Pictures.

had to be optically matted in afterward in post. "We installed modified boards on the SGI machines and other systems in order to adjust the frequency down to 48 Hz," explained Michael Backes, the production's display graphics supervisor. "So in the shots where the actors are controlling the computer graphics observing climate control or monitoring the storm, the actors are actually controlling them."[10]

Jurassic Park was originally supposed to end with the skeleton exhibits in the lobby collapsing on the attacking raptors, allowing Dr. Grant (Sam Neill) and his friends to escape. But as Spielberg saw more of the completed Tyrannosaurus rex footage from the middle of the movie, it made this ending feel anticlimactic. So he rewrote the ending to bring the T-rex back to kill the raptors, just in the nick of time. Until then ILM had been using the CG dinosaurs in long shots. But this would bring the CG image up close, with the T-rex just five feet away from the camera. The CG artists worried, would the pixels hold up, or would they go "jaggy" that close? When the scene was screened full size, nerves were eased. It all worked out beautifully. Although there are only 6 minutes of CG in the entire 126-minutefilm, they stole the show. Glen Entis of PDI recalled, "I came out of the theater stunned. They accomplished stuff I didn't think was possible yet. It really felt like CG had hit critical mass."[11]

Jurassic Park opened on June 11, 1993. To call it a critical and box office smash is to understate its impact. As the first *Star Wars* film had done in 1977, it became the event movie of the year. *Jurassic Park* took the public on a thrill ride they couldn't get enough of. Raking in a whopping $914 million, the film became the runaway box office champ, a title it held until James Cameron's *Titanic* four years later. Legendary stop-motion monster animator Ray Harryhausen called it an astounding achievement. A friend recalled, "When I asked him [Ray] how he thought it would affect his particular kind of filmmaking, he smiled with a twinkle in his eye, 'I think I and all the stop-motion animators of the world should find a high mountain . . . and jump off!'"[12]

The landmark success of *Jurassic Park* silenced all doubt that CG had come of age and was now *the* way to make movies. Veteran directors like Stanley Kubrick, Werner Herzog, and Peter Weir now began to consider the possibilities of CG. Down in New Zealand, Peter Jackson saw the tools now existed that could bring to life the imagery of Middle Earth as described by J. R. R. Tolkien in his *Lord of the Rings* books. The nerd in the hallway was no longer an unwelcome visitor in movie studios. "When I saw *T2*, I felt the tide pulling at my calves, but it wasn't until I saw those first T-rex tests on *Jurassic Park* that I saw the tidal wave on the horizon," said Phil Tippett.[13]

Traditional movie optical effects were cast aside in favor of the new CG way of doing things. On July 8, 1993, Industrial Light & Magic completed its transition to digital technology by shutting down its Anderson optical printer. The optical system of A and B mattes had been the way motion picture visual effects had been done since Georges Méliès. Stop-motion artist Phil Tippett converted his studio to creating CG and continued to do beautiful work, creating an arachnid-alien army for Paul Verhoven's *Starship Troopers* (1997). Even venerable old service houses like Pacific Art and Title, which had begun life in the 1920s painting title cards for silent movies, transitioned into CG houses. Veteran VFX house Boss Films had done hits like *Ghostbusters* (1984) and *Die Hard* (1988) and had given ILM serious competition as Hollywood's top VFX house. But it had just completed a $10 million update of its analog equipment when all this hit. By 1997 the continuing loss of business dragged it under into insolvency.

At the same time, a further revolution was occurring in off-the-shelf CG programs. In 1993 Brad Carvey at Newtek devised a simple and efficient animation and editing software for the Amiga computer. Called Video Toaster, it provided broadcast-quality visual effects tricks without the huge financial outlays required for a Cray or SGIs.[14] The Toaster proved its value in making convincing effects for TV series like *Babylon 5*, *Xena: Warrior Princess*, and *Star Trek: The Next Generation*. Now a television series could have the same kind of special effects that were once reserved for big-budget movies.

As we saw in the previous chapter, in July 1991 Pixar inked an agreement with the Walt Disney Company to produce an animated, feature-length film using CG. Pixar had been in existence for barely five years, but for the principal creators—John Lasseter, Ed

Catmull, and their team—it was the culmination of a lifetime of work. The dream to create films in CG, that for decades had wound its way through MIT, ARPA, the University of Utah, Xerox PARC, NYIT, Lucasfilm, the Homebrew Computer Club, and Robert Abel & Associates had at last came to an end in little Andy's bedroom. Ed Catmull mused, "The time between my hand film (*A Computer Animated Hand*, 1972) and *Toy Story* (1995) was the same length of time between [Winsor McCay's] *Gertie the Dinosaur* (1913), and Disney's Snow *White* (1937). Also, with both films people doubted that the audience could sit through an entire feature with the then-new technology."[15]

To the outsider, making movies seems just a matter of writing a script, then filming it. But in reality, the period of development for a major motion picture, from its first-draft script to the camera, can be a long, drawn-out process, a development hell that could take months, if not years. Animated film is an even more extreme process. A typical animated film could be completed in eight to fifteen months, but it might be in story development for years. Animation is like the high-stakes poker version of filmmaking, because if it hits right, it could net you billions of dollars worldwide in box office and merchandising. But if it flops, it could drag you and your studio down with it.

Toy Story began in 1991 as a treatment for a half-hour TV show that was expanded into a feature film idea.[16] Catmull recalled, "We had a proposal for a half-hour special that we pitched to every studio except Disney. The reason that we didn't pitch to Disney was John [Lasseter] was reluctant to work with them."[17] But all reluctance aside, they began work on the feature. The story originally started with Tinny, the little wind-up one-man-band toy from Pixar's hit short *Tin Toy* (1988) and a ventriloquist's dummy. As the story evolved the ventriloquist's dummy was changed to an old-fashioned cowboy doll with a pull-string speaker. He was named Woody after famed African American actor Woody Strode (*Sergeant Rutledge*, 1960). Tinny was replaced by a more up-to-date spaceman figurine based on 1960s astronaut toy Major Matt Mason. Originally called Tempus, he was renamed Buzz Lightyear after Apollo astronaut Buzz Aldrin. The other characters were designed to evoke childhood memories of favorite toys—Mr. Potato Head, Slinky, little green army men, Etch A Sketch. The rendering of the human characters like the boy Sid and his dog still looked a bit clunky and computery, but otherwise it all worked.

In those years the Walt Disney Studios had established a solid success rate by tying high-quality drawn animation to Broadway-style musical theater. There was a formula for how much music, the order of the songs, and the appeal of the characters. So when John Lasseter proposed to make an all-CG film that could not be done in traditional animation and would not be dependent on Broadway tunes, many at Disney were skeptical. At that time no one at was even sure an audience could sit still and watch that much computer animation. In 1991, when you thought computer animation you imagined satellites or killer cyborgs, not warm, cuddly Disney characters. Those critics were silenced when Lasseter had a test scene of dialog between Woody and Buzz rushed

through to completion. When the suits in Burbank saw this test, they said the characters looked so real they wanted to reach up and touch them.

Yet even with that success, the project was still a very near-run thing. Mattel initially refused to give them the rights to Barbie, and Hasbro refused the same for G.I. Joe. Because Pixar's deal with Disney allowed them to make the film without being under the direct jurisdiction of the internal supervising studio execs, there were already backroom voices urging Eisner to scuttle off the project. An initial review of the story reels by Disney went so badly, it is still known in Pixar circles as Black Friday. John Lasseter, Joe Ranft, and their team had to quickly fix all the problems with the story to get them back on schedule, as the release date had already been announced. Disney creative head Jeffrey Katzenberg gave many notes, as was his custom, and suggested several outside writers to help. "Joss Whedon worked out very well, and we had a great relationship with him," Catmull recalled.[18] Back at home, Pixar owner Steve Jobs had tired of dumping money down this endless money pit of a studio and was quietly soliciting buyers like Microsoft to take it off his hands.

But starting with the army men scene, as the film started to come together, the crew got more excited about it. Steve Segal recalled, "After one screening of the reels, I thought, 'If this film isn't a hit, there is something seriously wrong with the audience!'"[19] There was no room for failure. Like Walt Disney's *Snow White* artists six decades earlier, everyone at Pixar knew all their futures depended on this one film.

After a five-year roller-coaster ride of production, *Toy Story* finally opened on November 22, 1995, to universal praise. David Ansen of *Newsweek* called it "a winning animated feature that has something for everyone on the age spectrum." Janet Maslin of the *New York Times* called it "the sweetest, savviest movie of the year!"[20] After a record-breaking Thanksgiving weekend take of $67 million, the film went on to earn $365 million in worldwide box office and billions more from toys and ancillary products. *Toy Story* was not just the first all-CG film, it was the first CG hit.

The creative team under John Lasseter and the technical teams under NYIT alumni Bill Reeves and Ralph Guggenheim had worked in harmony, and the final results exceeded expectations. There was no longer any reason for industry apologists to make excuses for clunky images in the hope that someday it would look better. No need to mask with traditional filmmaking tricks what the computer had failed to do. For once, the breakthrough CG was not undermined by a weak script. And most importantly, the filmmaking method did not overshadow the story. Jim Hillin summed it up: "What was unique about *Toy Story* was, for the first time people did not look at it and think first, 'I'm watching computer-animated figures.' They thought, 'I just want to know what happens to Woody and Buzz.' And that's victory."[21]

As volatile as Steve Jobs could be, one thing he did know very well was the importance of branding. Since the earliest negotiations he had fought hard for the Pixar name to have equal billing with the Walt Disney logo at the head of the picture, and not simply have it buried in the end-credit roll behind the caterer and production

Figure 14.3
Toy Story.
© 1995 Disney/Pixar. Courtesy of Pixar.

accountants, as was the custom with most subcontractors. It worked. *Toy Story* established Pixar as a brand. People at Walt Disney always knew that they owned something called "the Franchise." That is, when people think facial tissue, they think Kleenex. When people think photocopier, they think Xerox. And when they think quality family entertainment, they think Disney. The same couldn't be said of any of their competitors. Pixar now became one of those companies whose name alone would be a hint to the viewer that they could rely on seeing a well-made, family film.

Jobs had come around after seeing the test-screening numbers and, far from wanting to unload Pixar, he had arranged for Pixar's first stock offering (IPO) to be held a week after the opening of the movie. Apple had made Jobs rich, but Pixar made him a billionaire. Ed Catmull, the soft-spoken research scientist from Utah, admitted he found all this success a bit daunting. "I felt a little lost after the success of *Toy Story*. I took a year to think about it." Oscar Wilde had said that when the Gods wish to punish us, they give us what we want. Now that they had conquered the mountain and established CG animation as a viable platform for the creation of theatrical features, what was next? "Organizations are inherently unstable," Catmull thought. "Nothing stays the same. I realized the next goal was to create a culture that is sustainable. That can go on after John [Lasseter] and me."[22] Since *Toy Story*, Pixar has turned out one successful CG-animated movie after another, an unprecedented string of hits: *A Bug's*

Life (1998), *Toy Story 2* (1999), *Monsters, Inc.* (2001), *Finding Nemo* (2003), *The Incredibles* (2004), *Cars* (2006), *Wall-E* (2008), *Up* (2009), and *Toy Story 3* (2010). Pixar's momentum continued even with the loss over the years of some key personnel. Alvy Ray Smith had left the company before *Toy Story*. Master animator Glenn McQueen died in 2002 of acute melanoma,[23] Ralph Guggenheim left in 1997 to start his own company, and story department guru Joe Ranft was killed in a tragic car accident in 2005. Steve Jobs passed away in 2011 after a long battle with pancreatic cancer. Yet the system Pixar built has endured and could not be crippled by the loss of any one person. Perhaps that is the greatest creation one could hope to make.

Catmull said, "Pixar turned out ten hit films in a row, and I lived through all of it. I still find it mystifying."[24]

Toy Story showed other studios how to succeed making CG features. As mentioned previously, around the time *Toy Story* was being completed, Jeffrey Katzenberg left Walt Disney Studios and, with Steven Spielberg and David Geffen, set up DreamWorks. Out of the starting gate, Jeffrey felt he needed something fast and new. He now needed something to catch Pixar.

Shrek began as a simple, six-page children's book by William Steig. It needed to be fleshed out into a ninety-minute movie. Veteran screenwriters Ted Elliot and Terry Rosio (*Aladdin, Pirates of the Caribbean*) went through a score of rewrites. Katzenberg peppered the script with notes in blue Sharpie marker. At one point he wrote on the bottom of a draft, "You boys will thank me for this one day." *Shrek* had begun in 1996 as a motion-capture project, but that technology was ultimately abandoned in favor of keyframing. Then the original voice of *Shrek*, comedian Chris Farley, died of a drug overdose in and had to be replaced by fellow SNL alumni Mike Myers. DreamWorks had thought of *Shrek* as a low-budget quickie. They had hoped to do the film for just $20 million. But by the end of 1996 they were already writing off $32 million on the project, with no finished footage yet. Then, part way through production, Myers decided that Shrek's accent was wrong and wanted to redo everything. There were up to six changes of directors and art directors until they settled on codirectors Vicky Jenson and Andrew Adamson.

By the time *Shrek* was ready for its premiere on May 16, 2001, no one was sure how the audience would react to it. Would young teens, reared on gameboys and anime, embrace a Scottish-sounding ogre that makes jokes about fairy tales and boogies to old Sixties pop tunes? After six years in production, *Shrek* turned out to be the major hit DreamWorks had been jonesing for. PDI cofounder Richard Chuang said, "A friend who was deaf told me that when he saw *Shrek*, the animation was so good, it was the first animated film where he could lip-read the characters and understand everything they were saying."[25] *Shrek* garnered $267 million in North America and an additional $217 million worldwide, as well as billions in merchandising, spawning six sequels.

In 2001 CG animation received the ultimate reward from the film industry. The Motion Picture Academy of Arts and Sciences created a category for Best Feature-

Figure 14.4
The author's early 1996 design concept of *Shrek*, based on actor Chris Farley.
© 2001 DreamWorks Animation.

Length Animated Film. Animated shorts had been given Oscars since 1932, and an occasional feature got a special one, like in 1938 when Walt Disney received seven little Oscars from Shirley Temple for *Snow White and the Seven Dwarves*. But by creating this new category, the Academy finally acknowledged the importance of animated features to American film. The winner of the first-ever animated feature Oscar was not a *Bambi* or *Little Mermaid*, it was DreamWorks CG film, *Shrek*. In this first-ever competition, all three nominees were CG films: *Shrek, Ice Age*, and Nickelodeon's *Jimmy Neutron, Boy Genius*.

Even a few high-profile flops like Walt Disney's *Dinosaurs* (2000), *Final Fantasy: The Spirits Within* (2001), and the *A VeggieTales Movie* (2002) could not dampen the public's appetite for CG films. For over ten years Twentieth Century Fox had bankrolled the Don Bluth studios through ten feature cartoons, but since 1997's *Anastasia* it had not had a success. In 2001 they made a deal with a small studio called Blue Sky. It was not in New York City, but up the Hudson River Valley near the old state prison Sing Sing. Blue Sky had been formed in the late 1980s from the survivors of Magi/Synthavision after *Tron*. They had lived hand to mouth for a few years making short films, flying logos, and commercials, until they won a short film Oscar for Chris Wedge's character piece *Bunny*. Fox took the gamble and commissioned an original feature film.

But as some non-Disney efforts started to falter, like the flop of their feature *Titan A.E.* (2000), Fox began to have second thoughts. As Blue Sky was completing *Ice Age*,

Figure 14.5
Chris Wedge and storyboard artist Karen Disher of Blue Sky looking at storyboards (2005).
Courtesy of Blue Sky Studios.

Fox trimmed their staff down to a skeleton crew and made it known they would sell them off to the first bidder. There was very little advertising for *Ice Age*, and it was given a dead-zone release date, late March. There weren't many toy tie-ins because Fox didn't think it would do anything. *Ice Age* went on to become a smash hit, garnering $188 million in ticket sales in North America, more than that year's live action Best Picture Oscar winner, *A Beautiful Mind*. When the results of *Ice Age* came in, Fox producer Bill Mechanic was reputed to have exclaimed, "Aw shit! Now we have to stay in animation!" *Ice Age* spawned a series of successful sequels. *Ice Age: Dawn of the Dinosaurs* (2009) generated close to a billion dollars in worldwide box office, becoming the third-highest-grossing animated film of all time.

As CG animation's star rose, the 2D animated musical renaissance had run its course, and creative execs could not seem to come up with a suitable alternative. From the zenith of *The Lion King* (1994), Disney's traditionally animated features went into a decline with *Atlantis* (2001), *Treasure Planet* (2002), and *Home on the Range* (2004). Disney management decided the problem couldn't have been that their ideas were

weak or their management structure had become top-heavy (two vice presidents in 1991, nineteen vice presidents in 2003). One executive decided the feng shui of their building was the problem, so he added ferns to the stairwells. Finally they decided CG was the solution to all their problems. *Los Angeles Times* media analyst Jeffrey Logsdon said, "The realities are that consumer expectations are now driven by a new type of animation that has three dimensions."[26] Jeffrey Katzenberg put it more bluntly: "Traditional animation is a thing of the past."[27]

Revolutions are exciting, but they also have casualties. The day pencil-and-paint artists and animators had been dreading for years had finally arrived.

Phil Tippett said, "From the perspective of the traditional artist, I feel like we've all been bombed, and there is bound to be a huge displacement of people as this computer tool replaces many types of craftsmen by its sheer speed and miraculousness."[28] Starting in 2003 the Walt Disney Company had begun to eliminate most of the traditional animation crew trained by the golden age masters, as simply as one would dump an old typewriter in the attic. Warner Bros. Feature Animation and DreamWorks Animation shed their pencil-and-paint animators as well, just not as publicly. Forty or more senior artists were made to compete for sixteen digital animator slots. In 1979 the Animation Guild of Hollywood had calculated that 55 percent of their membership were professional ink-and-paint artists; by 2000 that was down to 3 percent. In Hollywood, traditionally drawn animation slipped to second-class status. Those who could not adapt to the new technologies dropped out of the business. Animators were spotted bagging groceries in supermarkets. Between 1997 and 2003 there were several suicides. When master animator Frank Thomas died in 2004, there was a memorial at the El Capitan Theater in Hollywood. Many of the former Disney animators there paused to wonder if they were there to mourn Thomas or their own careers. A top animator in London complained, "No one wants an animator with a pencil anymore!" The exception was Japanese anime, which continued primarily as a 2D medium. Japanese animation director Hayao Miyazaki (*Spirited Away, Princess Mononoke*) went against the trend by discontinuing his 3D digital unit as unnecessary. But he was the notable exception.

Traditional animation artists had been heavily in favor of trade unionism since their guild won recognition in the 1940s. The CG newcomers, coming from academia and defense industries, were apathetic at best to the concept of collective bargaining. The video game industry offered tempting profit sharing for new game development in lieu of defined workers' rights. The corporations that owned movie studios exploited legal disputes as to whether CG in a live-action movie constituted animation, and was so covered by Guild contracts, or a movie visual effect, which was outside most traditional locals' jurisdiction. While the Animation Guild and live-action locals haggled over this gray area, the studios made their profits. So Hollywood's closed shops took a heavy hit in their ability to bargain.

In 2006, after twenty years at the helm, Disney CEO Michael Eisner retired. Against his advice, the Walt Disney Company bought Pixar in a $7 billion deal. The industry

wondered if it was really Pixar that was acquiring the Walt Disney Feature Animation Studio. Steve Jobs was given a seat on the Walt Disney Executive Board. Ed Catmull became president of the animation studio and John Lasseter its creative head. They made the decision not to merge the two animation crews but to keep the Pixar team separate from the behemoth of Burbank down south.

After *Terminator 2*, *Toy Story*, and *Jurassic Park*, CG became a household word. And still the innovations continued to roll in. In 1999 the British CG VFX house The Framestore surprised Hollywood with the TV show *Walking with Dinosaurs*. They did high-end, feature-quality animation of dinosaurs on a TV budget and raised the bar for quality TV visual effects. For a long time CG had only marginally penetrated television animation. But as software became cheaper, CG TV animation production began in earnest with the French series *Insektors* (1994), followed by the Canadian series *Reboot,* run in the United States on the Disney Channel.[29] In 1999, a company named Macromedia took a simple 2D program for web animation called Final Splash and reworked it into a complete 2D animation package called Flash.[30] For the next fifteen years Flash became a standard tool for people in studios or at home to create 2D animation. While not as opulent as Pixar animation, it did quality TV animation at a reasonable cost. TV Shows like *Mucha Lucha* (2002) and *Atomic Betty* (2004) were done exclusively in Flash. In the CG gaming world, Nintendo released the Nintendo 64 game console in the United States in 1996. It was the first to offer full 3D imagery. This was followed closely by SEGA's Dreamcast, Sony's PlayStation2, Microsoft's Xbox and the Gamecube. Each release was marked by mobs of gamer fans in Yokohama and New York waiting all night outside stores. These consoles ushered in the second great wave of interactive games, finally making everyone forget the crash of the early 1980s. After 2000 the public's interest in network games like *Myst* grew with the games like *The SIMs*, *Second Life*, and *Farmville*. Players adopted avatar bodies and personas to explore a virtual world and interact with others. Players visited distant cities, planted crops, flirted, even played the stock market with virtual money.

Digital cinema projection spread around the country, and at old Hollywood film vaults like CFI and Technicolor, alleyway trash dumpsters bulged with unwanted 35 mm and 16 mm film cans, fulfilling Francis Ford Coppola's prediction. Studios announced a phasing out of all 35mm celluloid by the end of 2013.

By 2010 an Oxberry downshooter animation camera stand, which used to retail for $40,000–80,000, could be yours for nothing if you came with a truck that could haul it away.

The great Tyrannosaurus rex of *Jurassic Park* roaring in triumph as all came crashing down around him represented more than just the climax of one movie. It was a clarion blast to all Hollywood that their century-old way of doing production had changed forever.

Conclusion

Lots of people told us we were crazy. We weren't crazy. We were early.
—Michael Wahrman

It's been twenty years now since the key events of the CG revolution rocked Hollywood. Many of the pioneers have been replaced by businessmen. Innovators by artisans. The workforce currently includes generations who never knew an age without computers, who don't know what it was like to not be able to communicate with anyone around the world instantly or make a phone call from something in your pocket. As Jim Hillin noted, "When motion pictures first embraced sound technology, every movie had a big credit like 'This is an RCA Radio-PhotoPhone Sound Process Movie' or something similar. Then after awhile it just became 'movies.' CG films for a long time had big credits at the end explaining in detail the hardware and software utilized. It has become just 'movies' once again."[1] CG is vital in visualization for biology, medicine and earth sciences. Steve Job's prediction that one day everyone will want full color 3D graphics on their computer has come true. For those who brought about this revolution, it is hard for them to believe that their battle is won. They labored and lobbied for so long. Wandering from city to city, wherever there was an interesting project to work on. Preaching the doctrine of a digital future to the indifferent, the apathetic, and the cautious. This curious cadre were the shock troops of progress, all pressing forward on their own individual tracks toward a common goal. Sherry McKenna said, "My final triumph is that today I can stop any person on the street and ask them, 'Do you know what CGI is?' and they'd say yes. In 1984 they wouldn't have known what you were talking about!"[2]

Today the most basic movie of a melodrama like *The Glass Menagerie* will have among its credits one for visual effects. Steve Lisberger said, "The smartphone in your pocket now has more computing power than all the computers combined on the first *Tron* [movie]."[3] Over the course of the many interviews I did for this book, I'd always end with the same question: "Are you satisfied with where CG has

gone?" Most said the results were not achieved fast enough. For a long time they burned to achieve imagery that they knew was impossible to create. CG makers now are facing the same issues their traditional counterparts dealt with. Early CG artists enjoyed multitasking and refused to be pigeonholed into a narrow job classification. Today there are many specializations—modeling, rigging, lighting, compositing. CG artists' jobs, once thought unique, can now be outsourced cheaply overseas. And because the countercultural streak in early CG disallowed any notions of group action like unionization, the artists now are at the mercy of the employers, with no recourse but to cry in their Red Bull. The ranks of the Hollywood Animation Guild are back up to their pre-digital highs, now filled with CG artists. Even some of the most fiercely libertarian in philosophy conceal a Directors Guild of America or Writers Guild of America members card in their wallet, just in case.

Some pause to lament the pre-CG world they supplanted. Steve Lisberger said, "I missed the smell of raw stock in the morning or the sight of a huge, 70 mm Super-Panavision camera. On the animation side, I missed the paint brushes in the sink and the aroma of cedar from the pencil sharpeners." Michael Wahrman added, "I regret CG was so successful. We wiped out traditional visual effects and 2D animation."[4]

Some things the futurists foresaw have come to pass, and some have not. Many predicted CG would sweep away older forms of animation, particularly stop-motion animation, the technique of using puppets of clay and armatures articulated frame by frame. Despite Ray Harryhausen's initial despair for the future of stop-motion animation, by 2012 there were more stop-motion films in production than there had been in the 1950s. In 2009 two Academy Award nominees for best animated feature were stop-motion, Henry Selick's *Coraline* and Wes Anderson's *Fantastic Mr. Fox*. CG motion blur and replacement faces sculpted by CAD/CAM made stop-motion move with a greater fluidity and style than in the analog days. Just as the 1980s craze for synthesizer music spawned the original instruments movement in the jazz and classical worlds, so CG has created a hunger for older, traditionally drawn animation. New studios, like Ken Duncan's Duncan Studio in Pasadena, California, developed 2D-3D hybrid software in which the animator can animate in a 2D medium and have the computer translate the actions into a 3D Maya medium.[5] Disney's short *Paperworks* (2012) was another example.

Early proponents of CG touted it as allowing movies to be made more cheaply and with fewer people than traditional movies. Yet today budgets are pretty much the same or higher, and the end-credit rolls take just as long. But it is now possible to make a credible, good-quality film from your desktop and get it seen around the world online, like British animator Simon Tofield did when he created his *Simon's Cat* shorts.

Figure 15.1
4D Memory Cluster by artist Victor Acevedo, 2000. "Metaphoring a recollected memory, clustered and processed down from 11 dimensions. A texture mapped sphere is the center piece to this composition featuring a network of contiguous octahedral domains."
Courtesy of Victor Acevedo.

The digital revolution is over, but the evolution of digital media will go on. The modern software programs described here will one day seem as quaint as a candlestick telephone. It's taken only one lifetime to go from Ivan Sutherland's Sketchpad, with a glowing white line on a four-inch-square computer monitor, to the digital blockbuster movies of today. Who knows what we will see in another lifetime?

As Bob Abel liked to say, "The magic never stops!"

Appendix 1: Dramatis Personae

Figure 16.1
Alvy Ray Smith in 2007.
Photograph by Kathleen King. Courtesy of Alvy Ray Smith.

Abel, Robert (1937–2001): Digital artist, producer. After graduating from UCLA, he began working on visual effects for films and was the director of several award-winning documentaries. In 1971 he founded Robert Abel & Associates. After losing his company in the DOA affair (see chapter 10), Abel became an Apple Fellow and taught at UCLA until his death in 2001.

Alcorn, Alan (1949–): Computer scientist who created the game *PONG* in 1972. He was also involved in the founding of Catalyst Technologies and Zowie Entertainment.

Allen, Rebecca (1954–): CG designer. After graduating from Brown University, she worked at NYIT and MIT and created landmark rock videos for David Byrne, Kraftwerk, and Peter Gabriel.

Baecker, Ronald (1942–): Computer scientist. A graduate of MIT, Baecker organized the teaching of computer science at the University of Toronto and was the first to recognize the importance of computer graphic visualization.

Baer, Ralph (1922–): Creator of the earliest video game console, the Magnavox Odyssey. Called the father of video games. He was awarded the National Medal of Technology in 2006.

Bergeron, Philippe (1959–): CG animator and designer who teamed up with Daniel Langlois at the University of Montreal to do the film *Tony de Peltrie* (1985). He worked at Digital Productions and Whitney-Demos, does film acting, and is president of Paintscaping, Inc.

Blinn, James "Jim" (1948–): CG pioneer, educator. Studied at the University of Michigan and University of Utah. Interned at NYIT. Creator of animations for the Voyager flyby films for NASA's Jet Propulsion Laboratory, Carl Sagan's *Cosmos* series, *Project Mathematics*, and *The Mechanical Universe*. Inventor of Blinn shading and bump mapping. He was also a graphics fellow at Microsoft.

Buffin, Pierre (1954–): French CG animation artist. Founded BUF Compagnie in 1984. BUF became a premier studio in CG visual effects, contributing surreal photoreal effects in *City of Lost Children* (1995), *Fight Club* (1999), and *The Matrix* (1999).

Bush, Vannevar (1890–1974): Computer pioneer and futurist. He was the provost of MIT and was involved with the development of the atomic bomb and the founding of the Raytheon Corporation. In an article in the July 1945 issue of *The Atlantic*, "As We May Think," he predicted the computer workstation. His writings inspired computer pioneers of the 1950s and 1960s to achieve his predictions.

Bushnell, Nolan (1943–): Computer games designer. He founded Atari, Sente, and the Chuck E. Cheese Pizza Time Theater chain of family restaurants. In 2010 Bushnell was invited back to the Atari board of directors, and today he runs Anti-Aging Games.com. He was named by *Newsweek* to its list of "50 People Who Changed America."

Bute, Mary Ellen (1906–1983): Texas-born avant-garde artist. She created abstract films with mechanical means like oscilloscopes, then worked on early computer imaging at Bell Labs.

Cameron, James (1954–): Film director known for his science fiction/action films. A student of physics before getting into film, he pushed the boundaries of film technology in each project.

Today many of his films are considered important milestones in the development of CG. *The Abyss* (1989) had the pseudopod water creature, *Terminator 2: Judgment Day* (1991) had human-CG morphing interaction, *Titanic* (1997) had realistic human synthespian extras and effects, and *Avatar* (2009) had advanced performance capture and stereoscopic 3D projection.

Carpenter, Loren (1947–): Chief scientist at Pixar and a cofounder. He began at Boeing, where he adapted Mandelbrot's theories on fractals to create realistic landscapes. He created the film *Vol Libre*, which he used to get hired by Ed Catmull at Lucasfilm Graphics Group. Later he moved with the crew when they broke away and became Pixar.

Cartwright, Randy (1951–): Disney animator and inventor. Graduated UCLA and in 1976 became part of the famous Disney animation trainee department that included Brad Bird and John Lasseter. Cartwright aided in the development of Pixar's CAPS system for Disney and modified software to create a pencil-test system for Disney animation. He also animated the Carpet, an early CG-traditional hybrid character, in Disney's *Aladdin*, and created a film stopwatch app for the iPhone.

Catmull, Edwin "Ed" (1945–): Computer scientist and studio CEO. Catmull graduated as one of the star pupils of David Evans and Ivan Sutherland in the computer department at the University of Utah. He invented breakthroughs in texture mapping, anti-aliasing, and z-buffering. He organized the NYIT computer animation program before he went west to set up George Lucas's computer graphics division. When the Lucasfilm Graphics Group was purchased by Steve Jobs and became Pixar, Catmull was chief technical officer. There he contributed to the creation of their RenderMan system and produced their string of hit movies. In 2006, when the Walt Disney Studios acquired Pixar, Catmull became the executive head of both studios.

Clark, James H. "Jim" (1944–): Founder of Silicon Graphics computer systems and Netscape Communications. He holds a degree from the University of Utah and spent time at NYIT's Computer Graphics Lab.

Cray, Seymour (1925–1996): Engineer called father of the supercomputer. He began at CDC and later moved to IBM, where he designed mainframes like the IBM 360. He went into business for himself, forming Cray Research to design and retail mainframes. The company was eventually acquired by Silicon Graphics. Cray died in a traffic accident in 1996.

Csuri, Charles (1922–): Artist, college football star, veteran of World War II, and modern artist who exhibited works with Roy Lichtenstein and George Segal. Csuri went on to create the computer engineering program at Ohio State University. In 1968 he created the short *Hummingbird*, one of the first films to attempt representational movement in computer graphics. He also cofounded the CG commercial studio Cranston/Csuri (1981–1987).

Cuba, Larry (1950–): Conceptual artist. A graduate of Washington College and CalArts, Cuba experimented with computer animation in his films *Objects and Transformations* (1978), *Two Space* (1979), and *Calculated Movements* (1985). He did some of the earliest CG animation in George Lucas's *Star Wars* (1977), and founded the iotaCenter for the preservation and development of experimental nonobjective film.

Demos, Gary (1949–): Algorithm scientist, producer. After studying at Caltech under John Whitney Sr., Demos formed a partnership with John Whitney Jr. at Triple-I. They founded Digital Productions Inc, later Whitney-Demos. He created CG effects for the films *Westworld* (1973), *Looker* (1981), *The Last Starfighter* (1984), and *Labyrinth* (1986). He also did the landmark raster short *The Juggler* (1980) and Mick Jagger's video *Hard Woman* (1985). In 1988 Demos formed DemoGraFX.

DiFrancesco, David (1947–): Senior research scientist at Pixar. DiFrancesco began his career working with Lee Harrison on Scanimate systems, at Xerox PARC with Dick Schoup, and at JPL with Jim Blinn. He became part of the legendary tech team that Ed Catmull and Alvy Ray Smith brought from NYIT to Lucasfilm and then Pixar. He did pioneering work in digital film recording and won two Scientific and Technical Awards from the Academy of Motion Picture Arts and Sciences.

Disney, Roy Edward (1930–2009): Studio executive. The nephew of Walt Disney, Roy grew up on the studio lot. He edited TV's *Dragnet* and produced the documentary series *True-Life Adventures*. After taking control of the Disney Company in 1984, he fostered the Disney animation renaissance of the 1990s and encouraged a rigorous development of CG within the studio with technologies like the CAPS system, as well as nurturing of the growth of Pixar. Shortly before his death he took direct control of the company again and arranged the Disney merger with Pixar in 2006.

Elson, Matt (1957–): CG artist. After graduating Pratt Institute and doing graduate work at NYIT, Matt went to work at Symbolics Graphics Division (SGD) in 1984. He was Director of Special Projects by the time he left. Then to Dreamworks, Walt Disney, Digital Domain, The Post Group and Afterworld LLC.

Emshwiller, Ed (1925–1990): Experimental filmmaker. Born in Lansing, Michigan, Emshwiller studied graphic design at the University of Michigan and the École des Beaux-Arts in Paris. A Hugo Award–winning illustrator for his cover art for science fiction magazines, Emshwiller took an interest in experimental film in 1964. In 1979 at NYIT he collaborated with Alvy Ray Smith to create the groundbreaking CG film *Sunstone*. From 1979 to 1990 Emshwiller was dean of film/video at CalArts.

Engelbart, Douglas (1925–): Inventor of the computer mouse. As head of the Stanford Research Institute's Augmented Human Intellect Research Center, he also foresaw GUI, e-mail, and the first hypertext.

Evans, David C. (1924–1998): Computer scientist. Evans built the computer department at the University of Utah, which trained some of the finest minds in CG. With Ivan Sutherland he built the company Evans & Sutherland in 1969, which developed graphic design mainframe computers of the 1970s and 1980s, including the flight simulator for NASA's space shuttle.

Fetter, William (1928–2002): Art director at Boeing. Fetter was involved in aircraft flight simulators and coined the term *computer graphics*. He also built the first wireframe model of a human being, in 1961.

Foldes, Peter (1924–1977): Hungarian-born artist who lived in London, Paris, and Canada. He created the National Film Board of Canada film *Hunger/La faim* (1974), the first computer film to be nominated for an Oscar. His other films include *A Short Vision* (1956), and *Visage* (1977).

Fredkin, Ed (1934–): Computer scientist. In 1956 the Air Force assigned him to MIT, where he contributed to the development of the PDP-1. In 1962 he founded International Intelligence, Inc. (Triple-I). In 1968 he returned to MIT as a full professor and director of its artificial intelligence lab.

Gielow, Tad (1957–): Software engineer. An engineer at California State University, Northridge, he also spent time at Raytheon. Gielow started at Walt Disney Imagineering when the studio began its CG department. Gielow aided in adapting the first CG programs for Disney animated features like *The Black Cauldron* (1985), *The Great Mouse Detective* (1986), and *The Little Mermaid* (1989). Later he helped set up the systems at Disney's Florida studios. At Warner Bros., he aided with the systems to create *The Iron Giant* (1999). Then on to Sony Imageworks.

Gouraud, Henri (1944–): Computer scientist. Gouraud studied at École Centrale de Paris. At the University of Utah he developed Gouraud shading for CG surfaces. His 1971 doctoral dissertation *Computer display of curved surfaces* became a classic in the literature of the medium.

Guggenheim, Ralph (1951–): Video graphics designer. A graduate of Carnegie-Mellon, he was part of the core group around Ed Catmull and Alvy Ray Smith at NYIT that later jumped to Lucasfilm and finally formed Pixar. Guggenheim left Pixar in 1997 to become an executive at Electronic Arts and later CEO of his own company, Alligator Planet LLC.

Harrison, Lee, III (1929–1998): Inventor of ANIMAC and Scanimate, early analog CG systems that were popular in the early 1970s. His studio, ImageWest, was at one time the dominant VFX house in Hollywood. He won an Emmy for his work in 1972.

Hillin, James "Jimbo" (1955–): VFX artist and screenwriter. Educated at Baylor and California State University, Northridge. Hillin worked at deGraf/Wahrman, Filmation, Digital Domain, Walt Disney, Warner Bros., and Sony Imageworks. His credits include *Beauty and the Beast* (1991), *Aladdin* (1992), *Apollo 13* (1995), *Spiderman* (2002), and *I Am Legend* (2007).

Hopper, Grace M. (1909–1992): U.S. Navy officer who devised the first computer languages, for early systems like UNIVAC. She coined the term *computer bug* when she retrieved a moth that had caused a circuit to blow out. She was the first woman to achieve the rank of rear admiral in the U.S. Navy.

Hughes, John C. G. (1948–): Developer, producer. Hughes graduated from the University of Minnesota–Twin Cities, then worked at Robert Abel & Associates. In 1987 he founded Rhythm & Hues Studios, which won Academy Awards for *Babe* (1995) and *The Golden Compass* (2007).

Inglish, Dave (1943–): Engineer. Glendale College. Later after serving in Vietnam in the USAF, in 1967 he joined Walt Disney Imagineering and completed his studies at Cal Poly Pomona. Dave became technical lead of the Disney computer efforts and later Chief Engineer at Disney Feature Animation. He left in 1995, to be Director of Audio Visual Technologies at Universal Studios.

Jobs, Steve (1955–2011): Business icon and inventor. After a brief stint at Atari, Jobs founded Apple Computer with Steve Wozniak. He purchased Pixar from George Lucas and, after merging it with Walt Disney, served on the executive board of Disney. Ousted from Apple's leadership in 1985, Jobs got back control of the company in 1997. After taking Apple to the pinnacle of corporate success, in 2011 Jobs died of pancreatic cancer at the age of fifty-six.

Johnston, Scott (1964–): Computer artist/engineer. After graduating from Brown University, Johnston joined Walt Disney Features, where his talents contributed to *Beauty and the Beast* (1991), *Aladdin* (1992), and *Fantasia 2000* (2000). He worked on the team that created the wildebeest stampede scene in *The Lion King* (1994). In 1998 Johnston went to Warner Bros., where, for Brad Bird's film *The Iron Giant* (1999), he wrote ToonShader, a program to make 3D CG figures blend seamlessly with traditionally drawn cartoons.

Katzenberg, Jeffrey (1950–): Movie executive. Katzenberg began at Paramount Pictures as an assistant to Barry Diller, then paired with Michael Eisner to revive the *Star Trek* franchise. Moving with Eisner to Walt Disney in 1984, he became the head of Disney Studio productions and proceeded to turn the studio into a leading producer of live action and animation. He left in 1995 and started Dreamworks SKG, later Dreamworks Animation.

Kawaguchi, Yoichiro (1952–): Digital filmmaker. Kyushu University. Kawaguchi is a professor at the University of Tokyo and lives on an island off the Japanese mainland. For many years he has created short films and installations of abstract splendor, combining his love of marine biology with CG.

Kay, Alan C. (1940–): Computer scientist. University of Utah. At Xerox PARC Kay pioneered the idea of objective programming. He also worked on the Dynabook concept, which became the conceptual basis for all laptops and e-books. Kay also worked at Atari, Apple, and Disney Imagineering.

Kleiser, Jeff (1953–): Designer, director. Kleiser worked with Judson Rosebush and Omnibus before becoming president of Digital Effects, Kleiser/Walczak Construction Company, and Synthespian Studios, Inc. He created the landmark short *Don't Touch Me* in 1989.

Knoll, John (1962–): Industrial Light & Magic VFX artist/inventor. With his brother Thomas, Knoll invented Adobe Photoshop. His screen credits include *The Abyss* (1989), the *Star Wars* and *Pirates of the Caribbean* series, and *Avatar* (2009).

Knowlton, Ken (1931–): Artist/scientist at Bell Labs, MIT. Knowlton wrote one of the earliest CG languages, BEFLIX, in 1963. He also created digital art, and collaborated with experimental filmmakers like Stan VanDerBeek and Lillian Schwartz.

Kovacs, Bill (1949–2006): Software designer. Carnegie Mellon University, Yale University. After working at Robert Abel & Associates, Kovacs founded Wavefront, producing the first industry-standard, off-the-shelf CG animation software. SGI later purchased Wavefront and merged it with the Canadian company, Alias. Kovacs died of a cerebral stroke on May 30, 2006, at age fifty-six.

Kroyer, Bill (1950–): Animator. Kroyer earned a degree from Northwestern University. He trained at Walt Disney as a traditional animator, and became interested in computers while working on

the film *Tron* (1982). He interacted with software engineers to create the Coca-Cola Polar Bears and animation for Mick Jagger's "Hard Woman," video and *Scooby-Doo: The Movie* (2002). He directed the 2D animated feature *FernGully: The Last Rainforest* (1992) and received a 1987 Oscar nomination for his short *Technological Threat,* about traditional and CG characters' fears about one another.

LaCroix, Georges (1945–): French CG animator and designer. After graduating from L'École supérieure des arts décoratifs de Strasbourg, LaCroix did comic art and illustration for magazines like *Pilot* and *L'Express.* In 1985 he formed the studio Fantôme. He directed *Insektors* (1994), the first animated TV series to be done completely as CG.

Langlois, Daniel (1961–): Canadian software developer. After helping create *Tony de Peltrie* with Philippe Bergeron at the University of Montreal, Langlois developed Softimage. It became one of the premiere software packages for computer visual effects in entertainment. He later founded the Daniel Langlois Foundation and Ex-Centris.

Lansdown, John (1929–1999): CG educator in the UK. Originally an architect, Lansdown began to explore the possibilities for computers in design in 1960. He was professor emeritus of computer-aided art and design at Middlesex University, where he served as head of the Centre for Electronic Arts from 1988 to 1995. He was one of the founders of the Computer Arts Society in Britain and the author of *Teach Yourself Computer Graphics* (1987).

Laposky, Ben (1914–2000): Sign painter and part-time mathematician. Laposky's *Oscillons,* done in the 1950s with army surplus oscilloscopes, are some of the earliest examples of computer art.

Lasseter, John (1957–): Animator/director, chief creative officer of both Pixar and the Walt Disney Animation Studios. Trained at CalArts and in the Walt Disney traditional animation program, Lasseter became the key creative artist at Lucasfilm's Graphics Group. When that group became Pixar he organized the artistic team. He is the winner of two Academy Awards, one for the short *Tin Toy* (1988) and a special one for the first all-CG feature, *Toy Story* (1995). He was named chief creative director at Walt Disney Animation in 2006.

Licklider, J. C. R. (1915–1990): One of the key developers of the Internet. Called the Johnny Appleseed of computing, Licklider was the director of ARPA who supported Ivan Sutherland's efforts.

Lisberger, Steven (1951–): Director of *Tron* (1982) and producer of *Tron: Legacy* (2010). His other screen credits include *Animalympics* (1980) and *Slipstream* (1989).

Lucas, George (1944–): Filmmaker. Born in Modesto, California, Lucas became interested in film at USC. His thesis film, *THX-1138* (1971), was made feature length and launched his career. After his huge success with films like *American Graffiti* (1973) and *Star Wars* (1977), Lucas relocated his operations to Marin County and built Industrial Light & Magic, THX, and Skywalker Sound. An early advocate of digital technology in cinema, he assembled the crew of the Lucasfilm Graphics Group that later became Pixar. Even after he sold off his Pixar team in 1985, he continued to encourage digital advances with his ILM VFX team.

Machover, Carl (1927–2012): Engineer whose advocacy for computer graphics led people to label him the "CG Evangelist." His 1998 documentary *The Story of Computer Graphics* is considered one of the first attempts to tell CG's story.

Mandelbrot, Benoit (1924–2010): Lithuanian-born mathematician. Mandelbrot coined the term *fractal* and described the Mandelbrot set.

McKenna, Sherry (?–): CG animation producer. McKenna had her own cinema effects company before joining Robert Abel & Associates and later becoming a vice president at Digital Productions and at Omnibus/Abel. Afterward she helped create the *Oddworld* video games.

McLaren, Norman (1914–1987): Famed filmmaker of the National Film Board of Canada. McLaren encouraged the development of computer graphics at the NFB in the 1960s.

McQueen, Glenn (1960-2002): Graduate of Sheridan College and NYIT. Lead animator for PDI, later Pixar. He died of melanoma at age 41.

Miyamoto, Shigeru (1952–): Senior designer/cartoonist at Nintendo. Miyamoto was the creator of *Donkey Kong, Donkey Kong Jr., Super Mario Brothers*, and *The Legend of Zelda*. He championed Nintendo's creation of *Pokémon*.

Muren, Dennis (1946–): Visual effects head at Industrial Light & Magic. Muren's career began when he joined George Lucas on the first *Star Wars* (1977), and he has been a major factor in every major ILM project since.

Newell, Martin (1943–): Created the famous Utah teapot surfacing exercise while at the University of Utah in the mid-1970s. Newell helped found Cambridge Interactive Systems with his brother Dick Newell. He also developed Newell's algorithm. He retired from Adobe Systems after serving as an Adobe Fellow.

Noftsker, Russell (1942–): Graduate of MIT. Created the computer company Symbolics SGD in 1979, which created breakthroughs in rendering and behavioral software. Forced out in 1988, he formed a group that bought the assets of the failing Symbolics Inc. in 1994.

Pajitnov, Alexey (1956–): Russian game designer who invented *Tetris*.

Parke, Fred (1943–): Computer scientist. Parke did the first modeling of a human face while at the University of Utah, and he worked with Ed Catmull at NYIT, Lucasfilm and Pixar. He now teaches visualization sciences at Texas A&M.

Pederson, Conrad "Con" (1934–): Animator and motion picture special effects artist. Pederson worked on many famous films, including *2001: A Space Odyssey* (1968), and he directed the 1964 World's Fair production *To the Moon and Beyond*. In 1973 he cofounded Robert Abel & Associates. After Omnibus/Abel foundered, he was a key artist at Rhythm & Hues Studios until his retirement.

Pennie, John (?–): President of Omnibus CG studios during the famous DOA affair (see chapter 9). After Omnibus, Pennie formed Windrush Entertainment and Racks.

Phong, Bui Tong (1943–1975): Creator of Phong shading, a landmark model for lighting 3D surfaces. Born in Hanoi, Phong graduated from the University of Utah.

Poniatoff, Alexander M. (1892–1980): Founder of the Ampex Corporation, for a time the world's leading supplier of magnetic recording tape. In the 1960s and 1970s much computer memory was stored on magnetic tape. Nolan Bushnell and Alan Alcorn began as engineers for Ampex.

Price, Tina (1954–): Computer animator, entrepreneur. Price spent most of her career at Walt Disney Feature Animation (1983–2006), where she garnered over twelve feature film credits and pioneered the CG efforts as head of Walt Disney Feature Animation's CG Department. She is the founder of the Creative Talent Network, an online networking organization. In 2009 she started the annual CTN Animation Expo in Burbank, California.

Ranft, Joe (1960–2005): Disney, later Pixar, storyboard artist, writer, and voice actor. CalArts. Ranft's screen credits include *Brave Little Toaster* (1987), *Who Framed Roger Rabbit?* (1988), *Nightmare Before Christmas* (1993), *Toy Story* (1995), *Toy Story 2* (1999), and *Finding Nemo* (2003). He was killed in a car accident in 2005.

Reeves, Bill (?–): Pixar head of animation research and development. A graduate of the University of Waterloo and the University of Toronto, Reeves did pioneering work on particle systems. He won Academy Awards in 1997 and 1998 for his work.

Reynolds, Craig (1953–): Graduate of MIT, Craig is called the Father of Behavioral Animation in CG. He began at Triple I, then was a founding member of Symbolics Graphics Division. Did breakthrough work on flocking software called Boids. Then Electronic Arts, Dreamworks Animation, Sony Computer Entertainment.

Rosebush, Judson (1947–): Computer pioneer who began making commercials using CG in 1972. Rosebush opened the earliest commercial CG studio, in New York City. In 1978, with Jeff Kleiser and other partners, he founded Digital Effects Productions, which did some of the work on Walt Disney's *Tron* (1982).

Rosendahl, Carl (1957–): Stanford. Founder and director of Pacific Data Images. Rosendahl's studio pioneered successful motion capture in *Waldo C. Graphic* (1989), and did visual effects in *Terminator 2: Judgment Day* (1991) as well as the CG animated film *Antz* (1997).

Russell, Steven "Slugg" (1931–): Dartmouth and MIT. Co-inventor of the early game *Spacewar!*, Russell also invented the first implementations for the computer language LISP for an IBM 704.

Schure, Alexander (1921–2009): Entrepreneur who founded the New York Institute of Technology. Schure's financing and support developed the first research lab/studio to attempt computer-animated features and commercial work.

Schwartz, Lillian (1927–): Experimental artist who created CG films at Bell Labs and IBM in the 1960's and 70s. Her films include *UFO* (1971), and *MOMA PSA* (1984).

Smith, Alvy Ray (1943–): CG artist pioneer. PhD from Stanford. Smith taught at New Mexico State University and New York University. He left to work at Xerox PARC, then moved to NYIT and then the Lucasfilm Graphics Group. One of the founders of Pixar, Smith also built the

Altamira software company. Today he is president of Ars Longa, a company that does digital photography. He is the winner of two Scientific and Technical Awards from the Academy of Motion Picture Arts and Sciences.

Sorensen, Vibeke (1954–): CG filmmaker, composer, and teacher. Sorensen taught some of the first computer graphics courses at Princeton, Virginia Commonwealth University, CalArts, and Caltech, as well as at the Art Center in Pasadena. She has worked as a consultant to NASA's Jet Propulsion Lab, Walt Disney Studios, and the San Diego Supercomputer Center. She set up the digital arts programs at USC, the University of Arizona, the University of Buffalo, and Nanyang Technological University in Singapore. Her films and performance work include *Sanctuary*, *Three Ring Circuit*, *Microfishe*, and *Dreamscape*.

Stehura, John (1943–): Experimental filmmaker. Stehura created one of the earliest digital abstract films, *Cibernetik 5.3*, at UCLA in 1965–1969.

Sutherland, Ivan E. (1938–): One of the fathers of computer graphics. While doing his PhD work at MIT, Sutherland created Sketchpad, the first graphic interface program. He later pioneered development of virtual reality, 3D modeling and design, and virtual simulations. With David Evans he created the computer graphics program at the University of Utah and the mainframe computer company Evans & Sutherland. Was a fellow at Sun Microsystems until his retirement.

Taylor, Richard (1947–): CG artist and art director. A graduate of the University of Utah, Taylor designed light shows for the rock band The Grateful Dead. He was an art director for Robert Abel & Associates and did preproduction art on *Tron* (1982). He also worked at Lee Lacy & Assoc., Electronic Arts, Rhythm & Hues, and XLNT FX, Inc.

Taylor, Robert (1932–): Scientist and director of ARPA. Taylor allocated the money for building the Internet and endowed the CG program at the University of Utah. A University of Texas graduate, Taylor went to Xerox PARC in 1970 to create the famous team that developed the Alto and pioneered GUI and Ethernet.

Terman, Frederick (1900–1982): Scientist and academic. A student of Vannevar Bush, as dean of electronics at Stanford, he built up the engineering department and spearheaded the university's leasing of land to high-tech start-up companies. Today he is considered the father of Silicon Valley.

Trumbull, Douglas (1942–): Special effects designer and director. His talents contributed to the films *2001: A Space Odyssey* (1968), *Close Encounters of the Third Kind* (1977), and *Blade Runner* (1982).

Turing, Alan (1912–1954): Considered the father of computer science. The Briton earned an Order of the British Empire (OBE) for his work during World War II breaking the Nazi Enigma code. In 1936 Turing theorized the concept of a computer as a device that could solve any problem if it was presented to it as an algorithm. In 1945 he predicted the first computer games. In 1949 he developed one of the earliest electronic computers with the capacity for storing programs—the Manchester Mark I, nicknamed the Manchester Baby. He was so influential in the

new field that for a time computers were called Turing machines. In 1952 he was convicted of homosexuality under the same 1885 law that led to the imprisonment of writer Oscar Wilde. Confronted with jail, Turing underwent hormone injections and chemical castration before finally choosing suicide. He was a fan of *Snow White and the Seven Dwarves*; on June 7, 1954, he injected an apple with cyanide and bit into it.

van Dam, Andries (1938–): One of the creators of the computer science program at Brown University and one of the founders of ACM SIGGRAPH.

VanDerBeek, Stan (1927–1984): Experimental filmmaker. In the 1960s VanDerBeek collaborated with Ken Knowlton at Bell Labs to create several computer animation films under the titles *Poem Field* and *Poem Field #2*.

Veevers, Wallace "Wally" (1916–1983): One of the top artists in British traditional visual effects. His credits included *Things to Come* (1936), *Lawrence of Arabia* (1962), *Dr. Strangelove* (1964), and *The Rocky Horror Picture Show* (1975).

Walczack, Diana (?–): CG director. She worked for Omnibus in 1986 and formed Kleiser/Walzack Construction Company and Synthespians Inc. With Jeff Kleiser she created the first female Synthespian performer, Dozo, for the music video "Don't Touch Me." (1989) Her credits include *Monsters of Grace* (1997), *Judge Dredd* (1995) and *Stargate* (1994).

Wahrman, Michael (1948–): Technologist. After graduating from UCLA Wahrman ran ARPANET at the Rand Corporation until joining Robert Abel & Associates. After the DOA collapse he formed deGraf/Wahrman with Brad deGraf.

Wedge, Chris (1957–): Animation director. Wedge studied at Ohio State University under Charles Csuri, then worked at MAGI/Synthavision on projects like Disney's *Tron* (1982). He formed Blue Sky Studios with several partners in 1987. Winning an Oscar for his short *Bunny* (1998), he wrote and directed the 2001 hit *Ice Age* (2002).

Weinberg, Richard (1951–): Director and founder of the USC Computer Animation Laboratory, established in 1985. Weinberg holds degrees in computer science and computer graphics from the University of Minnesota and Cornell. His research has included work in the areas of computer animation, neurosurgery visualization, graphics system design, multimedia, scientific visualization, and entertainment technology. He established the Computer Graphics Group at Cray Research and has developed computer graphics software and systems for NASA, Lockheed, Digital Productions Inc., Ardent Computer, and the USC University Hospital.

Whitney, James (1921–1982): Experimental filmmaker, abstract painter, and ceramicist. With his brother, John Whitney Sr., he collaborated on *Twenty-Four Variations on an Original Theme* (1940), *Variations on a Circle* (1941–1942), and *Five Abstract Film Exercises* (1945). His own solo work includes *Yantra* (1957), *Lapis* (1966), *Kang Jing Xiang* (1982), and *Li* (unfinished).

Whitney, John, Jr. (1946–): Filmmaker. John began helping with his father, John Sr.'s, work before moving on to independent films like *Side Phase Drift* (1965) and multimedia shows like the one at Montreal's Expo 67. He formed a partnership with Gary Demos Information International, Inc. (Triple-I), where he did some of the earliest CG in motion pictures, and then the two

formed Digital Productions, Inc. They left after the Omnibus takeover to found Whitney-Demos Productions. Then Whitney created USAnimation. His credits include *Westworld* (1973), *Looker* (1981), *The Last Starfighter* (1984), and *Labyrinth* (1986). He did the landmark raster short in *The Juggler* (1980), and was the director of Mick Jagger's video "Hard Woman" (1985).

Whitney, John, Sr. (1917–1995): Called the father of computer animation. He began experimenting with ways to create art and music with automated means as early as 1940. He was the founder of Motion Graphics, Inc. in the early 1960s. His films include *Five Abstract Film Exercises* (1945), *Catalog* (1961), and *Arabesque* (1975). In addition, he did some of the earliest computer graphics with the opening to Alfred Hitchcock's *Vertigo* (1958), was the first artist in residence at IBM, and taught extensively about CG at Caltech and other schools.

Williams, Lance J. (1949–): Engineer, researcher. After earning degrees from the University of Kansas and the University of Utah CG program, Williams worked at NYIT. He did pioneering work on surface textures and shadowing. After leaving NYIT he worked at Apple, DreamWorks SKG, Walt Disney Animation, and Google Earth.

Williams, Steven "Spaz" (1963–): Canadian-born CG animator, graduate of Sheridan College. Williams joined Industrial Light & Magic from Alias and did keyframe animation on *The Abyss* (1989), *Terminator 2: Judgment Day* (1991), *Casper* (1995), and *Jurassic Park* (1993). In 2006 he directed *The Wild.*

Yamauchi, Hiroshi (1927–): Third president of Nintendo, Inc., 1949–2002. Yamauchi oversaw the transition of Nintendo from a maker of playing cards to an electronics giant. Under his leadership Nintendo produced *Donkey Kong*, *Super Mario Brothers*, the Russian game *Tetris*, the Game Boy handheld console, and the Famicom (NES) 64-bit game console. He retired in 2002 and bought a controlling interest in the Seattle Mariners baseball team.

Yokoi, Gunpei (1941–1997): Engineer for Nintendo, inventor of the Game Boy handheld interactive game player. Yokoi also worked on the design of many of the Nintendo NES games, like *Meteroid*. He resigned from Nintendo in 1996 over the failure of the Virtual Boy handheld console and started his own company, Koto, Inc. He was killed in a car accident on an expressway outside of Kyoto on August 15, 1997.

Zemeckis, Robert (1952–): Film director. Zemeckis created films that broke new ground technologically, including *Who Framed Roger Rabbit?* (1988), *Death Becomes Her* (1992), and *Forrest Gump* (1994). In 2004 he became a leading exponent of performance-capture animated films. He formed his own company, ImageMovers Digital, to make the films *The Polar Express* (2004), *Monster House* (2006), *Beowulf* (2007), *A Christmas Carol* (2009), and *Mars Needs Moms* (2011).

Appendix 2: Glossary

Figure 17.1
The computer mainframe room of Digital Productions (Hollywood) in 1982, showing the Cray XM-P supercomputer in the center.
Courtesy of John Whitney Jr.

The nomenclature of computer graphics changes rapidly, and every new label may mean a potential patent or logo. Many terms are made up to describe something that hadn't had a name before or to differentiate the commands of new proprietary software, to make it distinct from others. So this section may prove as much an archive of historic terminology as a description of current practices.

algorithm A step-by-step problem-solving procedure, especially an established, recursive computational procedure for solving a problem in a finite number of steps. (*American Heritage Dictionary* definition.)

alpha channel The basic way to combine multiple layers of images into a complete picture while preventing figures from moving through one another or the background. It is the equivalent of the traditional animation process of placing the characters, a table, and the painted background of a room together on registration pegs and photographing them. The name is taken from the ancient Greek word meaning "first": *alpha*.

analog Early, pre-digital computers that relied on transistors or vacuum tubes.

anti-alias A program for smoothing jagged "staircase steps" or "jaggies," the edges of a raster image.

Bezier curves Curves used to plot out smooth curves and arcs of movement.

Blinn shading A shading method developed by Jim Blinn in 1977 to diffuse, specular, and otherwise customize the qualities of light in a graphic frame.

bump mapping A way to create irregular surface detail on a raster shape.

byte A unit comprising eight bits, or binary digits. Binary for 0s and 1s, the basic units for a computer.

compositing The final process in the creation of a CG scene, where all the visual elements and lighting are combined with the camera movements. The equivalent in traditional animation would be optical-camera, optical printing, final checking, and scene planning combined.

Cray A type of mainframe supercomputer, from designs by Seymour Cray.

CRT Cathode-ray tube. The most common type of television monitor picture tube from 1931 to the beginning of the twenty-first century, when liquid crystal and other flat screen technologies began to replace it.

digital From the Latin *digitus,* meaning finger, as in counting on your fingers. The opposite of analog.

DOS Disc operating system. An early computer language.

fractals From the Latin *fractus,* meaning broken or segmented. A rough or fragmented geometric shape that can be subdivided into parts, each part a reduced copy of the whole. The shape is too irregular and complex to be defined in terms of standard Euclidian geometry. First described by mathematician Benoit Mandelbrot in 1975.

frame buffer An external memory storage device used in the 1970s for the large amount of information needed to create graphic images. As the core memories of computers were expanded and other external means of storage were invented, frame buffers became obsolete.

gigabyte One billion bytes, or one thousand megabytes.

hackers The general label for hard-core computer aficionados. After 1991, when personal computing became accessible to the general public, *hacker* came to more narrowly mean someone who digitally invaded secure files without permission and took data without clearance.

hierarchy An ordering of the set of objects in a scene that defines dependencies of rotation and size. The object above is called the parent. The one below is the child.

hypertext A format that allows opening and closing programs without having to type in lengthy access codes; just point on a word or symbol and click.

inbetweens and tweening In animation, inbetweens are the drawings needed between key poses to complete a movement. In 1976 Ed Catmull developed the first program to create these electronically.

key pose The animation process of drawing out the major points of an action. A golfer raises his club and strikes the ball. Each terminal point before changing direction is a key pose. Also called keyframes, after the individual pictures (frames) running on a strip of movie film.

killer app A killer application, old hacker slang meaning a program that revolutionizes the way we all use our computers, like e-mail or hypertext.

kinematics The way in which an object created by lines or shapes can move as a defined unit. For instance, if you draw an arm and want to move it, instead of just one part of the outline moving, the entire arm flexes according to its joints.

Lissajous curves Curves resulting from the combination of two harmonic motions. Named for French scientist Jules A. Lissajous (1822–1880).

mattes The original, nondigital cinematic process for creating visual effects. Objects to be combined are shot against black on separate strips of film. Then the strips of film are run together in an optical printer and photographed once more as a single strip of film. This was replaced by digital matting in the 1990s.

megabyte Approximately one million bytes.

motion capture The process of rigging a flesh-and-blood actor with sensors to record movement that will be reproduced in the creation of a CG figure.

open source A code or program made available for free for anyone to use or develop.

Phong shading A landmark model used to light and render 3D raster objects smoothly.

pixel An abbreviation of "picture element." The smallest single element of a raster image.

previsualization A type of program that takes what a motion picture storyboard does, then expands the image to a virtual set, giving the filmmaker the flexibility to set the cameras, lights, and figures within the frame.

raster graphics 3D images created not by linking lines like a drawing but modeling shapes from collection of pixels. Also called a bitmap.

spline A curve defined by a mathematical function.

terabyte One trillion bytes, or one thousand gigabytes.

vector graphics Computer imagery consisting of wireframe lines, without surfacing.

wireframe replacement In vector graphics, a way of making the lines behind the surfaces disappear so the object appears solid, not just as a glowing schematic.

z-buffer In management of a 3D image, the z-buffer keeps a record of what parts of an image can be rendered fully and what can be hidden, taking into account not only the light sources but also where the objects are in relation to the camera.

zoom The distance from the camera to what is being photographed. Objects in the lens can be enlarged or reduced by moving the camera zoom.

Appendix 3: Alphabet Soup: CG Acronyms and Abbreviations

ACM Association for Computing Machinery. The parent organization of SIGGRAPH.

AI Artificial Intelligence

Ampex Alexander M. Poniatoff Excellence. A company that was one of the leading producers of magnetic recording tape, founded in 1947. Nolan Bushnell and Alan Alcorn began at Ampex.

ARPA Advanced Research Projects Agency. A Defense Department agency responsible for developing new technology, which funded the development of many early computer technologies. In 1972 the name changed to DARPA, Defense Advanced Research Projects Agency. It was changed back for a time but then returned to DARPA in 1996.

ASIFA Association Internationale du Film d'Animation. International animators' society chartered by UNESCO in 1962.

BeFlix For Bell Flicks, an early animation software program developed at Bell Telephone Labs.

C One of the most widely used computer languages, developed by Dennis Ritchie at Bell Labs in 1972.

CAD/CAM Computer-aided design and manufacturing. Computers created specifically to create patterns and 3D molds for industrial designs, such as those used to create new automobiles, aircraft, and boats.

CalArts California Institute of the Arts.

Calcomp California Computer Products. A producer of moderately priced computers, plotters and printers from 1959 to 1999.

CAPS Computer Animation Production System, called sometimes Computer Animated Paint Systems. The system used for painting Disney animated feature cartoons, 1989–2003.

CDC Control Data Corporation. A Minnesota-based company that gave IBM some serious competition in the retail computer industry from 1957 to 1986. In 1964 they created the CDC 6600, the first supercomputer.

CGI Computer graphic imaging or computer graphic interface.

CGL Computer Graphics Lab (New York Institute of Technology).

CPU Central processing unit. The hardware in a computer that carries out the instructions of a computer program.

CRT Cathode ray tube monitor. The standard computer screen.

CSUN California State University, Northridge.

DAC-1 Design augmented by computer. The IBM computer custom-built for General Motors in 1964 to design new automobiles.

DARPA See ARPA.

DEC Digital Equipment Corporation. A Maynard, Massachusetts, vendor of mainframe computers in the 1960s.

DOA Digital-Omnibus-Abel. An amalgamation of three top CG houses in the 1980s.

DOD U.S. Department of Defense.

ENIAC Electronic Numerical Integrator and Calculator. One of the earliest electronic computers.

FORTRAN FORmula TRANslator, A high level computer language developed at Westinghouse in 1957 that greatly simplified the writing of new programs.

FK and IK Forward kinematics and inverse kinematics. Formulas used in 3D animation.

ftp File transfer protocol.

GRASS Graphics symbiosis system. A programming language.

GUI Graphical user interface. A system that allows pointing and clicking on a symbol to open a program instead of having to write out code commands.

HAL 9000 Heuristically programmed Algorithmic Computer. The evil computer in Stanley Kubrick's 1968 film *2001: A Space Odyssey*.

IBM International Business Machines. Nicknamed "Big Blue." The dominant maker of computers in the mid-twentieth century.

IATSE International Alliance of Theatrical and Screen Engineers. Coalition of Hollywood backstage labor unions that have represented film and TV workers since the 1930s.

IC Integrated circuit.

ILM Industrial Light & Magic, the special effects division of Lucasfilm.

IMI Interactive Machines International.

LISP Locator Indicator Separation Protocol. Computer language developed by John McCarthy in 1958 and used as the basis for Symbolic Inc software.

LSD Lysergic acid diethylamide, more commonly called acid. One of the first modern hallucinogenic drugs, discovered by Dr. Albert Hoffman in 1938 while trying to examine the herbs used by ancient Greeks in their religious rites. LSD became a recreational drug for many in the radical counterculture of the 1960s. It was officially banned by the United States in 1966.

MAGI Mathematical Applications Group, Inc. One of the earliest privately owned computer graphic studios. Also called Synthavision. Formed in 1972 in Elmsford, New York, by Robert Goldstein, Bo Gehring, and Larry Elin.

MIT Massachusetts Institute of Technology.

MITRE Massachusetts Institute of Technology Research Enterprises.

NASA National Aeronautics and Space Administration.

NCGA National Computer Graphics Association. A one-time rival organization to SIGGRAPH.

NFB National Film Board of Canada. The chief funder of independent and experimental filmmakers in Canada.

NURBS Non-uniform rational basis spline. A special class of B-splines (mathematical models) developed by Alias software. The technology enables the modeler to work with a more complex basic surface.

OSU Ohio State University.

PDP-1 Programmed Data Processor, aka "the Deck." Created by Bolt, Beranek and Newman, it was one of the most successful early multitasking, multiuse computers. The first computer game was designed on a PDP-1. Subsequent generations, like the PDP-10 and PDP-11, played important roles in the development of CG until replaced by VAX, then SGI.

PRISMS Production of realistic image scene mathematical simulation. An animation program developed by Omnibus in 1985.

RAND Research and Development Corporation.

REYES Renders Everything You Ever Saw. Reyes rendering is a type of computer software architecture. The name is based on a Lucasfilm (now Pixar) joke about a locale near their studio named Point Reyes.

ROTC Reserve Officer Training Corps. A U.S. government program to provide students a way to pay for their college education in exchange for serving a term in the military.

SAGE Semi-Automatic Ground Environment. A computer project used in a U.S. air defense system, 1958–1983.

SAIL Stanford Artificial Intelligence Lab.

SCUAIDE A 1960s computer animation user group, a forerunner of SIGGRAPH.

SGD Symbolics Graphic Division, the CG arm of computer company Symbolics Inc. (1981–1991).

SGI Silicon Graphics Imaging.

SIGGRAPH Special Interest Group on Computer Graphics, also called ACM SIGGRAPH.

SRI Stanford Research Institute.

SUN Stanford University Network, a campus computer network. The design for SUN workstations later became the basis for the productions of Sun Microsystems.

TMRC Tech Model Railroad Club (MIT).

Triple-I Information International, Inc. An early CG visual effects house.

UCLA University of California, Los Angeles.

UNIX Uniplexed. A general-purpose, multitasking computer operating system developed by AT&T Bell Labs in 1969. The name derived from Bell-MIT-GE's first system, Multics, or Multiplexed Information and Computing Service.

UPA United Productions of America. Cartoon studio formed in 1945 that produced characters like Gerald McBoing-Boing and Mr. Magoo.

USC University of Southern California.

VAX Virtual address extension. A line of computers that succeeded the PDP-11 series and was used throughout the 1970s.

VFX Visual F/X, or visual effects.

WDI Walt Disney Imagineering. The branch of the Walt Disney Company most concerned with the design, building, and maintenance of their theme parks. Imagineers were the people who pioneered the development of animatronic figures.

Weta Weta Digital, the premier visual effects CG studio in Wellington, New Zealand, which produced the Lord of the Rings trilogy (2001–2003), *King Kong* (2005), and *Rise of the Planet of the Apes* (2011). The name is not an acronym, but is taken from a big fat insect the size of your hand that is native to New Zealand.

WYSIWYG What You See Is What You Get. A computing system developed at Xerox PARC. It means that what you print out will be the same as what you see on your screen.

Xerox PARC Xerox Palo Alto Research Center.

Notes

Chapter 1 Film and Television at the Dawn of the Digital Revolution

1. Joseph Kennedy Sr. quoted by Cari Beauchamp in "The Mogul in Mr. Kennedy," *Vanity Fair*, April 2002, 1.

2. Back in Eastern Europe, Sam Goldwyn was born Schmuel Gelpfish; the original family name of the Warner Bros. was Eichelbaum.

3. Gabler, *Empire of Their Own*.

4. Dave Snyder to the author, March 26, 2012.

5. Quoted in Byskind, *Easy Riders, Raging Bulls*, 18.

6. I explore this case in Sito, *Drawing the Line*, 214–15.

7. Lucas quoted in Vaz and Duignan, *Industrial Light and Magic*, 6.

8. Rubin, *Droidmaker*, 100.

Chapter 2 Analog Dreams: Bohemians, Beatniks, and the Whitneys

Epigraph: Van Doesberg quoted in Cuba, "Analog Roots."

1. Eadweard Muybridge (1830–1904) conducted experiments in stop-motion photography at Stanford University in 1877 that are considered the forerunner of modern motion pictures and animation. Inventor Thomas Edison and James Stuart Blackton, the first American animator, consulted with Muybridge before beginning their own cinema experiments.

2. For much of the detail on Oskar Fischinger's life, we have to credit Dr. William Moritz (1941–2004) of the California Institute of the Arts. He was a friend and confident of Fischinger's wife, Elfriede, in her later years and became Fischinger's official biographer. The anecdotes used here are described in greater detail in Moritz, *Optical Poetry*.

3. Moritz, *Optical Poetry*, 85. For the record, when *Fantasia* was released most critics were pleased, but more highbrow critics in magazines like the *New Yorker* savaged it for being kitsch. In 1997,

when Disney Studios did a digital restoration and re-released the film, the *New Yorker* reprinted its original negative review from November 1940.

4. Fischinger wrote a letter to Stokowski about combining music and art in 1936. Leopold Stokowski had also discussed the idea of combining music and art with New York filmmaker Mary Ellen Bute in 1933. Bute, "Abstronics," 266. The official Walt Disney version of the origin of *Fantasia* is Walt met Stokowski over dinner at Chasens restaurant one evening in 1938, and there began a discussion on how best to combine classical music with animation.

5. Moritz, *Optical Poetry*, 100.

6. These performance installations of abstracts moving to music and projected onto a wall evolved into the concept of the light show. John Whitney collaborated on creating such a show in 1958, projected onto the wall of a Moscow science show.

7. Oskar Fischinger did a TV spot for local LA appliance retailer Earl "Mad Man" Muntz in 1960. Muntz's name was used for a character in the 2009 Pixar film *Up*.

8. Bute, "Abstronics," 262.

9. Mary Ellen Bute: Seeing Sound, by Dr. Bill Moritz, Animation World Magazine, http://www.awn.com/mag/issue1.2/articles1.2/moritz1.2.html. Leo Theremin (Lev Sergeyevich Termen 1893–1996) invented the strange instrument named for him in 1920. Soviet leader Lenin hailed it as "Socialism Electrified!" Composer Bernard Hermann used a theremin extensively in his soundtrack for the film *The Day the Earth Stood Still* (1951). Since then, the theremin sound has become a cliché for alien invaders or other such science fiction horrors.

10. Cohen, *Forbidden Animation*.

11. For an overview of VanDerBeek's work, see Amidi, "Stan VanDerBeek."

12. Youngblood, *Expanded Cinema*, 246.

13. Amidi, "Stan VanDerBeek."

14. Gianalberto Bendazzi, *Cartoons: One Hundred Years of Cinema Animation*, 140.

15. Jordan Belson quoted in Youngblood, *Expanded Cinema*, 167.

16. Moritz, "Hy Hirsh and the Fifties." Hirsh's Parisian friends said this incident may be exaggerated.

17. Moritz, "Hy Hirsh and the Fifties," 6.

18. The E.A.T. Program (Experiments in Art and Technology) was a nonprofit group set up in 1967 by artist Robert Rauschenberg and engineer Billy Kluver. Their purpose was to develop collaborations between artists and technicians to create contemporary art. Twenty chapters of E.A.T. were established across the United States.

19. R. T. Taylor interview by the author.

20. Cuba, "Analog Roots," 14.

21. Drain, "Lapolsky's Lights."

22. Bute, "Abstronics," 266.

23. John Whitney Sr. quoted in Youngblood, *Expanded Cinema*, 215.

24. John Whitney Sr. quoted in Youngblood, *Expanded Cinema*, 214.

25. Bill Mortiz, "Digital Harmony: The Life of John Whitney, Computer Animation Pioneer," *Animation World Network*, no. 2.5, August 1997.

26. James Whitney (1970) quoted in Moritz, *Optical Poetry*, 168.

27. Fischinger letter, December 11, 1943, in Moritz, *Optical Poetry*.

28. James Whitney quoted in Youngblood, *Expanded Cinema*, 228.

29. Michael Whitney, "The Whitney Archive: A Fulfillment of a Dream," *Animation World Magazine*, no. 2.5, August 1997, 2.

30. Cuba, "Analog Roots." 4.

31. Moritz, "You Can't Get Then from Now."

32. Of the five film exercises, John authored the first and fifth, and James the three in between. Bendazzi, *Cartoons*, 244.

33. Moritz, "You Can't Get Then from Now."

34. The site today is the Barnsdall Art Park (on Hollywood Boulevard near Vermont Boulevard). It was endowed by Aline Barnsdall in 1919 to be a collective for aspiring artists. Barnsdall was fond of young artists and radicals. The wealthy oil heiress allowed the fences of her estate to be wallpapered with socialist propaganda posters and union meeting notices.

35. D. W. Griffith (1875–1948), the director of *Birth of a Nation* (1915) and *Intolerance* (1918), was by the late 1940s a forgotten has-been. Seeing him pathetically beg MGM studio chief Dore Schary for work inspired Billy Wilder to write the script for *Sunset Boulevard* (1951).

36. Youngblood, *Expanded Cinema*, 227.

37. Amidi, *Cartoon Modern*, 142–44. Ernie Pintoff went on to create award-winning animated shorts like *The Critic* (1963). Fred Crippen created the TV series *Roger Ramjet* (1965).

38. Amidi, *Cartoon Modern*.

39. Youngblood, *Expanded Cinema*, 213–214.

40. Saul Bass (1913–1996) was a top graphic designer in Hollywood in the 1950s and 1960s. He was known for visually unique opening title sequences for films like *Spartacus* (1960), *Around the World in Eighty Days* (1956), and *The Man with the Golden Arm* (1955).

41. There is an old story that John Whitney's *Vertigo* designs were the basis for the popular baby boomer toy the Spirograph, but the toy was actually invented by a British designer, Denys Fisher, in 1965, who then sold the concept to Kenner Toys.

42. Dr. Jack Citron quoted in Youngblood, *Expanded Cinema*, 216. He follows with a detailed explanation of his GRAF program package.

43. R. T. Taylor interview by the author.

44. Cuba interview by the author.

45. John Whitney Sr. biography, Center for Visual Music, http://www.centerforvisualmusic.org/Library.html.

46. John Whitney Jr. to the author.

47. See John Stehura's autobiography on his webpage, Cybernetic Cinema, http://cyberanimation.tripod.com/historypage.htm.

48. Ibid.

49. Youngblood, *Expanded Cinema*, 241.

50. Csuri, *Charles A. Csuri Beyond Boundaries*, 45.

51. Csuri, *Charles A. Csuri Beyond Boundaries*, 46.

52. Foldes quoted in Bendazzi, *Cartoons*, 432.

53. Foldes quoted in Bendazzi, *Cartoons*, 433.

54. Sorenson interview by the author.

55. Cuba interview by the author.

56. Cuba interview by the author.

57. David Em interview by the author.

58. Cuba interview by the author.

59. Rebecca Allen to the author, February 2012.

60. Cuba quoted in Wolff interview by the author.

Chapter 3 Spook Work: The Government and the Military

1. According to the Computer History Museum (Mountain View, Calif.), the U.S. Army originally gave the name "computers" to the people who manually calculated ballistic trajectories for artillery pieces.

2. John Whitney quoted in Youngblood, *Expanded Cinema*.

3. According to the Computer History Museum, ENIAC's existence was not revealed to the public until February 15, 1946. It stayed in service until 1955.

4. Cruickshank, "Inevitable Engine," 18.

5. The log page and the toasted moth are today in the Smithsonian Institution in Washington, D.C.

6. The first commercially available general purpose computer was Britain's Ferranti Mark I, the grandchild of the Manchester Baby. It came out in 1951, a few months before the TXO Whirlwind.

7. Cruickshank, "Inevitable Engine," 18.

8. The British Manchester Baby had a tiny screen and stored programs as early as 1948.

9. Quoted in Abella, *Soldiers of Reason*, 107.

10. Robert Taylor quoted in Mayo and Newcomb, "How the Web Was Won."

11. Department of Defense Directive 5105.41, February 1958.

12. Sutherland interview by Aspray.

13. Wahrman interview by the author.

14. SAGE stayed operational until 1983. Long after most computers were using silicon chips, SAGE computers still needed outdated vacuum tubes. Most domestic companies had stopped making them, so when the air force needed replacements it had to shop abroad, sometimes even buying them from the intended target, the Soviet Union.

15. Poem reprinted permission of the MIT Museum, Whirlwind Project collection.

16. Ivan Sutherland's first name is sometimes given as John, an anglicized version of Ivan.

17. John McCarthy, stated it nicely: "It was tough to go to the directors and say I've got a neat idea, can I borrow your $500,000 computer to see if it works?" Panel discussion at "The Mouse that Roared: The PDP-1 Celebration" conference, Computer History Museum, Mountain View, Calif., May 15, 2006.

18. Ivan Sutherland lecture, Computer History Museum, Mountain View, Calif., 2005.

19. Smith interview by the author.

20. Alan Kay quoted in Hiltzik, *Dealers of Lightning*, 91.

21. Kay, "Ivan Sutherland's Sketchpad."

22. Sutherland's official title at ARPA was Director of the Information Processing Techniques Office (IPTO).

23. Sutherland interview by Aspray.

24. Adapting an old concept of being on a telephone line, Professor Douglas Engelbart of Stanford first used the term *online* in 1963. He called his pre-Internet concept of interconnected computers NLS, for "online systems." Markoff, *What the Dormouse Said*, 52.

25. Today both Baran and Davies are given credit for inventing packet switching, although they mainly worked independently of one another.

26. Keenan Mayo and Peter Newcomb, "How the Web Was Won," *Vanity Fair*, July 2008, 108.

27. Leonard Kleinrock quoted in Mayo and Newcomb, "How the Web Was Won."

28. Sutherland interview by Aspray.

29. Kerlow and Rosebush, *Art of 3D Computer Animation*, 8.

30. Sorensen interview by the author.

31. Les Earnest, referenced in Markoff, *What the Dormouse Said*, 109.

32. Blinn interview, by the author, April 20, 2009.

33. For the previous ten years JPL had had a traditional animator on staff named Bill Matthews. Matthews began at Walt Disney Studios on the film *Sleeping Beauty*. He made instructional films for JPL and said he grew proficient at painting tennis balls to hang on strings and look like Mars and Jupiter.

34. David Em to the author, April 18, 2012.

35. Blinn interview by the author, April 20, 2009.

36. Blinn interview by the author, April 20, 2009.

37. Blinn interview by the author, April 20, 2009.

38. The term *3D animation* is used here not to denote 3D stereoscopic imagery but, following the film industry use of the term, to refer to animated images rendered and lit in the round, distinct from flat cartoon animation images.

39. In 1975 Gentry Lee was one of the managers of the Mars Viking lander program and wrote science fiction novels in collaboration with Arthur C. Clarke.

40. Blinn interview by the author, April 20, 2009.

41. Blinn interview by the author, October 13, 2007.

42. People at Disney, Pixar, and PDI called that commute "The Burbank Shuttle." Southwest Airlines offered nine flights a day for the one-hour jump from the Los Angeles area to the San Francisco Bay Area, where ILM was situated.

43. Blinn quoted in Rubin, *Droidmaker*, 234.

44. The French government under Francois Mitterrand pushed government investment in CG development through a program called Plan Recherche Image. The earliest CG work was done by the Institut national de l'audiovisuel (INA), an offshoot of Radio France, the government broadcast entity.

Chapter 4 Academia

Epigraph: Charles Csuri, interview by Kerry Freedman, October 23, 1989, Charles Babbage Institute Collections, Center for the History of Informational Processing, University of Minnesota, Minneapolis.

1. The term *blue sky research* was popularized in scientific circles after 1945, when MIT computer pioneer Vannevar Bush used it in an article titled "Science: The Endless Frontier."

2. Several important companies got their beginnings at MIT. These include the Digital Equipment Corporation (DEC), and the Symbolics Graphics Division, set up in 1980 in part with hardware architecture from MIT researchers.

3. Charles Babbage (1791–1871) was an English mathematician who in the 1830s conceived of a calculating machine that was in effect a programmable computer. Although Babbage's machine was never completed in his own time, modern models based on his original plans work perfectly. The revelation that computers were almost invented in the Victorian era set off the Steampunk theme in Japanese manga in the 2000s.

4. Nick Montfort, "TMRC," in Burnham, *Supercade*, 39.

5. The *Ms. Pac-Man* arcade game was also developed by MIT hackers Doug McCrae and Kevin Curran.

6. Corbato and Fano quoted in Green, *Bright Boys*, 232.

7. Hiltzik, *Dealers of Lightning*, 66.

8. There is a detailed description of Douglas Engelbart's 1968 demonstration in Markoff, *What the Dormouse Said*, 148–51. In the footnote on p, 148, Markoff explored the confusion over who first called Englebart's cursor control a mouse.

9. Markoff, *What the Dormouse Said*, 94.

10. Markoff, *What the Dormouse Said*, 158.

11. Scott Johnston to the author, March 21, 2011.

12. Rebecca Allen to the author, February 20, 2012.

13. Csuri interview by Freedman.

14. Csuri interview by Freedman.

15. Wedge interview by the author.

16. Wedge interview by the author.

17. Masson, *CG101*, 320–23.

18. Cuba interview by the author.

19. Cuba interview by the author.

20. Of course, back in the 1950s and 1960s, a mass-produced computer meant they created a dozen or so, not the millions made today. The Digital Equipment Company sold only 150 PDP-1 mainframe computers. That was considered one of the best sellers of the age.

21. David Em interview by the author.

22. Robert Taylor of ARPA and Xerox PARC should not be confused with Richard Taylor, art director of *Tron,* or R. T. Taylor, systems engineer at Robert Abel & Associates.

23. Sutherland interview by Aspray.

24. Stern interview by the author.

25. Alan Kay quoted in Hiltzik, *Dealers of Lightning,* 90.

26. Alan Kay quoted in Hiltzik, *Dealers of Lightning,* 90.

27. Sutherland quoted by John Markoff for the obituary of David Evans, *New York Times,* October 12, 1998.

28. Stern interview by the author.

29. Catmull interview by the author, May 2, 2007.

30. Richard Taylor interview by the author.

31. Today the original teapot has been donated to the Computer History Museum in Mountain View, California.

32. Lance Williams interview by the author.

33. John Markoff, obituary for David Evans, *New York Times,* October 12, 1998.

34. Catmull quoted in Lewell, *Computer Graphics,* 16.

35. Bergeron interview by the author.

36. Bergeron interview by the author.

37. Bergeron interview by the author.

38. Elmer-DeWitt, "Computers."

39. Fiume interview by the author.

40. Fiume interview by the author.

41. Vibeke Sorensen to the author.

42. Sorensen interview by the author.

43. Joanna Priestley quoted in "The Influence of Jules Engel on Contemporary Animation," A Centennial Celebration, sponsored by Cal Arts, and the Center for Visual Music, REDCAT Theater, Los Angeles, April 18, 2009.

44. Terrence Masson, *CG101,* 317–318.

45. Quoted in Timothy Leary, Ralph Metzner, and Richard Alpert, *The Psychedelic Experience* (Citadel Press, 1964), 11.

46. The term *tripping,* referring to an LSD acid trip, evolved from California surfer slang of the 1950s. To "go tripping" originally meant to take a ride down the coast road.

47. Program notes by Pamela Turner, *Infinite Animation: The Work of Adam Beckett*, sponsored by the iotaCenter and the AMPAS Science and Technology Council, August 17, 2009, Linwood Dunn Theater, Hollywood.

Chapter 5 Xerox PARC and Corporate Culture

Epigraph: Simonyi quoted in Hiltzik, *Dealers of Lightning*, 357.

1. In 1911 the company changed its name to the Computing, Tabulating and Recording Corporation (CTR) and finally, in 1924, to International Business Machines (IBM).

2. Hiltzik, *Dealers of Lightning*, 101.

3. Knowlton, "Portrait of the Artist."

4. Knowlton, "Portrait of the Artist."

5. Knowlton, "Portrait of the Artist."

6. Markoff, obituary for Seymour Cray, University of Wisconsin, September 1996.

7. Christiansen interview by the author.

8. Weinberg interview by the author.

9. Christiansen interview by the author.

10. Christiansen interview by the author.

11. Sutherland interview by Aspray.

12. Christiansen interview by the author.

13. Sutherland interview by Aspray.

14. Smith interview by the author.

15. Smith interview by the author.

16. Xerox was originally the Haloid Company, based in Rochester, New York, where it produced photo-enlargement paper for Eastman Kodak. In 1935 hairdresser Chester Carlson invented the photocopier process. After being turned down by Edison and Kodak, he sold rights to his process to Haloid, which went on to success under its new name, Xerox.

17. Hiltzik, *Dealers of Lightning*, 95.

18. Bob Taylor quoted in Hiltzik, *Dealers of Lightning*, 97.

19. Kroyer interview by the author, July 9, 2010.

20. Wolff interview by the author.

21. This description and Shoup quote from Hiltzik, *Dealers of Lightning*, 229–33.

22. Smith interview by the author.

23. Smith quoted in Hiltzik, *Dealers of Lightning*, 234.

24. Em interview by the author.

25. Shoup quoted in Hiltzik, *Dealers of Lightning*, 238.

26. Smith interview by the author; Hiltzik, *Dealers of Lightning*, 240.

27. Only two thousand Altos were ever sold, mostly to the research wings of large universities.

28. Isaacson, *Steve Jobs*, 96.

29. Issacson, *Steve Jobs*, 96.

Chapter 6 Hackers

1. Alan Kay quoted in Hiltzik, *Dealers of Lightning*, 81.

2. Peter Samson quoted in Levy, *Hackers*, 34.

3. Levy, *Hackers*, 39.

4. Michael Disa to the author, Burbank, California, June 2005.

5. From Nick Montfort, "TMRC," in Burnham, *Supercade*, 39.

6. "An Abridged Dictionary of the TMRC Language" (1960), on Peter Samson's personal web page, www.gricer.com.

7. Steve Jobs quoted in Goodell, "The Steve Jobs Nobody Knew."

8. Steve Wozniak quoted in Price, *Pixar Touch*, 83.

9. Brand and the *Whole Earth Catalog*'s origins are described in greater detail in Markoff, *What the Dormouse Said*, 152–57.

10. Digibarn, Online Computer Museum, http://www.digibarn.com/collections/newsletters/peoples-computer/peoples-1972-oct/index.html

11. Felsenstein quoted in Vance, *Geek Silicon Valley*, 161–67.

12. Entis interview by the author, June 24, 2011.

13. November 15, 2006, lecture by Richard Chuang for the Stanford University Computer Systems Colloquium (EE 380), http://www.youtube.com/watch?v=cQkEA62KWQQ

14. Machover, "Looking Back."

15. Figures quoted in Brown and Cunningham, "History of ACM SIGGRAPH."

16. Weinberg interview by the author.

17. Lasseter, "Principles of Traditional Animation."

18. Johnston interview by the author.

19. Kroyer interview by the author.

20. Davidson interview by the author.

21. Price interview by the author.

22. Carpenter interview by the author.

23. Cope interview by the author, June 16, 2007.

24. Neuromancers tech log, August 10, 2007.

25. President Richard M. Nixon was born in Whittier, California; the library moved his wood-framed bungalow birthplace to the library site. Of many politicians, Nixon was a particular bête noire for the counterculture. He ran in 1968 on a peace platform, yet he expanded the Vietnam War into Laos and Cambodia. He obsessed about student antiwar protesters, calling them "bums," and waged a media offensive against them. Gonzo writer Hunter H. Thompson trained his dogs to growl at the word *"Nixon."*

26. Seymour, "Ben Snow."

27. Quoted in Willman, "Would Richard Nixon Ever Appreciate Any of This?"

Chapter 7 Nolan Bushnell and the Games People Play

Epigraph: Ralph Baer, foreword to Burnham, *Supercade.*

1. Kent, *First Quarter*, 19–22. Baer wrote his own account of this event in *Videogames.*

2. William Higginbotham quoted in Poole, *Trigger Happy*, 15–16.

3. Alan Kotok, panel discussion at "The Mouse that Roared: The PDP-1 Celebration" conference, Computer History Museum, Mountain View, Calif., May 15, 2006.

4. Markoff, *What the Dormouse Said*, 88–89.

5. Steve "Slug" Russell, panel discussion at "The Mouse that Roared: The PDP-1 Celebration" conference, Computer History Museum, Mountain View, Calif., May 15, 2006.

6. Kent, *First Quarter*, 17.

7. Tom Zito in Kent, *First Quarter*, 17.

8. Bill Harrison quoted in Wolverton, "Father of Video Games."

9. Kent, *First Quarter*, 20.

10. Wolverton, "Father of Video Games."

11. Ralph Baer quoted in Winter, "Magnavox Odyssey."

12. The first joystick control was developed by Werner von Braun's German scientists in World War II to direct guided missiles, based on the steering stick that fighter pilots used in World War I.

13. Nolan Bushnell quoted in Kent, *First Quarter*, 28.

14. Burnham, *Supercade*, 78.

15. Nolan Bushnell quoted in Rubin, *Droidmaker*, 291.

16. Bjorke interview by the author.

17. *Neuromancer* game designers were Bruce Balfour, Michael Stackpole, Brian Fargo, and Troy A. Miles.

18. In 1996 *Computer Gaming World* named *Neuromancer* among the 150 Best Games of All Time.

19. Kent, *First Quarter*, 96.

20. Loc, "History of Videogames Timeline."

21. David Rosen quoted in Kent, *First Quarter*, 260.

22. Savage, "8 Interesting Facts."

23. Besides *Pac-Man*, the Smithsonian has a copy of *PONG* and *Dragon's Lair*.

24. Loc, "History of Videogames Timeline."

25. Kohler, *Power-Up*.

26. Ron Judy quoted in Kent, *First Quarter*, 129.

27. Coleco (1932–1989) was originally founded as the Connecticut Leather Company by Morris Greenberg.

28. Loc, "History of Videogames Timeline."

29. Kent, *First Quarter*, 143.

30. Rubin, *Droidmaker*, 385.

31. Howard Lincoln quoted in Pitta, "This Dog Is Having a Big Day," 160.

32. Kent, *First Quarter*, 99.

33. Groenendijk, "Gunpei Yokoi."

34. The game creators were John Carmack, John Romero, and Jason Blochowiak, programmers; Tom Hall, creative director; Adrian Carmack, artist; and Robert Prince, musician.

35. Although cut scenes were used as early as 1983, in *Donkey Kong II,* the first cinematic may have been in *Bega's Battle* in 1983. Data East created the storyline and cutaways from footage lifted from an anime feature called *Harmageddon.*

36. Nolan Bushnell quoted in Chafkin, "Nolan Bushnell Is Back in the Game."

Chapter 8 To Dream the Impossible Dream: The New York Institute of Technology, 1974–1986

Epigraph: Maher quoted in Prince, "Projects."

1. Smith interview by the author; Blinn interview by the author, October 13, 2007.

2. Alvy Ray Smith quoted in Price, *Pixar Touch,* 23.

3. Rubin, *Droidmaker,* 104.

4. For a thorough account of the NYIT computer lab, see Rubin, *Droidmaker,* 103–39.

5. On the West Coast, the first class of trainees for the Walt Disney character animation program at the California Institute of the Arts had begun in 1976.

6. John Celestri, e-conversation with the author, May 15, 2009.

7. Michael Sporn, e-conversation with the author, April 20, 2009.

8. Catharine Crane, Will Johnson, Kitty Neumark, and Christopher Perrigo, "Pixar 1996" (case study), University of Michigan Business School, 1–2.

9. Schure quoted in Price, *Pixar Touch,* 17.

10. "A Brief History of the New York Institute of Technology Computer Graphics Lab," in Masson, *CG101,* 1.

11. A pun on one of the early names for a computer—a Turing machine, named for English computer pioneer Alan Turing.

12. Price, *Pixar Touch,* 21.

13. John Celestri, conversation with the author, 1976, New York City.

14. Blinn interview by the author, October 13, 2007.

15. Alvy Ray Smith interview by the author.

16. Smith interview by the author.

17. Czech science fiction writer Karel Capek (1890–1938) coined the term *robot* for his 1921 play *RUR* (*Rossums Universal Robots*). American writer Isaac Asimov took up the use of the word in his own books, like *I, Robot.*

18. Ed Catmull interview by the author.

19. Stern interview by the author.

20. Price, *Pixar Touch,* 23–24.

21. "A Brief History of the New York Institute of Technology Computer Graphics Lab," in Masson, *CG101,* 2.

22. Maher interview by the author.

23. Alvy Ray Smith interview by the author.

24. In 1953 Hollywood animator Preston Blair created a workbook for the Walter T. Foster Company. It was reprinted every year until 2009 under several titles, but is still considered one of the best how-to books for first timers in the cartoon animation and visual effects field.

25. Smith quoted in Freiburghouse, "Legends."

26. Culhane, *Talking Animals*, 437–38. In hand-drawn animation, a background was a painting on cardboard of the setting in which the character moved.

27. Catmull interview by the author, May 2, 2007.

28. Catmull interview by the author, May 2, 2007.

29. The quote can be traced to Don Bajus of Minneapolis-based animation studio Bajus Jones, from the late 1970s. He put it into his promotional advertising.

30. Stern interview by the author.

31. Smith interview by the author.

32. Grignon interview by the author.

33. Smith quoted in Rosinski, "Early Computer Generated Video Art."

34. Initially Lucas had run Lucasfilm out of a place across from the Universal Studios lot called the Egg Company. The visual effects for the first *Star Wars* were created in a small warehouse he rented in Sherman Oaks, California.

35. Rubin, *Droidmaker*, 163–65.

36. Catmull and Smith to the author.

37. Interoffice electronic mail had existed since the 1960s.

38. Smith interview by the author.

39. Besides working on the *Star Wars* films, Richard Edlund was an Oscar-winning effects supervisor on such films as *Alien* (1979), *Ghostbusters* (1984), and the HBO series *Angels in America* (2003).

40. Smith interview by the author.

41. Loren Carpenter interview by the author.

42. Rebecca Allen interview by the author.

43. Williams interview by the author.

44. Bil Maher, e-mail to the author.

45. The creators of *Max Headroom* were George Stone, Annabel Jankel, and Rocky Morton.

46. Maher interview by the author, February 28, 2011.

47. Stern interview by the author.

48. Stern interview by the author.

49. Alexander Schure, obituary, *New York Times*, January 24, 2010.

50. Smith interview by the author.

51. Matt Elson quoted in Panettieri, "Out of This World."

52. Williams interview by the author.

53. Fred Parke quoted in Panettieri, "Out of This World."

54. Rebecca Allen to the author, February 2012.

Chapter 9 Motion Picture Visual Effects and *Tron*

Epigraph: Gibson, quoted in Solomon, *Enchanted Drawings* 293.

Cameron quoted in Keegan, "Hollywood VFX Shops."

1. Jean Eugène Robert-Houdin (1807–1871) was the most famous French magician of the Belle Epoque. He inspired American magician Erich Weiss to change his stage name to the Great Houdini.

2. Robinson, *History of World Cinema*, 22–23.

3. The matte process was refined and patented in 1918 by Hollywood director Norman O. Dawn (1884–1975).

4. The first French theatrical film with CG effects would be *L'Unique* by Jérôme Diamant-Berger in 1986.

5. Although there have been several movie versions of the Pompeii story since Arturo Ambrosio did one in Italy in 1908, the 1935 Hollywood film starring Preston Foster is the most well known.

6. Catmull interview by McHugh.

7. Because the Barons were not members of the New York musicians' union, Local 802, or Local 47, the Hollywood musicians' union, MGM had to change their screen credit from music to "electronic tonalities."

8. Con Pederson quoted in Moritz, "Talking with Con Pederson."

9. Interestingly, Stanley Kubrick had been developing his script for *A.I.* (artificial intelligence) since the 1970s. Kubrick delayed the production for years because he predicted that the development of computer graphics would explode one day, enabling him to do justice to this futuristic subject. After seeing 1993's *Jurassic Park*, he felt CGI was at last at the level he envisioned. He asked Steven Spielberg to direct *A.I.*.

10. There had been forms of slit-scan (streaking artwork under a camera) kicking about Hollywood effects houses over the years, but John Whitney's version, with his meticulously calibrated motion control, was the most famous.

11. Baxter, *Stanley Kubrick*, 216.

12. An optical printer was a device that could run two or more separate strips of film and record the combined images onto a new piece of film. Since *Jurassic Park* (1993), it has been replaced by CG methods.

13. Baxter, *Stanley Kubrick*.

14. Lee Harrison III created Scanimate from an earlier system he developed called Animac (a hybrid graphic animation computer), nicknamed "the Bone Generator." He had been working on such a system since 1962 at his first company in Pennsylvania, Lee Harrison & Associates.

15. Ed Kramer, "Scanimate and the Analog Computer Era," in Masson, *CG101 Version 2*, 458.

16. Masson, *CG101 Version 2*, 247.

17. Dave Sieg, e-mail to the author, June 18, 2010.

18. Dave Sieg, e-mail to the author, June 18, 2010.

19. Much of the MAGI story I owe to Masson, *CG101 Version 2*, 267–74.

20. Rosebush interview by the author.

21. Rosebush interview by the author.

22. Jeff Kleiser quoted in Masson, *CG101 Version 2*, 235.

23. Triple-I is sometimes written as Triple-iii or Triple-III.

24. Gary Demos became acquainted with John Whitney Sr. in 1970, while taking classes from him at Caltech.

25. Demos, "My Personal History," 3.

26. Richard Taylor interview by the author.

27. Freidkin quoted in Byskind, *Easy Riders, Raging Bulls*.

28. Pederson quoted in Moritz, "Talking with Con Pederson."

29. Larry Cuba had designed *First Fig* at CalArts but completed it at JPL because at the time CalArts didn't have the necessary computer power.

30. Cuba interview by the author.

31. Cuba interview by the author.

32. By 1985 the Lucasfilm CG team was headquartered at Building C on Kerner Boulevard in San Rafael, California.

33. Smith interview by the author. A Moviola was an upright manual editing machine invented by Iwan Serrurier in 1924. It was used extensively in the film and TV business until replaced by flatbed KEM, or "Steenbeck," systems in the late 1970s. Historian Michael Rubin described a Moviola as "a pair of upended movie projectors, film reels locked together with a motor and gears, operated with foot pedals. . . . a crazy contraption that made as much noise as a small outboard motor" (*Droidmaker*, 10–12).

34. Smith interview by the author.

35. Smith interview by the author.

36. McKenna interview by the author.

37. Peter Greenwood to the author, July 6, 2010.

38. Lisberger, "Not Your Father's Grid."

39. Bill Kroyer interview II by the author.

40. Richard Taylor interview by the author.

41. Rosebush interview by the author.

42. Kroyer interview II by the author; Cartwright interview by the author, 2010.

43. Kroyer interview II by the author, 2010.

44. Kroyer interview II by the author, 2009.

45. Van Vliet interview by the author.

46. Kroyer interview II by the author, 2010.

47. Kroyer interview by the author; Van Vliet interview by the author.

48. Silver interview.

49. Rosebush interview by the author.

50. Tim McGovern, panel on Bob Abel at the Animazing Festival, Woodbury College, Burbank, Calif., September 4, 2010.

51. Bonifer interview by the author.

52. Kay quoted in Hiltzik, *Dealers of Lightning*.

53. Walt Disney made a sequel to *Tron* in December 2010—*Tron: Legacy,* with Steve Lisberger as producer and cowriter. In a 2010 interview about the sequel, retired Disney president Ron Miller said he felt vindicated for making *Tron*: "It was something special, and ahead of its time." Lowry, "Disney's History Gets a Reboot."

54. Lisberger, "Not Your Father's Grid."

55. Bonifer interview by the author.

56. Richard Taylor interview by the author.

57. Greenwood interview by the author.

58. *The Last Starfighter* was one of actor Robert Preston's final film roles. He died of lung cancer in 1987 at age sixty-nine.

59. Jeff Okun, panel discussion, "Twenty-fifth Anniversary of *The Last Starfighter*," at the American Cinemateque conference, Santa Monica, Calif., March 27, 2009.

60. Whitney and Demos's Digital Productions should not be confused with similarly named companies, like Judson Rosebush's Digital Effects of New York, Digital of England, and Digital Equipment Corporation of Boston.

61. Demos, "My Personal History."

62. This idea of wear and tear on spaceships first came from observing the condition of the Apollo space capsules after they returned to Earth.

63. Demos, "My Personal History."

64. McKenna interview by the author.

65. Kroyer interview I by the author.

66. Kroyer interview I by the author.

67. Silver interview by the author.

68. Mazurkewich, *Cartoon Capers*, 284–85.

69. Smith interview by the author.

70. Mazurkewich, *Cartoon Capers*.

71. Rubin, *Droidmaker*.

Chapter 10 Bob Abel, Whitney-Demos, and the Eighties: The Wild West of CG

1. Quoted in Hiltzik, *Dealers of Lightning*, 311.

2. Silicon Graphics made some risky moves, like acquiring Cray supercomputers. It went bankrupt in 2009 and sold its assets to Rackable, Inc.

3. Masson, *CG101 Version 2*, 305.

4. David Wolper was a legendary producer known for his 1952 *Victory at Sea* documentary series, scored by composer Richard Rogers. Abel won a Golden Globe and an Emmy Award for his documentaries with Wolper, *Mad Dogs and Englishmen* (1971) and *The Making of the President, 1968* (1969).

5. Sherry McKenna interview by the author.

6. R. T. Taylor interview by the author.

7. Allen Battino, panel on Bob Abel at the Animazing Festival, Woodbury College, Burbank, Calif., September 4, 2010.

8. Johnson interview by the author, 2008.

9. Michael Wahrman to the author.

10. Richard Taylor, interview by the author.

11. For much of the story of Bill Kovacs, I am indebted to his friend and fellow RA&A employee Ellen Wolff.

12. Frank Vitz quoted in Wolff, "Remembering Bill Kovacs."

13. Wolff interview by the author.

14. Bill Kovacs quoted in Wolf, "The First Wave."

15. Wolf, "The First Wave."

16. Abel quoted in Wolf, "The First Wave."

17. McKenna interview by the author.

18. Ken Mirman, panel discussion, Animazing Festival, Woodbury College, Burbank, Calif., September 4, 2010.

19. Richard Taylor interview by the author.

20. Much of this story was explained thoroughly in Menache, *Understanding Motion Capture*, 4–5.

21. Bob Abel quoted in Menache, *Understanding Motion Capture*, 4–5.

22. Menache, *Understanding Motion Capture*.

23. Rosendahl interview by the author.

24. Jim Hillin interview by the author.

25. Segal interview by the author.

26. Silver interview by the author.

27. McKenna interview by the author.

28. McKenna interview by the author.

29. Mike Patterson, recollection to the author, Los Angeles, December 2011.

30. Mirman, "Remembering Bob Abel."

31. Not to be confused with the similarly named Digital Equipment Corporation of Massachusetts (1957–2002), Digital Studios of London, or Judson Rosebush's Digital Effects (1974–1991) in New York City.

32. John Whitney Jr. interview by the author.

33. Youngblood, *Expanded Cinema*, 228–36.

34. Demos, "My Personal History," 1.

35. After Whitney and Demos left Triple-I, the company got out of the motion picture visual effects business altogether and resumed doing print work. Triple-I was bought by Autologic in 1996, which merged it with the German film-stock producer Agfa/Gevaert in 2001.

36. Matt Elson to the author.

37. McKenna interview by the author.

38. Demos, "My Personal History," 15.

39. Weinberg interview by the author.

40. Weinberg interview by the author.

41. Tim McGovern, panel on Bob Abel at the Animazing Festival, Woodbury College, Burbank, Calif., September 4, 2010.

42. "Life in the Background," *Animation Magazine*, 21.

43. "Life in the Background," *Animation Magazine*.

44. Dan Phillips interview by the author.

45. Will Anielewicz quoted in Mazurkewich, *Cartoon Capers*, 278.

46. *The Third Wave* TV series was based on a book by futurist writer Alvin Toffler. Toffler wrote the seminal bestseller *Future Shock* and coined the term *techno*.

47. Omnibus animator Paul Griffin quoted in Mazurkewich, *Cartoon Capers*, 281.

48. Dave Sieg, e-mail to the author, June 18, 2010.

49. McKenna interview by the author.

50. Bettino interview by the author.

51. McKenna interview by the author.

52. Kasper interview by the author.

53. New York CG studio R. Greenberg was run jointly by two brothers, Richard and Robert Greenberg, who couldn't decide which name should come first on the logo. So the compromise was to call it R. Greenberg.

54. Kasper interview by the author.

55. Dave Sieg e-mail to the author, June 18, 2010.

56. Dan Phillips interview by the author.

57. Ken Mirman to the author.

58. Dave Sieg e-mail to the author, June 18, 2010.

59. Colin Green later used previsualization for *Judge Dredd* (1992), and then George Lucas used it heavily for the later trilogy of *Star Wars* films.

60. Mazurkewich, *Cartoon Capers*, 279–80.

61. Davidson interview by the author.

62. Kasper interview by the author.

63. Kasper interview by the author.

64. Dave Sieg e-mail to the author, June 18, 2010.

65. Steve Goldberg inteview by the author, April 7, 2008.

66. Battino interview by the author.

67. McKenna interview by the author.

68. Bailey interview by the author.

69. Silver interview by the author.

70. Quotations from Ken Mirman, "Remembering Bob Abel." http://design.osu.edu/carlson/history/VFXProAbel.html

71. Kroyer interview I by the author.

72. Audri Phillips to the author, Hollywood, May 12, 2010.

73. Wahrman interview by the author.

74. Masson, "Computer Graphics Essential Reference."

75. Pauline Ts'o to the author. Rhythm & Hues actually began working in John Hughes's apartment above a furniture store, then moved to the dental office space three months later.

76. McKenna interview by the author.

77. Dave Sieg e-mail to the author, June 18, 2010.

78. Kasper interview by the author.

79. Rosendahl interview by the author.

80. McKenna interview by the author.

Chapter 11 Motion Capture: The Uncanny Hybrid

1. A great analysis of motion capture has been done by Prof Maureen Furniss for the MIT Communication Forum. http://web.mit.edu/comm_forum/papers/furniss.html

2. Shamus Culhane (1914–1994), personal communication with the author, New York City, November 1977. Myron Henry Natwick, nicknamed Grim (1890–1990), was the lead animator on Walt Disney's *Snow White*, as well as the designer of Max Fleischer's *Betty Boop*.

3. The term *audio-animatronic* was first coined in May 1960 to describe the figures developed for the Nature's Wonderland figures at Disneyland.

4. Anson MacDonald [Robert Heinlein], "Waldo," *Astounding Science Fiction*, August 1942.

5. Anderson, "Great Big Beautiful Tomorrow."

6. New York City's famed master builder Robert Moses (1888–1981) designed the Triborough bridge system, the Henry Hudson Parkway, and Jones Beach.

7. Dave Snyder interview by the author, March 26, 2012.

8. Rick Lazzarini, *Screen Actor Magazine*, Summer 1991, http://www.character-shop.com/pasgwldo.html

9. Dave Sieg e-mail to the author, June 18, 2010.

10. Bil Maher to the author, Ontario, February 18, 2011.

11. Grignon interview by the author.

12. Pat Hanaway interview by the author.

13. Glen Entis interview by the author.

14. Rosendahl interview by the author.

15. Grignon interview by the author.

16. Grignon quoted in Menache, *Understanding Motion Capture*, 8.

17. Menache, *Understanding Motion Capture*, 40.

18. In 2003 Angel Studios changed its name to Rockstar San Diego.

19. This famous mistake occurred in the film *Spartacus* (1960).

20. J. J. Abrams went on to a successful career in live-action film, writing and directing such hits as the TV series *Lost* (2004) and the movies *Star Trek* (2009) and *Super 8* (2011). Rob Letterman created a noted early student film at USC of a cosmic Silver Surfer. He directed DreamWorks' *Monsters vs. Aliens* (2009) and *Shark Tale* (2004).

21. Despite the experience of *Final Fantasy: The Spirits Within*, the Final Fantasy franchise continued as a successful series of interactive games and spawned more, albeit more traditional, anime-type feature films. *Final Fantasy VII: Advent Children* (2005) earned much critical acclaim and was popular among game aficionados.

22. Following *Polar Express*, Zemeckis produced *Monster House* (2005), *Beowulf* (2007), and *A Christmas Carol* (2010). After the high-profile failure of *Mars Needs Moms* (2011), Disney Studios dropped any further performance-capture projects and ImageMovers Digital closed.

23. James Cameron quoted in Abramowitz, "*Avatar*'s Animated Acting." Interestingly enough, Cameron draws very well himself. For instance, in the scene in *Titanic* where Jack is drawing Rose, it is Cameron's own drawing and hand in the shot.

24. Eric Furie to the author, USC, August 27, 2011.

25. Unnamed VFX artist to the author, Los Angeles, 2010.

26. Patricia Hannaway to the author, Los Angeles, March 2010.

27. Furie to the author, USC, August 27, 2011.

28. Ang Lee interview by Carlos Cavagna, December 2005, AboutFilm.com.

29. Professor Mark Mayerson quoted in "Is Beowulf Animation? Animators Sound off on Paramount, Robert Zemeckis Film." November 19, 2007. Suite101.com. http://animatedfilms.suite101 .com/article.cfm/is_beowulf_animation_pt2#ixzz0grXWOjsu.

30. MIT grad Bob Sabiston created a digital rotoscope software called Rotoshop that was used to do both films.

31. Henry Selick quoted in Abramowitz, "*Avatar*'s Animated Acting."

32. Johnson interview by the author.

33. Menache, *Understanding Motion Capture*, 41.

Chapter 12 The Cartoon Animation Industry

1. Ron Miller, who had married Walt Disney's daughter Diane, was president of the Walt Disney Company from 1980 to 1984.

2. Kroyer interview II by the author, 2009.

3. Jones, "Animation Is a Gift Word," 27.

4. *Petitioners v Paramount Studios*, later renamed *United States v. Paramount Pictures*, 334 US 131, was a lawsuit brought against the major Hollywood studios to ban the practice of "blockbooking." Studios stipulated if a theater wanted to book a first-run feature film, it must also show their second feature, newsreel, and short subjects. In 1948 the Supreme Court declared this practice a violation of the Sherman Antitrust Act. It also ordered movie studios to sell off their national theater chains.

5. Csuri, *Charles A. Csuri Beyond Boundaries*.

6. Stangl interview by the author.

7. Keith Ingham interview by the author.

8. Wolf interview by the author.

9. Frank Thomas in a 1987 SIGGRAPH panel discussion, as recalled by Ken Cope, interview by the author, June 16, 2009.

10. Ollie Johnston quoted in Price, *Pixar Touch*, 60.

11. Cartwright interview by the author. Randy Cartwright continues to be unique among his colleagues in that he is a traditional animator who can also write code. In 2009 he wrote and patented an iPhone app for an animator's stopwatch, breaking time down into 35 mm film standard feet and frames.

12. Cartwright interview by the author.

13. Snyder interview by the author.

14. Segal interview by the author.

15. Walt Disney Studios bought the rights to the Prydain novels in 1971 but kept putting off production because of script problems, the Don Bluth team quitting the studio in 1979, a labor strike in 1982, and the training of younger animators. At one point the film *The Fox and the Hound* was moved up in the schedule because the senior animators felt the younger ones needed the experience of doing it before taking on *The Black Cauldron*.

16. Gielow interview by the author.

17. The studio does not count *Tron* (1982) or *The Black Hole* (1979) here, because CG production on those films was done in the main by outside contractors.

18. The film was originally titled *Basil of Baker Street*, but after the flop of *Young Sherlock Holmes* the producer wanted no reference to Holmes in the title.

19. Gielow interview by the author.

20. For a detailed account of the boardroom maneuvers in Roy Disney's first takeover of Disney in 1984, see Taylor, *Storming the Magic Kingdom*.

21. Price interview by the author.

22. Michael Peraza e-mail to the author, Burbank, November 2011.

23. Gielow interview by the author.

24. Gielow interview by the author.

25. Sorensen interview by the author.

26. Cartwright interview by the author.

27. After *The Little Mermaid* (1989), Disney's Animation Technology Department was officially called the CG Department.

28. Gielow interview by the author.

29. Gielow interview by the author.

30. Dave Inglish interview by the author.

31. Barry Sandrew interview by the author.

32. Doug Cooper interview by the author.

33. Teevan interview by the author.

34. In 1992 the Motion Picture Academy honored the creators of CAPS—Tom Hahn, Peter Nye, and Michael Shantzis of Pixar and Lem Davis, Randy Cartwright, David Coons, Mark Kimball, Jim Houston and David Wolf from Disney. The Disney group also developed the DALS—Disney Animation Logistics Systems. Masson, *CG101 Version 2*, 144.

35. In 2004 Disney animation retired CAPS. When they started a 2D production again in 2006, they changed over to Toon Boom. Perkins interview by the author.

36. Scott Johnston interview by the author.

37. Price interview by the author, June 16, 2007.

38. Rosendahl interview by the author.

39. On the Eisner-Katzenberg rift, see Stewart, *Disney War*, and LaPorte, *The Men Who Would Be King*.

40. Entis interview by the author.

41. PDI was called PDI/Dreamworks.

42. When DreamWorks attempted to get into TV animation with an exclusive deal with ABC network, Eisner bought ABC and shut them out. DreamWorks in turn lured many leading Disney artists to jump ship to join them. When DreamWorks built their own studio lot, Disney bought all the land around it so they could never expand.

43. Smith quoted in LaPorte, *The Men Who Would Be King*, 48.

44. For more detail of the *Bug's Life–Antz* debacle, see LaPorte, *The Men Who Would Be King*, 180; Price, *Pixar Touch*, 170–174.

45. Pixar's *A Bug's Life* earned $363,398,565, while *Antz* made $171,757,863.

46. Russell Calabrese interview by the author.

47. Silver interview by the author.

Chapter 13 Pixar

1. One of the best behind-the-scenes accounts of the development of Pixar is Price, *Pixar Touch*.

2. There was a third founder of Apple Computer, named Ron Wayne, but he left the partnership two weeks after they filed papers to form the company in April 1976. Worried he'd get stuck paying all the bills if their venture went under, in 1977 he sold his share of Apple back to Jobs and Wozniak for $800.

3. The board of directors at Apple Computer didn't technically "fire" Steve Jobs. On April 10, 1985, they stripped him of all decision-making powers, leaving him in a ceremonial role. By that

September, Jobs resigned this honorary chairmanship. He regained the active chairmanship in 1997 and held it until his health forced him to resign in August 2011.

4. Bushnell quoted in Rubin, *Droidmaker,* 359.

5. Isaacson, *Steve Jobs,* 475.

6. Smith quoted in Price, *Pixar Touch,* 54.

7. Smith quoted in Price, *Pixar Touch,* 54.

8. McKenna interview by the author.

9. Ed Catmull to the author via e-mail, Burbank, November 2011.

10. Smith interview by the author.

11. Carpenter interview by the author; Blinn interview by the author, 2007.

12. Quoted in Price, *Pixar Touch,* 70–71.

13. Pixar's founding members were Tony Apodaca, Loren Carpenter, Ed Catmull, Rob Cook, David DiFrancesco, Tom Duff, Craig Good, Ralph Guggenheim, Pat Hanrahan, Sam Lefler, Darwyn Peachy, Tom Porter, Eben Ostby, Bill Reeves, Alvy Ray Smith, and Rodney Stock. Masson, *CG101 Version 2,* 299.

14. Carpenter interview by the author.

15. Ed Catmull interview I by the author.

16. Isaacson, *Steve Jobs,* 239–40.

17. Catmull interview II by the author.

18. Smith interview by the author.

19. Segal interview by the author.

20. McKenna interview by the author.

21. After leaving Pixar, Alvy Ray Smith built the software company Altamira, which he sold to Microsoft in 1994. He then became the first Graphics Fellow at Microsoft. He is currently founder and president of Ars Longa, a digital photography company.

22. Catmull interview II by the author.

23. *The Uncanny Valley* was a term coined by Japanese robotics scientist Masahiro Mori in 1970. It refers to the notion that we enjoy robot characters like R2-D2 or Robbie the Robot, but as androids come to look more like humans and more realistic, the effect causes revulsion and dread in people.

24. Catmull interview by McHugh.

25. Segal interview by the author.

26. Solomon, *Enchanted Drawings,* 298.

27. Segal interview by the author.

28. Price, *Pixar Touch*, 90–92.

29. *Steamboat Willie* (1928) is considered the first Mickey Mouse cartoon, although two earlier silent Mickey shorts preceded it.

30. Walt Disney called his experimental short cartoons Silly Symphonies to keep their production budgets separate from the Mickey, Donald, and Goofy cartoons, which were the studio's moneymakers.

31. Isaacson, *Steve Jobs*, 248.

32. Canemaker, *Two Guys Named Joe*, 62.

33. Jobs quoted from a *Hollywood Reporter* blurb in Price, *Pixar Touch*, 123.

Chapter 14 The Conquest of Hollywood

Epigraph: Dan Phillips e-mail to the author, Toronto, December 2010.

Phil Tippett quoted in Cruikshank, "Real Science."

1. Steve Williams, quoted in Mazurkevich, *Cartoon Capers*, 289.

2. Carl Rosendahl interview by the author.

3. Entis interview by the author.

4. Rosendahl interview by the author.

5. Spielberg quoted in Schultz et al., *Making of Jurassic Park*.

6. There is a discrepancy in accounts about just how much the "secret" dinosaur tests were sanctioned and how much Williams and Dippé were acting on their own. See Vaz and Duignan, *Industrial Light and Magic*, 215–16.

7. Tippett quoted in Schultz et al., *Making of Jurassic Park*.

8. Spielberg quoted in Schultz et al., *Making of Jurassic Park*.

9. Knep quoted in Littlehales, "Digital Sleight of Hand," 32.

10. Crispin Littlehales, "Digital Slight of Hand," *Iris Universe*, no. 28, Summer 1994.

11. Entis interview by the author.

12. Gladstone interview by the author, 2010.

13. Vaz and Duignan, *Industrial Light and Magic*, 235.

14. The first use of the Video Toaster was in the 1993 movie pilot *Babylon 5: The Gathering.* Effects were created by Foundations Imaging. Sito, *Drawing the Line*, 326.

15. Catmull e-mail to the author, December 7, 2009.

16. A more detailed description of the creation of *Toy Story* can be found in Price, *Pixar Touch* 117–56. See also Canemaker, *Two Guys named Joe*, 62–73.

17. Catmull e-mail to the author, December 7, 2009.

18. Catmull e-mail to the author, December 7, 2009.

19. Segal interview by the author.

20. *Newsweek*, November 27, 1995; *New York Times*, November 22, 1995.

21. Jim Hillin to the author, 2007.

22. Ed Catmull, lecture, USC, December 7, 2009.

23. The character Lightning McQueen in the film *Cars* (2006) and *Cars 2* (2011), is named in honor of Glenn McQueen.

24. Ed Catmull, lecture, USC, December 7, 2009.

25. Richard Chuang, "25 Years at PDI" (lecture for EE380, Computer Systems Colloquium, Stanford University, November 16, 2006), http://www.stanford.edu/class/ee380/

26. Logsdon of Harris Nesbitt-Gerard quoted in Richard Verrier, "Disney Pushed Towards Digital," *Los Angeles Times*, September 29, 2003.

27. Katzenberg quoted in "Drawing the Line," *New York Times*, July 16, 2003, 339.

28. Tippett quoted in Vaz and Duignan, *Industrial Light and Magic*, 231.

29. There is dispute as to which was the first regular CG animated TV series, Fantôme's *Insektors*, from France or Mainframe's *Reboot*, from Canada. They premiered within months of one another in 1994. The earliest TV show with CG animation may be the Canadian *Captain Power* in 1989, a live-action adventure show with short animated inserts. AFT's *Attack of the Killer Tomatoes*, 1991, was the first TV show animated 2D on digital tablets instead of paper.

30. Sito, *Drawing the Line*, 327.

Conclusion

Epigraph: Michael Wahrman, Oceanside, to the author, January 2012.

1. Jim Hillin interview by the author.

2. McKenna interview by the author, July 2, 2010.

3. Steve Lisberger quoted in "Not Your Father's Grid," *Variety*, December 6, 2010.

4. Steve Lisberger and Michael Wahrman quoted in "Not Your Father's Grid," *Variety*, December 6, 2010.

5. The software developer working with Ken Duncan was Oskar Urretabizkaia.

Bibliography

Interviews

Allen, Rebecca, Feb, 20, 2012 Westwood, Calif.

Bailey, Chris. May 28, 2010, Hollywood, Calif.

Battino, Allen. September 8, 2010, Los Angeles, Calif.

Bergeron, Philippe. September 5, 2008, West Hills, Los Angeles, Calif.

Bjorke, Kevin. February 12, 2011, Los Angeles, Calif.

Blinn, Jim. October 13, 2007; April 20, 2009, Seattle, Wash.

Bonifer, Mike. June 29, 2009, Burbank, Calif.

Brice, Jerry Lee. February 17, 2010, Los Angeles, Calif.

Calabrese, Russell. July 12, 2010, Los Angeles, Calif.

Carpenter, Loren. January 20, 2010, Emeryville, Calif.

Cartwright, Randy. May 31, 2011, Los Angeles, Calif.

Catmull, Ed. May 2, 2007, Burbank, Calif.; II: December 7, 2009, University of Southern California, Los Angeles.

Christiansen, Hank. September 15, 2011, Salt Lake City, Utah.

Cooper, Doug. January 4, 2012, Glendale, Calif.

Cope, Ken. June 16, 2007; October 2009, Marin County, Calif.

Cuba, Larry. May 23, 2008, Santa Cruz, Calif.

Davidson, Kim. July 28, 2011, Toronto, Ontario.

Douglas, Deborah. June 20, 2008, Boston, Mass.

Duncan, Ken. December 21, 2011, Pasadena, Calif.

Elson, Matt. August 15, 2012, Santa Monica, Calif.

Ems, David April 18, 2012 San Marcos, Calif.

Entis, Glen. June 24, 2011, Vancouver, B.C.

Fiume, Eugene. August 29, 2011, Toronto, Ontario.

Garboy, Barton. May 15, 2011, Los Angeles, Calif.

Gielow, Tad. July 14, 2011, Culver City, Calif.

Gladstone, Frank. May 9, 2011, Los Angeles, Calif.

Goldberg, Steve. April 7, 2008, Glendale, Calif.

Greenwood, Peter. July 6th, 2010, Los Angeles.

Grignon, Rex. January 27, 2010, via e-mail.

Hillin, Jim February 16, 2007, Los Angeles.

Hughes, John. April 16, 2008, Playa Del Rey, Calif.

Inglish, David. May 8, 2012, Burbank, Calif.

Johnson, Tim. March 25, 2008, Glendale, Calif.

Johnston, Scott. March 21, 2011, Burbank, Calif.

Kasper, Steve. June 22, 2010, Los Angeles, Calif.

Kroyer, Bill. July 7, 2008, Burbank, Calif.; September 23, 2009, Los Angeles; July 9, 2010, Woodland Hills, Calif.

Lehman, Mike. March 3, 2010, Burbank, Calif.

Maher, Bill. February 18, 2011, Toronto, Ontario.

Mayerson, Mark. April 20, 2009, Toronto, Ontario.

McKenna, Sherry. July 2, 2010, Berkeley, Calif.

Micallef, Joe. February 17, 2010, Los Angeles, Calif.

Mirman, Ken. July 25, 2012, Santa Monica, Calif.

Perkins, Bill. September 20, 2008, San Francisco, Calif.

Phillips, Audri. May 12, 2010, Hollywood, Calif.

Phillips, Dan. June 15, 2010, Toronto, Ontario.

Price, Tina. January 10, 2007, Santa Monica, Calif.

Rosebush, Judson. August 11, 2010, New York, N.Y.

Rosendahl, Carl. June 22, 2011, Redwood City, Calif.

Sandrew, Barry. January 25, 2012, San Diego, Calif.

Segal, Steve. August 3, 2011, Marin County, Calif.

Silver, Jesse. June 24, 2010, Burbank, Calif.

Smith, Alvy Ray. May 16, 2009, Berkeley, Calif.

Snyder, David. March 26, 2012, Los Angeles, Calif.

Sorensen, Vibeke. June 14, 2007, Buffalo, N.Y.

Stangl, Norm. July 17, 2011, Sherman Oaks, Los Angeles, Calif.

Stern, Garland. January 26, 2010, via e-mail.

Taylor, R. T. (Richard), April 20, 2009, Playa del Rey, Calif.

Taylor, Richard. September 21, 2010, Hollywood, Calif.

Teevan, Shauna. May 22, 2007, Toronto, Ontario.

Van Vliet, John. October 2008, Burbank, Calif.

Wahrman, Michael. January 5, 2012, Oceanside, Calif.

Wedge, Chris. February 10, 2010, Greenwich, Conn.

Weinberg, Richard. August 1, 2008, West Los Angeles, Calif.

Whitney, John, Jr. September 24, 2008, Burbank, Calif.

Williams, Lance. July 16, 2009, Toluca Lake, Calif.

Wolf, Dave. July 29, 2011, Burbank, Calif.

Wolff, Ellen. March 17, 2011, Ventura, Calif.

Books, Articles, and Online Sources

Abella, Alex. *Soldiers of Reason: The Rand Corporation and the Rise of the American Empire.* Orlando, Fla.: Harcourt, 2008.

Abramowitz, Rachel. "*Avatar*'s Animated Acting." *Los Angeles Times*, February 18, 2010.

Amidi, Amid. *Cartoon Modern: Style and Design in Fifties Animation.* San Francisco: Chronicle Books, 2006.

———. "Stan VanDerBeek." *ASIFA Magazine: The International Animation Journal* 22(2) (2009): 27–43.

Anderson, Paul F. "The Great Big Beautiful Tomorrow: Disney and the World's Fairs." *Persistence of Vision* nos. 6 and 7 (144 pages total).

Baer, Ralph H. *Videogames: In the Beginning.* Springfield, N.J.: Rolenta Press, 2005.

Baxter, John. *Stanley Kubrick: A Biography*. New York: Carol and Graff, 1997.

Bendazzi, Giannalberto. *Cartoons: 100 Years of Cinema Animation*. Bloomington: Indiana University Press, 1996.

Biskind, Peter. *Easy Riders, Raging Bulls: How the Sex-Drugs-and-Rock-'n'-Roll Generation Saved Hollywood*. New York: Simon and Schuster, 1999.

Brown, Judy, and Steve Cunningham. "The History of ACM SIGGRAPH." *Communications of the ACM* 50, no. 5 (May 2007).

Burnham, Van. *Supercade: A Visual History of the Videogame Age, 1971–1984*. Cambridge, Mass.: MIT Press, 2001.

Bute, Mary Ellen. "Abstronics: An Experimental Filmmaker Photographs the Esthetics of the Oscillograph." *Films in Review* 5, no. 6 (June–July 1954), 284–286. http://www.centerforvisual music.org/ABSTRONICS.pdf.

Canemaker, John. *Two Guys Named Joe: Master Animation Storytellers Joe Grant and Joe Ranft*. New York: Disney Editions, 2010.

Carlson, Wayne E. CGI Historical Timeline. http://design.osu.edu/carlson/history/timeline.html.

Catmull, Ed. Interview by Michael P. McHugh. *Networker* (University of Southern California) 8, no. 1 (September/October 1997), 1–4.

Center for Visual Music (CVM). http://www.centerforvisualmusic.org/.

Chafkin, Max. "Nolan Bushnell Is Back in the Game." *Inc.*, April 1, 2009. http://www.inc.com/magazine/20090401/the-gamer.html.

Cohen, Karl. *Forbidden Animation: Censored Cartoons and Blacklisted Animators in America*. Jefferson, N.C.: McFarland, 1997.

Cruickshank, Douglas. "The Inevitable Engine: The Evolution of Visual Computing." *Iris Universe* 34 (Winter 1996), 18–22.

———. "The Real Science Behind Jurassic Park." *Iris Universe* 25 (Summer/Fall 1993).

Csuri, Charles A. *Charles A. Csuri Beyond Boundaries, 1963–present*. Edited by Janice M. Glowski. Columbus: Ohio State University College of the Arts in cooperation with ACM SIGGRAPH, 2006. Exhibition catalog.

Cuba, Larry. "The Analog Roots of Computer Art." In *Kinetica 3*, 14–15. Los Angeles: iotaCenter, 2001. Film exhibition catalog. www.iotacenter.org/static/k3catalog.pdf.

Culhane, Shamus. *Talking Animals and Other People*. New York: St. Martin's Press, 1986.

Demos, Gary. "My Personal History in the Early Explorations of Computer Graphics." *Visual Computer* 21, no. 12 (December 2005): 961–78.

Drain, Alison. "Lapolsky's Lights Make Visual Music." *Symmetry Magazine*, 4, no. 3 (April 2007).

DeWitt, Elmer Phillip. "Computers: Artistry on a Glowing Screen." *Time*, August 5, 1985, 14–16.

Freiburghouse, Andrew. "Legends: Alvy Ray Smith." *Forbes ASAP*, May 28, 2001, 52–53.

Gabler, Neal. *An Empire of Their Own: How the Jews Invented Hollywood*. New York: Crown, 1988.

Goodell, Jeff. "The Steve Jobs Nobody Knew." *Rolling Stone,* October 27, 2011, 1–2.

Green, Thomas J. *Bright Boys: The Making of Information Technology.* Natick, Mass.: A. K. Peters, 2010.

Groenendijk, Ferry. "Gunpei Yokoi, 1941–1997" (eulogy). October 4, 1997. http://www.virtual -boy.org/gunpei%20yokoi.htm.

Hiltzik, Michael A. *Dealers of Lightning: Xerox PARC and the Dawn of the Computer Age*. New York: HarperCollins, 1999.

Isaacson, Walter. *Steve Jobs*. New York: Simon and Schuster, 2011.

Jones, Charles. "Animation Is a Gift Word." Quarterly report, American Film Institute, Summer 1974.

Journal: The Southern California Art Magazine (Los Angeles Museum of Contemporary Art). 29 (Summer 1981). II. The Whitney Brothers, 38–40.

Kay, Alan. "Ivan Sutherland's Sketchpad." Lecture. Uploaded to YouTube July 10, 2007. http:// www.youtube.com/watch?v=mOZqRJzE8xg.

Keegan, Rebecca. "In Hollywood VFX Shops, Trouble in Boom Times." *Time*, May 31, 2010.

Kent, Steve L. *The First Quarter: A 25-Year History of Video Games*. Bothell, Wash.: BWD Press, 2000.

Kerlow, Isaac V. *The Art of 3D Computer Animation and Effects*. 3rd ed. Hoboken, N.J.: John Wiley and Sons, 2004, 6–12.

Knowlton, Ken. "Portrait of the Artist as a Young Scientist." 2004. Digital Art Guild. http://www .digitalartguild.com/content/view/26/26/.

Kohler, Chris. *Power-Up: How Japanese Video Games Gave the World an Extra Life*. Indianapolis, Ind.: BradyGames, 2005.

Lasseter, John. "Principles of Traditional Animation Applied to 3D Computer Animation." *Computer Graphics* 21, no. 4 (July 1987): 35–44. http://www.siggraph.org/education/materials/ HyperGraph/animation/character_animation/principles/prin_trad_anim.htm.

LaPorte, Nicole. *The Men Who Would Be King: An Almost Epic Tale of Moguls, Movies, and a Company Called DreamWorks*. Boston: Houghton-Mifflin Harcourt, 2010.

Levy, Steven. *Hackers: Heroes of the Computer Revolution*. Sebastopol, Calif.: O'Reilly, 2010.

Lewell, John. *Computer Graphics: A Survey of Current Techniques and Applications*. New York: Van Nostrand Reinhold, 1985. 13–17.

"Life in the Background." *Animation Magazine* 1, no. 4 (Spring 1988): 21 (Terry Thoren).

Lisberger, Steven. "Not Your Father's Grid." *Variety*, December 6–12, 2010.

Littlehales, Crispin. "Digital Sleight of Hand." *Iris Universe* 28 (Summer 1994): 30–35.

Loc, Larry. "History of Videogames Timeline."2007. http://www.agni-animation.com/hallof game/gametimeline.pdf.

Loguidice, Bill, and Matt Barton. *Vintage Games: An Insider Look at the History of* Grand Theft Auto, Super Mario, *and the Most Influential Games of All Time.* Burlington, Mass.: Focal Press/Elsevier, 2009.

Lowry, Brian. "Disney's History Gets a Reboot, Too." *Variety,* December 6–12, 2010.

Machover, Carl. "Looking Back to SIGGRAPH's Beginnings" (interview with San Matsa). CG Pioneers, *SIGGRAPH/Computer Graphics Quarterly* 32, no. 1 (February 1998). http://old.siggraph .org/publications/newsletter/v32n1/columns/machover.html.

Markoff, John. *What the Dormouse Said: How the Sixties Counterculture Shaped the Personal Computer Industry.* New York: Viking, 2005.

Masson, Terrence. *CG101: A Computer Graphics Industry Reference.* Indianapolis: New Riders, 1999.

———. *CG101 Version 2: A Computer Graphics Industry Reference.* Williamstown, Mass.: Digital Fauxtography, 2010.

———. "The Computer Graphics Essential Reference: Historically Significant Companies." http:// www.cs.cmu.edu/~ph/nyit/masson/companies.htm.

Mayo, Keenan, and Peter Newcomb. "How the Web Was Won." *Vanity Fair,* July 2008.

Mazurkewich, Karen. *Cartoon Capers: The History of Canadian Animators.* Toronto: McArthur, 1999.

Menache, Alberto. *Understanding Motion Capture for Computer Animation and Video Games.* San Diego, Calif.: Academic, 2000.

Milman, Lenny. "Remembering Bob Abel." *Animation World Network,* January 31, 2002.

Mirman, Ken. "Remembering Bob Abel" (eulogy). September 27, 2001. http://design.osu.edu/ carlson/history/VFXProAbel.html.

Moritz, William. "Hy Hirsch and the Fifties: Jazz and Abstraction in Beat Era Film." In *Kinetica 3,* 5–8. Los Angeles: iotaCenter, 2001. Film exhibition catalog. www.iotacenter.org/static/k3catalog .pdf.

———. *Optical Poetry: The Life and Works of Oskar Fischinger.* Bloomington: Indiana University Press, 2004.

———. "Talking with Con Pederson." *Animation World Magazine* 4.3 (June 1999).

———. "You Can't Get Then from Now." Pt. 1. *Journal: Southern California Art Magazine* (Los Angeles Institute of Contemporary Art) 29 (Summer 1981). http://www.centerforvisualmusic.org/ WMThenFromNow.htm.

Panettieri, Joseph. "Out of This World." *NYIT Magazine*, Winter 2004, 2–5.

Pitta, Julie. "This Dog Is Having a Big Day." *Forbes*, January 22, 1990.

Poole, Steven. *Trigger Happy: Videogames and the Entertainment Revolution*. New York: Arcade, 2000.

Price, David A. *The Pixar Touch: The Making of a Company*. New York: Alfred A. Knopf, 2008.

Prince, Susan D. "Projects: Inside 'The Works.'" *Computer Pictures*, March/April 1983.

Robinson, David. *The History of World Cinema*. New York: Stein and Day, 1972.

Rosinski, Andrew. "Early Computer Generated Video Art: Sunstone (1979) by Ed Emshwiller." March 28, 2010. DINCA.org. http://dinca.org/date/2010/03.

Rubin, Michael. *Droidmaker: George Lucas and the Digital Revolution*. Gainesville, Fla.: Triad, 2006.

Savage, David. "8 Interesting Facts about Gaming's Greatest Companies." August 19, 2009. Joystick Division. www.joystickdivision.com/2009/08/8_interesting_facts_gaming_companies.php.

Saxenian, Annalee. *Regional Advantage: Culture and Competition in Silicon Valley and Route 128*. Cambridge, Mass.: Harvard University Press, 1996.

Schultz, John, James Earl Jones, Universal City Studios, and Amblin Entertainment. *The Making of Jurassic Park*. VHS video. Universal City, Calif.: MCA Universal Home Video, 1995.

Seymour, Mike. "Ben Snow: The Evolution of ILM's Lighting." FXGuide.com. Posted January 20, 2011 at http://www.fxguide.com/featured/ben-snow-the-evolution-of-ilm-lighting-tools/.

Sieg, Dave. Scanimate News (early analog computers). http://scanimate.zfx.com.

Sito, Tom. *Drawing the Line: The Untold Story of the Animation Unions from Bosko to Bart Simpson*. Lexington: University Press of Kentucky, 2006.

Solomon, Charles. *Enchanted Drawings, The History of Animation*. New York: Knopf, 1989.

Stehura, John. "A History of Cybernetic Animation." April 14, 2003. http://cyberanimation.tripod.com/historypage.htm.

Stewart, James B. *Disney War*. New York: Simon and Schuster, 2005.

Sturman, David. "The State of Computer Animation." *SIGGRAPH/Computer Graphics Quarterly*, 32, no. 1 (February 1998). http://www.siggraph.org/publications/newsletter.

Sutherland, Ivan. Interview by William Aspray. May 1, 1989. OH 171, Charles Babbage Institute Collections, Center for the History of Informational Processing, University of Minnesota, Minneapolis.

Taylor, John. *Storming the Magic Kingdom: Wall Street and the Battle for Disney*. New York: Viking, 1987.

Vance, Ashlee. *Geek Silicon Valley: The Inside Guide to Palo Alto, Stanford, Menlo Park, Mountain View, Sunnyvale, San Jose, San Francisco*. Guilford, Conn.: Globe Pequot Press, 2007.

Vaz, Mark Cotta, and Patricia Rose Duignan. *Industrial Light and Magic: Into the Digital Realm.* New York: Ballantine Books, 1996.

Willman, Chris. "Would Richard Nixon Ever Appreciate Any of This?" *Los Angeles Times*, August 6, 1993.

Winter, David. "Magnavox Odyssey: First Home Video Game Console." PONG-Story! http://www .pong-story.com/odyssey.htm.

Wolff, Ellen. "Remembering CG Pioneer Bill Kovacs." Digital Content Producer. June 1, 2006. http://www.creativeplanetnetwork.com/dcp/news/remembering-cg-pioneer-bill-kovacs/42296 . Digitalcontentproducer.com.

———. "The First Wave: The Origins of Wavefront Software." Digital Content Producer. November 1, 1998. http://www.creativeplanetnetwork.com/dcp/feature/first-wave-origins-wavefront -software/52838.

Wolverton, Mark. "The Father of Video Games." *American Heritage's Invention and Technology* 24, no. 3 (Fall 2009).

Youngblood, Gene. *Expanded Cinema.* London: Studio Vista, 1970.

Index

ABC (the American Broadcasting Company TV network), 7, 135, 160, 173, 315n42

ABC Monday Night Football, 135

Abel, Robert, 2, 57, 83, 173, 175
 Apple and, 194
 background of, 173, 272
 business acumen of, 176–177
 death of, 194–195
 growth of CG and, 173–180, 184, 187–197
 Bill Kovacs and, 176
 managerial style of, 179–180
 Omnibus and, 189–192, 196–197, 206, 278
 John Pennie and, 190
 Sexy Robot ad and, 177–179, 206
 Star Trek and, 161, 177, 189
 John Whitney, Sr. and, 17

Abrams, J. J., 211

Abstronic (Bute), 21

Abyss, The (film), 57, 169, 195, 254, 273, 276, 282

Acevedo, Victor, 35, 269

Action for Children's Television (ACT), 112

Adam Powers, The Juggler (Triple-I), 67, 171, 180, 205, 274, 282

Adams, Douglas, 121

Adelson, Gary, 166

Adlum, Eddie, 117

Adobe Systems, 66, 79, 88, 170, 172, 276, 278

Advanced Computing Center for the Arts and Design (ACCAD), 59

Adventures of Andre and Wally B., The (Lasseter), 68, 229, 242, 248

Adventures of Ichabod and Mr. Toad, The (Walt Disney Studios), 245

Adventures of Raggedy Ann and Andy, The (Williams), 3, 224–225

Akira (Otomo), 119

Aladdin (Walt Disney Studios), 224, 232–233, 262, 273, 275–276

Albertin, Christophe, 211

Albrecht, Bob, 93

Alcorn, Alan, 109, 272

Alexander, Lloyd, 120, 225

Alias, 172

Alien (Scott), 155

Aliens (Cameron), 254

Allen, Paul, 94, 224

Allen, Rebecca, 3, 35, 57, 194, 272
 games and, 111–112
 motion capture and, 203–205
 New York Institute of Technology (NYIT) and, 138–144

Allen, Woody, 231, 235

Alpha Channel, 132

Altair, 88, 90, 93–94

Alto, 84

Amblimation, 231

Amdahl V6, 152

American Film Technologies, 231

Amiga, 224, 258

Ampex Corporation, 107–108, 203

Ampex Video Art (AVA), 87

Analog Cam, 26, 28

Anastasia (Bluth), 202, 263

Anderson, Scott, 57, 170

Anderson, Wes, 268

Anderson, Woody, 151

Anderson optical printer (ILM), 170, 258

Andreessen, Marc, 37

Anemic Cinema (Duchamp), 12

Animalympics (Lisberger), 159–160

Animation

avant-garde, 3, 12, 16, 19–20, 35, 70, 87, 124, 132, 272

cartoons and, 1–3, 7, 11, 18

claymation and, 133, 250, 255–256, 268

commercials and, 7, 25, 71, 130, 133, 135, 140, 150, 154, 172–173, 181–182, 187, 190, 194, 220, 244–245, 263, 279

digital tablets and, 32, 41, 167, 226, 231, 318n29

downshooter cameras and, 3, 132, 149, 173, 224, 266

hand drawn, 14, 59, 132, 231–234, 304n26

inbetweening and, 3, 132–133, 142, 218–220, 230–231, 285

limited animation system and, 219

motion capture and, 199–215

Oxberry cameras and, 3, 18, 162, 172, 266

performance-capture and, 212, 212–215, 273, 282, 312n22

raster graphics and, 32, 60, 64, 67, 75, 80, 97, 118, 121, 131, 155, 166, 171, 176, 180, 206, 221, 274, 282, 284–286

stop-motion and, 59, 97, 140, 181, 215, 255–258, 268, 291n1

storyboards and, 3, 49, 138, 161, 177, 190, 218, 241–242, 249, 254, 279, 286

three-dimensional, 20, 23

traditional methods of, 2–3, 11 218–219

Tweening program and, 132–133, 150, 285

Animation (workbook by Preston Blair), 132

Animatronics, 202–203, 256, 290, 312n3

Antheil, George, 12

Anthology of American Folk Music (Smith), 20

Anti-alias, 64, 273, 284

Antz (film), 235–236, 279

AOL/Time Warner, 236

Apple Computers, 142, 245. *See also* Jobs, Steve

Abel and, 194, 272, 276, 282

Apple I and, 90, 111

Apple II and, 61, 88, 110, 112, 120

Artwick and, 61

corporate culture and, 77, 84, 88

games and, 61, 110–112, 120

hackers and, 90, 100

Lisa and, 88

MacIntosh and, 67, 88, 170, 224, 236

profits of, 261

Arabesque (Whitney), 28–29

Arakawa, Minoru, 114–115, 119

Armstrong, Eric, 255

Arneson, David, 120

ARPA (Advanced Research Projects Agency). *See also* DARPA

building first computer network and, 44

Dave Evans and, 62, 66, 79

Intergalactic Computer Network and, 44

J. C. R. Licklider and, 39–40, 43–45, 54, 277

military research and, 39–40, 43–45, 48, 55–56, 61–62, 79, 82, 250, 277, 280, 287–288, 295n22, 298n22

Ivan Sutherland and, 43–44, 79, 277

ARPANET

Internet and, 45, 47, 83, 105, 281

Massachusetts Institute of Technology (MIT) and, 45, 47

University of Utah and, 45

Art and Cinema (Stauffacher and Foster), 19–20

Art Center College (Pasadena, CA), 23

Artificial intelligence

computers and, 2, 47, 54–55, 80, 102, 120, 275, 287, 289, 305n9

Stanford Artificial Intelligence Lab (SAIL), 2, 47, 55–56, 93, 102, 289

Art of Computer Programming, The (Kluth), 56

Artwick, Bruce, 60, 110–111

Ascent of Man, The (Bronowski), 51

Ashton, Alan, 66

Association for Computing Machinery
(ACM), 94, 100, 281, 287, 290

Asteroids (game), 110

Astro Boy (TV show), 119

"As We May Think" (Bush article), 54

AT&T (American Telephone and Telegraph),
44, 74–75, 290

Atari Games, 66, 108–112, 116–118, 121, 167,
240, 272, 276

Atomic Betty (TV show), 266

Automatic Computing Engine (ACE), 102

Avant-garde, 3, 12,-14, 16, 20, 23, 35, 70,
124, 132, 272

Avatar (Cameron), 210, 212–214

Avery, Fred "Tex," 201

Babbage, Charles, 54

Babbitt, Art, 127

Baby Huey (cartoon character), 133

Backes, Michael, 257

Back to the Future (Zemeckis), 211

Baecker, Ronald, 69–70, 272

Baehr, Ted, 134

Baer, Ralph, 101, 104–110, 272

Bailey, Chris, 176, 183, 194

Bailey, Pearl, 126

Baily, Richard "Doc," 35, 161

Bakshi, Ralph, 134, 202

Ballet Méchanique (Léger and Ray), 12, 19

Bally (Games company), 113–114

Bambi (Walt Disney Studios), 126, 263

Banchos, Tom, 57

Baran, Paul, 43–44, 295n25

Barbetta, Dante, 133

Barbie (doll), 116, 260

Barels, Larry, 196

Baron, Bebe, 147

Baron, Louis, 147

Barton, Christie, 132

BASIC, 94, 222–224

Bass, Saul, 26–28, 147, 173, 293n40

Bat Fink (TV show), 127

Battino, Allen, 175, 181, 189, 192, 195

Battlezone (game), 115

Baudelaire, Patrick, 85

Bay, Michael, 210

BBOP, 69, 142, 150

Beach Chair (Pixar), 57, 247

Beatles, 127, 140

Beatniks, 11, 19–20, 89, 147

Beatty, John, 69

Beatty, Warren, 9

Beauty and the Beast (Cocteau), 114

Beauty and the Beast (Walt Disney Studios),
232, 251

Beck (rock band), 99

Beckett, Adam, 34–35

Beckmann, Max, 12

BEFLIX, 75, 287

Bell Telephone Laboratories, 19, 21, 75, 146
Mary Ellen Bute and, 272
corporate culture and, 74–75, 88
government work and, 37
hackers and, 89, 91
Ken Knowlton and, 276, 281
Lillian Schwartz and, 279

Belson, Jordan, 19–20, 34, 180

Bendazzi, Giannalberto, 19

Bendix Corporation, 61, 73

Benjamin, Bob, 8–9

Benjamin, Richard, 153

Bergeron, Philippe, 67–69, 97, 99, 272

Berman, Ted, 225

Bernhardt, Walter, 46–47

Betty Boop (cartoon character), 97, 201, 312n2

Betuel, Jonathan R., 166

Bézier, Pierre, 78

Bézier curves, 78

Big Bad Voodoo Daddy, 99

Big Broadcast of 1937, The (film), 14

BigPaint, 131, 230

Bird, Brad, 236, 249

Bissell, Jim, 190
Bjorke, Kevin, 111–112, 194
Black Cauldron, The (Walt Disney Studios),
 225–226, 230, 275, 314n15
Blinn, Jim, 2
 background of, 48, 272
 bump-mapping and, 48, 66, 272, 284
 Ed Catmull and, 98
 Industrial Light & Magic (ILM) and, 52
 JPL and, 48–49, 52, 66, 138, 159
 NASA and, 48–49, 272
 New York Institute of Technology (NYIT)
 and, 48–49
 Pixar and, 242, 247
 SIGGRAPH and, 98–99
 3D surfacing and, 66
 Voyager flyby films and, 49–52, 138, 159,
 171, 272
Bluth, Don, 116–117, 164–165, 202, 263,
 314n15
Boeing Aerospace Corporation, 46–47, 89,
 97–98, 183, 273–274
Bo Gehring Aviation, 171
Bolt, Beranek and Newman (computer
 company), 73, 289
Bonifer, Michael, 164, 166
Booth, Kelly, 69
Bossert, Dave, 227
Boss Films, 258
Boule, Cliff, 196
Brand, Stuart, 55, 93
Brave Little Toaster, The (film), 165, 217, 249,
 279
Bray, John Randolph, 142, 201
Breakout (game), 110
Breer, Robert, 21
Bridges, Jeff, 160, 164
Brigham Young University (BYU), 67
Brodax, Al, 127
Bronowski, Jacob, 51
Brookhaven National Laboratory, 102
Brown, David, 165
Brown Box, the, 105

Browne, Cliff, 150
Brown University, 56, 94, 232, 276, 281
Bryan, Larry, 108
Brynner, Yul, 153
Buddhism, 24, 72, 92
BUF Compagnie, 172
Buffin, Pierre, 172, 272
Bugs Bunny (cartoon character), 126, 213,
 219, 236
Bug's Life, A (Pixar), 236, 260–261, 315n44
Bump-mapping, 48, 66, 272, 284
Bunny (Wedge), 60
Buñuel, Luis, 19
Burroughs, William S., 111
Burroughs Corporation, 73
Burtnyk, Nestor, 32, 70, 132, 220
Burton, Tim, 249
Burwell, Carter, 142
Bush, George H. W., 116, 254
Bush, Vannevar, 37, 54–55, 87, 272, 280,
 297n1
Bushnell, Nolan
 Atari Games and, 66, 108–112, 116–118,
 121, 167, 240, 272, 276
 background of, 107–108, 272
 Chuck E. Cheese and, 112–113
 game development and, 66, 107–117, 121,
 142, 240, 272
 PONG and, 109–110, 114–116, 160, 272
 Sente and, 111
 Syzygy and, 108
 Warner Bros. (Warner Communications)
 and, 111
Bute, Mary Ellen, 16, 21–22, 75, 272
Byrne, David, 142, 205

C (computer language), 78, 287
Cabbage Patch Kids, 117
Cabinet of Dr. Caligari, The, 19
CADCAM, 32, 229
Cage, John, 18, 147, 180
Cailliau, Robert, 45
Calabrese, Russell, 222

California Institute of the Arts (CalArts), 18, 34–35, 287
 academia and, 70, 72
 "A113" joke and, 249
 Cuba and, 273, 306n29
 Ed Emshwiller and, 142, 274
 first class of character animation of, 303n5
 John Lasseter and, 241, 247, 249, 277
 Joe Ranft and, 249, 279
 Vibeke Sorensen and, 227, 250, 280
Calculated Movements (Cuba), 34
California Institute of Technology (Caltech), 24, 41, 47, 67, 70, 153, 180, 274, 280, 282, 306n24
Calloway, Cab, 201
Cambridge Systems UK, 230–231
Cameron, James, 99, 234
 The Abyss and, 57, 169, 195, 254, 273, 276, 282
 Avatar and, 211, 213
 background of, 272–273
 Digital Domain and, 209–210
 motion capture and, 195, 109–214
 Terminator 2 and, 195, 208, 251, 253–255, 254, 266
 Titanic and, 1, 195, 210, 258, 273, 316
 visual effects and, 145, 155, 169–170
Cap'n Crunch (John Draper), 93–94
Carlson, Chester, 82
Carlson, Wayne, 59
Carpenter, Loren, 66, 97–98, 138, 157–159, 273, 316n13
Cars (Pixar), 262, 318n23
Carter, Jimmy, 87, 160
Cartoon Capers (Mazurkewich), 190
Cartwright, Randy, 222, 224, 226, 228, 233, 273, 315n34
Carvey, Brad, 258
Casady, Chris, 35
Casper (film), 255, 282
Castle, Nick, 166, 190
Catacomb Abyss (game), 120
Catalog (Whitney), 28

Catherine Wheel, The (Byrne), 142, 205
Catmull, Ed, 2, 183
 academia and, 62, 64
 background of, 128, 273
 BigPaint system and, 87
 James Blinn and, 48, 98
 Loren Carpenter and, 98
 Jim Clark and, 137
 A Computer Animated Hand and, 64, 127, 154, 203, 259
 Computer Graphics Lab (CGL) and, 128–144
 David DiFrancesco and, 129, 274
 Dave Evans and, 273
 Genesis Effect and, 80, 241
 Ralph Guggenheim and, 275
 hidden surface algorithm and, 64
 Steve Jobs and, 245
 John Lasseter and, 97, 218, 236, 241–242, 245–246, 248, 261
 George Lucas and, 48, 80, 98, 137–138, 157–158, 241, 259, 273
 management style of, 244
 New York Institute of Technology (NYIT) and, 83, 98, 128
 Fred Parke and, 64
 Pixar and, 66, 241–248, 251, 260–262, 266, 316n13
 Alex Schure and, 128, 131, 246
 Alvy Ray Smith and, 129, 251
 texture mapping and, 48, 50, 64, 128, 132, 184, 230, 233, 273
 traditional artists and, 133–134
 Tubby the Tuba and, 126–127, 129, 133–135, 144, 241
 Tweening program and, 132–133, 150, 285
 University of Utah and, 67, 83, 128, 131, 151, 259, 261, 273
 visual effects and, 147, 150–151, 154, 157–158
 Walt Disney Studios and, 220, 236, 266
CBC (Canadian Broadcasting Company), 187
CBS (Columbia Broadcasting System TV network), 7, 25, 134–135, 140

CDC. *See* Control Data Corporation

CDC 3200, 77

CDC 6600, 77

Cedeno, Michael, 222, 229

Cellular Automata: The Mathematics of Self-Reproducing Machines (NYU course), 80

Centipede (game), 110, 115

Centropolis, 171

Cerf, Vint, 45

Chekhov, Anton, 210

Chess, 44, 101–102, 108, 111, 226

Chin, Candace, 192

Christiansen, Hank, 63, 67, 78–80

Chronicles of Prydain (Alexander), 120, 225

Chrysler Corporation, 73, 175

Chuang, Richard, 94, 206, 234, 262

Chuck E. Cheese, 112–113

Chutes and Ladders (game), 116

CIA (Central Intelligence Agency), 39, 47, 72

Cibernetik 5.3 (Stehura), 31, 45, 57

Citron, Jack, 28

Clark, Jim, 2
 background of, 273
 Geometry Engine and, 172
 Netscape and, 66, 142, 273
 New York Institute of Technology (NYIT) and, 137–138, 172
 Alex Schure and, 137–138, 172
 Silicon Graphics and, 52, 66, 70, 79–80, 142, 170, 172, 273, 290, 308n2
 University of Utah and, 137
 visual effects and, 157

Clarke, Arthur C., 75, 148

Claymation, 133, 250, 255–256, 268

Clements, Ron, 233

Cleo (cartoon character), 210–211

Clinton, Bill, 254

Clokey, Art, 133

Close Encounters of the Third Kind (Spielberg), 155, 160, 172, 177

Clyde in the Cockpit (CGL), 130

Cobb, Ron, 166

Cocteau, Jean, 11, 16, 114

Cole, Pat, 52

Coleco, 115–117

Colenso, Gary, 195

Colley, Steve, 105

Collins, Joan, 98

Colorization of black and white movies, 231

Colossus (British WWII analog computers), 38

Columbia Pictures, 8, 18, 20, 160, 220

Columbus, Chris, 169

Commercials
 Bob Abel and, 173
 Desenex and, 193–194
 Oskar Fischinger and, 292n7
 Sherry McKenna and, 181–182
 Pixar and, 194
 Sexy Robot ad and, 177–179, 206
 visual effects and, 7, 25, 71, 130, 133, 135, 140, 150, 154, 172–173, 181–182, 187, 190, 194, 220, 244–245, 263, 279

Commodore Computers, 84, 88, 90, 112, 117, 224, 239

Comparetti animation system, 70–71

Composition in Blue (Fischinger), 13–14

Computer Animated Hand, A (Catmull and Parkes), 64, 127, 154, 203, 259

Computer Animation Production System (CAPS), 87, 229–232, 251, 273–274, 287, 315nn34,35

Computer Arts Society (CAS), 94

"Computer as a Communication Device, The" (Taylor and Sutherland), 44

Computer Chaos, 94

Computer Film Company (CFC), 172

Computer Generation, The (documentary), 19

Computer graphics (CG). *See also specific companies*
 avatars and, 160, 199, 210–215, 221–222, 266
 BEFLIX and, 75
 Bézier curves and, 78
 bump-mapping and, 48, 66, 272, 284

commercials and, 7, 25, 71, 130, 133, 135, 140, 150, 154, 172–173, 181–182, 187, 190, 194, 220, 244–245, 263, 279

Computer Animation Production System (CAPS) and, 87, 229–232, 251, 273–274, 287, 315nn34,35

digital tablets and, 32, 41, 167, 226, 231, 318n29

drum scanner and, 40

frame buffers and, 85, 87, 128, 131, 180, 194, 285

government work and, 37, 40–42, 46, 48, 51–52

hidden surface algorithms and, 64, 80, 180

Jurassic Park and, 172, 179, 253–258, 266, 282, 305n9, 306n12

light pens and, 19, 39, 41, 54, 75

motion capture and, 199–215

as multibillion-dollar industry, 1

origin of the term, 46–47

Phong shading and, 66, 279, 285

PRISMS and, 191, 195, 289

raster graphics and, 32, 60, 64, 67, 75, 80, 97, 118, 121, 131, 155, 166, 171, 176, 180, 206, 221, 274, 282, 284–286

rotoscope and, 2, 201–202, 209, 313n30

scientist-engineers and, 11

Star Wars and, 34, 52, 60–61, 111, 136, 155–157, 160, 166–167, 172–173, 242–243, 258, 273, 276–278, 304nn34,39, 311n59

Terminator 2 and, 195, 208, 251, 253–255, 266, 279, 282

texture mapping and, 48, 50, 64, 128, 132, 184, 230, 233, 273

three-dimensional, 20, 23, 46

Toy Story and, 57, 144, 172, 211, 234, 236–237, 252–253, 259–263, 266, 277, 279

unions and, 268

vector graphics and, 29, 84, 121, 221, 286

Waldo suit and, 202–204, 207–208, 212, 256

John Whitney as father of, 23

Computer Graphics Lab (CGL of NYIT)
Ed Catmull and, 128–144
managerial style of, 131
Alvy Ray Smith and, 128–144, 241
Tubby the Tuba and, 126–127, 129, 133–135, 144, 241

Computer Graphics Research Group (CGRC), 32, 59, 172

Computers
academia and, 53–72
Altair, 88, 90, 93–94
Alto, 84, 88
Amdahl V6, 152
Amiga, 224, 258
Apple I, 90, 111
Apple II, 61, 88, 110, 112, 120
artificial intelligence and, 2, 47, 54–55, 80, 102, 120, 275, 287, 289, 305n9
Charles Babbage and, 54
BASIC and, 94, 222–224
bugs and, 38
CDC (Control Data Corporation), 77
Colossus, 38
Commodore, 84, 88, 90, 112, 117, 224, 239
corporate culture and, 73–88
Cray, 77, 100, 167, 182–184, 187–195, 258
CRT displays and, 40, 108, 147, 157, 205, 256, 284
Electronica 60, 118
ENIAC, 38, 74
Foonly, 56, 185, 187–188, 190
Fortran and, 28, 31, 34, 176, 222, 227, 288
games and, 101–121
GRASS and, 60, 157, 288
hackers and, 89–100
HAL 9000, 75, 288
Hollywood and, 253, 256–260, 265–269
Grace Hopper and, 38
IBM, 74–75, 91, 102, 111, 151, 279, 288
IMI, 225
integrated circuits and, 172, 288
Internet and, 7, 31, 37, 45, 57, 89, 100, 103, 120–121, 166, 190, 227, 239, 277, 280

Computers (cont.)
Lisa, 88
LISP and, 54, 77–78, 92, 181, 279, 288
MacIntosh, 67, 88, 170, 224, 236
magnetic tape and, 48, 107–108, 152, 172, 279
mail-order kits and, 90, 93
military research and, 37–52
Moore's Law and, 87
motion capture and, 199, 202–215
mouse and, 12, 55, 84, 88
New York Institute of Technology (NYIT) and, 123, 126–144
paper tape memory and, 103, 107
PDP, 2, 60, 62–63, 83, 102–104, 107–108, 118, 153, 172, 275, 289
Pixar and, 241–252
Project SAGE and, 40–43, 289, 295n14
Project Whirlwind and, 38–39, 41, 102, 295nn6,15
PS-300, 8–10
punch cards and, 57, 73, 75, 172, 203, 221
SDS, 83
SEAC, 40
SGI Iris 1000, 179
supercomputers, 67, 70, 77–78, 157, 167, 170, 182, 192, 195, 273, 280, 284, 287
Tectronics 4013, 152
Thinking Machine CM-2, 195
Tixo, (TX-0, TX-1, TX-2) 38, 41, 102–103
Alan Turing and, 38, 101–102, 280–281, 303n11
UNIVAC, 38
UNIX and, 78, 290
VAX, 2, 98, 131
visual effects and, 145–170
websites and, 2, 45, 89, 239
Computers Arts Society, 71
Computer Space (game), 108, 110
Connolly, Jennifer, 168
Control Data Corporation (CDC), 61, 73, 77, 100, 181, 187–188, 273, 287
Cook, Randy, 213, 222

Cook, Rob, 158–159
Cooper, Doug, 195, 231, 282
Cooper Union Institute, 17
Cope, Ken, 98–99, 196, 222
Copeland, Aaron, 21
Coppola, Francis Ford, 9, 136–137, 157–158, 171, 243
Coraline (Selick), 268
Corbato, Fernando, 54
Core Design (UK), 120
Cornell University, 49, 57, 87, 120, 142, 230, 281
Cosmos (PBS TV series), 51–52, 138, 171, 272
Cowan, Bill, 69
Cox, David, 151
Cranston/Csuri Productions, 172, 195
Cray, Seymour, 77, 273
Cray Research, Inc., 77, 100, 167, 182–184, 187–195, 258
Crichton, Michael, 121, 152–154, 254
Crippen, Fred, 25, 293n37
Croft, Lara (character), 120–121
Cronenburg, David, 151
Crow, Frank, 59, 64, 66
Crowley, Tom, 75
Crownx Insurance Company, 192
CRT displays, 40, 108, 147, 157, 205, 256, 284
CSK, 118
Csuri, Charles, 97, 172, 195, 253
academia and, 53, 57–60, 157, 227, 281
ACCAD and, 59
background of, 31–32, 273
Craston/Csuri and, 172, 195
Hummingbird and, 32, 58, 221, 271
Ohio State University (OSU) and, 31, 32, 57–59
George Segal and, 31
Chris Wedge and, 59
CTV (Canadian TV network), 187
Cuba, Larry, 29, 34–35, 60–61, 94, 111, 136, 157, 273
Cuban Missile Crisis, 43

Culhane, Shamus, 5, 133, 202
Cunningham, Merce, 18
Currey, Jim, 84–85
Cybernetics (Weiner), 93
Cyberpunk, 111, 119–120
CYCLADES (French national Internet system),
 45

Dabney, Ted, 108
Daly, Donnachada, 211
DARPA (Defense Advanced Research Projects
 Agency), 2, 48, 52, 287–288. *See also* ARPA
Davidson, Kim, 97, 195
Davies, Donald, 44, 295n25
Da Vinci, Leonardo, 11, 77
Davis, Jamie, 133
Davis, Lem, 228–229
Deep Canvas, 233
DeFanti, Tom, 59, 60
deGraf, Brad, 196, 206, 281
deGraf/Wahrman, 170–171, 196, 232, 275,
 281
DeMille, Cecil B., 1, 146
Demos, Gary, 67, 135, 137, 171
 background of, 274
 Caltech and, 180
 computing power issues and, 181
 Digital Productions and, 70, 77, 159, 161,
 167–169, 180–184, 187–188, 192, 195, 216,
 222, 242, 245, 272, 274, 278, 281–282,
 308n60
 Digital Scene Simulation and, 180
 motion capture and, 205–206
 reputation of, 180
 visual effects and, 153–154
 John Whitney, Jr. and, 180–184, 187–188,
 190, 195, 197, 272
de Seversky, Alexander, 124
Desktop publishing, 40
Die Hard (film), 258
DiFrancesco, David
 background of, 274
 Industrial Light & Magic (ILM) and, 52

JPL and, 49
 Lucasfilm and, 274
 New York Institute of Technology (NYIT)
 and, 129, 138
 Pixar and, 245, 316n13
 Smith and, 128–129, 274
 visual effects and, 157, 159
 Xerox PARC and, 85, 128
Digimon (game), 119
Digital Domain, 99, 195, 209–210, 234,
 274–275
Digital Effects (NY), 142, 151–153, 161
Digital Equipment Corporation (DEC), 2, 83,
 102–103, 131, 288, 297n2
Digital Harmony, 23, 28
*Digital Harmony: On the Complementarity of
 Music and Visual Art* (Whitney), 28
Digital Productions, Inc. (Hollywood), 161,
 272, 274, 281–282, 308n60
 beginnings of, 180–184, 192, 195
 cartoon animation industry and, 217, 222
 Cray computers and, 70, 77, 182–184,
 187–188, 192, 195
 Hard Woman video and, 183–184, 188
 McKenna and, 183, 188–189, 193, 197, 217,
 242, 245, 278
 Omnibus purchase of, 187–188
 visual effects and, 159, 161, 167–169
Digital tablets, 32, 41, 167, 226, 231, 318n29
Diner, The (Segal), 31
Dinosaur Input Device, 256
Dinosaurs, 3, 146, 254–257, 263–264, 266
Dinosaurs (Walt Disney Studios), 3, 263
Dippé, Mark, 100, 170
Dire Straits, 183–184
Disa, Michael, 90
Disney, Diane, 313n1
Disney, Roy E., 226, 229–230, 250, 274,
 314n20
Disney, Walt, 3, 8, 107, 123, 128, 134, 136,
 263, 292n4
Disney Animation Logistics Systems (DALS),
 315n34

Disney Channel, 266
"Disney Dust," 14
Disneyland, 202–203, 225, 315
Docter, Peter, 249, 250
Donald Duck (character), 242, 317n30
Donkey Kong (game), 114–115, 118–119, 171
Donkey Kong Jr. (game), 115
Dot Matrix (character), 132, 141
Douglas, Deborah, xi, 1
Downshooter cameras, 3, 132, 149, 173, 224, 266
Dragon Quest (game), 120
Dragon's Lair (game), 116, 171
Drankov, Alexander, 5
DreamWorks (SKG, also called DreamWorks Animation), 274, 276, 279, 282
 academia and, 57
 cartoon animation industry and, 224, 231, 234–236
 Disney's tactics against, 315n42
 innovation and, 262–265
 interactivity and, 235
 motion capture and, 208, 211
 Shrek and, 1, 211–213, 235, 262–263
 Spielberg and, 211, 234, 262
Drum scanner, 40
Duchamp, Marcel, 12, 19, 23
Duff, Tom, 142, 158–159, 316n13
Dumbo (Walt Disney Studios), 219, 249
Duncan, Ken, 268
Dungeons and Dragons (game), 120
Dunn, Bob, 95
Du Pont, Alfred I., 126
Dwija (Whitney), 25
Dynabook, 84
Dynamic Graphics Project (DGP), 69–70

Earnest, Lee, 56
E.A.T. Program (Experiments in Art and Technology), 21, 75
École nationale supérieure des Arts Décoratifs (ENSAD), 70–71
Edison, Thomas, 5, 8, 145

Edlund, Richard, 138, 188
Ed Sullivan Show (TV show), 7
Eggeling, Vikdun, 12
Eidos, 120–121
Eisenhower, Dwight, 39
Eisner, Michael, 189, 226–230, 234, 236, 260, 265, 276, 315n42
Ekert, John Presper, 38
Electric Light Orchestra, 20
Electronica 60, 118
Electronic Arts, 120, 275, 279–280
Electronic Image (EI), 67
Electronic Music Studios, 34
Electronic Visualization Laboratory (EVL), 60
Elkind, Jerry, 87
Elliot, Ted, 262
Elson, Matt, 77, 144, 181, 274
Em, David, 35, 48, 62, 85–86
Emery, Myron, 70
Emmy Award, 52, 87, 140, 150, 275, 308n4
Empire Strikes Back, The (Lucasfilm), 138
Emshwiller, Ed, 70, 135–136, 142, 274
Eneri (Hirsh), 20
Engel, Jules, 15, 34, 70
Engelbart, Douglas, 44, 55–57, 84, 87, 93, 241, 274, 295n24, 300n8
ENIAC, 38, 74
Enigma machine, 37, 280
Entis, Glen, 87, 94, 135, 206, 234–235, 239, 257
Eskuri, Neil, 178, 196
E.T. the Extra-Terrestrial (Spielberg), 117, 165
Evans, Dave
 ARPA and, 62, 66, 79
 background of, 43, 274
 Bendix Corporation and, 61
 Ed Catmull and, 273
 as electronics professor, 43
 G-15 computers and, 61
 G-20 computers and, 61
 General Electric and, 62
 Alan Kay and, 2, 63, 82
 LDS-1 system and, 79

military and, 43, 62, 66

Mormonism and, 79

Dr. Schure and, 128

Sketchpad and, 43, 61–63

Ivan Sutherland and, 43, 62–63, 280

University of Utah and, 63–64, 82, 83, 84, 107

Evans & Sutherland, 43, 78–80, 127–128, 131–132, 172, 180, 183, 184, 274, 280

Evans, Joy, 63

Everett, Jim, 38

Evolution of the Red Star (Beckett), 34

Expanded Cinema (Youngblood), 28, 34

Family Computer (Famicom), 118

Fano, Robert, 54

Fantasia (Walt Disney Studios), 14–15, 219, 276, 291n3, 292n4

Fantastic Animation Festival, The (TV show), 33

Fantastic Mr. Fox (Anderson), 268

Fantastic World of Hanna & Barbera, The (theme park attraction), 196

Farley, Chris, 262

Farmville (game), 266

FBI (Federal Bureau of Investigation), 16–17, 80, 94, 244

Feeny, Ray, 197

Felix the Cat (character), 77

Fetter, William A., 46–47, 274

Filmation Studios, 133, 188, 222

Final Fantasy (game), 120, 211, 245

Finding Nemo (Pixar), 262, 279

Firedrake, George, 93

First Fig (Cuba), 34

Fischer, Fritz, 85

Fischinger, Elfriede, 12–14, 16, 34, 291n2

Fischinger, Oskar, 12–20, 23–24, 34, 75, 292n4, 292n7

Fishbone, 100

Five Abstract Film Exercises (Whitney brothers), 24

Flash (program), 266

Flegal, Bob, 84–85

Fleischer, Dave, 126, 201

Fleischer, Max, 59–60, 123, 126, 201, 213, 218–219, 312n2

Flesh Flows (Beckett), 34

Fletcher, James, 62

Flume, Eugene, 69

Fly, The (Cronenberg), 151

Foldes, Peter, 3, 32–33, 70, 124, 220–221, 275

Fonda, Peter, 154

Foonly F1, 56, 185, 187–188, 190

Forbidden Planet, The (film), 147

Ford, John, 8

Forrest Gump (Zemeckis), 170, 282

Fortran, 28, 31, 34, 176, 222, 227, 288

Foster, Preston, 305n5

Foster, Richard, 19

Foucault's pendulum, 24

Four Dimensional Rotation of Hypercubes (Strauss and Banchos), 57

Fournier, Alain, 69–70

Fox (Twentieth Century Fox) Studios, 263–264

Fractals, 64, 158, defined 284

Frame buffers, 85, 87, 128, 131, 180, 194, 285

Framestore (UK), 172, 266

Frangmeier, Stefen, 255

Fredkin, Ed, 93, 153, 275

Freidkin, William, 9

Freleng, Friz, 236

French, Gordon, 93

Frog (Csuri), 32

Froud, Brian, 168

Fuller, Buckminster, 18, 93, 180

Futureworld (MGM), 154, 166

Gabriel, Peter, 142

Galaga (game), 164

Game Boy, 119–120, 282

Games

arcade, 108–117, 142, 161, 164, 166, 171, 225

Artwick and, 60, 110–111

Games (cont.)
Ralph Baer and, 101, 104–110, 272
Nolan Bushnell and, 66, 107–113, 115–117,
 121, 142, 240, 272
checkers, 102
chess, 44, 101–102, 108, 111, 226
computers and, 101–121
Console Wars and, 121
cyberpunk and, 111, 119–120
Gamecube and, 266
Great Video Game Crash of 1983 and,
 116–117, 121
hackers and, 104
home computers and, 101, 117–118
IBM and, 102, 111
interactivity and, 60, 72, 92, 103, 120–121,
 195, 266, 312n21
Japan and, 113–121
Massachusetts Institute of Technology (MIT)
 and, 103–104, 108, 120
John McCarthy and, 102–103, 108
Sherry McKenna and, 195–196
Nintendo and, 114–121, 266, 278, 282
Odyssey and, 105–107, 109–110, 272
PlayStation and, 118, 121, 266
profit of, 121
public opinion on, 112–113
role-playing, 118–120
Russell and, 103, 107–108
SEGA and, 113, 117–118, 120
video, 92, 101–121, 142, 171
Xbox and, 118, 266
Gamut-H, 47
Gard, Toby, 120–121
Garland, Judy, 195, 231, 282
Gates, Bill, 84, 94, 104
Geffen, David, 211, 234, 262
Gehring, Bo, 151
General Dynamics, 31
General Electric, 62, 105, 109
General Motors, 243
Genesis Effect (Star Trek II), 80, 158–159, 241
Gennegren, Gustav, 15

Gennis, Sari, 176
Gentilella, John, 133
Geometry Engine, 172
Gerald McBoing-Boing Show, The (TV show), 25
Geri's Game (Pixar), 248
Gertie the Dinosaur (McCay), 259
Ghostbusters (film), 258
Ghost in the Shell (Oshii), 119
Gibson, Charles, 145, 178, 196
Gibson, William, 111
Gielow, Tad, 225–227, 229, 232, 236–237,
 275
Gillespie, Dizzy, 20
Gilliam, Terry, 140
Gindy, Bob, 137
Ginsburg, Alan, 20
Giraud, Jean "Moebius," 161, 222
Glebas, Francis, 138
Goddard, Gary, 188
Godfather, The (Coppola), 9
Goldberg, Adele, 88
Goldberg, Eric, 134, 232
Goldberg, Steve, 97, 192, 232
Goldfarb, Keith, 196
Goldstein, Robert, 151
Goofy (character), 127, 317n30
Gouraud, Henri, 66, 80, 275
Government work
ARPANET and, 45, 47, 83, 105, 281
Blinn and, 49–52, 138, 272
cartoons and, 66, 80
CIA and, 39, 47, 72
computer graphics (CG) and, 37, 40–42, 46,
 48, 51–52
IBM and, 37–38, 40, 73
JPL and, 34, 48–52, 66, 157, 159, 184, 242,
 274, 296n33, 306n29
Licklider and, 39–40, 43–45, 54, 277
MITRE and, 39
NASA and, 39 (see also NASA)
National Bureau of Standards and, 40
National Security Agency (NSA) and, 43
Project SAGE and, 40–43, 289, 295n14

Project Whirlwind and, 38–39, 41, 102, 295nn6,15

Rand Corporation and, 37

space program and, 39–40, 47–49, 52

Stanford Research Institute (SRI) and, 44–45, 47, 55

U.S. Air Force and, 39–40, 62, 104, 113, 153, 275, 295n14

Voyager flyby films and, 49–52, 138, 159, 171, 272

Walt Disney Studios and, 203

Xerox PARC and, 48

GRAF (Graphic Additions to Fortran), 28

Graham, Wesley, 69

Grand Theft Auto (game), 121, 210

Grand Track (game), 110

Grant, Joe, 249

Graphic Gathering, 94

GRASS (Graphics Symbiosis System), 60, 157, 288

Grateful Dead, 175, 280

Great Mouse Detective, The (Walt Disney Studios), 226–228, 275

Greenberg, Andrew, 120

Greenberg, Donald, 87, 230

Greenberg, R. (studio), 171, 189, 310n53

Greenwood, Peter J., 166, 307n37

Gribble, Mike, 206

Griffith, D. W., 25, 293n35

Grignon, Rex, 135, 142, 208, 215, 235, 250

Guggenheim, Ralph, 134, 137, 157, 260, 262, 275, 316n13

Guggenheim, Solomon, 24

Guggenheim Fellowship, 24, 135

Gulliver's Travels (Fleischers), 133, 201

Gumby (Klokey), 250

Guyot, Alan, 210–211

Gygax, Gary, 120

Habitat (game), 120

Hackers

beatniks and, 89

cartoons and, 97

computers and, 89–100

concept of, 89

Counterculture and, 92–94

games and, 104

hippies and, 89–92

Homebrew Computer Club and, 88, 93–95, 100, 206, 259

IBM and, 89, 91, 93–94

Kay and, 89, 93

language of, 91–92

mail-order kits and, 90, 93

Manifesto of, 89

MIT and, 90–92

SIGGRAPH and, 95–100

Smith and, 98

Xerox PARC and, 93

Hackers: Heroes of the Computer Revolution (Levy), 90

Hahn, Steve, 222

HAL 9000 (*2001: A Space Odyssey*), 75, 288

Hale, Joe, 225

Hamilton, Linda, 99, 254

Hanks, Tom, 123

Hanna-Barbera, 3, 87, 142, 180, 196, 219, 230

Hannah, Marc, 172

Happy Feet (Miller), 237

Hard Day's Night, A (United Artists), 9

Hard Woman (Jagger), 183–184, 188, 274, 277, 282

Haring, Keith, 112

Harrison, Bill, 104

Harrison, Lee, 2, 149, 203, 274–275, 306n14

Harry (paint system), 151

Harryhausen, Ray, 3, 258, 268

HBO (Home Box Office TV network), 140, 211

Heavy Fire (game), 114

Heavy Metal (film), 68

Heinlein, Robert A., 203

He-Man and the Masters of the Universe, 116, 188, 222

Henson, Jim, 168, 205–208, 210, 215

Hermanovic, Gregg, 191, 195
Heumer, Dick, 249
Hewlett, William, 54, 219
Hewlett-Packard (HP), 93–94
Hidden surface algorithms, 64, 80, 180
Higginbotham, Willy, 102
Hillin, Jim, 97, 170, 196, 222, 232, 275
Hindemith, Paul, 11
Hippies, 2, 11, 19–21, 49, 56, 72, 82, 83, 85,
 89, 108–109, 120, 244
Hirsh, Hy, 19–21, 292n16
Hitchcock, Alfred, 26–28, 147, 173
Hobby Computer Club, 94
Hoe-Down (Bute), 21
Hoffman, Bob, 151
Hollerith, Herman, 73
Hollyhock House, 24
Holzman, Bob, 48
Homebrew Computer Club, 88, 93–95, 100,
 206, 259
Honeywell, 2, 44, 73–74, 89, 225
Hook (film), 255
Hope, Bob, 14, 28
Hopper, Grace, 38, 275
Houston, Jim, 228, 315n34
Howard, Tom, 148
Howard the Duck (Lucasfilm), 243
Hubley, Faith, 126
Hubley, John, 126
Hughes, Howard, 8, 46
Hughes, John, 196, 275, 311n75
Hulk, The (Lee), 213–214
Hummingbird (Csuri), 32, 58, 221, 271
Hunger/La faim (Foldes), 3, 33, 70, 124,
 220–221, 275
Hyams, Peter, 77, 184

IBM (International Business Machines), 180
 beginnings of, 73
 as Big Blue, 28, 73–74, 288
 BUNCH competitors and, 73–74
 corporate culture and, 74, 77–78, 82, 88
 Cray and, 273
 DAC-1 computer and, 288
 Digital Productions and, 187
 digital revolution and, 2
 dominance of, 74, 82, 239
 407 machine and, 91
 games and, 102, 111
 Hollerith and, 73
 military and, 37–38, 40, 73
 modular mainframes and, 78
 PC, 111
 Project SAGE and, 40–43, 289, 295n14
 Selectric and, 93
 704 mainframe and, 91, 279
 709 computer (Hulking Giant) and, 102
 7094 computer and, 74–75
 Ivan Sutherland and, 73
 360 mainframe and, 151
 visual effects and, 146–147, 151
 Watsons and, 73, 77
 Whitney and, 28–32, 282
Ice Age (Fox), 263–264
ImagePro, 172
Image West, 150–151
Imagineers (Walt Disney Imagineering),
 202–203, 225, 228, 275–276, 290
IMI computers, 225
Incredibles, The (Bird), 245, 262
Indiana Jones and the Temple of Doom
 (Spielberg), 111
Industrial Light & Magic (ILM) 49, 52, 57,
 111, 138, 170, 209, 213, 255, 256, 258
 The Abyss and, 169, 254
 The Adventures of Andre and Wally B. and, 68,
 242, 248
 beginnings of, 157–158
 building of, 136–137
 Ed Catmull and, 138, 158
 DiFrancesco and, 49, 52
 Tom Duff and, 142
 economic issues and, 187, 242–243
 Jurassic Park and, 255–258
 Dennis Muren and, 255–256, 278
 Omnibus and, 187

reputation of, 159, 169–170, 197
SIGGRAPH and, 99–100
Star Trek: The Wrath of Khan and, 158, 256
stop-motion and, 255–258, 256
Terminator 2: Judgment Day and, 254–255
Steve Williams and, 170, 255
work environment of, 158–159
Young Sherlock Holmes and, 57, 169, 254, 314n18
Informer, The (Ford), 8
Inglish, Dave, 226–230, *275*
Insektors (TV show), 188, 266, 318n29
Integrated circuits, 172, 288
Intel, 172
Interactivity, 41–42, 60, 70, 72, 92, 103, 120–121, 195, 235, 266, 278, 286, 312n21
Interface Conference, 137, 171, 266
Intergalactic Computer Network, 44
Internet, 2, 7, 31, 37, 43–45, 47, 57, 83, 89, 100, 102, 105, 120–121, 239, 280, 281, 277
Interplay Productions, 112
Iron Giant, The (Bird), 236–237
Iwatami, Toru, 113
Iwerks, Don, 228

Jackson, Michael, 140, 183
Jackson, Peter, 210–214, 258
Jagger, Mick, 183–184, 188, 274, 277, 282
James, Earl, 133
Jazz, 12, 14, 19–20, 59, 179, 201, 268
Jazz Singer, The (film), 253
Jeopardy (game show), 124
Jet Propulsion Lab (JPL), 34, 48–52, 52, 66, 138, 157, 159, 171, 184, 242, 272, 274, 306n29
Jimbo's Bop City, 20
Joblove, George, 170
Jobs, Steve
animation industry and, 236, 239–252
background of, 276
Atari and, 111, 240
Brand and, 93

Catmull and, 245
corporate culture and, 84
Counterculture and, 92
death of, 262
firing from Apple, 239–240
games and, 111
hackers and, 92–94
Alan Kay and, 240–241
John Lasseter and, 245–249
George Lucas and, 243
management style of, 240
Pixar and, 239–252
John Sculley and, 239–240
Alvy Ray Smith and, 245, 251
Stanford Artificial Intelligence Lab visits, 2, 56
Walt Disney Studios and, 266
Wozniak and, 56, 92, 94, 111, 239, 276
Xerox PARC and, 88
Johnson, Doug, 243
Johnson, Tim, 175, 215
Johnston, Ollie, 202, 222
Johnston, Scott, 57, 97, 232–233, 236–237, 276
Joint Computer Conference, 55
Jolson, Al, 253
Jones, Chuck, 3, 123, 219, 233, 236
Jones, Waldo F., 203
Joshi, Kiran, 232, 233
Jungle Book, The (Walt Disney Studios), 217, 219
Jurassic Park (Spielberg), 172, 179, 253–258, 266, 282, 305n9, 306n12

Kahl, Milt, 219
Kahn, Robert, 45
Kaiser, Karen, 250
Kamberg, Mario, 194
Kaneko, Mits, 195
Kang Jing Xiang (Whitney), 25
Kanuth, Robert, 172
Kasper, Steve, 175, 177, 191–192, 197
Kassar, Ray "The Czar," 111, 117

Katzenberg, Jeffrey
 DreamWorks SKG and, 211
 motion capture and, 211
 Paramount and, 177
 Pixar and, 243, 251
 Star Trek and, 276
 Walt Disney Studios and, 189, 211, 226,
 229, 233–236, 243, 251, 260, 262, 265, 276
Kaufman, Philip, 19–20
Kawaguchi, Yoichiro, 98, 276
Kay, Alan
 background of, 276
 corporate culture and, 82–84, 88
 Evans and, 2, 63, 82
 hackers and, 89, 93
 Jobs and, 240–241
 Lucasfilm and, 170, 241
 Pixar and, 240–241
 Sketchpad and, 42, 63
 Special Projects Lab and, 83
 Sutherland and, 42, 82
 University of Utah and, 63
 visual effects and, 160, 165, 170
 Xerox PARC and, 82–84, 88
Kay, Bonnie, 83
Keane, Glen, 217
Kennedy, Joseph, Sr., 5
Kennedy, Kathleen, 214
Kerlow, Isaac, 67
Kermit the Frog (character), 206
Kilby, Jack, 172
Kim, Scott, 94
Kimball, Mark, 228
King, Stephen, 209
King Kong (1933 film), 115, 146,
King Kong (2005 film), 214, 290
Kirsch, Russell A., 40
Kitsch In Sync (Beckett), 34
Kleinrock, Leonard, 31, 44–45
Kleiser, Jeff, 122, 151–152, 187, 195, 206,
 276
Klokey, Art, 250
Kluth, Donald, 56

Knoll, John, 170, 276
Knoll, Thomas, 170
Knowles, Alison, 34
Knowlton, Ken, 19, 74–76, 253, 276, 281
Kohler, Dylan, 228
Kohlhase, Charley, 49, 51
Kolstad, Chuck, 244
Koop, C. Everett, 112
Kotok, Alan, 102–103
Kovacs, Bill, 2, 176, 196, 228–229, 276
Kraftwerk, 142
Krim, Arthur, 8–9
Kronrod, Alexander, 102–103
Krostoff, James, 195
Kroyer, Bill
 background of, 276–277
 Digital Productions and, 183–184
 Ferngully the Last Rainforest and, 195
 hackers and, 97
 Hard Woman video and, 184
 Alan Kay and, 84
 Labyrinth and, 168–169, 184
 Technological Threat and, 195
 Tron and, 161–164
 visual effects and, 161–163, 167–169
 Walt Disney Studios and, 84, 167, 222–223,
 276
Kroyer, Sue, 195
Kubrick, Stanley, 31, 148, 155, 157, 173, 258,
 288, 305n9
Kurosawa, Akira, 119, 158, 243
Kurtz, Gary, 157
Kushner, David, 165
Kushner, Don, 160–161

Labanotation, 201, 203
Labyrinth (Henson), 77, 168–169, 184, 194,
 205, 274, 282
Lachapelle, Pierre, 67–69
LaCroix, Daniel, 277
Lady and the Tramp (Walt Disney Studios),
 217, 225, 249
Laemmele, Carl, 5

Lamb and Associates, 171

Lambert, Bob, 228

LaMolinara, Anthony, 250

Lampson, Butler, 83–84

Landi, Isabelle, 211

Landwon, John, 155

Lane, Chris, 161

Lang, Fritz, 12

Langlois, Daniel, 67–69, 97, 272, 277

Lanning, Lorne, 195–196

Lansdown, John, 71, 94, 277

Lapis (Whitney), 25

Laposky, Ben, 21, 277

Lasseter, John

 Andre and Wally B. and, 68, 229, 242, 248

 background of, 277

 Brain Trust and, 249

 The Brave Little Toaster and, 217

 A Bug's Life and, 236

 CalArts and, 241, 247, 249

 Catmull and, 97, 218, 236, 241–242, 245–246, 248, 261

 creative teams of, 246, 260

 feature films and, 248, 259–260

 Geri's Game and, 248

 growth strategies of, 249, 251

 interest of in computer graphics (CG), 241–242

 as Interface Designer, 242

 Steve Jobs and, 245–249

 Glen Keane and, 217

 Lucasfilm and, 277

 Luxo Jr. and, 247

 managerial style of, 246–247

 moving perspective shot and, 217

 Pixar and, 97, 236, 247

 Joe Ranft and, 249

 SIGGRAPH and, 97, 99, 218, 242, 245

 SIGGRAPH paper on animation principles, 97

 Alvy Ray Smith and, 241–242, 248, 251

 Tin Toy and, 248, 250–251, 277

 Toy Story and, 236

 Walt Disney Studios and, 2, 217–218, 225, 236, 241–242, 247–252, 259–260, 266, 277

 Where the Wild Things Are and, 217–218

 Young Sherlock Holmes and, 169

Last Starfighter, The (Lorimar), 58, 77, 166–168, 183, 274, 282

Lavoy, Mark, 87, 142, 230

Lawrence Livermore National Laboratory, 69

Lazzarini, Rick, 203

Leary, Timothy, 47, 72, 100, 111

Lee, Ang, 213–214

Lee, Spike, 121

Legend of BraveStarr, The (TV show), 222

Legend of Zelda, The (game), 118

Léger, Fernand, 11, 12

Leibovitz, Annie, 83

Leich, Don, 151

Lemaire, Raymond, 113

Letterman, Rob, 211

Levinson, Barry, 169

Levoy, Marc, 57

Levy, Don, 70

Levy, Steven, 90

Lichtenstein, Roy, 31

Licklider, J. C. R. "Lick," 39–40, 43–45, 54, 277

Lieberman, Sen. Joseph, 112

Light pens, 19, 39, 41, 54, 75

Lincoln, Howard, 115

Lincoln Center for the Performing Arts, 124

Line Drawing System-1 (LDS-1), 79

Linklater, Richard, 214

Lion King, The (Walt Disney Studios), 224, 232–233, 264, 276

Lipschitz, Jacques, 12

Lipson, Joseph, 60

Lisberger, Steven, 159–161, 241, 267–268, 277

LISP (programming language), 54, 77–78, 92, 181, 279, 288

Little Mermaid, The (Walt Disney Studios), 201, 219, 225, 229–232, 263, 275

Little Rural Riding Hood (Avery), 201

Live from Lincoln Center (PBS), 135

Lloyd, Peter, 161
Locomotion (Goldberg), 97
Logan's Run (film), 150
Logsdon, Jeffrey, 265
Looker (MGM), 154–155, 166
Lord of the Rings (Tolkien), 120, 202, 210,
 212–213, 258
Lost World, The (silent film), 146, 255
LSD, 47, 72, 100, 111, 244, 289, 298n46
Lubitsch, Ernst, 13–14
Lucas, George, 8–9, 144
 background of, 277
 Beckett and, 34–35
 Ed Catmull and, 137–138, 241, 273
 Coppola and, 137
 Cuba and, 34
 film perspective of, 159
 Genesis effect and, 241
 hot rods and, 2
 ILM and, 49 (*see also* Industrial Light &
 Magic (ILM))
 Interface Conference and, 137, 171
 Jobs and, 243
 Smith and, 241
 THX and, 157, 209, 277
 Whitney and, 157
Lucasfilm
 Ed Catmull and, 80, 98, 138, 157–158, 259,
 273
 David DiFrancesco and, 274
 economic issues and, 243
 Games Group, 169
 Graphics Group, 69, 137, 157–158, 169–170,
 234, 242–243, 273, 277, 279
 Habitat and, 120
 Howard the Duck and, 243
 improving postproduction and, 234
 Alan Kay and, 170, 241
 John Lasseter and, 277
 Fred Parke and, 278
 Pixar and, 242–243 (*see also* Pixar)
 Bill Reeves and, 69
 SGI Iris 1000 system and, 179

 Alvy Ray Smith and, 48, 275, 279
 Star Wars and, 34, 52, 60–61, 111, 136,
 155–157, 160, 166–167, 172–173, 242–243,
 258, 273, 276–278, 304nn34,39, 311n59
 visual effects and, 155–159, 169–170
 Willow and, 243
Lucent Technologies, 75
Luft, Sid, 195, 231, 282
Lumière bothers, 5, 145–146
Luxo Jr. (Pixar), 3, 68, 97, 246–248
Lye, Len, 16
Lyon/Lamb, 224

Machover, Carl, 278
MacMillian, Doug, 185
Magic Egg, The (Mueller and Weinberg), 100
MAGI/Synthavision, 59, 140, 151, 157,
 160–161, 165, 189, 281, 289
Magnavox, 105
Magnetic tape, 48, 107–108, 152, 172, 279
Maher, Bil, 123, 132, 138, 140, 142, 203–204
Mainframe UK, 183
Mallen, George, 71, 94
Malone, Larry, 181
Maltin, Leonard, 134, 247
Mandelbrot, Benoit, 273, 278, 284
Manga, 119, 243, 247, 297n3
Manhattan Project, 102
Mansfield Amendment, 47–48, 82
Mansur, Nick, 225
Marey, Étienne-Jules, 200–201
Marie, Rebecca, 194
Mark Williams Company, 142
Mars Rover, 107
Martin, André, 222
Marvin the Martian in the Third Dimension
 (film), 236
Maslin, Janet, 260
Massachusetts Institute of Technology (MIT),
 1, 3, 38, 54, 56, 259, 272
 academia and, 53–56, 61–63
 Rebecca Allen and, 138, 272
 ARPANET and, 45, 47

Ralph Baer and, 108
Vannevar Bush and, 37, 54–55, 87, 272, 280, 297n1
Center for Advanced Visual Studies and, 19
Communication Forum and, 311n1
company startups at, 77, 297n2
Digital Computer Laboratory and, 38
Engineering Department and, 54
Fredkin and, 153, 275
games and, 103–104, 108, 120
hackers and, 90–92
Knowlton and, 74, 276
LISP and, 77
McCarthy and, 54–56, 108
military and, 37–47
Moreland and, 54
Noftsker and, 278
Olson and, 38
Plywood Palace and, 90, 102
Project Whirlwind and, 38–39
protests at, 63
Reynolds and, 279
Roberts and, 44
Rusch and, 104
Russell and, 103, 108, 279
Sabiston and, 313n30
Samson and, 89
Servomechanisms Lab and, 38
Sutherland and, 41–44, 54, 61–62, 75, 280
Symbolics and, 77
Tech Model Railroad Club (TMRC) and, 90–91, 100, 290
Tixo and, 41, 102
VanDerBeek and, 18–19
visual effects and, 146, 153
Masters of the Universe (film), 188–189
Master-System, 118
Matsushita, 137
Mattel, 116, 260
Matthews, Max, 75
Mauchley, John 38
Max Headroom (character), 140
Mayer, Louis B., 5–6

Mayerson, Mark, 187, 313n29
Maynard, Jay, 166
MazeWar (game), 105, 107
Mazurkewich, Karen, 190
McBird, Bonnie, 165
McCarthy, Doug, 236
McCarthy, John, 54–56, 102–103, 108, 288, 295n17
McCartney, Paul, 123
McCay, Winsor, 3, 259
McDermott, Robert, 132
McGovern, Tim, 164, 195
McKenna, Sherry, 267
 Bob Abel and, 173, 179, 242
 background of, 278
 commercials and, 181–182, 193–194
 Digital Productions and, 183, 188–189, 193, 197, 217, 242, 245, 278
 games and, 195–196
 Omnibus and, 194, 196–197, 278
 stop-motion and, 181
 visual effects and, 168, 171, 173
McLaren, Norman, 16–17, 21, 32, 34
McMahon, Tom, 181
McQueen, Glenn, 99, 135, 235, 250, 262, 278
Mead, Syd, 161
Meads, Jon "The Troll," 95
Mechanic, Bill, 264
Medal of Honor (game), 121
Méliès, Georges, 19, 145–146, 157, 173, 258
MetaData (Foldes), 32–33
Metalanguage, 31
Metrocel, 231
Metrolight, 171, 195
MGM (Metro-Goldwyn-Mayer), 6, 8, 14, 147, 152, 160, 196, 201, 220, 293n35
Mickey Mouse (character), 236, 251, 317nn29,30
Microfishe (Sorensen), 34
Microsoft, 272, 316n21
 academia and, 61
 Allen and, 224

Microsoft (cont.)
 Apple and, 239
 corporate culture and, 84
 Gamecube and, 266
 game development and, 110–111, 118, 188, 266
 hackers and, 100
 patents and, 142
 Pixar and, 260
 Xbox and, 188, 266
Microsoft Flight Simulator, 110–111
Microvision, 116
Middlesex University, 71
Midway (games company), 113
Mike Tyson's Punchout (game), 118
Miller, George, 237
Miller, Leslie, 32
Miller, Ron, 165, 189, 217–218, 226, 307n53, 316n1
Milton Bradley (games company), 116, 119
Mindmaster (game), 111
Mindscape (game), 72
Minsky, Marvin, 63, 80, 103
Mirman, Ken, 161, 177, 180, 190
MITRE, 39, 54, 289
MITS Altair 8800, 88
Mitten, Jack, 31
Mittleman, Phil, 151
Miyamoto, Shigeru, 114, 118–119, 121, 278
Miyazaki, Hayao, 3, 265
Mizoguchi, Kenji, 5
Moholy-Nagy, László, 23
Mona by the Numbers (Peterson), 77
Monkhouse, Richard, 34
Monsters, Inc. (Pixar), 249, 262
Moore, Steve, 93
Moore's Law, 87
Moreland, Edward, 54
Morocco Memory II (Sorensen), 34
Mortal Kombat (game), 121
Moritz, William, 20, 291nn2,3, 292n9
"Mother of All Demos" (Engelbart), 55, 57, 241

Motion capture
 Adam Powers, The Juggler and, 67, 171, 180, 205, 274, 282
 avatars and, 160, 199, 210–215, 221–222, 266
 cartoons and, 201, 207, 211–212
 computers and, 199, 202–215
 Gary Demos and, 205–206
 Fleischers and, 201, 213
 human movement and, 199–215
 Labanotation and, 201
 Lucasfilm and, 48
 Jules Marey and, 200–201
 Muppets and, 205–208
 photography and, 201
 Carl Rosendahl and, 206–209
 rotoscope and, 2, 201–202, 209, 313n30
 Andy Serkis and, 212, 214
 SIGGRAPH and, 206, 208
 Waldo suit and, 202–204, 207–208, 212, 256
 Walt Disney Studios and, 201–203, 211–212
 John Whitney, Jr. and, 205–206
Motion Graphics Inc., 28
Motion Picture Academy of Arts and Sciences, 214, 262–263, 274, 280
Motion pictures, 2. *See also specific studios*
 academia and, 64, 71
 advent of, 11
 animation and, 212 (*see also* Animation)
 complexity of producing, 259
 early funding of, 8
 fantasy and, 6
 game cinematics and, 121
 graphic design and, 26 (*see also* Computer graphics (CG))
 Muybridge and, 11, 200, 218, 291n1
 New York Institute of Technology (NYIT) and, 123
 performance capture and, 212–215, 273, 282, 312n22
 sound technology and, 267
 unions and, 6–7
 visual effects and, 51 (*see also* Visual effects)

Motion Picture Screen Cartoonists, 18, 127, 151

Motorola, 73, 77, 110, 117

MOVIE.BYU (animation software), 67, 227

Moviola, 158, 164, defined 307n33

Ms. Pac-Man (game), 115

MTV, 140, 183

Mucha Lucha (TV show), 266

Mueller, Dick, 100

Muppets, 168, 205–208

Muren, Dennis, 255–256, 278

Museum of Modern Art, New York, 19, 24

Music, 11–13, 21, 23, 60, 107, 114, 134, 144, 199, 264, 259, 268

Musker, John, 232

Muybridge, Eadweard, 11, 200, 218, 291n1

Myers, Mike, 262

Myst (game), 266

Nader, Bob, 203

Namco (game company), 113–114

NASA

 ARPA and, 39, 79

 Blinn and, 48–49, 272

 JPL and, 34, 48–52, 66, 157, 159, 184, 242, 274, 296n33, 306n29

 Mars Rover and, 107

 Space Shuttle and, 79–80, 183, 274

 telefactoring and, 202–203

 3D images of planets and, 46

 Voyager flyby films and, 49–52, 138, 159, 171, 272

 Waldo suit and, 202–203, 208

 Wavefront Technologies and, 196

 Weinberg and, 183

National Bureau of Standards, 40

National Centre for Computer Animation, 71–72

National Education Association, 51

National Film Board of Canada, 17, 32–33, 69, 275, 278, 289

National Research Council of Canada, 32

National Science Foundation, 37, 39, 58

National Security Agency (NSA), 43

Natural Bureau of Standards, 40

NBC (National Broadcasting Company, TV network), 7, 124, 160

Neighbors (McLaren), 17

Neill, Sam, 257

Neiman, Leroy, 87

Nelson, Ted, 57

Nelvana Ltd., 221

Netscape, 66, 142, 273

Neuromancer (game), 72, 111–112

Neuromancer (Gibson novel), 111

Newell, Martin, 66, 128–129, 278

"Newell Teapot" (The Utah Teapot), 66, 98

New School for Social Research, 134

Newton, Helmut, 111

New York Institute of Technology (NYIT)

 achievements of, 131–132

 Blinn and, 48, 49

 Bushnell and, 111–112

 campus grounds of, 129

 cartoons and, 126–130, 133–134, 142, 144

 Catmull and, 83, 98, 128

 CGL (Computer Graphics Lab) and, 2, 123, 128–144, 157, 202, 288

 Clark and, 137–138, 172

 computers and, 123, 126–144

 computer upgrades and, 130–131

 DiFrancesco and, 129, 138

 as diploma mill, 124

 Kerry House and, 130–131

 Rockefeller family and, 124, 127–129

 Dr. Alex Schure and, 124–144, 158–159, 172, 246, 279

 SIGGRAPH and, 133, 138, 140, 142, 144

 Smith and, 82–83, 128–144, 230, 241, 251, 275

 traditional artists and, 133–134

 Tubby the Tuba and, 126–127, 129, 133–135, 144, 241

 U.S. Selective Service and, 124

New York Institute of Technology (NYIT)
(cont.)
 Westbury and, 3, 123, 126, 129, 135,
 137–138, 142, 158
 The Works and, 97, 130–140, 171, 221
 Wyndam House mansion and, 129
Nibbelink, Phil, 222, 227
Nickelodeon, 237, 263
Nicolai, Otto, 13
Night Gallery (TV show), 7
Nine Old Men, 222
Nintendo (game company), 114–121, 266,
 278, 282
Nixon, Richard, 47–48, 99–100, 301n25
Noftsker, Russell, 77, 278
Noonan, Tom, 209
Norby, Doug, 243
Norden bombsite, 37, 73
Nova (PBS), 135
Novak, Kim, 28, 147
NPL (British regional internet), 45
Nutting & Associates, 108
Nystrom, Jan Eric, 224

O'Brien, Willis, 255
Oddworld (game), 195–196
Odyssey (Magnavox), 105–107, 109–110,
 272
Ohio State University, 31–32, 57, 59–60, 157,
 172, 185, 195, 221, 273, 281, 289
Oilspot and Lipstick (Walt Disney Studios),
 229–230
Okawa, Isao, 118
Okun, Jeffrey, 166
Oliver and Company (Walt Disney Studios),
 227–229
Olson, Ken, 38
Omnibus, 142, 276, 281–282, 289
 Abel and, 189–192, 196–197, 206, 278
 academia and, 69
 bankruptcy of, 192–194
 cartoon animation industry and, 232, 234
 Crownx and, 192

 Digital Productions acquisition by, 187–188
 McKenna and, 194, 196–197, 278
 motion capture and, 206
 Pennie and, 142, 150, 185, 187–192, 196,
 278
 PRISMS and, 191, 195, 289
 visual effects and, 150, 165, 169–170
One Hundred and One Dalmations (Walt Disney
 Studios), 233, 245, 249
O'Neill, Pat, 34
Oppenheimer, Robert, 49
Optical Poem, An (Fischinger), 14
Oscillons (Laposky), 21
Oscilloscopes, 20–21, 40, 72, 75, 100, 102,
 221, 272, 277
Oshii, Mamoru, 119–120
Ostby, Eben, 57, 247, 316n13
Otomo, Katsuhiro, 119
Oxberry cameras, 3, 18, 162, 172, 266

Pacific Data Images (PDI), 94, 278
 cartoon animation industry and, 232–236
 DreamWorks and, 211, 235, 262
 Glen Entis and, 234, 257
 Steve Goldberg and, 232
 innovation and, 254, 257, 262
 Tim Johnson and, 215
 motion capture and, 206–208, 211, 215
 Pixar and, 236
 Carl Rosendahl and, 175, 179, 197, 206–207,
 254
Packard, David, 54, 219
Pac-Man (game), 113–115
Paint programs (surfacing of images), 35, 48,
 64, 66–69, 84–87, 131, 133, 142, 171–173,
 181, 184, 218–219, 230–233, 251, 287
Pajitnov, Alexy, 118–119, 278
Pal, George, 126
Paley, William, 7
Panasonic, 137
Panushka, Christine, 35, 70
Paper tape memory storage, 103, 107
Paperworks (Walt Disney Studios), 268

Paramount Studios, 13–14, 126, 127, 142, 150, 155, 158–159, 168, 177, 185, 189, 276, 313n29, 313n4

Parke, Fred, 80, 64, 127, 132, 154, 203, 259, 278

Particle Systems, 158–159

Patents, 54, 74, 92, 102, 110, 142, 177, 209, 284, 305n3, 314n11

Patrick, Robert, 254

Patten, Fred, 221

Patterson, Michael, 179, 183

PBS (Public Broadcasting System), 7, 33, 51–52, 87, 135

PDP computers, 172
 academia and, 60, 62–63
 corporate culture and, 83
 games and, 102–104, 107–108, 118
 PDP-1, 2, 62, 102–103, 108, 153, 275, 289, 295n17, 297n20
 PDP-10, 83, 289
 PDP-11, 60, 107, 118, 289–290

Pearl Harbor (Bay), 210

Pederson, Con, 148, 155, 173, 176, 178, 219–220, 278

Peet, Bill, 249

Pennie, John, 142, 150, 185, 187–192, 196, 278

Pentagon, 43, 47, 80

People's Computer Company (PCC), 93

Peraza, Mike, 226–227

Performance-capture method, 212–215, 273, 282, 312n22

"Perimeters of Light and Sound and Their Possible Synchronization, The" (Bute), 16

Periscope (game), 113

Permutations (Schwartz), 75

Peterson, H. Philip, 77

Phillips, Audri, 195

Phillips, Dan, 185, 190, 192, 232, 253

Phillips Electronics, 73, 115–116, 243

Phong, Bui Tuong, 66, 279

Phong shading, 66, 279, 285

Photocopiers, 82, 218, 229, 261, 297n16

Pickford, Mary, 8

Pierce, David Hyde, 237

Pinkava, Jan, 250

Pink Floyd, 20

Pink Panther, The (United Artists), 9

Pinky and the Brain (TV show), 236

Pinocchio (Walt Disney Studios), 14, 125, 133, 213, 217, 219, 251

Pintoff, Ernie, 25, 293n37

Pioneer LDV1000 laserdisc, 116

Pirates of the Caribbean (Walt Disney Studios), 262

Pitts, Bill, 107

Pixar, 2–3, 211, 234
 A Bug's Life and, 236, 260–261, 315n44
 academia and, 57, 66, 69
 Academy Awards and, 248
 acquisition by Walt Disney Studios, 265–266
 Beach Chair and, 57, 247
 Black Friday and, 260
 Jim Blinn and, 242, 247
 Brain Trust and, 249
 Burbank Shuffle and, 296n42
 CAPS system and, 273–274, 315n34
 Loren Carpenter and, 98, 138, 273, 316n13
 Cars and, 262, 318n23
 cartoons and, 244–245, 248, 250–251
 Ed Catmull and, 66, 241–248, 251, 260–262, 266, 273, 316n13
 commercials and, 194
 computers and, 241–252
 corporate culture and, 87–88
 David DiFrancesco and, 245, 274, 316n13
 digital paint system development and, 228–231
 economic issues of, 250
 Michael Eisner and, 260, 265
 Electronic Theater and, 97
 feature films and, 248, 259–262
 Finding Nemo and, 262, 279
 Flash and, 266
 founding members of, 316n13
 Geri's Game and, 248

Pixar (cont.)
 growth strategy of, 251–252
 Ralph Guggenheim and, 275, 316n13
 Imaging Computer and, 244
 increasing success of, 250–252
 The Incredibles and, 245, 262
 Steve Jobs and, 239–252, 260–261, 276
 Alan Kay and, 240–241
 John Lasseter and, 97, 236, 247, 277
 George Lucas and, 169–170, 276, 277
 Luxo Jr. and, 3, 68, 97, 246–248
 Monsters, Inc. and, 249, 262
 PDI and, 236
 principle creators of, 258–259, 319n13
 Joe Ranft and, 249, 279
 Bill Reeves and, 279, 316n13
 RenderMan and, 196, 248, 251, 256, 273
 Schure and, 144
 shorts and, 97, 194
 SIGGRAPH and, 242, 245, 247
 Smith and, 236, 242–245, 248, 251, 262,
 279, 316nn13,16
 Tin Toy and, 248, 250–251, 277
 Toy Story and, 57, 144, 172, 211, 234,
 236–237, 252–253, 259–262, 266, 277, 279
 Toy Story 2 and, 262
 Toy Story 3 and, 262
 Up and, 262, 292n7
 Wall-E and, 262
Pixilation, 17
Playstation, 118, 121, 266
Poem Fields, One through Eight (VanDerBeek),
 18–19, 75
Pokémon (game), 119–120
Pokémon: The First Movie (Warner Bros.), 120
Pokeno (game machines), 114
Polar Express, The (Walt Disney Studios), 199,
 209, 212, 282, 312n22
Pollock, Jackson, 31
PONG (game), 109–110, 114–116, 160, 272
Poniatoff, Alexander M. 279, 287
Popeye (character), 114, 126, 201
Porter, Tom, 87

Potter, Ralph, 21
PreVisualization (PreViz) defined, 286
Price, Tina, 97, 222, 227, 233, 279
Printz, Jan, 151
PRISMS, 191, 195, 289
Project SAGE, 40–43, 289, 295n14
Project Whirlwind, 38–39, 41, 102,
 295nn6,15
Psychedelic subculture, 20–21, 72, 120, 244
Punch cards, 57, 73, 75, 172, 203, 221
Puppetoons (George Pal), 126

*Q*bert* (game), 115
Quantel Computers, 171
Quéau, Phillippe, 222

RA&A (Robert Abel & Associates), 173,
 175–177, 181, 189–190, 195–196
Rabins, Sandy, 235
Radar, 21, 38–40, 46, 91, 104, 114
Radarscope (game), 114
Radio Dynamics (Fischinger), 14
Radio-Electronics magazine, 77
Raggedy Ann and Andy: A Musical Adventure
 (Williams), 127
Rainbow Bright, 116
Rand Corporation, 37, 40, 43, 281, 289
Ranft, Joe, 249, 260, 262, 279
Raposo, Joe, 127
Raskin, Jeff, 63, 67
Raster graphics
 Bob Abel and, 206
 Adam Powers, The Juggler and, 67, 171, 180,
 205, 274, 282
 anti-alias and, 64, 273, 284
 bump mapping and, 28, 66, 272, 284
 computer graphics (CG) and, 32, 60, 64, 67,
 75, 80, 97, 118, 121, 131, 155, 166, 171,
 176, 180, 206, 221, 274, 282, 284–286
 Chuck Csuri and, 32
 Evans & Sutherland and, 80
 EVL sessions and, 60
 Generation X audience and, 121

Ken Knowlton and, 75
newness of, 65–67
Nintendo and, 118
Phong shading and, 66, 279, 285
Dick Schoup and, 131–132
SGI machines and, 176
SIGGRAPH and, 67, 97
Alvy Ray Smith and, 131–132
storage of complex, 221
3D renderings and, 64
visual effects and, 155, 166
Whitney-Demos and, 180, 274
wire frames and, 171
Raudseps, J. G., 31–32
Ray, Man, 11–12, 16
Raytheon Corporation, 73, 225, 272, 275
RCA, 115, 117, 267
Reagan, Ronald, 112
Rebay, Hilla, 24
Reboot (TV show), 188, 266, 318n29
Red Hot Chili Peppers, 100
Reed, Jerry, 29
Reed, Lou, 221
Rees, Jerry, 161, 163, 165
Reeves, Bill, 69, 157–159, 246, 279, 316n13
Ren and Stimpy (TV show), 195, 231
RenderMan, 196, 248, 251, 256, 273
RePlay magazine, 117
Rescuers Down Under, The (Walt Disney
 Studios), 232, 251
Reynolds, Craig, 137, 171, 181, 279
R. Greenberg and Associates, 189
Rhythm and Hughes, 145, 196
Rich, Richard, 225
Riddle, Jay, 170
Rifkin, Ed, 103
Right Stuff, The (Kaufman), 19–20, 176
Ritchie, Dennis, 74
RKO (Radio Keith Orpheum movie studio),
 15
Roach, Steve, 99
Roberts, Larry, 31, 44–45
Roberts, Randy, 179

Robidoux, Pierre, 67
Rob Zombie, 99
Rock clubs, 20
Rockefeller family, 124, 127–129
Rodchanko, Vladimir, 23
Rogers, Wathel, 203
Rolling Stone magazine, 83, 89, 244
Rolling Stones (band), 183
Romancing the Stone (Zemeckis), 211
Roosevelt, Franklin D., 6, 37
Roosevelt, Teddy, 123
Rosebush, Judson, 140, 151, 161, 165, 279
Rosen, David, 113, 118
Rosendahl, Carl
 cartoon animation industry and, 234
 Glen Entis and, 94
 motion capture and, 206–209
 Pacific Data Images (PDI) and, 175, 179,
 197, 206–207, 254
Rosenthal, Ken (*The Juggler*), 171, 205
Rosicrucians, 51
Rosio, Terry, 262
Ross, Scott, 99, 209–210
ROTC (Reserve Office Training Corps), 41, 43,
 289
Rotoscopes, 2, 201–202, 209, 313n30
Royal College of Art, 71
Rubik, Erno, 119
Rundgren, Todd, 123, 150
Rusch, Bill, 104
Russell, Steve "Slug," 103, 107–108, 279
Ruttmann, Walter, 12

Sagan, Carl, 49, 51, 138, 171, 272
St. Pierre, Dan, 232
Sakaguchi, Hironobu, 211
Salesin, David, 57
Salvio, Gerard, 127
Samson, Peter, 89, 91
Sanctuary (Sorensen), 34
Sanders, Bob, 103
Sanders, Royton, 105
Sanders & Associates, 101, 104–105, 110

Sandin, Dan, 60

Sandin Image Processor, 60

Sandrew, Barry, 231

Sarnoff, David, 7

Scanimate, 149–151, 153, 155, 185, 203,
 274–275, 306n14

Schiff, Dobbie, 195

Schillinger, Joseph, 16

Schlesinger, Leon, 126

Schneider, Peter, 234

Schoenberg, Arnold, 14

Schumacher, Tom, 234

Schure, Dr. Alexander
 background of, 124–125, 279
 Ed Catmull and, 128, 131, 246
 Jim Clark and, 137–138, 172
 computer animation and, 127–144
 Computer Graphics Lab (CGL) and,
 128–144
 computer upgrades and, 130–131
 death of, 144
 David DiFrancesco and, 129
 educational cartoons and, 126
 Evans & Sutherland and, 127–128, 132
 Jeopardy win of, 124
 managerial style of, 131
 New York Institute of Technology (NYIT)
 and, 124–144, 158–159, 172, 246, 279
 patent applications of, 142
 personality of, 124
 retirement of, 144
 Rockefeller family and, 124, 127–129
 Alvy Ray Smith and, 129
 Tubby the Tuba and, 126–127, 129, 133–135,
 144, 241
 wealth of, 124, 128, 131

Schure, Louis, 138

Schwartz, Lillian, 32, 58, 75, 221, 271, 279

Schwarzenegger, Arnold, 235–236, 254

Scientific American journal, 63

Scorcese, Martin, 9, 121, 231

Scott, Ridley, 155

Scriabin, Alexander, 16

Scroggins, Mike, 70

Sculley, John, 239–240

SEAC (Standards Eastern Automatic
 Computer), 40

Second Life (game), 266

Secret of NIMH, The (Bluth), 164–165

Sederberg, Tom, 67

SEGA, 113, 117–118, 120, 266

Segal, George, 31

Segal, Steve, 179, 244–245, 247, 250

Selick, Henry, 215, 268

Sendak, Maurice, 217

Sente, 111, 142

Serkis, Andy, 212, 214

Sesame Street, 84, 127, 211

Sexy Robot ad, 177–179, 206

Sherman Antitrust Act, 8, 74, 316n4

Shiffman, Bob, 95

Shogakukan, 243, 247

Shore, Dinah, 28

Shoup, Dick, 82, 84–85, 87, 131–132

Shrader, Paul, 243

Shrek (DreamWorks), 1, 211–213, 235,
 262–263

Side Effects Software, 97

Sieg, Dave, 150, 187–192, 194, 196

SIGGRAPH (Special Interest Group on
 computer Graphics)
 academia and, 55, 59, 66–68, 72
 Association for Computing Machinery
 (ACM) and, 94, 100, 281, 287, 290
 birth of, 94–97
 Electronic Theater and, 97, 247
 hackers and, 95–100
 National Computer Graphics Association
 and, 289
 New York Institute of Technology (NYIT)
 and, 133, 138, 140, 142, 144
 parties of, 99–100, 189, 197, 236
 raster graphics and, 67, 97
 SCUAIDE and, 289

Silicon Graphics (SGI), 52, 66, 70, 79–80, 142,
 170, 172, 273, 290, 308n2

Silicon Valley, 54, 56, 88, 94, 108, 160, 197, 206, 239, 243, 249, 280

Silly Putty, 116

Silver, Jesse, 164, 168, 169, 179, 194

Silverman, David, 134

Simon's Cat (Tofield), 268

Simonyi, Charles, 73, 83–84

Simpsons, The (TV show), 134, 235

SIMs, The (game), 266

Sinden, Frank, 75

Singer, Sam, 127

Sketchpad (computer program)
 cartoons and, 1
 curved lines breakthrough of, 42
 documentary of, 43, 61–62
 Dave Evans and, 43, 61–63
 as graphical communication system, 1, 41
 interactivity and, 41–42
 Alan Kay and, 42, 63
 Ivan Sutherland and, 1, 41–43, 54, 61, 63, 75, 148, 269, 280
 visual effects and, 148

Sleeping Beauty (Walt Disney Studios), 222

Slit-scan technique (motion control) 24, 148, 173

Sloat, Jay, 196

Smith, Alvy Ray, 2–3, 271
 Alpha Channel and, 132
 background of, 80–81, 279–280
 BigPaint system and, 87
 Jim Blinn and, 48–49, 59
 Ed Catmull and, 129, 251
 Computer Graphics Lab (CGL) and, 128–144, 241
 David DiFrancesco and, 128–129, 274
 Genesis effect and, 241
 hackers and, 98
 Industrial Light & Magic (ILM) and, 49, 52
 Steve Jobs and, 245, 251
 John Lasseter and, 241–242, 248, 251
 George Lucas and, 48, 138, 241, 275, 279
 New York Institute of Technology (NYIT) and, 82–83, 128–144, 241, 251, 275

New York University resignation of, 82

Pixar and, 236, 242–245, 248, 251, 262, 316n13

raster graphics and, 131–132

Dick Shoup and, 82

Skiing accident of, 80–81

Stanford University and, 80–82, 279

Ivan Sutherland and, 41

Tubby the Tuba and, 129, 241

"Turino machine" and, 128

visual effects and, 157–159, 170

Voyager flyby films and, 49–52, 138, 159, 171, 272

Walt Disney Studios and, 135, 220

Wyndam House mansion and, 129

Xerox PARC and, 82, 82–87, 128, 131

Smith, E. E. "Doc," 103

Smith, Harry, 19, 19–20

Smothers, Tommy, 123, 149–150

Smurfs, The (TV show), 230

Snoopy, 80

Snow White and the Seven Dwarves (Walt Disney Studios), 133, 202, 218, 248, 259–260, 263, 281, 312n2

Snyder, Dave, 6–7, 203, 225

Sofian, Sheila, 35

Softimage, 69, 172

Solomon, Charles, 247

Soman, Loren, 211

Sonic the Hedgehog (game), 118

Sony, 118, 137, 234, 237, 266

Sorensen, Vibeke, 2
 academia and, 67, 70–71
 background of, 34, 280
 CalArts and, 227, 250
 Cubicomp and, 70
 The Magic Egg and, 100
 military and, 47

Soviet Union, 37, 102, 210, 295n14

Soylent Green (film), 108

Space Ace (game), 116

Space Invaders (game), 113

Space Shuttle simulator, 79–80, 183, 274

Spacewar! (game), 54, 92, 103–104, 107–108, 279

Spectre, 34

Sperry Rand, 74, 77

Spielberg, Steven 7, 111, 117, 165, 214, 231
 Close Encounters of the Third Kind and, 155, 160, 172, 177
 DreamWorks and, 211, 234, 262
 Jurassic Park and, 172, 179, 253–258, 266, 282, 305n9, 306n12
 Young Sherlock Holmes and, 57, 169, 254, 317n18

Spook Sport (Bute), 16

Sporn, Michael, 127, 224

Sputnik, 39

Stanford Artificial Intelligence Lab (SAIL), 2, 47, 55–56, 93, 102, 289

Stanford Research Institute (SRI), 44–45, 47, 55, 93, 290

Stanford University, 54, 103, 172, 108–109, 280, 294n1
 academic research and, 54–56, 63, 146
 Augmented Human Intellect Research Center and, 55–56
 Douglas Engelbart and, 93, 274, 295n24
 Carl Rosendahl and, 94, 206, 279

Stangl, Norm, 221

Stanley & Stella Breaking the Ice (Reynolds), 181

Stanton, Andrew, 249

Starr, Cecile, 34

Starr, Ringo, 149–150

Starchasers the Legend of Orin 3D, 222

Starship Troopers (film), 258

Star Trek franchise, 155
 Abel and, 161, 177, 189
 animated TV series of, 133
 Genesis Effect and, 80, 158–159, 241
 Jeffrey Katzenberg and, 276
 original TV series, 56
 Star Trek: The Motion Picture (movie), 177
 Star Trek: The Next Generation (movie), 258
 Star Trek: The Next Generation (TV show), 258

Star Trek II: The Wrath of Khan (movie), 80, 158–159, 165, 256

Star Trek III: The Search for Spock (movie), 168, 187

Star Wars (game), 111

Star Wars (*Star Wars IV: A New Hope*, 1977, Lucasfilm), 304n39, 311n59
 Adam Beckett and, 34
 Jim Blinn and, 52
 Larry Cuba and, 34, 60, 136, 273
 Death Star and, 60, 99, 111, 157
 impact of, 136, 155, 25
 profits from, 136, 242–243
 visual effects and, 155–157, 160, 166–168, 172, 304n34

Stately, Joan, 59

Stauffacher, Frank, 19–21

Steamboat Willie (Walt Disney Studios), 247, 317n29

Stehura, John, 30–31, 45, 57, 280

Stein, Milt, 127

Stern, Garland, 63, 66–67, 129, 131, 132, 135, 142, 150

Stockert, Hank, 21

Stockham, Tom, 63

Stockhausen, Karl, 16

Stokowski, Leopold, 15, 292n4

Stop-motion
 Harryhausen and, 258, 268
 Industrial Light & Magic (ILM) and, 255–258
 McKenna and, 181
 Muybridge and, 291n1
 rebirth of, 268
 Selick and, 215, 268
 SIGGRAPH 84 and, 140
 Wedge and, 59, 97

Storyboards, 3, 49, 138, 161, 177, 190, 218, 241–242, 249, 254, 279, 286

Strachey, Christopher, 102

Strategic Air Command, 43

Strauss, Charles, 57

Strawberry Fields (Beatles), 140

Street Fighter (game), 121

Stuart, Richard, 113
subLOGIC, 60–61
Sullivan, Bill, 192
SUN Microsystems, 56, 189–190, 280, 290
Sunstone (Emshwiller), 135
Superman, 127, 201
Super Mario Brothers (game), 115, 118
Superpaint, 85–87, 230
Supervisions (Smith and Shoup), 87
Surfacing. *See* Paint programs
Sutcliffe, Alan, 71, 94
Sutherland, Bert, 41
Sutherland, Ivan (John), 2
 academia and, 48, 54, 61–64, 67, 73, 75,
 78–82, 84
 ARPA and, 43–45, 48, 79, 277
 background of, 41, 280
 Jim Blinn and, 48, 52
 building first computer network and, 44
 Caltech and, 67
 Ed Catmull and, 273
 doctoral thesis of, 41, 63
 Evans & Sutherland and, 43, 78–80,
 127–128, 131, 172, 176, 180, 183–184, 221,
 241, 274, 280
 Dave Evans and, 61–63, 78–80, 274, 280
 hidden surface algorithms and, 80, 180
 IBM and, 73
 Alan Kay and, 42, 82
 LDS-1 and, 79
 Massachusetts Institute of Technology (MIT)
 and, 41–44, 54, 61–62, 75, 280
 military and, 43–44, 62, 79, 277
 as pioneer, 253, 269
 ROTC and, 41, 43
 rubber banding and, 42
 Alex Schure and, 128
 Sketchpad and, 1, 41–43, 54, 61, 63, 75,
 148, 269, 280
 Alvy Ray Smith and, 41
 studio rounds of, 147, 154
 3D modeling and, 64
 time-sharing and, 62

TX2 and, 41
University of Utah and, 43, 45, 48, 62–64,
 78–79, 82, 84, 107, 128, 180, 280
Sylvania, 105
Sylvester, Mark, 196
Symbionese Liberation Army, 129
Symbolics, 77, 98, 181, 196, 203, 209, 222,
 274, 278–279, 289, 297n2
Symetricks (VanDerBeek), 19
Synchromy #2 (Bute), 16
Synthavision, 59, 140, 151, 157, 160–161,
 165, 189, 281, 289
Synthesizers, 60, 268
Syzygy, 108

TAARNA, 68
Taijiri, Satoshi, 119
Taito (games company), 113, 116
Tank (game), 110
Tank Girl (Hewlett and Martin), 120
Taylor, Richard, 64, 155, 161, 166, 171,
 175–177, 280, 301n22
Taylor, Robert, 44–45, 48, 82–83, 88, 280,
 301n22
Taylor, R. T., 21, 175, 298n22
TDI (Thompson Digital Imagery), 142, 172
Tech Model Railroad Club (TMRC), 54, 90–91,
 100, 102–104, 290
Technicolor, 152, 248, 266
Tectronics 4013, 152
Teeven, Shauna, 231
Television, 17
 beginnings of, 2–3, 7–9
 commercials and, 7 (*see also* Commercials)
 games on, 101–121 (*see also* Games)
 limited animation system and, 219
 Saturday morning cartoons and, 112, 130,
 220
Ten Commandments, The (film), 146
Tennis for Two (Higginbotham), 102
Terman, Frederick, 54, 280
Terminator II: Judgment Day (Cameron), 169,
 195, 208, 251–255, 266, 273, 279, 282

Terry, Paul, 126
Terrytoons, 126–127
Teske, Edmund, 25
Tesla, Nick, 88
Tetris (game), 118–119
Texas Instruments (TI), 77, 115
Texture mapping, 48, 50, 64, 128, 132, 184,
 230, 233, 273
Thalberg, Irving, 5
Tharp, Twyla, 142, 205
Theme parks, 152–154, 196, 207, 220, 290
Theremin, Leon, 16
Thinking Machine CM-2, 195
Thomas, Frank, 222, 265
Thompson, Ken, 74
3DV (DynaDigiDatavac), 140
Three Little Pigs, The (Walt Disney Studios),
 249
Three Ring Circuit (Sorensen), 34
3/78 Objects and Transformations (Cuba), 34, 60
THX sound, 157, 209, 277
Time-lapse photography, 12, 17, 158
Time magazine, 111, 114
Time-sharing, 54, 62, 93, 107, 131
Time Warner, 7, 236
Timm, Bruce, 236
Tin Toy (Pixar), 248, 250–251, 277
Tippett, Phil, 253, 255–256, 258, 265
Titanic (film), 1, 195, 210, 258, 273, 313n23
Tixo computers, 38, 41, 102–103
Tofield, Simon, 268
Tolkien, J. R. R., 56, 120, 258
Tomb Raider (game), 120–121
Tony de Peltrie (Bergeron and Langlois), 3,
 67–69, 97, 210, 272, 277
Tooley, James, 232
Total Recall (film), 195, 206
Toy Story (Pixar), 57, 144, 172, 211, 234, 236,
 237, 252, 259–262, 266, 277, 279
Toy Story 2 (Pixar), 262
Toy Story 3 (Pixar), 262
Transmutation (Fischinger), 19
Tresidder Union coffeehouse (Stanford), 107

Triple-I, 279, 290, 310n35
 academia and, 67
 Adam Powers, The Juggler and, 67, 171, 180,
 205, 274, 282
 Demos and, 180–181, 274
 Foonly and, 185
 Fredkin and, 153, 275
 Futureworld and, 154
 hackers and, 93
 motion capture and, 205
 Omnibus and, 185
 visual effects and, 153–154, 157, 161, 167
 Whitney and, 180–181, 281
Tron (Walt Disney Studios), 59, 84, 151,
 160–167, 180, 185, 217, 222, 254, 263, 267,
 279–281, 298n22
"Tron Guy," 166
Tron Legacy (2011) sequel of, 189, 307n53
Troubetzkoy, Eugene, 151, 165
Trumbull, Douglas, 148, 177, 280
Ts'o, Pauline, 196
Tubby the Tuba (NYIT), 126–127, 129,
 133–135, 144, 241
Tuber's Two Step (Wedge), 59–60
Turing, Alan, 38, 101–102, 280–281, 303n11
Turner, Kathleen, 178
Turner, M. J., 228
Turner, Ted, 195, 231, 282
Turner Animation, 231
Tweening program, 132–133, 150, 285
Twenty-Four Variations on an Original Theme
 (Whitney), 24
*Two-Gyro Gravity Gradient Altitude Control
 System, A* (Zajac), 75
Two Space (Cuba), 34
2001: A Space Odyssey (Kubrick), 31, 75, 78,
 148, 155, 173
2010 (Hyams), 77, 184, 187
Tytla, Bill, 219

"Uncanny Valley," 212, defined, 316n23
Unions, 5–7, 18, 127, 219, 265, 268,
 305n7

United Productions of America (UPA), 25, 70, 126, 219

United States v. Paramount, 8

UNIVAC, 38

Universal Studios, 8, 115, 220, 256, 275, 304n34

University of Bath, 71

University of Bournemouth, 71–72

University of California, Los Angeles (UCLA), 30–31, 44–45, 57, 173, 194, 220, 272–273, 280–281

University of Illinois, 60–61, 110, 157

University of Montreal, 67–69, 272, 277

University of Southern California (USC), 70, 79, 195, 213, 220, 222, 277, 280–281, 290

University of Toronto, 69–70

University of Utah, 3

 academic environment and, 63–67

 ARPANET and, 45

 Blinn and, 272

 Catmull and, 67, 83, 128, 131, 151, 259, 261, 273

 Clark and, 137, 273

 Crow and, 59

 Engelbart and, 241

 Evans and, 61, 61–64, 78, 80, 82–84, 107, 274

 Fletcher and, 62

 Gouraud and, 275

 Guggenheim and, 137

 Kay and, 82, 276

 Mormonism and, 63

 Newell and, 278

 Parke and, 132, 203, 278

 Phong and, 279

 Richard Taylor and, 175, 280

 Robert Taylor and, 280

 Schure and, 128, 131

 Sutherland and, 43, 45, 48, 62–64, 78–79, 82, 84, 107, 128, 180, 280

 Williams and, 282

University of Waterloo, 69

University of Wisconsin, 60

UNIX, 78, 290

Up (Pixar), 262, 292n7

U.S. Air Force, 39–40, 62, 104, 113, 153, 275, 295n14

USAnimation, 195, 231, 282

U.S. Army, 26, 38, 43, 102, 294n1

U.S. Defense Department, 39, 41, 43, 47, 53, 62, 82, 221, 287

User Friendly, 132, 140

U.S. Selective Service, 124

USS *Enterprise*, 80

van Dam, Andries, 56–57, 94, 281

VanDerBeek, Stan, 17–19, 59, 75, 97, 123, 276, 281

Vanderbilt, Cornelius, 126

Van Doesberg, Theo, 11

Van Dyke, Dick, 126

Vangelis, 51

Vanguard 1, 39

Variety magazine, 137, 160

Variety shows, 7–8

Vaudeville, 7–8

VAX computers, 2, 98, 131

Vector graphics, 29, 84, 121, 221, 286

Veevers, Wally, 148, 281

Veilleux, Jim, 158

Vertigo (Hitchcock), 28, 147, 153, 173

Viacom, 7

Victory through Air Power (Walt Disney Studios), 124

Videotape, 8, 149, 218, 224

Video Toaster, 258

Vietnam War, 47, 63, 66, 78, 105, 124, 126, 173, 275, 301n25

Vinton, Will, 250

Virtual reality, 40, 46, 62, 137, 209, 280

Visual effects (VFX), 51

 Jordan Belson and, 19–20

 cartoons and, 151, 163, 165

 Ed Catmull and, 147, 150–151, 154, 157–158

Visual effects (VFX) (cont.)
 commercials and, 7, 25, 71, 130, 133, 135,
 140, 150, 154, 172–173, 181–182, 187, 190,
 194, 220, 244–245, 263, 279
 computers and, 145–170
 Deep Canvas and, 233
 Demos and, 153–154
 DiFrancesco and, 157, 159
 Genesis effect and, 80, 158–159, 241
 The Harry and, 171–172
 IBM and, 146–147, 151
 Jurassic Park and, 172, 179, 253–258, 266,
 282, 305n9, 306n12
 Kay and, 160, 165, 170
 Kroyer and, 161–163, 167–169
 The Last Starfighter and, 166–168
 Lisberger and, 159–161, 241, 267–268, 277
 Looker and, 154–155
 Lucasfilm and, 155–159, 169–170
 Lumière brothers and, 5, 145–146
 Massachusetts Institute of Technology (MIT)
 and, 146, 153
 motion capture and, 199–215
 movie credits and, 267–268
 raster graphics and, 32, 60, 64, 67, 75, 80,
 97, 118, 121, 131, 155, 166, 171, 176, 180,
 206, 221, 274, 282, 284–286
 SIGGRAPH and, 150, 161–162
 Sketchpad and, 148
 Smith and, 157–159, 170
 software packages for, 171–172
 Terminator 2 and, 195, 208, 251, 253–255,
 266, 279, 282
 Tron and, 59, 84, 140, 151, 160–167, 180,
 183, 185, 189, 217, 222, 241, 254, 263,
 267, 277, 279–281, 298n22, 307n53,
 314n17
 Toy Story and, 57, 144, 172, 211, 234,
 236–237, 252–253, 259–263, 266, 277, 279
 2001: A Space Odyssey and, 148, 155
 Westworld and, 152–153
 Whitney and, 153–154
Vol Libre (Carpenter), 98

von Stroheim, Erich, 6
Vortex Concerts, 20
Voyage dans la lune, Le (Méliès), 146, 173
Voyager flyby films, 49–52, 138, 159, 171,
 272

Wahrman, Michael, 40, 57, 175, 183, 196,
 206, 267–268
 Bob Abel and, 175
 background of, 281
 cartoon animation industry and, 232
 Digital Productions and, 183
 deGraf/Warhman and, 170–171, 196, 232,
 275, 281
 motion capture and, 206
 Omnibus and, 206
 Rand Corporation and, 40
Waisler, Andy, 211
Walczak, Diana, 195, 206, 281
Waldo C. Graphic, 207
Waldo suit, 202–204, 207–208, 212, 256
Walking with Dinosaurs (TV show), 266
Wall-E (Pixar), 262
Walt Disney Studios, 187, 247, 291n3
 acquisition of Pixar by, 265–266
 The Adventures of Ichabod and Mr. Toad and,
 245
 Aladdin and, 224, 232–233, 262, 273,
 275–276
 Animation Tracking System (ATS) and, 224
 audio-animatronics and, 202–203, 290,
 312n3
 Bambi and, 126, 263
 Beauty and the Beast and, 232, 251
 The Black Cauldron and, 225–226, 230, 275,
 317
 Black Friday and, 260
 Don Bluth and, 116–117, 164–165, 202, 263,
 314n15
 Broadway-style musical theater and, 259
 Nestor Burtnyk and, 32
 CADCAM and, 229
 CalArts and, 34, 70, 249, 303n5

CAPS and, 87, 229–232, 251, 273–274, 287, 315nn34,35

Randy Cartwright and, 222, 224, 273

Ed Catmull and, 128, 220, 236, 246, 248, 259, 266, 273

computers and, 217, 220–236

Dinosaurs and, 3, 263

Disney Animation Logistics System (DALS) and, 315n34

Donald Duck and, 242, 317n30

Dumbo and, 219, 249

Michael Eisner and, 189, 226–230, 234, 236, 260, 265, 276, 315n42

European immigrants at, 14–15

family entertainment and, 261

Fantasia and, 14–15, 219, 276, 291n3, 292n4

Oskar Fischinger and, 14–15, 292n4

games and, 116

Sari Gennis and, 176

Tad Gielow and, 236–237, 275

Francis Glebas and, 138

Eric Goldberg and, 134

Goofy and, 127, 317n30

government work and, 203

Joe Grant and, 249

The Great Mouse Detective and, 226–228, 275

growth strategies of, 249

Hewlett-Packard and, 219

hidden line software and, 227

Jim Hillin and, 275

Max Howard and, 237

ImageMovers Digital and, 212

imagineers of, 202–203, 225, 228, 275–276, 290

IMI computers and, 225–226

Dave Inglish and, 275

innovation and, 231–234

job losses at, 265

Steve Jobs and, 246, 252, 266, 276

Scott Johnston and, 202, 236–237, 276

The Jungle Book and, 217, 219

Katzenberg and, 177, 189, 211, 226, 229, 233–236, 243, 251, 260, 262, 265, 276

Kinsey and, 243

Kroyer and, 84, 167, 222–223, 276

Lady and the Tramp and, 217, 225, 249

Lasseter and, 2, 217–218, 225, 236, 241–242, 247–252, 259–260, 266, 277

The Lion King and, 224, 232–233, 264, 276

Lisberger and, 159–161, 241, 267–268, 277

The Little Mermaid and, 201, 219, 225, 229–232, 263, 275

live-action and, 201–202

Mary Poppins and, 160

Matthews and, 296n33

Mickey Mouse and, 236, 251, 317nn29,30

Mickey's Prince and the Pauper and, 251

military and, 45, 124, 203

Ron Miller and, 165, 189, 217–218, 226, 307n53, 313n1

motion capture and, 201–203, 211–212

MOVIE.BYU and, 67

Nine Old Men of, 222

Oilspot and Lipstick and, 229–230

Oliver and Company and, 227–229

One Hundred and One Dalmations and, 233, 245, 249

Paperworks and, 268

performance-capture projects and, 212, 312n22

Dan Philips and, 195

photography and, 219, 222

Pinocchio and, 14, 126, 133, 213, 217, 219, 251

Pirates of the Caribbean and, 262

The Polar Express and, 199, 209, 212, 282, 312n22

Tina Price and, 279

Joe Ranft and, 279

reputation of cartoonists at, 128, 220, 261

The Rescuers Down Under and, 232, 251

shorthand stylization and, 245

SIGGRAPH and, 161

Silly Symphony system and, 248, 317n30

Tom Sito and, 3–4

Sleeping Beauty and, 222

Walt Disney Studios (cont.)
 Smith and, 135, 220
 Snow White and the Seven Dwarves and, 133,
 202, 218, 248, 259–260, 263, 281, 312n2
 Vibeke Sorensen and, 280
 Steamboat Willie and, 247, 317n29
 theme parks and, 220, 290
 The Three Little Pigs and, 249
 traditional animation and, 32, 34, 177, 183,
 217, 222, 227, 233–234, 237
 Tron and, 59, 84, 140, 151, 160–167, 180,
 183, 185, 189, 217, 222, 241, 254, 263,
 267, 277, 279–281, 298n22, 307n53,
 314n17
 Twenty Thousand Leagues Under the Sea and,
 160
 2D shading software and, 236–237
 Bill Tytla and, 219
 Victory through Air Power and, 124
 Wavefront and, 196
 Who Framed Roger Rabbit? and, 170, 201,
 211–212, 232, 249, 251
 Richard Williams and, 280
 Kathy Zielinski and, 169
Walt Disney's Wonderful World of Color (TV
 show), 203
Walter Cronkite's Universe (TV show), 140
Warhol, Andy, 21
War Memorial Center, 19–20
Warner, Michael, 161
Warner Bros., 5, 8, 265, 275–276
 cartoon animation industry and, 220, 224,
 236–237
 games and, 111, 120
 influence of, 236
 visual effects and, 160
 Taz and, 224
Warner Communications, 111–112, 116–117
Warnock, John, 66, 79
Watson, Thomas, Jr., 73, 77
Watson, Thomas, Sr., 73
Wavefront, 70, 172, 196, 206, 227–228
Wayne, Ron, 315n2

Weaver, Sigourney, 7
Websites, 2, 45, 89, 239
Wedge, Chris, 59–60, 97, 281
 background of, 59–60
 Blue Sky and, 60, 164–165, 263–264
Wein, Marceli, 32, 70, 132
Weinberg, Richard, 57, 79, 100, 182, 281
Weiner, Don, 151
Weiner, Norbert, 93
Weinstock, Roy, 150
Weir, Peter, 258
Weitzman, Moses, 151
Welles, Orson, 6, 8, 15, 231
Wells, Frank, 251
Wesley, Ken, 142
WestStar/Mihanan, 222
Westworld (MGM), 152–153
Whedon, Joss, 260
Where the Wild Things Are (Sendak),
 217–218
Whitney, James, 19, 23–26, 221, 281
Whitney, John, Jr., 70, 135, 137, 171
 background of, 25–26, 29–30, 281–282
 Gary Demos and, 180–184, 187–188, 190,
 195, 197, 272
 Digital Productions and, 70, 77, 159, 161,
 167–169, 180–184, 187–188, 192, 195, 216,
 222, 242, 245, 272, 274, 278, 281–282,
 308n60
 Digital Scene Simulation and, 180
 motion capture and, 205–206
 reputation of, 180
 USAnimation and, 195, 231, 282
 visual effects and, 153–154
Whitney, John, Sr., 2, 38, 94, 123, 128, 147,
 221
 Abel and, 17
 Analog Cam and, 26, 28
 avant-garde and, 23–31
 background of, 23, 282
 Saul Bass and, 26–28
 Blum and, 25
 Digital Harmony and, 23, 28

experimental non-narrative filmmaking and, 24

as Father of Computer Graphics (CG), 23

Oskar Fischinger and, 19–20, 23–24

Foucault's pendulum and, 24

IBM and, 28–32

inventions of, 25–30

Motion Graphics Inc. and, 28

music and, 23–30, 148, 180, 282, 292n6

photography and, 23, 173

style of, 25

technical developments of, 25–26

works of, 25–30

visual effects and, 153

Whitney, Mark, 25

Whitney, Michael, 25

Whitney, William C., 126

Whitney-Reed RDTD, 29

Who Framed Roger Rabbit? (Walt Disney Studios), 170, 201, 211–212, 232, 249, 251

Whole Earth Catalog (Brand), 55, 82, 93

Wii (game platform), 121

Wilde, Oscar, 261

Wilhite, Tom, 160, 161, 165, 217

Williams, G. Mennen, 39

Williams, Lance, 66, 131–132, 135, 138, 140, 142, 144, 203, 282

Williams, Richard, 3, 127, 224

Williams, Steve 'Spaz', 100, 255, 282

Willie Wonka and the Chocolate Factory (film), 149

Willow (Lucasfilm), 243

Wilson, Gahan, 231

Winecki, General John, 43

Winky Dink and You (TV show), 17

Winston, Stan, 209–210, 256

Wired magazine, 244

Wire frames, 171

Wizardry (game), 120

Wizard of Oz (1939 film), 146

Wolf, Dave, 222, 315n34

Wolfe, Tom, 176

Wolper, David, 17, 308n4

Woodhead, Robert, 120

Works, The (CGL), 97, 130–140, 171, 221

World of Warcraft (game), 120

World's Fair (New York 1964–65), 7, 202–203, 278

World War I era, 5, 37, 45, 53, 201, 302n12

World War II era, 16, 19, 21, 37, 45–46, 53–55, 73, 92, 124, 203, 273, 280, 302n12

Wozniak, Steve, 56, 92, 94, 111, 239, 276, 315n2

Wright, Frank Lloyd, 25

Wu Ming (Whitney), 25

Wuts, Frank, 196

WYSIWYG (What You See Is What You Get) system, 84

Xander, Paul, 133

Xaos, 171

Xbox, 118, 266

Xerox PARC, 3, 35, 48, 55–56

Bob Abel and, 83

Alto computer and, 84, 88

corporate culture and, 82–88

corporate headquarters (Stamford, CT), 82, 83, 87

David DiFrancesco and, 85, 128

dress code at, 82–83

government work and, 48

hackers and, 93

Steve Jobs and, 88

Alan Kay and, 82–84, 88

photocopiers and, 82, 88

Rolling Stone article on, 83

Dick Shoup and, 82, 84–85, 87, 131

Alvy Ray Smith and, 82–87, 128, 131

Special Projects Lab and, 83

Yamauchi, Hiroshi, 114, 282

Yamauchi, Fusajiyo, 114

Yantra (Whitney), 25

Yellow Submarine (Beatles movie), 127, 140

Yokoi, Gunpei, 118, 282

Youngblood, Gene, 25, 28, 31, 34–35, 180

Young Sherlock Holmes (Spielberg), 57, 169,
 254, 314n18
Yu-Gi-Oh (game), 119

Zajac, Ed, 75
Zanuck, Darryl F., 5
Zappa, Dweezil, 99
Z-buffer, 286
Z Channel, 140
Zemeckis, Robert, 170, 211–212, 282
Zenith Corporation, 105
ZGRASS, 60
Zielinski, Kathy, 169
Zukor, Adolphe, 5
Zuse, Konrad, 37

Printed in the United States
by Baker & Taylor Publisher Services